Following are testimonials from women who joined Asheritah in the early days of the 2020 lockdown for daily live prayer calls. The overwhelming resonance of the REST prayer format in the months that followed led to the book you hold in your hands today.

God used *Prayers of REST* in my life by teaching me how to pray, using Scripture. These prayers helped me fix my eyes on Jesus, on His goodness, instead of all that was going on in the world. Praying together was very encouraging.

LAURIEN VAN BELZEN

Participating in *Prayers of REST* gave me a sense of community when the physical church was closed due to COVID. Engaging in prayer with these women every morning helped me focus on Jesus, His goodness, and His peace—no matter the circumstance. It was a blessing to be a part of that early prayer group!

CANDICE ANN

I was in the middle of figuring out how to deal with other issues before the pandemic happened. Add to that the stress and anxiety of being locked down and life seemed grim and depressing. When I found the *Prayers of REST* calls, it became something I looked forward to because I knew that God would be there. It was amazing the peace that those calls provided in an already turbulent time. I'm very appreciative of that time and how it changed my outlook and renewed my hope.

MERI WILLIAMS

God used those prayer times during the pandemic, to focus on Him and not what was happening around the world! I found a group of sweet ladies that I could be honest with in sharing my struggles and Asheritah always kept us focused on Him! The verse Asheritah always ended with (Jude 1:24–25) brought me such comfort and still does today! It was such a bright spot during the pandemic; I will always remember it with fond memories.

HANNAH MARKLEY

Prayers of REST stirs a deeper hunger in my heart to keep seeking Jesus. It makes me realize how precious prayer truly is to our Lord. Following the REST prayer prompt helps me to build my prayer life. Because of *Prayers of REST*, my prayer life has grown stronger little by little, and definitely has become more meaningful. More significantly, it helps me to evaluate how much more I still need to know my Lord and Savior.

JACLYN CASTRO

DAILY
PROMPTS TO
SLOW DOWN
AND HEAR
GOD'S VOICE

PRAYERS

OF

REST

ASHERITAH
CIUCIU

Moody Publishers

CHICAGO

All Scripture quotations, unless otherwise indicated, are taken from the Holy Bible, New International Version®, NIV®. Copyright ©1973, 1978, 1984, 2011 by Biblica, Inc.™ Used by permission of Zondervan. All rights reserved worldwide. www.zondervan.com The "NIV" and "New International Version" are trademarks registered in the United States Patent and Trademark Office by Biblica, Inc.™

Scripture quotations marked CSB are been taken from the Christian Standard Bible®, Copyright © 2017 by Holman Bible Publishers. Used by permission. Christian Standard Bible®, and CSB® are federally registered trademarks of Holman Bible Publishers.

Scripture quotations marked ESV are from the ESV® Bible (The Holy Bible, English Standard Version®), copyright © 2001 by Crossway, a publishing ministry of Good News Publishers. Used by permission. All rights reserved.

Scripture quotations marked NLT are taken from the Holy Bible, New Living Translation, copyright © 1996, 2004, 2015 by Tyndale House Foundation. Used by permission of Tyndale House Publishers, Inc., Carol Stream, Illinois 60188. All rights reserved.

All emphasis in Scripture has been added.

Wording from Scripture has been paraphrased and integrated into the devotional wording and prayers.

The concepts and verses behind some prayers and collections have been inspired by the works of other authors. These include the prayers Absolute Surrender, Eternal Perspective, Starting Your Work Day, and the collection Prayers for Overcoming. Two collections were based on the author's book *Unwrapping the Names of Jesus* and *Uncovering the Love of Jesus*.

Published in association with Tawny Johnson of Illuminate Literary Agency, www.illuminateliterary.com.

Edited by Amanda Cleary Eastep
Interior and cover design: Erik M. Peterson
Cover image of geometric pattern copyright © 2020 by RODINA OLENA / Shutterstock (485991985). All rights reserved.
Author photo: Ashley McComb Productions

Library of Congress Cataloging-in-Publication Data

Names: Ciuciu, Asheritah, author.
Title: Prayers of rest : daily prompts to slow down and hear God's voice / Asheritah Ciuciu.
Description: Chicago : Moody Publishers, [2022] | Summary: "Asheritah Ciuciu offers you a respite from your spiritual to-do list. She provides guided prayers that will focus your mind and heart on Scripture. Using a memorable acronym and daily Bible verses, this prayer devotional will guide you through worship, confession, stillness, and surrender"-- Provided by publisher.
Identifiers: LCCN 2021038698 (print) | LCCN 2021038699 (ebook) | ISBN 9780802419484 (hardcover) | ISBN 9780802498090 (ebook)
Subjects: LCSH: Prayer--Christianity. | Prayers. | BISAC: RELIGION / Christian Living / Prayer | RELIGION / Christian Living / Devotional
Classification: LCC BV215 .C555 2022 (print) | LCC BV215 (ebook) | DDC 242/.8--dc23
LC record available at https://lccn.loc.gov/2021038698
LC ebook record available at https://lccn.loc.gov/2021038699

Originally delivered by fleets of horse-drawn wagons, the affordable paperbacks from D. L. Moody's publishing house resourced the church and served everyday people. Now, after more than 125 years of publishing and ministry, Moody Publishers' mission remains the same—even if our delivery systems have changed a bit. For more information on other books (and resources) created from a biblical perspective, go to www.moodypublishers.com or write to:

Moody Publishers
820 N. LaSalle Boulevard
Chicago, IL 60610

1 3 5 7 9 10 8 6 4 2

Printed in the United States of America

For the women who joined together online for Prayers of REST
during unprecedented times: thank you.
May you always find rest in God's presence.

CONTENTS

LET'S GET STARTED

"TEACH ME HOW TO PRAY, LORD," I wrote in my journal.

I'd just read the story of Jesus' disciples making that very request, and I figured honesty was a good place to start.

My pen scratched against the paper: "I'm embarrassed to admit that even though I grew up in a Christian home, and I should be an expert at this by now, I feel like a kindergartener when it comes to prayer."

I was thirteen at the time, just beginning to consider my relationship with Jesus as personal and not merely inherited from my parents.

That I thought I should be an "expert" in prayer at such a young age amuses me now. But my desire was earnest. In my few years in Christendom, first as a pastor's kid and then as a missionary kid, I had witnessed some people talk to God with both reverence and familiarity. There was power in their words and conviction in their speech—characteristics that had nothing to do with a demanding spirit or a bargaining tactic, but had everything to do with a place of quiet rest.

And I wanted that for myself too.

So I asked God to teach me how to pray.

And two decades later, He's still teaching me to this day. I'm not any closer to "expert" status now than I was then, but I could tell you hundreds of stories of how God met me in prayer, how He's tenderly taking me deeper in this place of quiet rest, how

He's expanded my vocabulary and is giving me confidence to ask without doubting.

But I still struggle some days.

As a mom to three kids eight and under, I'm tempted to believe I don't have time for prayer. As a millennial who's active on social media, I'm easily distracted thirty seconds into my prayers. And as a twenty-first-century woman, I struggle to turn to God before turning to Google.

In other words, we're in the same boat—you and I.

If you're reading this right now, I'd venture to guess that you want to pray more, but you feel like you don't have time, you don't know what to say, or you just can't seem to focus.

Or perhaps, in your most honest moments, you'd admit that you don't *really* *want* to pray more—you've just heard that it's "the right thing to do," and you feel guilty for failing God.

You're not alone.

A COMMON SECRET STRUGGLE

A 2018 survey by Crossway revealed that the number one obstacle to a thriving prayer life is *distraction,* followed closely by indifference, busyness, and loss for words.[1] Millions of Christians like you and me sit in church pews on Sundays but struggle to carry that conversation with God into our Monday–Saturday.

And I'm not just referring to our environment. Sure, the people living with us are distracting; the cable news droning in the background is distracting; the constant pings and buzzes on our phones are distracting.

But what about those rare blissful moments when your environment is quiet but your thoughts are racing? Have you ever tried to quiet your mind and be still with God? *It's hard!*

You've experienced this too, haven't you? You start praying, but before long, you're thinking about that bill that needs to be paid, the oil that needs to be changed in the car, that friend whose birthday is coming up—basically everything BUT your conversation with God.

Most of us struggle in secret, ashamed of our prayerlessness and fearful of being judged. So we carry on with our lives as if nothing's wrong, but deep inside, we

wonder if we're missing out.

I believe one of the greatest dangers facing Western Christians today is not external persecution but internal distraction. It's not theologically inaccurate prayers that will be our undoing, but our utter *lack* of prayer.

We are a distracted and divided people, and God is calling us to rediscover the unity, devotion, and joy found only in His presence.

When God's people pray, the first thing to change is not our country nor our circumstances but our very selves. We become women and men who seek His face with earnestness. We become those who call on Him not just for a few minutes in the morning but every moment of our day. We become the very fragrance of Christ to a broken world because we become aware of His constant presence in our everyday lives.[2]

So how do we become such people of prayer?

In my years of ministry, and in reading church fathers and mothers who've gone before us, I've discovered that God can certainly work in dramatic ways— breaking chains of addiction, redeeming dysfunctional relationships, transforming presupposed destinies—but most often, He chooses to work through daily means of grace: small habits built into our daily rhythms that gradually shape our affections and behaviors through the Spirit's work within us.

In my own life, I've found that when I start small—tiny, even—I develop spiritual habits that can grow and change with each new season. Recent brain science confirms that incremental changes over time lead to momentum and transformation.[3]

That's how Prayers of REST was born.

HOW PRAYERS OF REST BEGAN

In the spring of 2020, it felt as if our world was falling apart. Due to the COVID-19 pandemic, most of us went from daily commutes to video calls; from corporate worship to live-streamed services; from family gatherings to sheltering at home. We lost jobs, we lost loved ones, and we lost rhythms of life.

Two weeks into our quarantine, I found myself on the floor of my laundry room: heart racing, hyperventilating, swiping at the tears streaming down my cheeks. "I

can't do this anymore," I whispered, over and over again. In the stillness came the words: "God is our refuge and strength, an ever-present help in trouble" (Ps. 46:1).

The verse, memorized long ago, brought comfort, but it also presented an invitation: I sensed God's gentle call to meet with Him each day to find my refuge and *rest* in Him.

I knew I wasn't the only one struggling, so I invited my online community to join me for a live prayer call each morning. I didn't know if anyone else would show, but I knew *I* needed to start my day face-to-face with the Lord.

So I hit "Go live."

And in that sacred space on my closet floor, surrounded by dress clothes that would go unworn for months, God began to move. Dozens of women from around the world joined together for eight weeks of daily prayer calls, using the REST prayer format to guide us into **R**eciting God's goodness, **E**xpressing our neediness, **S**eeking His stillness, and **T**rusting His faithfulness.

We learned how to pray not by reading a book or sitting in a lecture, but by actually praying together. And each morning, God filled our hearts with His peace in a pandemic world—a miracle that didn't make headlines, but made our quarantine experiences dramatically different from that of our neighbors.

Eventually, the daily calls turned into a weekly prayer podcast called "Prayers of REST," so listeners could join in prayer regardless of time zones. Again, God's Spirit worked mightily, bringing together thousands of listeners from over a hundred countries, many of which were closed to missionary work.

The good news of Jesus brought hope to a broken world despite closed borders and locked-down countries! Such is the goodness of God in answer to prayer. Such is the power of the gospel.

Eighteen months after that laundry room moment, I still found myself amazed at what God had done. And I was humbled that He'd used my weakness to invite a new generation to experience His rest.

WHAT EXACTLY IS A PRAYER OF REST?

Throughout the book, each day is set up in a similar pattern in order to lead you into restful prayer.

We begin with a key verse or two that serves as our focal point for prayer. I've learned that the surest way to grow in our confidence in prayer is to pray God's Word. Praying God's Word is also an excellent way to grow in our theology (our knowledge of God) and our devotion (our love for God), so Scripture serves as the underpinning of each prayer. You'll also find additional passages "For Further Prayer and Study" at the bottom of each prayer if you'd like to continue the conversation with the Lord and go deeper.[4]

Before you begin, I encourage you to find a quiet place where you won't be interrupted, and take a deep breath as you become aware of God's presence around you and within you. Breathing deeply isn't Eastern mysticism, nor should Christians be afraid of slowing our breathing. In fact, researchers have found that just a few minutes of deep breathing helps our God-given nervous system move from a "fight-or-flight" response to a "rest and relax response," which continues to affect our well-being long after we've ended our prayer.[5]

After a few deep breaths, read the day's Scripture again, then follow along as you pray through the acronym REST:

RECITE GOD'S GOODNESS

We begin by praising God for who He is and what He has done in our lives. I've attempted to highlight attributes of God identified in the key verse and to lead you in worshiping Him. I encourage you to pause after reading this section and thank God for *specific* ways He has revealed that aspect of His character in your own life.[6]

EXPRESS YOUR NEEDINESS

Prayer isn't just about praising God or asking for things—it's allowing God to shape our inner beings. So we confess our sins and acknowledge our need for God and His forgiveness. Looking at the key verse, I identified specific sins that the passage brings to my mind, hoping this will serve as a springboard for your own personal confession. I've also verbalized my own needs for spiritual growth and transformation, in the hope that it will prompt you to express your own neediness to God.[7]

Seek HIS STILLNESS

After confessing our sins and needs to God, remember God's promise to be faithful and just to forgive our sins and cleanse us of all unrighteousness (see 1 John 1:9–10). Bask in God's glorious love for you, and let Him quiet you with His love. Throughout Scripture, we're exhorted to be still before God, so I've intentionally included this space for you to simply be quiet with Him. If prayer is a conversation (and it is), then this is your chance to let God's Spirit speak to your spirit.

Trust HIS FAITHFULNESS

We all suffer from soul amnesia, forgetting who God is and what He has done from one day to the next.[8] This is the place where we preach to our own hearts, reminding ourselves of how God has been faithful throughout history. So we tell ourselves the gospel story over and over again, until it becomes the narrative framework of our own lives. With such assurance of God's faithfulness, we can then bring our burdens before the Lord and entrust them to His loving care, confident that He will continue to be faithful in our lives, just as He has always been. This is the place to bring your specific requests to God, and then end by declaring to Him and to yourself: God, I trust You.

The acronym itself, REST, serves as a reminder that God welcomes us to cease striving, to stop worrying, to pause our hustling, and to rest in Him.

This is why I believe it's so important that we train ourselves in prayer—not just intercessory prayer or warfare prayer, which certainly have their place, but also restful prayer, or if you will, *prayers of rest.* These prayers are pauses in our day when we stop what we're doing and become aware of God's presence alongside us, inviting us to live life empowered by His Spirit, not our own limited resources.

As you practice this daily habit of Prayers of REST, I hope the acronym will become engrained in your memory, an easy-to-retrieve mnemonic device that becomes your lifeline when anxiety takes your breath away and worry keeps you up at night.

I hope you become proficient in applying the Prayers of REST framework to any passage of Scripture, learning to wield the sword of the Spirit against the enemy in his conniving schemes.

Finally, I hope your journey of learning to pray doesn't end with you, but

becomes part of the legacy you leave for the next generation. I hope these Prayers of REST become a teaching tool for your own children, discipleship groups, and churches, equipping the saints to do the good work God has called all of us to do (see Ephesians 4:12–16).

HOW TO USE THE PRAYERS OF REST BOOK

If you're one of the many who don't know *what* to pray, I hope the words of these prayers will help you verbalize what's on your own heart. And if you feel indifferent? Well, a quick scan of the titles of the prayers will surely reveal pain points that will cause you to long for rest in God's presence. Each prayer can be read in less than two minutes, so busyness ought never to get in the way, but it can easily serve as a springboard to longer prayers. May this book become worn with use as you make your way into God's throne room again and again.

To help you grow a habit of daily prayer, I've structured this book into collections of prayers centered on common prayer requests and common struggles. If you're eager to dive in, you may want to start with Resting in the Promises of God, Prayers for Overcoming, or Prayers for Others.

But I've also included collections of prayers we might not think to pray, but that serve to form our souls, our theology, and our affections with the good news of Jesus. These were some of my favorite prayers to write, and I hope they stir in you great affection and devotion to our King Jesus.

Some of these collections correlate with books I've read or written myself. Where that is the case, I've noted those titles in the endnotes if you'd like to further explore that particular topic. Additionally, I've created a partial index at the back of this book if you want guided prayers at particular times of the calendar or liturgical year.

Whether you read this book straight through or jump in and out of collections, I encourage you to follow these simple steps for habit formation:

1. Start Small

The daily prayers are intentionally brief to avoid overwhelm. Because it takes less than sixty seconds to read, you'll be more likely to remain consistent even on the days you don't "feel like it." And remember that God doesn't despise small

beginnings (see Zechariah 4:10) but rewards faithfulness day after day. Ask Him to help you be consistent in your tiny prayer habit, and He will do it![9]

2. Link Your Habit

Think about your daily routine: what's something you do each day without even trying? Maybe it's making your morning coffee, brushing your teeth at night, or sitting in the carpool line. Identify one established habit, and then link your new prayer habit to your established one, either doing them at the same time or immediately after. This way you'll never forget to pray, and over time you'll feel it's a natural part of your daily life.[10]

3. Celebrate Growth

God is the One who plants the seed of His Word in our hearts, and He's also the One who causes it to grow. As you become more fluent and consistent in prayer, pause to celebrate that growth—God's the One who's doing it! He's transforming you into a person of prayer, and as you look back on the past couple weeks, you can probably see other changes He's making in your life.[11]

4. Personalize Your Habit

God made you just the way you are, with your own unique genetic makeup and personality. And He welcomes you to come to Him just as you are. Resist the temptation to compare your prayer life with someone else's. In fact, embrace creativity and individuality when it comes to your prayer habit. Are you a kinesthetic learner? Try writing out your prayers. An auditory learner? Try listening to the *Prayers of REST* podcast while you pray. A visual learner? Consider adding highlights and doodles to your prayers. God is the originator of creativity, and He welcomes your creativity in conversation with Him.[12]

5. Build Your Habit

Now that your prayer habit is a regular and enjoyable part of your day, you can build a rhythm of prayer that is unique to you. Try expanding your prayer time from 2–3 minutes to five minutes, then ten minutes, and continuing as is appropriate to your season of life. Or perhaps you'll choose to build additional pauses for prayer

into your day, a few minutes at a time, linked to various habits in the morning, at lunchtime, in the afternoon, and in the evening.

There's no right or wrong way to pray as long as you are seeking God with a sincere heart. Just as Jesus taught His disciples to pray, so He will teach you through His Spirit, guiding you into your new prayer habit and leading you deeper in conversation with Him.

You'll find additional training materials and prayer resources, as well as the *Prayers of REST* podcast, at *www.prayersofrest.com*.

I'm so grateful we serve a God who is not a heartless taskmaster, but a compassionate and gracious God, slow to anger and abounding in faithful love, welcoming us into His presence to find rest for our souls. He is the God who is calling to you, inviting you, and drawing you into a life of rest through prayer.

As we begin this journey toward starting a prayer habit, may I pray a blessing over you?

Now to Him who is able
to keep you from stumbling,
and to present you before His glorious
presence without fault and with great joy,
to the only God our Savior be glory and
majesty, power and authority
through Jesus Christ our Lord, before all
ages, now, and forevermore.
Amen
(Jude 24–25)

—

FINDING
QUIET
REST

—

REST FOR YOUR SOUL

"Come to me, all you who are weary and burdened, and I will give you rest.
Take my yoke upon you and learn from me, for I am gentle and humble in heart,
and you will find rest for your souls. For my yoke is easy and my burden is light."

MATTHEW 11:28-30

RECITE GOD'S GOODNESS

Thank You, Jesus, for Your invitation to come to You, even when I'm tired and
have nothing to offer. You are gentle. You are humble. And You promise not just
comfort or reassurance, but rest for my soul. Thank You.

EXPRESS YOUR NEEDINESS

O God, I need You. So often I rush through life, collapsing at the end of the day,
exhausted. You know how tired I am. Help me slow down and acknowledge the
weight of my burdens. I'm worn out. I'm weary. I can't do this on my own.
I need You.

SEEK HIS STILLNESS

Take a few moments to become aware of God's loving presence surrounding you this
very moment. Just be still with Him.

TRUST HIS FAITHFULNESS

Precious Jesus, You don't turn away anyone who comes to You. I bring my
heavy burdens and lay them at Your feet. I trade all my big expectations for
Your simple expectation: to love You and to love others. What a light load,
for You have loved me first. So God, I trust You.

For Further Prayer and Study

Exodus 33:14 • Psalm 116:7 • Jeremiah 6:16 • John 7:37 • 1 John 5:3

GOD IS OUR REFUGE

"God is our refuge and strength, an ever-present help in trouble.
Therefore we will not fear."

PSALM 46:1–2

RECITE GOD'S GOODNESS

O God my Refuge,[1] You command the universe, yet You long for a relationship with those You created. What a privilege! Thank You that You are not removed from Your creation, but You are here with us, our refuge and strength. Always present. Always loving. Thank You, God.

EXPRESS YOUR NEEDINESS

I confess that even though You are available, so often I don't run to You. It's so easy to run to my phone, to my pantry, to my preferred distraction instead of running to You. My heart is prone to wander. Draw me back to Yourself in steadfast love and devotion.

SEEK HIS STILLNESS

Confess what distracts you from running to God, and ask Him to give you a desire for Himself. Then sit quietly with your loving God, who desires to be your refuge and strength.

TRUST HIS FAITHFULNESS

Lord God, because of Your perfect love, I have nothing to fear. No matter how bad things get, I am not a slave to fear because perfect love casts out fear, and You are love. So I place before You the very things that cause my heart to tremble, and I trust You.

For Further Prayer and Study

Exodus 15:7–11 • Psalms 9:9; 18:1–2; 34:4 • Lamentations 3:57–58

RESTING IN GOD'S SALVATION

"This is what the Sovereign LORD, the Holy One of Israel, says: 'In repentance and rest is your salvation, in quietness and trust is your strength, but you would have none of it.'"

ISAIAH 30:15

RECITE GOD'S GOODNESS

O Just and Gracious God, You welcome us not because of what we offer, but because of who You are. You are faithful, gracious, compassionate, and kind. Thank You for inviting me to turn from old habits and find rest in You.

EXPRESS YOUR NEEDINESS

God, it's humbling to recognize how foolish I am to turn to false saviors. My heart is prone to wander, even though those places never offer the peace I seek. Forgive me for all the ways I run away. Give me *a heart that seeks hard after You;* help me return to You, rest in You, and be quiet with You.

SEEK HIS STILLNESS

Become mindful of God's loving presence surrounding you this very moment. Allow His peace to fill you, His love to quiet you. Be still.

TRUST HIS FAITHFULNESS

O God, You are the unchanging One; even when I'm fickle, You remain faithful to Your character. Thank You that You receive me whenever I come back to You. You never turn Your back on me or send me away. I trust You with everything that's on my heart today.

For Further Prayer and Study

Exodus 14:14 • Isaiah 30:15–18; 32:17 • Jeremiah 29:12–13

RESTING IN THE FINISHED WORK OF JESUS

"Have the same mindset as Christ Jesus: Who, being in very nature God, did not consider equality with God something to be used to his own advantage; rather, he made himself nothing by taking the very nature of a servant, being made in human likeness."

PHILIPPIANS 2:5–7

RECITE GOD'S GOODNESS

Loving God, I praise You for Your loving obedience to the point of death on a cross. It was love that held You there. I've been forgiven because of Your sacrifice, but I have hope because of Your glorious resurrection. You are the victorious King, and I bow before the Lord of lords.

EXPRESS YOUR NEEDINESS

I get caught up in daily responsibilities and worries, quick to forget the good news of who Jesus is and what He accomplished on the cross. Forgive me. Draw me back to the beauty of the gospel and Your love for me in Jesus Christ. Help me rest in the finished work of Jesus.

SEEK HIS STILLNESS

Ask God if there's anything He'd like to show you about resting in the finished work of Jesus, and just be still as you listen to His voice.

TRUST HIS FAITHFULNESS

O Jesus, You humbled Yourself by walking dusty roads, washing dirty feet, and touching the shunned. Not only are You good, but You are powerful, Lord above all. If anyone is trustworthy with my life, my burdens, and my loved ones, it is You. I trust You.

For Further Prayer and Study

Matthew 20:26–28 • John 1:1–18 • Romans 8:3 • Hebrews 2:17

RESTING WITH THE GOOD SHEPHERD

"The thief comes only to steal and kill and destroy;
I have come that they may have life, and have it to the full."

JOHN 10:10

RECITE GOD'S GOODNESS

O Gentle Shepherd, You've come to bring life to the fullest, even in the hardships I'm facing. You are so good that You would not abandon me because of my own wandering heart, but You seek out Your lost sheep, remaining faithful and steadfast, gently shepherding me and leading me into green pastures.

EXPRESS YOUR NEEDINESS

Like a silly sheep, I search for greener pastures only to stumble upon poisonous distractions. Forgive me for running to all the wrong places, secretly believing that *something else* will comfort my heart. In Your kindness, turn my heart toward You alone so that I will again discover that You are enough.

SEEK HIS STILLNESS

In the next few moments, confess how you wander, and ask God to help you stay close to the Good Shepherd. Then allow His peace to fill you, His love to surround you.

TRUST HIS FAITHFULNESS

Lord Jesus, You are my Good Shepherd. A hired shepherd would run away from danger, but not You. When the enemy of our souls came against us with sin and death and destruction, You ran headlong into that threat, laying down Your own life for us. God, I can trust You. I trust that You are faithful.

For Further Prayer and Study

Psalm 65:11 • John 3:14–21 • Romans 5:17

RESTING IN GOD'S SOVEREIGNTY

*"Lord Almighty, the God of Israel, enthroned between the cherubim,
you alone are God over all the kingdoms of the earth."*

ISAIAH 37:16

RECITE GOD'S GOODNESS

King of the Universe, You reign over the whole world. You made us; we are Your people. Our distress does not go unnoticed, rather, You bend low from on high to hear our desperate cries. I praise You for caring enough to listen when we cry out to You.

EXPRESS YOUR NEEDINESS

Lord God, so often I act as if I rule my life. But crises reveal that I'm not really in control—You are. Forgive me for pride, for giving other things more influence in my life than You. Help me fix my eyes on You and give You the honor and respect You deserve.

SEEK HIS STILLNESS

Imagine bringing your burdens and placing them into God's loving hands. See Him holding them, relieving you of their weight. Be still with Him.

TRUST HIS FAITHFULNESS

O Lord, You are not an idol made of wood or stone that can be burned or lost or stolen. You are the one true God, my Creator, who made humanity and breathed life into us. You are the covenant-keeper who keeps His promises and is always faithful. So I trust You with all the worries that have weighed heavy on my heart.

For Further Prayer and Study

Deuteronomy 10:12–22 • Psalm 34:17 • Daniel 4:34–35

RESTING IN THE SPIRIT'S INTERCESSION

"In the same way, the Spirit helps us in our weakness. We do not know what we ought to pray for, but the Spirit himself intercedes for us through wordless groans."

ROMANS 8:26

RECITE GOD'S GOODNESS

Heavenly Father, what a gift You've given us—filling us with Your own Spirit! Not just indwelling me, but also interceding for me. When I don't know what to say, You still welcome me to come. When I have no words, Your Spirit searches my heart and prays on my behalf. Thank You, Father, for that incredible gift!

EXPRESS YOUR NEEDINESS

My prayers feel weak, Lord. So often I don't know what to say, so I just skip prayer altogether. Forgive me for measuring effectiveness by how eloquent my prayers are. Teach me to pray, just as You taught Your disciples, Jesus. And teach me how to be still, allowing Your Spirit to speak on my behalf.

SEEK HIS STILLNESS

Be still before God, becoming aware of His Spirit's prayers on your behalf. Don't rush to fill the silence. Just be with your heavenly Father.

TRUST HIS FAITHFULNESS

Lord God, You don't need me or my prayers, but still You invite me to keep coming back to You. Thank You for listening to me on my good days and bad. Even now Your Spirit is bringing You my prayers, and You hear me. Thank You for growing me in conversation with You.

For Further Prayer and Study

Zechariah 12:10 • John 14:16 • Romans 8:15–16 • Ephesians 2:18; 6:18 • Hebrews 7:25

RESTING IN GOD'S POWER

"He got up, rebuked the wind and said to the waves, 'Quiet! Be still!'
Then the wind died down and it was completely calm."

MARK 4:39

RECITE GOD'S GOODNESS

Sovereign Lord who commands the winds and the waves, You created everything, and every molecule in the world must obey Your Word. Jesus, You are Lord over all, and You will reign forever and ever, seated at the Father's own right hand. I praise You!

EXPRESS YOUR NEEDINESS

Lord God, like the disciples in the boat, I also struggle with fear and faithlessness. And when I shift my gaze from You and stare at the storm around me, I sink into despair. I need You. Help me fix my eyes on You. I believe in You, Jesus! Help my unbelief.

SEEK HIS STILLNESS

Just as Jesus slept in the storm-tossed boat, without a concern in the world, so now rest in God's presence. Listen to Him speak peace over your life just as He spoke it over the waves.

TRUST HIS FAITHFULNESS

I place into Your hands those things that are heavy on my heart, Lord. You have always been faithful, and You will continue to be faithful in my life. I receive Your peace that passes understanding. I trust Your loving care and Your power to work all things for good.

For Further Prayer and Study

Matthew 17:20 • Mark 9:24 • Hebrews 11:1, 6

RESTING IN JESUS' LOVE

"As the Father has loved me, so have I loved you. Now remain in my love."

JOHN 15:9

RECITE GOD'S GOODNESS

Precious Redeemer, even when we were Your enemy, You loved us. You perfectly kept the Father's commands and perfectly remained in His love, and then placed Your Spirit within us so that we may remain in Your love. I praise You for the privilege of being found in Your love.

EXPRESS YOUR NEEDINESS

O Jesus, open the eyes of my heart to grasp the enormity of Your love in me, so that it overflows toward my family, friends, and coworkers. On my own, I cannot muster enough love for those difficult and hurtful people in my life. Show me how to love them by remaining in Your love.

SEEK HIS STILLNESS

Allow God to show you a glimpse of His overwhelming, unending, all-encompassing love that He offers you in Christ Jesus. Let Him quiet you with His love.

TRUST HIS FAITHFULNESS

Lord Jesus, You spoke these words before going to the cross, yet assured Your disciples that their mourning would soon turn to rejoicing. And now, as I await Your return, I rejoice in Your love, assured that soon I'll see You face-to-face. You've kept every promise You've ever made, so I can trust You.

For Further Prayer and Study

Zephaniah 3:17 • Hosea 14:4 • John 14:15–21; 15:9–13; 17:20–26 • Philippians 3:10–14

RESTING IN JESUS' REIGN

"The Son is the image of the invisible God, the firstborn over all creation. . . .
He is before all things, and in him all things hold together."

COLOSSIANS 1:15, 17

RECITE GOD'S GOODNESS

King Jesus, You rule over every molecule in the universe, and in You everything holds together. Nothing escapes Your dominion because You created all things, You reign over all things, and You will renew all things.

EXPRESS YOUR NEEDINESS

You have created me to delight in You, yet so often I'm self-absorbed, consumed with my own worries. Thank You for this gentle reminder to take my gaze off myself and fix my sight on You. I humble myself before Your greatness, comforted by Your reign. Help me find rest for my soul in You alone, for You rule sovereign over all!

SEEK HIS STILLNESS

Take a few moments to become aware of God's presence right where you are—His love enveloping you; His sovereignty ruling over you; and His goodness following you all the days of your life.

TRUST HIS FAITHFULNESS

You are the One I can depend on. You've never slipped from Your throne; there has never been a threat to Your reign. Even the forces of hell cannot stand against You and Your church. Your purposes will prevail. So I bring my burdens and lay them before you, trusting that You are faithful.

For Further Prayer and Study

Isaiah 26:3 • John 1:1–18 • Romans 11:33–36 • 1 Corinthians 1:9 • 2 Corinthians 1:19;
Colossians 1:15–17

RESTING IN THE ASSURANCE OF A BEAUTIFUL FUTURE

"I saw the Holy City, the new Jerusalem, coming down out of heaven from God, prepared as a bride beautifully dressed for her husband."

REVELATION 21:2

RECITE GOD'S GOODNESS

O Lord God who inhabits eternity, my soul comes alive with the hope of what is to come! In Your kindness, You don't discard the broken and bruised, but You make all things new. I praise You for promising to dwell with us in all Your marvelous glory, when we will gaze upon Your beauty and see you face-to-face. What a glorious day that will be!

EXPRESS YOUR NEEDINESS

Lord God, how easily I forget the reality that I'm living in—this moment of Your union with Your people. Would you cause me to long for You with all the longing of a bride on the eve of her wedding day? I want to want You with all my heart.

SEEK HIS STILLNESS

Try to picture God wiping every tear, annihilating death and sickness, and receiving the water of life from Jesus Himself. Be still before God, and allow His loving presence to fill your heart.

TRUST HIS FAITHFULNESS

What a beautiful picture of the fulfillment of Your promise from Genesis 3:15! There is no doubt about it: You will keep Your promise to dwell with us again because You are faithful and true. I trust You.

For Further Prayer and Study

Isaiah 35 • Zechariah 2:10–13 • 2 Corinthians 5:17; 6:16 • Revelation 21:3–7

RETURNING TO REST

*"Return to your rest, my soul, for the L*ORD *has been good to you."*

PSALM 116:7

RECITE GOD'S GOODNESS

O Giver of every good and perfect gift—even the ability to rest my body and my soul comes from You. Only You offer the protection and safety I need. In You alone can I rest securely.

EXPRESS YOUR NEEDINESS

To be honest, my soul does not rest in Your goodness as it should. I'm either hustling from one project to the next, or I'm numbing my exhaustion with entertainment and distractions. My heart is restless; help me find my rest in You, Lord. Let me become so aware of Your goodness that my soul finally sighs with relief.

SEEK HIS STILLNESS

If you're able, lie flat on your back and take a few deep breaths as your whole body quiets down. Imagine resting in the goodness of God. There's nothing you need to do or say—just rest in the assurance that your heavenly Father holds you securely in His loving embrace.

TRUST HIS FAITHFULNESS

God, You are the One I can fully rely on. My soul finds rest in You alone. May Your goodness and mercy follow me all the days of my life, so that I may rest securely in Your presence as long as I live.

For Further Prayer and Study

Psalms 23:2, 6; 62:1 • Isaiah 30:15 • Matthew 11:28–30 • Colossians 1:15–17

PRAYING

LIKE

JESUS

TEACH US TO PRAY

"One day Jesus was praying in a certain place. When he finished, one of his disciples said to him, 'Lord, teach us to pray, just as John taught his disciples.'"

LUKE 11:1

RECITE GOD'S GOODNESS

O Jesus my Teacher, there's no request too big or too small for You. Thank You that I can be honest about my weaknesses and insecurities, and You welcome me with open arms. Thank You for opening the way to the Father. You are my Savior, my teacher, and my friend. I praise You!

EXPRESS YOUR NEEDINESS

Lord, I confess that I still have so much to learn when it comes to prayer. Help me adopt the posture of a student, humble and willing to receive Your instruction. I want to prioritize prayer in my life—that conversation with You would be my source of power, energy, and sustenance. Would you lead me in this?

SEEK HIS STILLNESS

Take a few moments to quiet your heart in God's loving presence surrounding you this very moment. Just be still with Him.

TRUST HIS FAITHFULNESS

Precious Jesus, just as You taught Your disciples how to pray, I trust that You will teach me and grow me in my prayer life. I can't wait to see how You will work in the days and weeks to come!

For Further Prayer and Study

Luke 10:42; 11:1–13 • John 14:26 • Romans 8:26–27

HOLY FATHER IN HEAVEN

"This, then, is how you should pray: 'Our Father in heaven, hallowed be your name.'"

MATTHEW 6:9

RECITE GOD'S GOODNESS

Precious heavenly Father, what a gift You've given us to be called children of God! Thank You that I don't have to fear when I approach You. Your name is a strong tower; I run to You and find safety. You are a patient, loving, and compassionate Father, and You welcome us to come to You as trusting children. I praise You!

EXPRESS YOUR NEEDINESS

I confess that most times when I pray, I'm more concerned about my own agenda and wants for the day than I am with Your name and Your glory. Forgive me, Father. Help me become so consumed with You that Your concerns become my own.

SEEK HIS STILLNESS

Take a few moments to be still with Your heavenly Father. Is there anything He wants to say to you?

TRUST HIS FAITHFULNESS

Your name is holy, Father God, and all the earth is filled with Your glory. One day every knee will bow in humble worship of Your name, and I humble myself before You now. I set You apart as holy in my heart and worthy of all honor and adoration. You are trustworthy and true, and I worship You!

For Further Prayer and Study

Proverbs 18:10 • Matthew 7:11; 23:9 • 1 Peter 1:17 • 1 John 3:1

GOD'S KINGDOM ON EARTH

"Your kingdom come, your will be done, on earth as it is in heaven."

MATTHEW 6:10

RECITE GOD'S GOODNESS

You are the King enthroned in heaven and reigning on earth. Nothing escapes Your notice; nothing is outside the realm of Your domain. Thank You, heavenly Father, for welcoming me into Your kingdom and inviting me to partner with You in Your work.

EXPRESS YOUR NEEDINESS

Lord Jesus, Your priority was to do the Father's will, but I confess that's not always the thrust of my prayers. Forgive me for being self-centered and self-seeking. Help me sacrifice my own wants for the sake of Your kingdom and Your work here on earth. You are enough.

SEEK HIS STILLNESS

How is God working in Your life these days? Take a few moments to quietly consider His kingdom expanding in you and around you, and be still with your heavenly Father.

TRUST HIS FAITHFULNESS

Father, Your kingdom is coming on this earth, and You've invited us to participate in Your glorious work here and now. Thank You for using imperfect people like me to accomplish Your plans. I am Yours. And You are mine. I trust You, God.

For Further Prayer and Study

John 6:38 • Matthew 4:17; 16:28; 26:39–42 • Acts 21:14

DAILY DEPENDENCE ON GOD

"Give us today our daily bread."

MATTHEW 6:11

RECITE GOD'S GOODNESS

Gracious and Generous Father, You have made us for Yourself, and our satisfaction is found in You alone. I praise You for generously providing everything we need. Morning by morning You meet me in this place of prayer and give me more than enough. I worship You.

EXPRESS YOUR NEEDINESS

In Your wisdom, You require us to come to You daily, but I confess I'd rather load up once for the whole week. Give me a hunger for You each day. Help me live in daily dependence on You, and cling to You as the source of every desire and the fulfillment of every need. I need You, and You are enough.

SEEK HIS STILLNESS

In what areas of your life do feel desperate need? Take a few moments to recognize God's generosity toward you, and rest in His loving presence right now.

TRUST HIS FAITHFULNESS

When I start to worry, help me actively trust You instead and discover more of Your radical generosity. No good thing do You withhold from those whose hearts trust in You. I trust You to give me all I need and more—abundantly more than I could ask for or imagine.

For Further Prayer and Study

Deuteronomy 8:2–5 • Exodus 16:16–35 • Psalm 56:3–11 • Matthew 6:34

FORGIVEN TO FORGIVE

"And forgive us our debts, as we also have forgiven our debtors."

MATTHEW 6:12

RECITE GOD'S GOODNESS

Merciful God, I praise You for forgiving my sins in Jesus Christ. You've cast them into the sea of forgetfulness, never to remind me of them again. How good You are, to not hold the sins of my youth against me. You wash me clean, and because of Jesus I stand righteous before You. I worship You!

EXPRESS YOUR NEEDINESS

I confess that I still struggle with holding grudges against those who wrong me. Even though I feel like some people don't deserve my forgiveness, the truth is that I don't deserve Yours either. Forgive me for being slow to forgive when You've forgiven me so much. Make me quick to forgive and seek restoration.

SEEK HIS STILLNESS

Bask in the blessed assurance that your sins are forgiven and all your iniquities are atoned for in Christ. Now, who is God calling you to forgive?

TRUST HIS FAITHFULNESS

You've said that the one who is forgiven much loves much. Help me become more aware of how great my sin was before You, and how much greater Your forgiveness is in Christ Jesus. Help me love and forgive as You have first loved and forgiven me.

For Further Prayer and Study

Exodus 34:7 • Psalms 32:1; 130:4 • Matthew 9:2 • 1 John 1:7–10; 4:11

DELIVERED FROM EVIL

"And lead us not into temptation, but deliver us from the evil one."

MATTHEW 6:13

RECITE GOD'S GOODNESS

Near-to-my-heart God, I don't have to face anything alone, because You are always with me, Your very Spirit my Guide through tricky moments. Thank You for generously providing everything I need right when I need it. You have been so good to me!

EXPRESS YOUR NEEDINESS

Just as Jesus responded to temptation with the Sword of the Spirit, help me also fight off the enemy with Your Word. Help me resist the devil with the truth of Scripture. I need Your help to memorize Your Word so that I'm prepared to respond when I face temptation.

SEEK HIS STILLNESS

Reflect on the temptations you faced in the past 24 hours. How was He present with you in those moments? Where was God providing a path of escape? Be still before God, and confess any sin He brings to mind, resting in His loving forgiveness.

TRUST HIS FAITHFULNESS

Heavenly Father, You are so faithful to always provide a way of escape out of any temptation. Give me eyes to see Your deliverance, and make my feet quick to run in the path of Your commands. You have always rescued those who cry to You, and I trust You to rescue me today too.

For Further Prayer and Study

Psalm 119:32 • 1 Corinthians 10:13 • Ephesians 6:10–20 • James 4:6–8

WITHDRAWING TO PRAY

"But Jesus often withdrew to lonely places and prayed."

LUKE 5:16

RECITE GOD'S GOODNESS

O God, how good You are to have preserved these details about Jesus' prayer life, that we may learn to imitate Him. Thank You for making Yourself available to Your children anytime and anywhere. Because of Jesus, we can boldly come before You whether assembled with others or by ourselves. You are so good to welcome us into Your presence!

EXPRESS YOUR NEEDINESS

As I consider Jesus' habit of withdrawing to pray, I realize how rarely I do this in my own life. I'm more likely to withdraw to check my phone or sneak a snack than to seek Your face. Help me get alone with You, God, not as my last resort but as my highest priority.

SEEK HIS STILLNESS

What are those places and times in your daily routine that you can get away with God? Even just for a few moments? Picture God already there, waiting for you. And in this moment, rest in His presence surrounding you and filling you.

TRUST HIS FAITHFULNESS

Lord, even though it feels nearly impossible to slow down my busy pace of life, You can help me do it. Show me how I can fold quiet breaks with You into my daily rhythm. Help me recognize opportunities for white space and get alone with You. I trust You alone.

For Further Prayer and Study

Matthew 14:23 • Mark 1:35 • Ephesians 6:18–20 • 1 Thessalonians 5:16–18

MORNING WHISPERS

*"Very early in the morning, while it was still dark, Jesus got up,
left the house and went off to a solitary place, where he prayed."*

MARK 1:35

RECITE GOD'S GOODNESS

O Living God, You're never asleep, never unavailable. Your mercies are
new every morning, and Your faithfulness is so great! Thank You for always
welcoming me, for awakening me each day with Your tender mercies. You are a
good, good Father, and I love You!

EXPRESS YOUR NEEDINESS

I confess that most days I'd rather sleep longer than sacrifice a few minutes to
get alone with You. *Change my heart, God! Make me long for Your presence* so
much that I create bedtime and morning routines that enable me to seek Your
face first thing in the morning.

SEEK HIS STILLNESS

*Take a few moments to become aware of God's loving presence surrounding you—
from the moment you opened your eyes to this very second. How is He calling you to
experience more of His love?*

TRUST HIS FAITHFULNESS

Lord God, You welcome me morning, afternoon, and evening, but there's
something special about exchanging morning whispers with You. I want to
seek You in Your Word before I interact with the world, so I surrender my daily
schedule to You. Remove whatever keeps me from seeking You first, and make
me long for more of You.

For Further Prayer and Study

Psalms 5:3; 84:1–2; 90:14; 121; 143:8 • Lamentations 3:22–23

PLEASED TO REVEAL

"I praise you, Father, Lord of heaven and earth, because you have hidden these things from the wise and learned, and revealed them to little children. Yes, Father, for this is what you were pleased to do."

MATTHEW 11:25–26

RECITE GOD'S GOODNESS

Lord of Heaven and Earth, You reveal Yourself to those the world considers unimportant. How I praise You! You show Yourself to those who seek You with their whole hearts, and You are pleased to uncover the hidden things to those whose hearts are devoted to You. How generous You are, Lord!

EXPRESS YOUR NEEDINESS

Forgive me for thinking too highly of myself, considering myself wise and learned, which ironically stands in the way of deeper communion with You. Help me take the posture of a child, eager to learn new things. I want to know You more.

SEEK HIS STILLNESS

Ponder the truth that God delights in revealing Himself to those who seek Him. What does this say about God? And is there anything that He wants to say to you?

TRUST HIS FAITHFULNESS

O Lord, You are all I want, all I really long for. My heart rejoices in You, and I trust in Your holy name! Thank You for welcoming me to receive the abundant delights of Your presence. Spread Your faithful love over me because I trust in You.

For Further Prayer and Study

Psalms 33:21; 36:7–10 • 1 Corinthians 3:2 • Hebrews 5:12–14 • 1 Peter 2:2

YOUR WILL BE DONE

"My Father, if this cannot pass unless I drink it, your will be done."

MATTHEW 26:42

RECITE GOD'S GOODNESS

Father God, I praise You for being perfect in all Your ways. Even when I don't understand You, I can trust You because You are good. When I walk through dark valleys and fiery trials, still Your presence never leaves me. I worship You!

EXPRESS YOUR NEEDINESS

I'm comforted that even Jesus asked for the cup of suffering to pass from Him. Because honestly, there are lots of situations in my own life I'd rather not endure. But as I face these hardships, help me say with Jesus: "Your will be done." May I long for Your will more than I desire my own comfort.

SEEK HIS STILLNESS

Make your requests known to God, big and small, and cast all your worries on Him. Then rest in His presence, knowing that He will do what is best.

TRUST HIS FAITHFULNESS

Thank You, Father, that I can always trust You to do the right thing, even if it's different from what I'm praying for. You see the world far broader than I see it—all the intricacies and ramifications of decisions that I could never foretell. I trust You to do what is right in every situation in my life and work it out for my good and Your glory.

For Further Prayer and Study

Matthew 6:10; 26:39–43 • John 6:38 • Hebrews 5:7

ONE WITH GOD AND ONE ANOTHER

*"I pray also for those who will believe in me through their message,
that all of them may be one, Father, just as you are in me and I am in you."*

JOHN 17:20-21

RECITE GOD'S GOODNESS

Precious Jesus, how kind of You to pray for me! Before I knew You, before I was even born, You were interceding before the Father on my behalf. I praise You for Your lovingkindness, and Your desire to be in me and I in You.

EXPRESS YOUR NEEDINESS

Help me value unity with other believers as much as You do. It's easy to get consumed with my personal relationship with You, forgetting that You've called me to be part of a larger community, all belonging to You. So I join myself to Jesus in praying: make us one.

SEEK HIS STILLNESS

Picture Jesus on the night He was betrayed, praying for you. And of all things He could pray for, He prays for your unity with God and with fellow believers. What does that say about Him? And what is He trying to say to you?

TRUST HIS FAITHFULNESS

On our own, we are selfish and self-destructive. Only You can accomplish this work of unity among us. So I trust You, Lord, to make us one with You and one another. May we persevere in Your love to the very end.

For Further Prayer and Study

2 Corinthians 13:11 • Philippians 2:1-4 • Ephesians 4:5-6

BEING WITH JESUS

"Father, I want those you have given me to be with me where I am."

JOHN 17:24

RECITE GOD'S GOODNESS

O Jesus, Your great love overwhelms me. On this last night, facing betrayal, torture, and execution, You prayed for *me*. You longed for all Your children to be with You. That's why You faced down the cross, desiring to spend eternity with us. How great is Your love!

EXPRESS YOUR NEEDINESS

It seems that You long to be with me even more than I long to be with You. Such love is beyond my comprehension. Stir in me a deeper love for You, a greater desire to be with You, not just someday in eternity, but here and now while I await Your return.

SEEK HIS STILLNESS

Quiet your heart and your mind as you to become aware of Jesus' loving presence with you right now through His indwelling Spirit. Just be with Him. Let His great love settle into your soul.

TRUST HIS FAITHFULNESS

In Your faithful love, You've gone to prepare a place for us to be with You forever, yet You've left Your Spirit to fill us. Lord Jesus, even though I've never seen You, my heart knows You and loves You. And I can't wait for the day I finally get to see You face-to-face!

For Further Prayer and Study

John 1:18; 14:1–3, 18–21; 16:12–15 • 2 Timothy 2:11–12

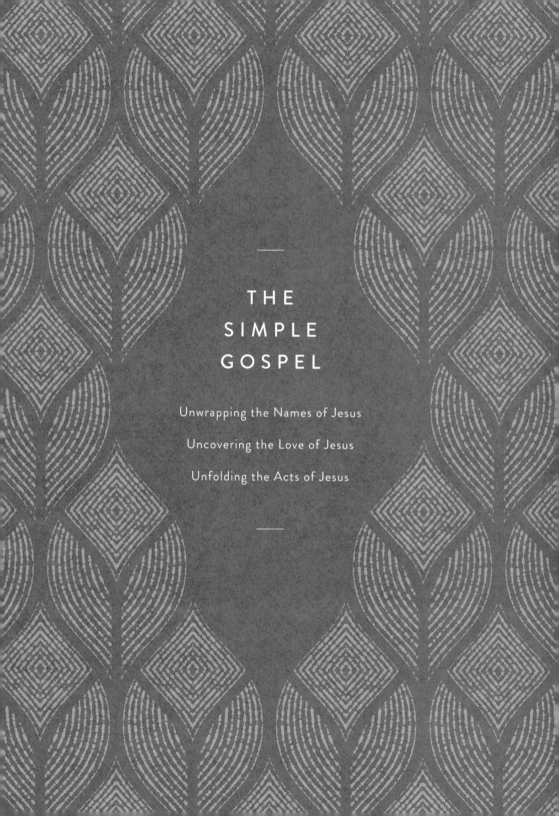

THE SIMPLE GOSPEL

Unwrapping the Names of Jesus

Uncovering the Love of Jesus

Unfolding the Acts of Jesus

*These prayers can be prayed
any time of year but can provide
guided prayer during Advent.[1]*

KING OF KINGS

*"Magi from the east came to Jerusalem and asked, 'Where is the one who has been born
king of the Jews? We saw his star when it rose and have come to worship him.'"*

MATTHEW 2:1–2

RECITE GOD'S GOODNESS

O King Jesus, You came humbly in a manger, worshiped by both shepherds
and magi; You allowed Yourself to be lifted on a cross, to the scorn of Romans
and Jews alike; yet You will return victorious, the King to rule all kings and all
nations. You are my King. I worship You.

EXPRESS YOUR NEEDINESS

Father, I want to honor You not just with my lips, but with my whole heart.
Consume me with passion for You. Transform my heart to respond with
devotion and adoration as befits the King of the universe. Let nothing compete
with my affection for You.

SEEK HIS STILLNESS

*Picture Jesus seated on His heavenly throne, worshiped by angels and heavenly
creatures. Enter His throne room, not as a fearful subject but as a child of the King,
and worship Him alone.*

TRUST HIS FAITHFULNESS

O Jesus, You've always kept Your promises, and I trust that You will return to
bring Your eternal kingdom here on earth. Even now, in these turbulent times,
You are reigning from on high. You alone are the true King, and You will reign
forever and ever.

For Further Prayer and Study

Jeremiah 23:5 • Zechariah 9:9 • John 19:14–16 • Revelation 19:11, 16

LIGHT OF THE WORLD

"When Jesus spoke again to the people, he said, 'I am the light of the world. Whoever follows me will never walk in darkness, but will have the light of life.'"

JOHN 8:12

RECITE GOD'S GOODNESS

O Great Light of the World, I praise You for not just speaking light into the darkness, but actually stepping into the darkness as the true light that gives life to everyone. Even death could not snuff out the light of life. You rose victorious, forever exalted—the Light of the world, my own light and salvation.

EXPRESS YOUR NEEDINESS

Shine Your light into my soul, illuminating the darkness and revealing what I'm hiding even from myself. I open my heart, my relationships, and my ambitions; search me, Lord. Let your light penetrate and convict my heart that I may confess my sin and walk in Your light.

SEEK HIS STILLNESS

Picture yourself walking into the light of God's presence. You are fully seen and fully known . . . and fully loved.

TRUST HIS FAITHFULNESS

God, I trust You with the darkness surrounding us today: Your light will overcome the darkness no matter how pervasive and invasive it seems. You've sent us as lights into the world, and the darkness of death and despair has no claim on us because You are the Light, and we are people of the Light, so we can trust You.

For Further Prayer and Study

Proverbs 4:18 • Matthew 5:14 • John 1:1–18

GOOD SHEPHERD

"I am the good shepherd; I know my sheep and my sheep know me . . .
and I lay down my life for the sheep."

JOHN 10:14–15

RECITE GOD'S GOODNESS

Good and Gentle Shepherd, You are the One who knows me and cares for me.
You lead me in green pastures and by still waters. You restore my soul. You saw
the consequence of sin and death and ran headlong to face it, laying down Your
life to protect us. What great love! I worship You.

EXPRESS YOUR NEEDINESS

God, I confess that, like a silly sheep, I often wander from You; help me stay
close to Your side. I pray also for my loved ones who are wandering: would You
seek them, save them, and bring them back into Your flock? Give me the heart
of the Good Shepherd who weeps over those who are wandering and missing.

SEEK HIS STILLNESS

Picture yourself as a sheep in the Good Shepherd's flock. See Him leading you into
green pastures, standing by your side in the dark valleys, and walking with you
toward still waters. Let His presence calm your soul.

TRUST HIS FAITHFULNESS

From the beginning of time, You have been our Shepherd. You sought us,
pursued us, and rescued us, and someday soon You will return for us, gathering
together all Your sheep from every tribe, nation, and language—one people
belonging to one God. I can't wait for that day!

For Further Prayer and Study

Psalm 23 • Ezekiel 34 • John 10:1–18

BREAD OF LIFE

"Then Jesus declared, 'I am the bread of life. Whoever comes to me will never go hungry, and whoever believes in me will never be thirsty.'"

JOHN 6:35

RECITE GOD'S GOODNESS

Heavenly Bread of Life, You came down from heaven to feed our hungry souls with Your very presence. Your body is the bread, broken for us; You nourish our souls and inner beings, energizing us for spiritual life and work with Your very self.

EXPRESS YOUR NEEDINESS

Jesus, You are everything I've ever wanted, but I so often turn to other things looking for satisfaction. Forgive me. Stir up my spiritual appetite for more of You. May everything else become distasteful as I learn to feast on Your daily bread of life.

SEEK HIS STILLNESS

Picture yourself as one of the hungry crowd, watching Jesus miraculously multiplying the little boy's lunch to feed everyone to complete satisfaction. Be still with Jesus, the One who feeds your hungry soul.

TRUST HIS FAITHFULNESS

From the garden of Eden—when You delighted in providing abundantly for Adam and Eve—to this very moment, You have always provided, not just for our physical needs, but in Jesus Christ, also for our spiritual needs. You give of Your very self to everyone who comes to You hungry. So I trust You to satisfy my soul.

For Further Prayer and Study

Deuteronomy 8:2–5 • Matthew 26:26 • John 6:1–58

MAN OF SORROWS

"He was despised and rejected by mankind, a man of suffering,
and familiar with pain."

ISAIAH 53:3

RECITE GOD'S GOODNESS

Man of Sorrows, You let go of the comforts of heaven to come and bear our burdens. You took upon Yourself the weight of our sin, grief, anger, betrayal, hurt, and rejection. If anyone knows what it means to carry sorrow in this world, it is You, Jesus, and You did it all for love.

EXPRESS YOUR NEEDINESS

What a gift that You don't expect me to paste on a smile and pretend with You, but You sit with me in my suffering and pain, broken over my brokenness. I bring to You the grief of being wounded and wounding others. Have mercy.

SEEK HIS STILLNESS

Tell Jesus all about your sorrows, picturing Him there with you in your moment of pain. Also take time to confess how you have hurt others and, implicitly, have hurt Him. Ask for, and receive, His forgiveness, grace, and comfort.

TRUST HIS FAITHFULNESS

You did not spare Your own Son but gave Him up for us all, so I can trust You to give me everything I need, even Your own Spirit within me. God, You are so faithful! I trust You to fill my heart with the love of Jesus that I would sacrifice my own comforts for the sake of loving others.

For Further Prayer and Study

Isaiah 53 • Matthew 16:21 • Hebrews 5:8

THE RESURRECTION AND THE LIFE

"Jesus said to her, 'I am the resurrection and the life.
The one who believes in me will live, even though they die.'"

JOHN 11:25

RECITE GOD'S GOODNESS

O Eternal Resurrection and Life, everything lives and moves and has its being in You. I praise You for conquering the grave! Death has no finality before You; even death must submit and surrender to You as You speak resurrection and life.

EXPRESS YOUR NEEDINESS

As You are the Resurrection and the Life, you've called us to be the aroma of life to a dead and dying world, the fragrance of Jesus Christ in this space. Forgive me for being so wrapped up in myself that I forget to be the fragrance of Jesus Christ to a dead and dying world.

SEEK HIS STILLNESS

Bring to Jesus the parts of your life that feel dead, and the people in your life who are grieving today. Let His resurrection power fill you with hope, power, and peace, spilling over into the lives of your loved ones.

TRUST HIS FAITHFULNESS

Though death entered the world through humans, You came as the Resurrection and the Life, reviving what was killed by sin. And because You have placed Your own Spirit of life in us, we are alive in Christ. I trust You to help me live as one who will never truly die.

For Further Prayer and Study

John 1:1–18; 3:15–17 • Colossians 3:1–4 • Revelation 1:8

PRINCE OF PEACE

*"For to us a child is born, to us a son is given, and the government will be
on his shoulders. And he will be called . . . Prince of Peace.
Of the greatness of his government and peace there will be no end."*

ISAIAH 9:6-7

RECITE GOD'S GOODNESS

Precious Prince of Peace, in a world where trust runs low and fear runs high,
You bring shalom by Your very presence. From calming a stormy sea to
restoring sight to the blind, Jesus, You brought peace wherever You went. In my
own life, You've been my peace. So I praise You.

EXPRESS YOUR NEEDINESS

You are my God. What can mere humans do to me? You are the Prince of
Peace. Let Your perfect peace guard my heart and mind. I bring all my anxiety
under Your rule, Jesus. Help me bring Your peace into all my relationships, as
Your ambassador to an anxious world.

SEEK HIS STILLNESS

*Consider how Jesus has brought His peace into your life, and praise Him. Then be
still, allowing His presence to fill you up and make you whole.*

TRUST HIS FAITHFULNESS

God, You are faithful to Your promises, so I wait for the Prince of Peace to
return and reign forever and ever. Even though I live in a broken world, my
citizenship is in heaven, and my allegiance is to You alone. I can rest in Your
peace today.

For Further Prayer and Study

Isaiah 26:3, 12 • Luke 2:14 • Ephesians 2:14–16

LION OF JUDAH

"Do not weep! See, the Lion of the tribe of Judah, the Root of David, has triumphed."

REVELATION 5:5

RECITE GOD'S GOODNESS

Glorious Lion of Judah, You alone are worthy to receive my worship and adoration. Though You are gentle, meek, and humble, You are also majestic and powerful and courageous. You will scatter Your enemies and ensure that Your people will live securely.

EXPRESS YOUR NEEDINESS

I confess how easy it is to limit You in my own imagination, as if I could fully know You or control You. Like a lion, You command wonder, awe, and humble adoration. Forgive me for how casually I approach You. Expand my capacity to worship You in spirit and in truth, to catch a glimmer of Your glory.

SEEK HIS STILLNESS

Be quiet with the Lion of Judah, and let Him captivate your soul with the beauty of His name.

TRUST HIS FAITHFULNESS

Because of Your faithfulness, I can rest in Your trustworthiness. Blessed are all who take refuge in You. I bring my burdens before You, confident that I can rest in the Lion of Judah and that You will do what is right.

For Further Prayer and Study

Genesis 49:9 • Micah 5:8 • Hebrews 7:14

IMMANUEL

*"The virgin will conceive and give birth to a son, and they will call him
Immanuel (which means 'God with us')."*

MATTHEW 1:23

RECITE GOD'S GOODNESS

Blessed Immanuel, You are so good that You would come to earth to be with
us. Not just God for us, over us, before us, and behind us, but God *with* us and
within us. And Jesus, because of your life, death, and resurrection, we get to be
with you forever.

EXPRESS YOUR NEEDINESS

God, forgive me for moving through my day completely oblivious to You. Help
me walk with You, every decision discussed with You, every hard conversation
entered into with You, every opportunity to love and serve . . . with You. Help
me live *with* You today.

SEEK HIS STILLNESS

*Visualize what you have planned today, including the hard moments that likely
await you. Picture Jesus with you in each of those places, and allow His presence with
you to bring rest to your soul.*

TRUST HIS FAITHFULNESS

From the beginning, Your desire was to be *with* us; and in Jesus, You have forever
united Yourself to humankind. And one day soon, God's dwelling place will once again
be with us. The promise fulfilled in Immanuel—God WITH us. So no matter what I
face today, I am not alone, because You are in me, and I get to live this life with You.

For Further Prayer and Study

Isaiah 7:14 • Matthew 28:20 • Romans 8:31 • Colossians 1:27 • Revelation 21:3

JESUS

*"She will give birth to a son, and you are to give him the name Jesus,
because he will save his people from their sins."*

MATTHEW 1:21

RECITE GOD'S GOODNESS

My Dear Jesus, You did what no one else could do. You are the One who
rescues us from our sins, who purchased our salvation with Your own blood.
Thank You for Your mercy and compassion on my soul. You alone are my
Savior. I praise You!

EXPRESS YOUR NEEDINESS

Too often I live as if my own goals, systems, and processes could somehow
rescue me from the effects of sin in this broken world. Forgive me for the times
I forget that I need You. There is salvation in no other name but the precious
name of Jesus. You alone are worthy to be praised.

SEEK HIS STILLNESS

*What parts of your life still need rescuing? How have you tried to rescue yourself
when Jesus is longing to be your Savior? Sit with Jesus, and let His name become
precious on your lips.*

TRUST HIS FAITHFULNESS

Faithful God, You sent a rescuer into the world, fulfilling Your promise from
long ago. This Jesus, misunderstood during His time on earth, is the same Jesus
who sits at Your right hand and reigns. If I can trust You with salvation from my
sins, how much more I can trust You with the hard situations in my life today!

For Further Prayer and Study

John 4:42 • Acts 4:12; 13:23 • Colossians 1:20

*These prayers can be prayed
any time of year but can provide
guided prayer during Lent.[2]*

JESUS DOESN'T GIVE UP

*"He went away a second time and prayed, 'My Father, if it is not possible for this
cup to be taken away unless I drink it, may your will be done.'"*

MATTHEW 26:42

RECITE GOD'S GOODNESS

Compassionate Jesus, though Your disciples failed to watch and pray with You,
You continued praying for them and loving them to the end. I praise You that
You don't give up on us, despite the ways we fail; You continue to show us Your
steadfast, persevering, never-stopping love.

EXPRESS YOUR NEEDINESS

My love is often fickle, based on how I feel each day or how others respond
to me. Would You pour Your love into my heart? Fill me with Your love
supernaturally, a love that exceeds human limitations, moods, and feelings, that
I would love those around me with the love of Christ in me.

SEEK HIS STILLNESS

*Become aware of God's great love for you in Jesus—a love that never gives up on you.
Be still with Him.*

TRUST HIS FAITHFULNESS

O Father, You invite me to continue steadfastly in prayer, as Jesus told His
disciples. Thank You that You do not grow tired of my prayers. You never give
up on me; even when I fail, You are there listening, welcoming me to come to
You. Father, I lay my burdens at Your feet today. I trust You.

—————— *For Further Prayer and Study* ——————

Matthew 26:36–46 • John 13:1–3 • Philippians 1:6 • Revelation 19:11

JESUS PROTECTS HIS OWN

*"Jesus answered, 'I told you that I am he. If you are looking for me, then let
these men go.' This happened so that the words he had spoken would be fulfilled:
'I have not lost one of those you gave me.'"*

JOHN 18:8–9

RECITE GOD'S GOODNESS

Even in these last moments, Jesus, You protected Your disciples with Your very
life. You protect Your loved ones. There is no safer place to be than by Your side.
Nothing comes against me without first passing through You; and if it comes,
You are with me, Your very presence is my protection.

EXPRESS YOUR NEEDINESS

I need Your protection today, Lord; You are my ever-present help in time of
trouble. Help me stop running to false protectors; You alone are my refuge.
Make me devoted to You alone, attached to Your side, staying close to Your
heart. I want to run to You throughout my day.

SEEK HIS STILLNESS

*Imagine God, your protector, standing before you, beside you, and behind you,
hemming you in with His presence. Rest in Him.*

TRUST HIS FAITHFULNESS

O God, You are a mighty fortress. Nothing can get past you. You are faithful,
steadfast, and powerful. All authority is given to You, Jesus, and You reign supreme
over all. Help me train my heart throughout the day to trust in You alone.

For Further Prayer and Study

Isaiah 54:17 • John 17:12; 18:1–13 • 2 Thessalonians 3:3–5

JESUS LOVES HIS ENEMIES

*"And one of them struck the servant of the high priest, cutting off his right ear.
But Jesus answered, 'No more of this!' And he touched the man's ear and healed him."*

LUKE 22:50-51

RECITE GOD'S GOODNESS

Lover of the Loveless, You healed this servant, not to barter for Your freedom but simply out of the overflow of Your love. Such goodness and kindness surpass anything humanly possible. I praise You, Jesus, for Your great love!

EXPRESS YOUR NEEDINESS

I know You want me to love my enemies, but this is oh so hard. Renew my mind as I meditate on Your love. Make me more like You, Jesus. I want to love even those who are mean to me, but I need Your Spirit to change my heart.

SEEK HIS STILLNESS

Meditate on the fact that while you were God's enemy, Christ loved you enough to die for you. What does that say about His love? About how He is calling you to love your "enemy"?

TRUST HIS FAITHFULNESS

I surrender myself to Your Spirit, Jesus. Bear this heavenly fruit of love for my enemies within me. Open my eyes to opportunities to love those who have hurt me, and help me experience Your Spirit working love in me and through me for Your glory and sake alone.

For Further Prayer and Study

Matthew 5:44 • Luke 6:28; 22:47–53; 23:34 • Acts 7:60 • Romans 8:35; 12:14 •
1 Peter 2:23

JESUS KEEPS NO RECORD OF WRONGS

"Simon, Simon, Satan has asked to sift all of you as wheat.
But I have prayed for you, Simon, that your faith may not fail.
And when you have turned back, strengthen your brothers."

LUKE 22:31–32

RECITE GOD'S GOODNESS

Lover of Your people, You keep no record of wrongs. Even knowing that Simon Peter would reject You, You still interceded for him; even as he denied You, You looked at him with love. How abundant is Your love toward us, though we don't deserve any of it. You are so good!

EXPRESS YOUR NEEDINESS

When my sin is deep and as dark as the night, Your grace abounds. Search me and know my heart. Make me quick to repent and turn to You. May Your great love and comfort cause me to love and comfort others as well.

SEEK HIS STILLNESS

Take a few moments to become aware of God's loving presence surrounding you this very moment.

TRUST HIS FAITHFULNESS

Like Peter, I sometimes have too great a view of myself. Yet, You love me not because of my lack of failures but despite them all. It is Your steadfast love that makes me stand, and You gladly take me back when I fall. Thank You for Your faithfulness! I trust in You alone.

For Further Prayer and Study

Luke 22:31–34, 54–62 • John 17:9, 15; 21:15–17 • Romans 8:34

JESUS REJOICES IN THE TRUTH

*"'The reason I was born and came into the world is to testify to the truth.
Everyone on the side of truth listens to me.' 'What is truth?' retorted Pilate."*

JOHN 18:37-38

RECITE GOD'S GOODNESS

O Great I AM, by Your truth we know truth. In Your tender mercy, You reveal what is true in my life, even while showing me my sin and deceit. In a world of relative truths, You alone define what is real because you are the Living Truth.

EXPRESS YOUR NEEDINESS

Apart from Your Spirit at work in me, I wouldn't be able to discern truth from lies. I need Your voice to be the loudest in my ears so I can walk in Your truth. Help me demolish half-truths and lies that seek to enslave me; set me free by Your Truth—Your very presence—alive in me.

SEEK HIS STILLNESS

Allow God's Spirit to search your heart and reveal any falsehoods you may believe. Invite Him to write His Word of truth on your heart, and be still in His presence.

TRUST HIS FAITHFULNESS

Thank You, God, for revealing what is true through Your Word—lighting the way for my next right step. Your truth doesn't change like shifting opinions or trends, but remains steadfast forever, like a rock under my feet. I trust in You with all my heart. Lead me by Your truth.

For Further Prayer and Study

Psalm 86:11 • John 8:47; 18:33–38 • 1 John 4:6

JESUS IS NOT SELF-SEEKING

"Greater love has no one than this: to lay down one's life for one's friends."

JOHN 15:13

RECITE GOD'S GOODNESS

Merciful Jesus, even when You were hanging on the cross, You still showed love toward others. You were not self-seeking or self-pitying, even when You had every right to be. Though we are undeserving and unable to reciprocate the enormity of Your love, still You continue to pour out Your love on us.

EXPRESS YOUR NEEDINESS

God, I confess that I cannot love like this. Pour Your love into my heart so that I would gladly die to myself for the sake of loving others. Empower me to love, not based on how I feel, but living and loving from Your bountiful never-ending supply of love in Jesus Christ.

SEEK HIS STILLNESS

Take a few moments to become aware of God's loving presence surrounding you this very moment.

TRUST HIS FAITHFULNESS

Thank You, God, for turning death to life. As I put to death my flesh each day, You promise to produce the fruit of love in me. I trust You to make me more like Jesus, to fill me up with Your loving compassion toward everyone.

For Further Prayer and Study

John 19:23–27 • Romans 5:7–8; 8:12–16 • 1 Peter 3:18

JESUS' LOVE FORGIVES

*"When they came to the place called the Skull, they crucified him there. . . .
Jesus said, 'Father, forgive them, for they do not know what they are doing.'"*

LUKE 23:33-34

RECITE GOD'S GOODNESS

Forgiving Jesus, what mercy and love You showed toward those nailing You to
a cross! You prayed for their pardon instead of their punishment, and You've
shown that same love toward me, chasing me down with Your love while I was
still Your enemy. Thank You for Your forgiveness.

EXPRESS YOUR NEEDINESS

I don't forgive like You, Jesus. It's easier to hold grudges, to fantasize about
revenge. Yet You've given me the love and forgiveness I don't deserve; how
could I withhold that from those who ask? Release in me Your healing power of
forgiveness that I would release those who have wronged me into Your hands.

SEEK HIS STILLNESS

*Allow God's love to fill you, His healing power to break the chains of unforgiveness
and bitterness in your life.*

TRUST HIS FAITHFULNESS

Father, even as I think of those I need to forgive, I'm afraid of being hurt again.
But You've given me a spirit of power, love, and self-control; and Your perfect
love casts out fear. So I trust You today to guide me, protect me, and give me
wisdom to love and forgive as You do.

For Further Prayer and Study

Psalm 86:5 • Matthew 5:44; 6:14 • Luke 23:32–34 • Ephesians 4:32

JESUS OFFERS HOPE

*"Then he said, 'Jesus, remember me when you come into your kingdom.'
Jesus answered him, 'Truly I tell you, today you will be with me in paradise.'"*

LUKE 23:42-43

RECITE GOD'S GOODNESS

O Lover of my Soul, thank You that it's never too late to come to You. As long as I have breath in my lungs, You offer mercy and forgiveness for my sins. Though the enemy of my soul intends to keep me bound to sin and far from You in shame and guilt, You invite me to come, believe, and rest.

EXPRESS YOUR NEEDINESS

It was my sin that put Jesus on that cross, but it was love that held Him there. Every agonizing breath was a declaration of love and commitment to reconcile us to You. So I confess my sins to You now, holding nothing back, receiving Your forgiveness.

SEEK HIS STILLNESS

Allow God's Spirit to convict and cleanse you of your sin. Then rest in God's loving presence as He declares you righteous in Jesus.

TRUST HIS FAITHFULNESS

Because of Jesus' death, I'm dead to sin and made alive to Your Spirit within me. I have hope of victory over sin. This isn't because of my goodness or dedication; it's because of Your matchless grace, mercy, and love. I trust You in my battle with my flesh today. You will be victorious.

For Further Prayer and Study

Luke 23:39–43 • Romans 6:1–14 • 1 John 1:9–10

JESUS SACRIFICED EVERYTHING

"And when Jesus had cried out again in a loud voice, he gave up his spirit."

MATTHEW 27:50

RECITE GOD'S GOODNESS

My Precious Jesus, with just one flex of muscles You could have freed and healed Yourself; a whisper would have brought legions of angels to destroy the centurions. But You were fighting the mortal enemy of our souls through Your very death. It was love that held You on that cross.

EXPRESS YOUR NEEDINESS

Guard my heart from complacency; may Your sacrifice never become common to me. Forgive me for my indifference. Bring a fresh awareness, conviction, and brokenness over the travesty of the cross that I would be moved to repentance, to humility, and to worship.

SEEK HIS STILLNESS

Take a few minutes to sit at the foot of the cross, picturing the scene in your sanctified imagination; put yourself in the scene, and just be silent before such a display of love.

TRUST HIS FAITHFULNESS

From the promise in the garden to the covenant at Mt. Sinai to Your enrobement in human flesh, You knew it would all lead to this moment on the cross. Yet, You did not shrink back, Jesus, giving Yourself up for us all. How much more will You graciously fulfill all Your promises to us! I trust You with my whole heart today.

For Further Prayer and Study

Matthew 27:45–54 • Mark 1:15 • Romans 5:7 • Ephesians 1:7–14

JESUS' LOVE NEVER FAILS

"The angel said to the women, 'Do not be afraid, for I know that you are looking for Jesus, who was crucified. He is not here; he has risen, just as he said.'"

MATTHEW 28:5–6

RECITE GOD'S GOODNESS

Victorious and Risen Jesus, Your death on the cross was not a tragic end, but the beginning of a new chapter You've written in love. You conquered the enemy of our souls on the cross, and Your resurrection proves that nothing can stand against You. I praise You!

EXPRESS YOUR NEEDINESS

Like the women at the tomb, I'm quick to forget Your promises and go searching for hope in all the wrong places. Forgive me. I want to believe in You, to trust You, to grow in faith in You. Help me, Lord.

SEEK HIS STILLNESS

Place yourself at the scene of the empty tomb. What would it be like to see the risen Lord after you'd seen Him dead? Let His presence fill your heart with hope.

TRUST HIS FAITHFULNESS

If even death could not hold You, Jesus, then nothing can stand in Your way! You are who You say You are, and You will do what You say You will do. None of Your promises will ever fail because You are powerful and loving to keep them. I trust in You with my whole heart!

For Further Prayer and Study

John 11:25–26 • 1 Corinthians 1:20–22 • Philippians 3:7–11 • Hebrews 2:14–15

*These prayers can be prayed
any time of year but can provide
guided prayer during Pentecost.*

EMPOWERED WITNESSES

*"But you will receive power when the Holy Spirit comes on you; and you will be my
witnesses in Jerusalem, and in all Judea and Samaria, and to the ends of the earth."*

ACTS 1:8

RECITE GOD'S GOODNESS

Loving Jesus, thank You for inviting us into Your story. You didn't need people
to advance Your kingdom here on earth, but in Your sovereign goodness You
chose us so that we get to be a part of what You're doing in the world.

EXPRESS YOUR NEEDINESS

I confess that when it comes to telling other people about Your life, death, and
resurrection, I often get tongue-tied. I don't want to offend or say the wrong
thing, so I don't say anything at all. Give me boldness and courage to be Your
witness right where You've placed me.

SEEK HIS STILLNESS

*Ponder what it would look like to live in the power of the Holy Spirit in your life.
Then sit quietly with the Lord, becoming aware of His loving and powerful presence
indwelling you right now.*

TRUST HIS FAITHFULNESS

Lord Jesus, Yours is the kingdom and the glory forevermore, and You will be
faithful to complete Your work through Your powerful Spirit working in us. I
cannot do this, but You can. So I trust You.

For Further Prayer and Study

Isaiah 43:10–12 • Matthew 28:19–20 • Colossians 1:21–29

POURED-OUT SPIRIT

"In the last days, God says, I will pour out my Spirit on all people....
Even on my servants, both men and women, I will pour out my Spirit in those days,
and they will prophesy."

ACTS 2:17-18

RECITE GOD'S GOODNESS

Lord God, this promise is simply amazing! In ages past, You spoke through a
pillar of cloud to Moses and through Your prophets to the Israelites, but now
You've poured Your very self—Your divine Spirit—into all those who belong to
You. I praise You for living inside me!

EXPRESS YOUR NEEDINESS

I don't fully understand the implications of what it means to be filled with Your
Spirit, but I want to stop living for myself and start living entirely for You, Jesus.
Empower me to surrender myself fully to Your purposes and Your glory in my
life. I want to receive all You have to offer through Your Spirit in me.

SEEK HIS STILLNESS

Listen quietly to God's own Spirit living within you. Is there anything He wants to
say to you?

TRUST HIS FAITHFULNESS

Lord God, You are the same from ages past, never changing, never shifting,
always faithful. And because Jesus ascended to You, He's sent His Spirit to
live in us, a promise from long ago finally fulfilled. I entrust myself to You—
whatever You have for me to do, I'll do it gladly.

For Further Prayer and Study

Numbers 11:25 • Isaiah 44:3 • Ezekiel 39:29 • John 7:37–39

ORDINARY PEOPLE WITH JESUS

"When they saw the courage of Peter and John and realized that they were unschooled, ordinary men, they were astonished and they took note that these men had been with Jesus."

ACTS 4:13

RECITE GOD'S GOODNESS

I praise You, Lord Jesus, because You're continuing to equip and empower Your church to powerfully declare You to those who don't yet believe. You're living and active through Your Spirit, and I praise You for how You're moving all around the world.

EXPRESS YOUR NEEDINESS

Sovereign Lord, I want to be a part of what You're doing in the world, but for that to happen, I need to be spending time with You. I surrender my life completely to You, abandoning my own selfish ambitions and vain goals for the sake of knowing Jesus and making You known.

SEEK HIS STILLNESS

Take a few moments to quietly reflect on how God has been changing you over the years you've spent with Jesus. What traits of His are most clearly evident in your life? Talk with Him about this.

TRUST HIS FAITHFULNESS

I am just an ordinary person, but You are an extraordinary God, and I trust that You will work in such a way that when others look at me, they will see Jesus. May Jesus be magnified in all I say and do today.

For Further Prayer and Study

Matthew 11:25 • Mark 3:14 • Acts 4:1–22

UNSTOPPABLE

*"Leave these men alone! Let them go! For if their purpose or activity is of
human origin, it will fail. But if it is from God, you will not be able to stop these men;
you will only find yourselves fighting against God."*

ACTS 5:38-39

RECITE GOD'S GOODNESS

Unstoppable God, You empowered the apostles to perform signs and wonders and
have given Your people spiritual gifts to build up Your body. I praise You, for even the
corrupt powers of hell cannot stand against Your church empowered by Your Spirit!

EXPRESS YOUR NEEDINESS

How much of my activity springs from fleshly ambition rather than from You?
Help me reevaluate my priorities and abandon anything that's not from You. I
want to be a woman full of grace and power and Spirit, devoted to prayer and
the Word, unstoppable for You.

SEEK HIS STILLNESS

*Consider how you can become involved in what God is doing through His
church—locally, nationally, and internationally. Then sit in quiet adoration of His
unstoppable Spirit at work in the world.*

TRUST HIS FAITHFULNESS

Creator God, You own everything I have. Use all I am and all I have for the
advancement of Your kingdom and the proclamation of the gospel around the
world. I trust that as I pour myself out, You will fill me up day by day with Your
grace and power in my life.

For Further Prayer and Study

2 Chronicles 13:12 • Proverbs 21:30 • Isaiah 46:10 • Matthew 15:13 • Romans 12:6-8

SENT

"Then Ananias ... placing his hands on Saul ... said, 'Brother Saul,
the Lord—Jesus, who appeared to you on the road as you were coming here
—has sent me so that you may see again and be filled with the Holy Spirit.'"

ACTS 9:17

RECITE GOD'S GOODNESS

Lord God, how amazing that You spoke so directly and personally to Ananias!
You sent an ordinary disciple to heal and evangelize a religious terrorist who
was to become a devoted apostle. Only You could so miraculously reform a
heart of stone into a heart that beats for You alone!

EXPRESS YOUR NEEDINESS

O Lord, I long to hear Your voice this clearly, knowing when to get up and where
to go out and whom to speak with. I want my life story to be filled with divine
encounters and answered prayers that can only be explained by Your hand at
work. Open my ears that I would listen and discern Your Spirit speaking to me!

SEEK HIS STILLNESS

Take a few moments to become aware of God's loving presence surrounding you this
very moment.

TRUST HIS FAITHFULNESS

Again and again, Jesus, You seek, save, and send people on Your mission. You're
personally growing Your kingdom here on earth. You did this while You were
walking this earth, and even after You ascended to heaven. I trust You with my
loved ones who do not yet know You. Seek them, Lord; save them; and send me.

For Further Prayer and Study

John 10:27–28 • Acts 1:8 • Romans 10:18

JESUS HEALS YOU

*"Peter said to him, 'Jesus Christ heals you. Get up and roll up your mat.'
Immediately Aeneas got up. All those who . . . saw him . . . turned to the Lord."*

ACTS 9:34-35

RECITE GOD'S GOODNESS

Divine Healer, during Your time on earth, You healed all those who came to
You; and after Your ascension, You continued healing the sick through Your
disciples. How good of You to pour out Your healing power as a sign of Your
restoration of this world!

EXPRESS YOUR NEEDINESS

As I pause to consider those in my sphere of influence, there are so many people
who need healing. I don't completely understand the mysterious connection
between modern medical treatments and Your divine healing, but would You restore
wholeness and healing to my loved one's lives? Yet not my will, but Yours be done.

SEEK HIS STILLNESS

*Take a few moments to speak the names of your loved ones who are sick before the
Lord, and then rest in the knowledge that Jesus hears, He knows, and He will do
what is best in each situation.*

TRUST HIS FAITHFULNESS

Lord Jesus, You bring healing to those who trust in You—whether in this world
or the next. And someday soon, when You return to establish Your kingdom
here on earth, death will be no more; and sickness and sorrow will be no more
because You will make everything new. Thank You for Your eternal faithfulness.

For Further Prayer and Study

Matthew 10:1 • Luke 9:1-2 • Acts 3:3-16; 4:10; 9:10-19

I NOW REALIZE

"Then Peter began to speak: 'I now realize how true it is that God does not show favoritism but accepts from every nation the one who fears him and does what is right.'"

ACTS 10:34–35

RECITE GOD'S GOODNESS

Lord Jesus, You welcome all women and men from around the world to worship You in Spirit and in truth. How kind of You to have prepared Peter for this realization beforehand, as he was spending time with You. You are the God who prepares our hearts to respond even before we hear Your Word!

EXPRESS YOUR NEEDINESS

Lord, just as You challenged Peter's religious preconceptions and ethnocentrism, so make me attentive to how You are moving in the world. I want to be quick to repent of the sin in my own heart and join You in whatever You are doing, even if it challenges my preconceived notions of what Your kingdom should be like. Give me a humble heart to follow You.

SEEK HIS STILLNESS

Sit quietly before the Lord and allow Him to reveal to you any thoughts or actions you need to repent of. Then receive His forgiveness and rejoice in His presence.

TRUST HIS FAITHFULNESS

You, Lord Jesus, have ransomed Your bride, and You are faithful to call women and men from every nation to join You. I praise You for how You're bringing Your kingdom, and I trust You to complete it.

For Further Prayer and Study

Isaiah 43:18–20 • Romans 12:1–2 • Galatians 3:26–29 • James 2:1–13

THE SPIRIT WOULDN'T LET ME

"Paul and his companions . . . [had] been kept by the Holy Spirit from preaching the word in the province of Asia. . . . They tried to enter Bithynia, but the Spirit of Jesus would not allow them to."

ACTS 16:6–7

RECITE GOD'S GOODNESS

My Dear Lord, I'm so grateful that You desire to lead and direct Your people, even if it means changing course. I praise You for the ways You personally and intimately reveal Your will to those who seek You.

EXPRESS YOUR NEEDINESS

O Jesus, make me sensitive to recognize Your voice saying "this is the way you should go," and quick to obey You. Put a stop to any plans I make that don't align with Your will, and redirect me to do what honors You.

SEEK HIS STILLNESS

In what area of your life are you needing God's direction and wisdom? Take a few moments to bring your specific needs and concerns to Him, and then be still in God's loving presence. Is there anything He wants to say to you?

TRUST HIS FAITHFULNESS

How good and faithful You are to use imperfect people to do Your will! It's comforting that even Your first disciples needed to be guided and corrected, and I can trust You for the same course correction in my life when I surrender to You.

For Further Prayer and Study

Isaiah 30:21 • Romans 8:9 • Galatians 4:6 • Philippians 1:16 • 1 Peter 1:10–12

HIS PRESENCE IS OUR PROTECTION

*"One night the Lord spoke to Paul in a vision:
'Do not be afraid; keep on speaking, do not be silent. For I am with you.'"*

ACTS 18:9-10

RECITE GOD'S GOODNESS

In Your lovingkindness, Lord, You have promised to never leave Your children.
It is Your presence that's our protection; Your very Spirit is our shield. How
good of You to cast out our fear with Your perfect loving presence!

EXPRESS YOUR NEEDINESS

Paul had legit reasons to fear persecution, and though what I fear may be less
life-threatening, they're nonetheless real. Help me become more aware of Your
presence, Lord. Be my protection and my peace, no matter what hardships I
face in the course of loving and proclaiming You.

SEEK HIS STILLNESS

*Ponder the reality that Jesus promises His own protection as the basis of our
boldness, then sit quietly with Him. Is there anything He wants to say to you?*

TRUST HIS FAITHFULNESS

How great is Your faithfulness, Jesus, that even though You're sitting at Your
Father's right hand, You're still present with Your people through Your Spirit.
And where Your Spirit is, there is freedom. I trust You with all the burdens and
worries and fears of my heart. You are with me, so I will fear no evil.

For Further Prayer and Study

Psalm 23:4 • Isaiah 32:1-7 • John 14:18 • 2 Corinthians 3:17

MAY JESUS BE LIFTED UP

*"God did extraordinary miracles through Paul. . . . and the name
of the Lord Jesus was held in high honor."*

ACTS 19:11, 17

RECITE GOD'S GOODNESS

It's always been about You, God. From the dawn of creation, to the coming of Jesus, to the present church age, and into Your future kingdom . . . every moment, every miracle, always pointing to You. How good and faithful You are to invite us into Your eternal mission!

EXPRESS YOUR NEEDINESS

Lord, I'm so weary of my self-centeredness: my plans for today, my goals for the year, and my hopes for my life are all about *me*. Forgive me. Reorient the affections of my heart so that every cell in my body pulsates with the desire to know Jesus and make Him known!

SEEK HIS STILLNESS

Pause and picture Jesus, high and lifted up, exalted by angels and heavenly beings and people of every ethnicity. Do you see yourself in that great crowd of worshipers? Sit before Him (or kneel or stand), and worship Him with your whole heart.

TRUST HIS FAITHFULNESS

One day, every knee in the universe will bow before You, and every tongue will confess that You, Jesus, are Lord. The Father will receive all the glory, and Your Spirit will present Your bride. I can't wait for that beautiful day! Come quickly, Lord Jesus!

For Further Prayer and Study

Psalm 95:6 • Matthew 28:18 • Ephesians 1:20–21 • Philippians 2:1–11 • Romans 14:11

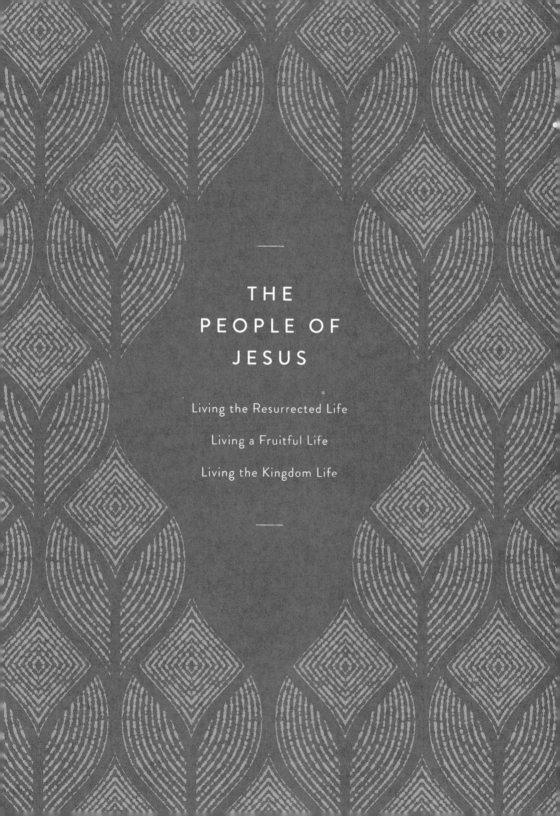

THE
PEOPLE OF
JESUS

Living the Resurrected Life

Living a Fruitful Life

Living the Kingdom Life

These prayers can be prayed any time of year but can provide guided prayer during Easter.

CALLED BY THE RESURRECTED ONE

"He asked her, 'Woman, why are you crying?' . . . She said, 'Sir, if you have carried him away, tell me where you have put him, and I will get him.' Jesus said to her, 'Mary.' She turned toward him and cried out . . . 'Teacher!'"

JOHN 20:15-16

RECITE GOD'S GOODNESS

O Jesus, You are the resurrection and the life! I praise You for loving and caring for each of Your children, entering with us into our pain and bringing hope to us in our despair. You are the One who sees me, loves me, and knows me by name. I worship You!

EXPRESS YOUR NEEDINESS

Like Mary, I can be so overcome by my grief that I fail to recognize Your presence with me. Make me aware of Your voice calling my name, speaking life into the places that feel like death. Help me hear Your voice and believe.

SEEK HIS STILLNESS

Take a few moments to become aware of God's loving presence surrounding you this very moment. Allow His peace to fill you, His love to surround you. Just be with Jesus.

TRUST HIS FAITHFULNESS

As You foretold Your death, so You reassured Your disciples of Your resurrection. And as with Mary Magdalene, Your faithful love is always personal, Jesus. Your resurrection power will transform us into Your resurrected people, and I trust You to lead me into new life forever with You.

For Further Prayer and Study

Luke 24:1-12, 36-47 • John 20:1-18 • Romans 6:5-6 • Philippians 3:10 • Revelation 20:6

THE FULLNESS OF CHRIST IN US

"And God placed all things under his feet and appointed him to be head over everything for the church, which is his body, the fullness of him who fills everything in every way."

EPHESIANS 1:22-23

RECITE GOD'S GOODNESS

All hail King Jesus! You who walked our dusty roads are now seated on Your heavenly throne, just as You foretold. You are powerful and majestic, Lord. And You've graciously invited us to join Your family as ones who will inherit the riches of Your glory. How kind You are!

EXPRESS YOUR NEEDINESS

How often I live in defeat, as if I'm alone and unknown. Yet, You have called me into fellowship with You and with all those who trust in You. Remind me that You've given us Your own Spirit, Your power, and Your hope. Open the eyes of my heart to understand the comfort, the community, and the fullness of Christ in us together.

SEEK HIS STILLNESS

Take a few moments to become aware of Jesus' rulership in heaven and earth right now. Allow Him to bring His peace, love, and power into your heart as you sit quietly with Him.

TRUST HIS FAITHFULNESS

Precious Father, You've held nothing back from Your children—placing at our disposal all the riches of heaven available through prayer! May Your fullness overflow through me toward others, and help me recognize You in others' love toward me as well.

For Further Prayer and Study

John 1:16; 17:24 • Ephesians 3:10-19; 4:10-13 • Hebrews 13:5-6

LIVING AS THOSE WHO NEVER DIE

*"Jesus said to her, 'I am the resurrection and the life. The one who
believes in me will live, even though they die; and whoever lives by believing
in me will never die. Do you believe this?'"*

JOHN 11:25-26

RECITE GOD'S GOODNESS

Jesus, You alone conquered death, raising the dead to life and then entering into
it to obliterate it through Your victorious resurrection. Yet, even so, You grieved
sin's curse in the world. I praise You for being both powerful and kind.

EXPRESS YOUR NEEDINESS

Just as you wept with Mary and Martha, teach me how to mourn with those
who mourn, while never losing sight of hope. Because You live, we also will
live; so help me live and work and love as one who will never truly die.

SEEK HIS STILLNESS

*Recall Jesus entering Mary and Martha's grief, and experience His presence with you
in your own grief and pain. Sit quietly with Him, and let Him comfort you with His
love.*

TRUST HIS FAITHFULNESS

Like Martha, I often fixate on temporary solutions: "If only I had a better job,"
or "If only I was healthier," or "If only my children . . . " Yet, You helped Martha
shift her attention from a future resurrection onto *You*. You were all she needed,
and You are all I need. I need You, Jesus. And I trust You.

For Further Prayer and Study

Matthew 25:46 • John 1:1–4; 3:14–17; 10:28–30 • 2 Corinthians 4:17–18 • 1 John 5:13

A KINGDOM OF PRIESTS

*"You have made them to be a kingdom and priests to serve our God,
and they will reign on the earth."*

REVELATION 5:10

RECITE GOD'S GOODNESS

O Jesus, how good You have been and continue to be! You, the Lamb of God,
were slaughtered to purchase us as a people of Your very own. And in Your
lovingkindness, You have made us priests—Your representatives—and given us
an inheritance reigning with You on earth. I worship You!

EXPRESS YOUR NEEDINESS

I so easily forget the identity You've given me: as a child of God, as part of Your
resurrected people, as a priest to represent You to the world. Teach me who—
and whose—I am. May Your voice be the loudest in my ears as I grow into the
person You've called me to be, both individually and as part of Your body here
on earth.

SEEK HIS STILLNESS

Take a few moments to meditate on the truth of this verse. What is God saying to you?

TRUST HIS FAITHFULNESS

I don't deserve to be part of Your kingdom, let alone Your representative; but
my inheritance is gifted, not earned. Thank You, Father! May Your faithful love
rest on me as I put my hope in You.

For Further Prayer and Study

Exodus 19:6 • Isaiah 61:6 • 1 Peter 2:5–9 • Revelation 1:5–6; 5:8–14

AN ANTHEM OF WORSHIP

*"Then I heard every creature in heaven and on earth and under the earth and on the sea,
and all that is in them, saying: 'To him who sits on the throne and to the Lamb
be praise and honor and glory and power, for ever and ever!'"*

REVELATION 5:13

RECITE GOD'S GOODNESS

O Jesus, You are worthy to receive all honor, all glory, all power, and all riches forever and ever. You, Jesus, deserve it all. I join with the heavenly creatures and cry out, "Worthy is the Lamb who was slain" because You're not dead anymore. You rose to victorious life, and one day soon, everyone will acknowledge You as Lord. What a glorious day that will be. You are worthy!

EXPRESS YOUR NEEDINESS

As I peek into this heavenly scene, I'm struck by the unending praise that is Yours. May this anthem of worship always be in my heart, whether I'm running errands or cleaning the house or finishing a work project. Lead me through Your Spirit into this life of adoration.

SEEK HIS STILLNESS

Sit quietly as you envision the scene taking place before God's throne right this moment. Allow this preview to quiet your heart in worship.

TRUST HIS FAITHFULNESS

God, You are worthy because You are faithful. From the garden to the cross to the throne room, and every moment in between, every nanosecond of history, You have always been faithful. I love You and trust You wholeheartedly.

For Further Prayer and Study

1 Chronicles 29:11 • Philippians 2:3–11 • Revelation 5:10–14

AN EVERLASTING LOVE

*"This is love: not that we loved God, but that he loved us and sent his
Son as an atoning sacrifice for our sins."*

1 JOHN 4:10

RECITE GOD'S GOODNESS

Thank You, God, for Your great love in Jesus. When I was still lost in my sins,
Your everlasting love sought me, called me, and rescued me. It's through Jesus'
death that You reveal Your desire for us, and it's through His life that You bring
us into relationship with You.

EXPRESS YOUR NEEDINESS

You've poured Your love into my heart, so that I would love others with
Your great love. Forgive me for keeping Your love to myself, as if there isn't
enough to go around. Help me see others as You see them—beloved, needy,
precious—and reach out to them in love.

SEEK HIS STILLNESS

*Take a few moments to become aware of God's loving presence surrounding you this
very moment. Allow His peace to fill you, His love to surround you. Just be with your
heavenly Father.*

TRUST HIS FAITHFULNESS

When I was most unlovable, You loved me still. Thank You for allowing me to
experience eternal life and everlasting love with You. I trust You to continue
guiding me in Your love and Your truth and to open my eyes to recognize
opportunities to love others with the love of Jesus today.

For Further Prayer and Study

Jeremiah 31:3 • John 13:34–35 • Romans 5:8–10 • 1 Corinthians 15:17 • 1 John 4:7–12

LIVING IN CHRIST

*"I have been crucified with Christ and I no longer live, but Christ lives in me.
The life I now live in the body, I live by faith in the Son of God,
who loved me and gave himself for me."*

GALATIANS 2:20

RECITE GOD'S GOODNESS

Thank You Jesus, for living the perfect human life none of us could live. Our hope is not in our own rule-keeping but in Your abundant love. Because You live, I too will live for You alone. I worship You, Jesus!

EXPRESS YOUR NEEDINESS

Even though I've been crucified with Christ, I often live as if that death never happened. Forgive me for my selfish living. I want to live in You. I want every breath, every thought, and every pursuit to be Christ in me. Help me rest in Your grace and be transformed into Your image.

SEEK HIS STILLNESS

Take a few moments to meditate on how Jesus would live your life: How would He love your family members? Tackle your work projects? Interact with your neighbors? Rest in His loving presence.

TRUST HIS FAITHFULNESS

Precious Jesus, You fulfilled every promise, every prophecy, and every principle, and now You're living Your perfect life *in* Your people. You've placed me in this exact time and place in history, and You will be faithful to accomplish Your work as I live in You today.

For Further Prayer and Study

Romans 6:10–14 • 2 Corinthians 5:15 • Galatians 2:19–21

KNOWING THE POWER
AND PRESENCE OF JESUS

*"I want to know Christ—yes, to know the power of his resurrection
and participation in his sufferings, becoming like him in his death,
and so, somehow, attaining to the resurrection from the dead."*

PHILIPPIANS 3:10-11

RECITE GOD'S GOODNESS

O God, You invite us to experience life—forever life, full life, resurrected
life—with You. My best moments are filled with Your resurrection power. My
lowest moments are filled with Your loving presence. I praise You for the gift of
knowing You.

EXPRESS YOUR NEEDINESS

Redeem the pain in my life and use it for good: to know You more and cling to
You. Help me cry out to You in the hard moments instead of numbing myself
with distractions. Tune my heart to seek You in the most difficult moments of
my day, and so rest in Your power and presence.

SEEK HIS STILLNESS

*Be still with Jesus, aware of His presence in your suffering and His power in your
celebrations. He is always with you. Is there anything He wants to say to you?*

TRUST HIS FAITHFULNESS

God, I'm holding nothing back—take all of my life and do whatever You know
is best to help me know You more. I trust that You will use all the moments of
my day today to reveal Yourself more to me. I love You.

For Further Prayer and Study

Romans 6:4–8 • 2 Corinthians 4:10 • Philippians 3:7–11 • Revelation 20:5–6

RAISED WITH CHRIST

*"Because of his great love for us, God ... made us alive with Christ
even when we were dead in transgressions. ... And God raised us up with
Christ and seated us with him in the heavenly realms in Christ Jesus."*

EPHESIANS 2:4–6

RECITE GOD'S GOODNESS

Dear God, You've shown me such great love! It wasn't my beauty or perfection
that attracted You because You saved me while I was still dead in my sin. I praise
You for Your rich mercy in calling me to a lifetime—and an eternity—with You.

EXPRESS YOUR NEEDINESS

You call me to die to my old selfish nature, but I need Your help. Through the
power of Your Spirit who raised Jesus from the grave, help me live victoriously
over sin in my life. I want to walk in step with Your Spirit today. Only You can
do this in me.

SEEK HIS STILLNESS

*Envision God's resurrection power raising you from death to life. What parts of your
life still need to die, so that His resurrection power may fully reign in you? Allow Him
to begin that work right now.*

TRUST HIS FAITHFULNESS

You are the Author and Finisher of my faith, and I trust You to continue
transforming me by Your Spirit's resurrection power at work in me. I live
because You live. My hope is in You alone, Jesus.

For Further Prayer and Study

John 5:21 • Romans 6:5; 8:11 • Ephesians 2:1–10 • 2 Timothy 2:11–13

HIDDEN WITH CHRIST

"For you died, and your life is now hidden with Christ in God.
When Christ, who is your life, appears, then you also will appear with him in glory."

COLOSSIANS 3:3–4

RECITE GOD'S GOODNESS

Lord God, how good of You to choose me from the creation of the world to belong to Your divine family. You have raised me with Christ, dead to my old self and alive to You in Christ Jesus. I praise You!

EXPRESS YOUR NEEDINESS

Lord, I still wrestle with the impurity, lust, evil desires, and greed that used to define me. But that's not who I am anymore because I am in You, and You are in me. Help me put to death what belongs to my old way of life and to be renewed in the knowledge of You. Be my all in all, Christ Jesus!

SEEK HIS STILLNESS

What does it mean that Christ is your life? Sit quietly with Him pondering the mysterious truth that your life is hidden with Christ in God. Let His loving presence guide you in a place of rest.

TRUST HIS FAITHFULNESS

You are the One who sustains me in this new resurrected life, and You continue to teach me what it means to live as one of Your chosen ones. I entrust myself completely into Your loving care.

For Further Prayer and Study

Romans 6:2 • Galatians 2:20 • Colossians 3:1–11 • 1 Peter 1:13 • 1 John 3:2

WORKING WITH CHRIST'S ENERGY

"I strenuously contend with all the energy Christ so powerfully works in me."

COLOSSIANS 1:29

RECITE GOD'S GOODNESS

Lord God, what an awesome gift that You would place Your own Spirit within
us and then invite us to join You in the work You are doing in the world. In
You I live and move and have my being. Every great idea comes from You. The
desire and the ability also come from You. You are a good, good Father.

EXPRESS YOUR NEEDINESS

Lord, I need your Holy Spirit to energize me for mighty works that I cannot do
on my own. Help me lean not on my own understanding or strength, but on
Your incomparably great power within me and by Your grace given to me.

SEEK HIS STILLNESS

*Become aware of God's presence surrounding you, filling you, and empowering you
for the work He has given you to do today. Is there anything He wants to say to you?*

TRUST HIS FAITHFULNESS

I want to proclaim You, Christ Jesus, to everyone I meet until my dying breath.
You have graciously supplied all my needs, so I trust You to exercise Your power
within me and through me as I work with the energy You so generously give
me. You will accomplish the good work You started, and I trust You.

For Further Prayer and Study

1 Corinthians 3:5–17; 15:10 • Colossians 2:1 • Ephesians 1:17–23; 3:7

GOD'S RESURRECTED PEOPLE

*"And I heard a loud voice from the throne saying, 'Look! God's dwelling place
is now among the people, and he will dwell with them. They will be his people,
and God himself will be with them and be their God.'"*

REVELATION 21:3

RECITE GOD'S GOODNESS

Precious Father, what a glorious picture of eternity! I praise You that someday
soon You will put an end to death, grief, crying, and pain. You Yourself will
dwell among us and *with* us. I can't wait for that day when I get to praise You
with all Your resurrected people!

EXPRESS YOUR NEEDINESS

On the days heavy with sin and brokenness, remind me of the eternal reality
that awaits all those who trust in You. Imprint on my soul the future hope of
glory so that I live today in light of this eternal reality.

SEEK HIS STILLNESS

*Imagine a world liberated from sin, death, and pain—you yourself in that very state.
Then be still with the One who will bring about that future and who is making it true
in your own life day by day.*

TRUST HIS FAITHFULNESS

You have always been faithful, Lord; so even though this sounds like a fairy-tale
ending, I trust that You, Jesus, are transforming us into Your resurrected
people through Your Spirit even now. I trust You to complete the work that
You started in me.

For Further Prayer and Study

2 Chronicles 6:18 • Zechariah 2:10 • John 14:1–3, 23 • Revelation 21:3–7

ABIDE

"I am the vine; you are the branches. If you remain in me and I in you, you will bear much fruit; apart from me you can do nothing."

JOHN 15:5

RECITE GOD'S GOODNESS

Divine Vine, You keep us connected to the Father. How good You have been to graft into Your family all who believe in You! Thank You for Your sustaining power and divine energy that bears fruit in our lives. Nothing is impossible for You!

EXPRESS YOUR NEEDINESS

Heavenly Father, prune away the offshoots that suck my time and attention and make me unfruitful. Trim anything that keeps me from abiding in You, anything that threatens my fruitfulness, even if it hurts in the moment. I want to bear lots of sweet fruit that points to You, Jesus, working in my life.

SEEK HIS STILLNESS

Ponder what daily abiding looks like in your life, and what distractions threaten that devotion. Is there anything you need to surrender to God? Be still in His presence, and remain quietly with Him a few extra moments.

TRUST HIS FAITHFULNESS

Thank You, Lord, that my part is to abide and Your part is to produce fruit through Your Spirit. May Your fruitfulness in my life distinguish me as belonging to You. I rest in Your commitment and ability to make me more and more like Jesus each day.

For Further Prayer and Study

Matthew 7:16–20; 13:1–23 • Romans 8:28–29 • 2 Corinthians 3:17–18 • Ephesians 3:16–17

LOVE

"My command is this: Love each other as I have loved you."

JOHN 15:12

RECITE GOD'S GOODNESS

O Loving God, how great is Your love! From patiently training Your disciples, to eating with social outcasts, to healing the incurable, to dying for my sins, You've always exuded love, precious Jesus, even toward me. Thank You!

EXPRESS YOUR NEEDINESS

Lord, give me power to grasp Your great love, and fill up my heart to overflow into the lives of those around me. I want to love with my actions, not just my words; empower me through Your Spirit to show Your abundant love toward those who mistreat me as well as those in my own household. May I be known for my great love to all.

SEEK HIS STILLNESS

Take a few moments to ponder just how much God has loved you, from the moment you were conceived, to those moments you were running from Him, to this moment right now. Is there anything you want to say to Him?

TRUST HIS FAITHFULNESS

Lord God, it's Your steadfast love that is new every morning and Your perfect love that casts out fear. Thank You for so patiently working Your love in me through Your Spirit. How great is Your love, Lord, to call me Your own! I just want to tell You that I love You too!

For Further Prayer and Study

Romans 14:1–15 • Ephesians 3:16–17; 4:2 • Philippians 2:1–3 • 1 John 3:1–2; 4:7–12

JOY

"Though you have not seen him, you love him; and even though you do not see him now, you believe in him and are filled with an inexpressible and glorious joy."

1 PETER 1:8

RECITE GOD'S GOODNESS

O Triune God, You are the God who rejoices over Your people with songs of celebration when anyone turns to You. How good You are to fill my heart with joy in Your presence. I rejoice in You, the God of my salvation!

EXPRESS YOUR NEEDINESS

Help me avail myself of the pleasures found only in Your presence. When I'm pummeled by hardship, fix my gaze on You and remind me of the eternal glories that await me at Your right hand. Through Your Spirit's work in my life, fill me with inexpressible and glorious joy.

SEEK HIS STILLNESS

God's kingdom is one of "righteousness, peace, and joy in the Holy Spirit" (Romans 14:17). Is this how you've experienced God's presence in your life? What is God inviting you to today?

TRUST HIS FAITHFULNESS

You promise to crown Your people with everlasting joy that will never be taken away when You return and we see You face-to-face. Until then, help me remain aware of Your presence in my life and rejoice in You, knowing that when You return, You will make my joy complete.

For Further Prayer and Study

Psalm 16:11 • Isaiah 12:6; 35:10 • Luke 15:7 • John 15:11; 16:22 • Hebrews 12:1–2

PEACE

"Peace I leave with you; my peace I give you."

JOHN 14:27

RECITE GOD'S GOODNESS

Prince of Peace, You offer Your peace to all who abide in You. Thank You for the many times You've guarded my heart and mind with Your peace, keeping me grounded in You.

EXPRESS YOUR NEEDINESS

Just as You spoke peace over the wind and the storms, so speak Your peace over my restless mind. I want to live in such a state of inner tranquility and rest that I can reflect that peace outward toward others around me. Help me be a peacemaker in my life, seeking to live at peace with everyone. Fill me with Your peace as I trust in You, and help me sow seeds of peace wherever I go.

SEEK HIS STILLNESS

Picture God's face turned toward you as a loving father looks upon his child, and let His presence fill you with His peace as you sit quietly with Him.

TRUST HIS FAITHFULNESS

You promise to keep in perfect peace all those who trust in You. And I do. I give You my hopes, my loved ones, my fears, my everything. You've always been faithful, so I place my whole life in Your hands. You are my eternal Rock, Lord, and I fix my hope on You.

For Further Prayer and Study

Numbers 6:26 • Isaiah 26:3–4 • Romans 12:18; 15:13 • Philippians 4:7 • James 3:17–18

PATIENCE

*"Be patient, then, brothers and sisters, until the Lord's coming. . . .
Be patient and stand firm, because the Lord's coming is near."*

JAMES 5:7–8

RECITE GOD'S GOODNESS

Compassionate Lord, You are so patient with Your people, not wanting anyone to perish, but desiring all to come and find refuge in You. Thank You for Your infinite patience with me; I praise You for not giving up on me (even though I would have long given up on myself). You are so good!

EXPRESS YOUR NEEDINESS

Lord, I'm quick to judge, quick to become angry, quick to demand my own way. Forgive me. I cast myself on Your mercy. As I receive the benefits of Your patient love, help me also become humble and gentle, patiently bearing with others in love.

SEEK HIS STILLNESS

Reflect on the past week: When has God shown His patience toward you, and when did He give you opportunities to reflect His patience toward others?

TRUST HIS FAITHFULNESS

Lord God, the truth is that I can't make myself more patient. I've tried. It can only be a supernatural work of Your Spirit in my life. So, Lord, here I am. Strengthen me with Your patience so that I may extend Your lovingkindness toward those You've placed in my life.

For Further Prayer and Study

Psalm 40:1 • Proverbs 15:18 • Romans 12:12; 15:5 • Galatians 6:9 • Colossians 3:12–13

KINDNESS

*"Whatever you did for one of the least of these brothers
and sisters of mine, you did for me."*

MATTHEW 25:40

RECITE GOD'S GOODNESS

O Jesus, You were kind and compassionate to all who came to You in need.
Never once did You turn someone away who sought You with a sincere heart.
You were good and kind then, just as You've proven Yourself to be good and
kind in my own life over and over again.

EXPRESS YOUR NEEDINESS

Dear Lord, I'm naturally selfish, looking out for my own interests instead of
seeking ways to serve others. Forgive me. Help me humble myself to be friendly
to strangers, generous toward the needy, and considerate to those in my own
home. Through Your Spirit's work in my life, make me tenderhearted and quick
to forgive, just as You've forgiven me.

SEEK HIS STILLNESS

*Bask in God's kindness toward you, and just sit quietly in His presence. Let His
tender mercy soften your heart toward those you find hard to love.*

TRUST HIS FAITHFULNESS

Lord God, You have shown Your everlasting lovingkindness toward us, revealing
Your great mercy in Christ Jesus. Thank You for Your great kindness when I least
deserved it. I trust You to continue working the fruit of Your Spirit in my life.

For Further Prayer and Study

Psalm 117:2 • Matthew 25:31–40 • Luke 6:27–30 • Ephesians 4:32 • 1 John 3:18

GOODNESS

"Who is wise and understanding among you? Let them show it by their good life, by deeds done in the humility that comes from wisdom."

JAMES 3:13

RECITE GOD'S GOODNESS

God of All Goodness and Grace, truly only You are good, perfect in all Your ways and above reproach. Thank You for living the perfect life, knowing we never could, and through Your death and life, giving us Your righteousness. I praise You for how You're working out Your goodness in my life too!

EXPRESS YOUR NEEDINESS

Lord Jesus, I'm acutely aware of my own sinfulness apart from You. Truly, any good thing in my life is the work of Your Spirit in me. So help me more fully surrender myself to You, so that I may be quick to do the good deeds You've prepared for me in advance and that all may see and glorify You, Jesus, not me.

SEEK HIS STILLNESS

Take a few moments to become aware of God's loving presence surrounding you this very moment.

TRUST HIS FAITHFULNESS

Lord, when You looked at Your creation, You declared it all "good." And despite all the ways Satan has tried to wreck my life, You are continuing to do a good work in me, and You will complete it. Help me to more fully trust You.

For Further Prayer and Study

Psalm 145:17 • Nahum 1:7 • Matthew 5:15–16 • 2 Corinthians 9:8 • Galatians 6:9–10

FAITHFULNESS

"His master replied, 'Well done, good and faithful servant!
You have been faithful with a few things; I will put you in charge of many things.
Come and share your master's happiness!'"

MATTHEW 25:21

RECITE GOD'S GOODNESS

Lord Jesus, Great High Priest, I praise You for being faithful to Your Father's call to the very end, even to death on a cross. How good You are! How faithful Your love!

EXPRESS YOUR NEEDINESS

Honestly, I struggle with daily faithfulness and consistency. On my own, I can do the right thing for a few days in a row, but eventually I get distracted or bored or tired. Forgive me, Lord. Make me steadfast in my faith in You and in the work You've given me to do. Only You can do this.

SEEK HIS STILLNESS

Take a few moments to become aware of God's faithful love pursuing you, rescuing you, and holding you. Is there anything you want to say to Him?

TRUST HIS FAITHFULNESS

How great is Your faithfulness, O Lord! Even when we are faithless, You remain faithful because that is who You are! It's because of Your faithful love that we're not consumed; it's that same faithfulness that allows me to trust You and rest in You even after I've failed. Thank You, Lord. You are so good!

For Further Prayer and Study

Psalm 107 • Lamentations 3:22–23 • Philippians 2:3–11 • Hebrews 10:23

GENTLENESS

"Let your gentleness be evident to all. The Lord is near."

PHILIPPIANS 4:5

RECITE GOD'S GOODNESS

Gentle and Lowly Jesus, while You walked this earth You restrained Your divine power for the benefit of our eternal salvation. I praise You for how compassionate You are, tender with the littlest lambs, full of grace toward all.

EXPRESS YOUR NEEDINESS

Lord, in this world that values power over gentleness and influence over meekness, I struggle to even want to be gentle. It makes me feel weak. But You, Jesus, were gentle, and You call us to be gentle; so renew my mind. Help me think Your thoughts and to reflect Your kind and tender heart toward all.

SEEK HIS STILLNESS

How does the Lord's imminent return encourage us toward gentleness? Meditate on today's verse as you ask God to reveal opportunities to reflect His gentleness in your life today.

TRUST HIS FAITHFULNESS

Lord, I want my gentleness to be known to all, my conversations to be full of grace, and my presence to exude humility and kindness. That sounds so different from who I am today, but I know that if anyone can do it, You can. I trust You to continue producing Your fruit in my life as I rest in You.

For Further Prayer and Study

Isaiah 40:11 • Matthew 11:28–29; 23:37 • Galatians 6:1 • Ephesians 4:2 • 1 Peter 3:15

SELF-CONTROL

"For the grace of God . . . teaches us to say 'No' to ungodliness and worldly passions, and to live self-controlled, upright and godly lives in this present age."

TITUS 2:11–12

RECITE GOD'S GOODNESS

My Great and High Priest, You know what it's like to suffer when being tempted, so You can empathize with our weaknesses. You never sinned, and You extend Your grace to us in our moment of desperate need. How good You are, Lord!

EXPRESS YOUR NEEDINESS

Lord, I submit my body to You as an instrument of righteousness. Take my hands, my feet, my eyes, my mouth, my ears, my mind, my fingertips, my everything. All I am is Yours! When I face temptation, help me look for Your way of escape instead of just fighting desire in my own power.

SEEK HIS STILLNESS

Reflect on the moment of your greatest temptation in the past 24 hours: How was God's grace opening an escape toward a life of self-control? Talk to God about that experience, and then rest in His loving presence.

TRUST HIS FAITHFULNESS

Lord, my own willpower cannot change me; only You can. So I surrender to Your Spirit. It's not by might or power that I'll gain victory over my flesh but by Your Spirit at work in me. I am Yours.

For Further Prayer and Study

Proverbs 16:32; 25:28 • Romans 6:12–14 • 1 Corinthians 9:27; 10:13 • 2 Timothy 1:7

PEOPLE OF THE COMING KINGDOM

*"Then the King will say to those on his right, 'Come, you who are
blessed by my Father; take your inheritance, the kingdom prepared for you
since the creation of the world.'"*

MATTHEW 25:34

RECITE GOD'S GOODNESS

O King of All Kings, how good You are to open the way for us to enter into
Your kingdom and, even more so, to become co-heirs with You. You have
blessed me abundantly, pouring out Your favor on my life, choosing me to be
one of Your own. With everything within me, I praise Your name!

EXPRESS YOUR NEEDINESS

Lord, many days Your kingdom still feels upside down to me. You challenge my
preconceptions and my ambitions. Change my heart. Transform me into the
kind of person who represents Your coming kingdom here on earth.

SEEK HIS STILLNESS

*Picture the scene described in the verse above. What will it be like to enter into God's
kingdom? What kind of a person will you be? And how is God's Spirit renovating
your soul to become that kind of person today?*

TRUST HIS FAITHFULNESS

Heavenly Father, I live for the day when Jesus returns and invites us to reign
with Him—not because of anything we have done, but because of Your great
kindness toward us. My soul rejoices in You! Come, Lord Jesus, come!

For Further Prayer and Study

Matthew 3:2; 5:1–12 • Acts 20:32 • 1 Corinthians 15:50 • Ephesians 1:11–14 • 1 Peter 1:4

THE POOR IN SPIRIT

"Blessed are the poor in spirit, for theirs is the kingdom of heaven."

MATTHEW 5:3

RECITE GOD'S GOODNESS

O Merciful King, You let go of the glories of heaven to become utterly poor, so that we may become richer than kings. You chose us, the spiritually destitute, to become rich in faith and inherit Your kingdom . . . because You love us! I praise You, Lord!

EXPRESS YOUR NEEDINESS

King Jesus, help me become aware of just how spiritually impoverished I am without You. Even my good deeds were done for the wrong reasons; apart from Your grace, there is nothing in me that merits Your blessings. Faced with Your perfect righteousness, I'm completely undone.

SEEK HIS STILLNESS

Sit quietly with King Jesus and empty your hands of anything you're holding on to so that you may receive His glorious riches of mercy and grace.

TRUST HIS FAITHFULNESS

Thank You that You don't choose the wise, the influential, or the noble, but rather You look for the humble who know just how much they need You. *I* need You, and I'm becoming more aware of my desperate need for You every day. And You are always enough, so I praise You, Lord!

For Further Prayer and Study

Isaiah 64:6 • Luke 12:21 • 1 Corinthians 1:26–28 • Philippians 2:3–11 • James 2:5

THOSE WHO MOURN

"Blessed are those who mourn, for they will be comforted."

MATTHEW 5:4

RECITE GOD'S GOODNESS

Precious King Jesus, it's because of Your mourning that we can rejoice in Your comfort. You wept for those in Jerusalem; You suffered on the cross; You died in the dark. It's because of You alone that we have hope, so I praise You!

EXPRESS YOUR NEEDINESS

O Lord, against You alone have I sinned and done what is evil in Your sight, and my actions have pained so many others. I'm undone in Your holy presence. I do not deserve Your forgiveness, but I cast myself on Your mercy.

SEEK HIS STILLNESS

Like the faithful from long ago who repented in sackcloth and ashes, humble yourself before the almighty God. Wait upon His mercy, and then watch as He lifts you up to become more and more like Jesus.

TRUST HIS FAITHFULNESS

You, Jesus, are the One who comforts us with Your own forgiveness, mercy, and grace. You remove the sting and rebuke of guilt, and one day You will wipe every tear from our eyes. You are so good and so faithful; I rejoice in You, the God of my salvation!

For Further Prayer and Study

Job 5:11 • Isaiah 6:1–8; 40:1; 61:1–3 • Luke 18:13–14 • 1 Peter 5:6 • Revelation 7:17

THE MEEK

"Blessed are the meek, for they will inherit the earth."

MATTHEW 5:5

RECITE GOD'S GOODNESS

Heavenly Lord Jesus, You humbled Yourself in order to glorify the Father in Your life. Like a lamb before its shearers, You did not defend Yourself. You were stripped of Your dignity, stripped of Your clothing, but Your cross became Your throne of victory over sin and death, and now the whole world belongs to You.

EXPRESS YOUR NEEDINESS

O Lord, strip me of any desire to grasp the power or prestige of this world. Help me humble myself and acknowledge that I am completely dependent on You. I throw myself on Your mercy, grace, forgiveness, and power. May You, King Jesus, become great, as I content myself to fade into the shadows of Your marvelous light.

SEEK HIS STILLNESS

Reflect on your actions and desires the last few days: Where were you trying to grasp for power? When did you willingly humble yourself for the sake of Christ? Sit quietly before the Lord, and let Him work the meekness of Jesus in your heart.

TRUST HIS FAITHFULNESS

What marvelous grace—that because of Your meekness, Jesus, I've received access to all the glories and riches of God, so that I may become more like You! Continue working out Your life in mine—for Your glory and honor alone.

For Further Prayer and Study

Isaiah 53:7 • Matthew 23:12 • James 4:7–10 • 1 Peter 5:5–6

THOSE WHO HUNGER AND THIRST FOR RIGHTEOUSNESS

"Blessed are those who hunger and thirst for righteousness, for they will be filled."

MATTHEW 5:6

RECITE GOD'S GOODNESS

O Water of Life, You declared "I thirst" on the cross so that we may thirst no more. How good You are to both stir up our hunger and thirst and satisfy us with Yourself! I praise You!

EXPRESS YOUR NEEDINESS

O Lord, give me Your desire for a life of love and integrity, justice and peace. Make me long for this earth to be filled with Your glory as the waters cover the sea and for Your righteousness to shine as bright as the noonday sun. Transform my heart to want what You want.

SEEK HIS STILLNESS

Picture the earth pulsating with God's glory and your own heart overflowing with His righteousness. Be still before the Lord, and let Him fill your heart.

TRUST HIS FAITHFULNESS

I throw myself on Your mercy, Lord God. I want to be found in You, not having a righteousness of my own, based on my own best efforts, but a righteousness that comes from You through faith in Jesus Christ.

For Further Prayer and Study

Isaiah 11:9 • Jeremiah 31:34 • Habakkuk 2:14 • Philippians 3:8–11 • Revelation 7:17

THE MERCIFUL

"Blessed are the merciful, for they will be shown mercy."

MATTHEW 5:7

RECITE GOD'S GOODNESS

Merciful Jesus, You endured betrayal, condemnation, flogging, and brutal execution so that we may obtain mercy in our time of need. You who received no mercy are generous and bountiful in extending it to us because You are our Great High Priest who empathizes with our weaknesses. I praise You, Jesus!

EXPRESS YOUR NEEDINESS

Having received such generous mercy, make me quick to extend mercy and forgiveness to those who have wronged me. Guard me from haughtiness and bitterness, and make me tender and compassionate toward all, for the sake of King Jesus.

SEEK HIS STILLNESS

Take a few moments to become aware of God's loving presence surrounding you this very moment. Who in your life do you struggle to extend mercy to? Whose face comes to mind? How might Jesus be inviting you to follow in His example of living a merciful life?

TRUST HIS FAITHFULNESS

I am unworthy, but You are eternally faithful and rich in mercy. I praise You, Jesus, for Your great love toward me. I trust You to continue working in me to make me more and more like You. Help me obey what You are calling me to do and trust You with any outcomes.

For Further Prayer and Study

Psalm 86:5 • Matthew 18:21–35 • Luke 6:36 • Ephesians 2:4–5 • Titus 3:5 • James 2:13

THE PURE IN HEART

"Blessed are the pure in heart, for they will see God."

MATTHEW 5:8

RECITE GOD'S GOODNESS

Glorious Jesus, You alone are pure. You were single-mindedly focused on doing the will of Your Father, even though it meant laying down everything. For the joy set before You, You endured the cross, scorning its shame, and sat down at the right hand of the throne of God. I praise You, Jesus!

EXPRESS YOUR NEEDINESS

Lord, give me purity of heart and singularity of mind to desire to do Your will alone. Help me seek not only my own good but also the good of others, laying aside any selfish ambition or vain pursuits and instead seeking Your glory and others' good.

SEEK HIS STILLNESS

Take a few moments to become aware of God's loving presence surrounding you this very moment. What does He want to say to you, and is there anything else you want to say to Him?

TRUST HIS FAITHFULNESS

King Jesus, You resisted the temptation of a shortcut, choosing instead obedience at the cost of Your very life. Thank You that we will someday see You face-to-face because of Your absolute obedience. You were faithful to the end, and we are now able to join You in a new beginning.

For Further Prayer and Study

Matthew 4:1–11 • Philippians 2:1–11 • 2 Timothy 2:20–21 • Hebrews 12:1–3 • 1 Peter 1:7

THE PEACEMAKERS

"Blessed are the peacemakers, for they will be called children of God."

MATTHEW 5:9

RECITE GOD'S GOODNESS

You, King Jesus, are the Prince of Peace who took on Yourself the world's enmity and savageness and sin, so that those who believe may be reconciled with God. My soul blesses You, Jesus, for making a way for us to become children of God.

EXPRESS YOUR NEEDINESS

Heavenly Father, fill me up with Your perfect peace that I may be a peacemaker wherever I go. May I no longer protect my own self-interests but confidently seek Your kingdom of righteousness, peace, and joy. Give me a heart that longs for others to come to know You as their Father, until knowledge of Your name fills the earth.

SEEK HIS STILLNESS

How is God working His truth and graciousness in your life and relationships right now? Sit with God and allow Him to reveal to you areas of your life where He's longing to bring His peace and restoration.

TRUST HIS FAITHFULNESS

Lord, thank You for inviting us to partner with You to be peacemakers in this world who sow in peace to reap a harvest of righteousness. On our own, our attempts at world peace are doomed to fail, but You, King Jesus, will soon bring Your peace to this earth. And You will reign forever and ever.

For Further Prayer and Study

Romans 14:17–19 • Hebrews 12:14 • James 3:17–18

THE PERSECUTED BECAUSE OF RIGHTEOUSNESS

*"Blessed are those who are persecuted because of righteousness, for theirs
is the kingdom of heaven. Blessed are you when people insult you, persecute you
and falsely say all kinds of evil against you because of me."*

MATTHEW 5:10–11

RECITE GOD'S GOODNESS

Lord Jesus, You who deserve all honor and praise and adoration let go of all
glory and made Yourself nothing for the sake of a greater treasure: redeeming
a people for Yourself. In doing so, You displayed the matchless riches of Your
grace toward us for all eternity. How wonderful You are!

EXPRESS YOUR NEEDINESS

Lord, help me consider this world worth nothing in comparison to the riches
of knowing You and making You known. No matter what the cost, make me
willing to lift up the name of Jesus and seek Your glory above all else.

SEEK HIS STILLNESS

*What's keeping you from giving Him everything? Sit with the One who let go of
everything to welcome you to inherit everything with Him.*

TRUST HIS FAITHFULNESS

Heavenly Father, make me ready and willing to lay down my life for You, to
rejoice in enduring hardship and opposition for the sake of Your glorious
name. May I live in a way that values making You known far above my life, my
reputation, and my earthly treasures.

For Further Prayer and Study

Psalm 73:25 • Romans 8:17–19 • Philippians 3:7–12 • 2 Peter 1:8

REJOICE AND BE GLAD

*"Rejoice and be glad, because great is your reward in heaven, for in the same way
they persecuted the prophets who were before you."*

MATTHEW 5:12

RECITE GOD'S GOODNESS

Blessed Jesus, any insult or injury I may endure for the sake of Your name,
You already experienced first. What a comfort to know that You're the One
who suffers with us, but also You're the victor who will ultimately turn our
mourning into dancing and our tears into laughter.

EXPRESS YOUR NEEDINESS

Lord, I want You to become so precious to me that I gladly abandon earthly
desires and pursuits that threaten my wholehearted devotion to You. Grow my
faith; make me so bold that I would gladly lay down my life for Your sake. And
strengthen my brothers and sisters around the world who are experiencing
persecution; may their witness bring many into Your kingdom.

SEEK HIS STILLNESS

*What would it cost you to be completely devoted to Jesus and His kingdom? Is there
anything He's calling you to lay down for Him? Sit quietly, and listen to His voice.*

TRUST HIS FAITHFULNESS

You are the Author and the Finisher of our faith, Jesus, and You will prepare
Your bride for Your return. Fill my heart with joy at the thought of seeing You
soon and make me zealous to make You known to others too.

For Further Prayer and Study

Luke 22:32 • John 15:21 • 2 Corinthians 12:9 • Ephesians 6:19–20 • Hebrews 11:32–38

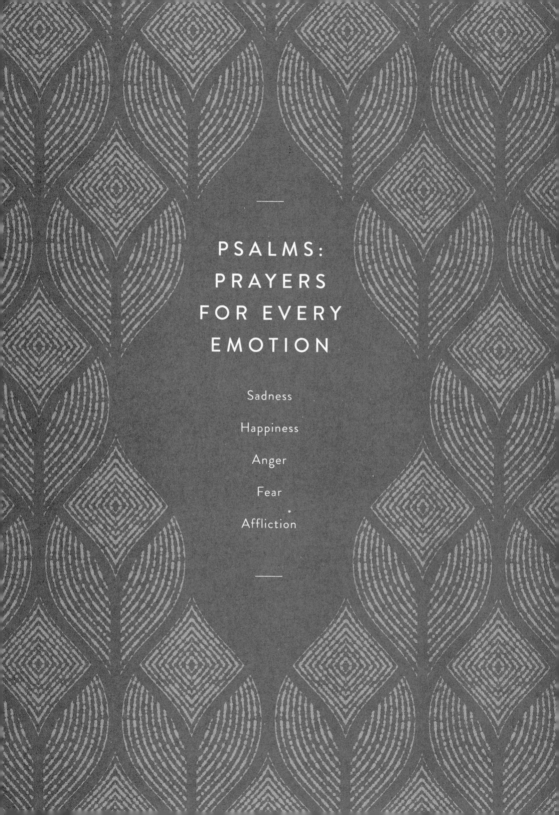

PSALMS: PRAYERS FOR EVERY EMOTION

Sadness

Happiness

Anger

Fear

Affliction

LONELY

"Yet I am always with you; you hold me by my right hand. You guide me with your counsel, and afterward you will take me into glory."

PSALM 73:23-24

RECITE GOD'S GOODNESS

God of All Comfort, thank You that You never leave me nor forsake me. Even when others turn their backs on me, You never will, because You have called me by name, and I am Yours. Thank You that Your Spirit never leaves me; even when I feel alone, You are always by my side.

EXPRESS YOUR NEEDINESS

God, I feel lonely. I want someone to share the joys and hardships of everyday life with me. I know You are always with me, but would You give me a sign of Your goodness in my life today? Help me become more aware of Your presence by my side and within my heart. Be just as real to me as an actual flesh-and-blood friend.

SEEK HIS STILLNESS

Take a few moments to become aware of God's loving presence surrounding you and within you this very moment.

TRUST HIS FAITHFULNESS

Though I've never seen You, God, You have proven Yourself more than enough for me. Help me rest in experiencing Your presence by my side. And through Your Spirit, empower me to reach out to fellow believers who feel lonely and express Your love to them today.

For Further Prayer and Study

Psalm 86:17 • Matthew 28:20 • John 14:18

VULNERABLE

"Turn to me and be gracious to me, for I am lonely and afflicted."

PSALM 25:16

RECITE GOD'S GOODNESS

Gracious Lord, You see and know what is done in secret. Nothing is hidden from You. You are the One who hears the cries of the needy, so I cry out to You today. Hear me. Have mercy on me, O Lord, for You are good and upright, and all Your ways are true.

EXPRESS YOUR NEEDINESS

Lord, I am hurt and lonely. It seems like all day long I feel mocked and abandoned. Turn Your face toward me and have mercy on me. Look at me and help me! My heart is full of sorrow. I feel weak and powerless to stop the pain. Come close, Lord, and protect my wounded heart.

SEEK HIS STILLNESS

Picture God turning toward you and sweeping you into His arms, like a loving Father coming to His child's rescue. Sense His loving presence surrounding you this very moment, and just be with Him.

TRUST HIS FAITHFULNESS

Even when I don't see You, I know You are near. Even when You don't rescue me the way I think You should, I know You are good. You hear my cry and You accept my prayer, and You will show faithful love to me because that is who You are. I trust You, Father.

For Further Prayer and Study

Numbers 6:24–26 • Psalms 6:8–9; 68:6 • John 14:18

DESPERATE

*"How long, LORD? Will you forget me forever? How long
will you hide your face from me?"*

PSALM 13:1

RECITE GOD'S GOODNESS

God of my Beginning and End, You know every day that has been allotted to me. You alone are my refuge and hiding place. It's Your promises that I cling to in my moments of desperation. Where else could I go if I didn't have You?

EXPRESS YOUR NEEDINESS

God, I can't face this by myself. Where are You? Why don't I hear from You? Please give me the courage and strength to face this trial. I know You haven't forgotten me, but it certainly feels that way. Give me a sign of Your favor, so I won't lose hope.

SEEK HIS STILLNESS

Sit quietly with God, waiting on Him. He is with you now, even if you don't feel Him. Is there anything He's trying to say to you?

TRUST HIS FAITHFULNESS

O God, I trust in Your faithful love. Even when I don't see You or feel You, I will continue to believe that You will never abandon the work of Your hands. Send me Your light and Your faithful care to guide me, even when I don't feel You. I'm putting my hope in You, for I will yet praise You, my Savior and my God!

For Further Prayer and Study

Psalm 43:1–5 • Habakkuk 3:17–18 • Romans 8:35–39 • 2 Corinthians 4:8–10

GUILTY

"Wash away all my iniquity and cleanse me from my sin."

PSALM 51:2

RECITE GOD'S GOODNESS

Precious Savior and Lord, You alone are generous in love and abundant in mercy.
You have the power to forgive and declare righteous because of Your intrinsic
holiness and because of the precious sacrifice of Jesus, the Lamb of God.

EXPRESS YOUR NEEDINESS

When I'm honest about my sins, I cannot bear the heaviness of guilt and regret.
I've sinned against You, Lord, and against others. Forgive me. Wash me of all
the evil I've done. Scrub away the guilt and make me pure from my sin. The
enemy tells me You could never love someone as sinful as I am. Give me faith in
Your cleansing power, and help me rejoice in Your purifying forgiveness.

SEEK HIS STILLNESS

*Confess your sins to God, naming them individually. Then receive His gracious
forgiveness and watch as He restores the joy of your salvation.*

TRUST HIS FAITHFULNESS

Lord, You created me to be in relationship with You, and You're the One who
restores me when I fall away. Thank You for Your faithfulness! Create in me
a pure heart and a steadfast spirit to remain faithful to You in secret and with
others watching. Only You can do this, and I trust You.

For Further Prayer and Study

Psalm 51 • Titus 2:14 • 1 John 1:9–10

DEPRESSED

"Hear my prayer, LORD; let my cry for help come to you. Do not hide your face from me when I am in distress. Turn your ear to me; when I call, answer me quickly."

PSALM 102:1-2

RECITE GOD'S GOODNESS

O Love Beyond Compare, You are compassionate and gracious, slow to anger and abounding in faithful love and truth. Were it not for Your lovingkindness, surely, I'd be gone by now. But because Your mercies are new every morning, I have lived to see this day. You are the true light in my darkness.

EXPRESS YOUR NEEDINESS

Lord, I feel alone and hopeless—even my heart and body have failed me. Some days I cannot find a reason to get out of bed. In this darkness, turn to me and answer me. Give me a sign of Your goodness in this land of the living. I desperately need You.

SEEK HIS STILLNESS

Take a few deep breaths, and become aware of God's loving presence surrounding you this very moment. Though you may not feel Him, He is near you. Do you believe it?

TRUST HIS FAITHFULNESS

Lord, let my prayers reach Your ears even though they seem to bounce off the ceiling. Even when I feel my life is empty, I believe that You are working within me for Your good purposes; my hope is alive in You. You promise that when I call to You in my day of trouble, You will rescue me. You've never failed me yet, and You won't start now, so I trust You.

For Further Prayer and Study

Exodus 34:5–7 • Psalms 27:13–14; 50:15; 102:1–11 • John 14:1–3

HURT

"But as for me, afflicted and in pain—may your salvation, God, protect me."

PSALM 69:29

RECITE GOD'S GOODNESS

O Great Physician, only You can heal my pain. I praise You because You care. You care about my hurt. You care about my tears. You care about the suffering I'm experiencing right now. You are the God who turns mourning into dancing.

EXPRESS YOUR NEEDINESS

Lord God, in my hurt and brokenness, I turn to You. Heal me, Lord! The pain seems unbearable. Bring relief to my body and to my heart. In my suffering, don't let me doubt Your goodness, but redeem this affliction by showing me Your joy in my time of suffering.

SEEK HIS STILLNESS

Picture Jesus, the Great Healer, reaching out and touching you, just as He healed countless people in His time on earth. What does He want to say to you?

TRUST HIS FAITHFULNESS

Nothing gets to me except through Your hand, so I trust that even though the enemy meant this for evil, You will turn for my good and Your glory. Your plans are to prosper and not to harm, and as You bring healing and restoration, these broken pieces will be stronger than they were before.

For Further Prayer and Study

Genesis 50:20 • Romans 8:28 • 2 Corinthians 4:17–18

REGRET

"I confess my iniquity; I am troubled by my sin."

PSALM 38:18

RECITE GOD'S GOODNESS

Lord God, You alone are holy, holy, holy, and in light of Your holiness, my own sin stands in dark contrast. You are the One who sees all things, knows all things, and loves me still. It's because of Your lovingkindness that I even dare stare my sin in the face. Only You can make my troubled soul whole again.

EXPRESS YOUR NEEDINESS

Lord, I admit that I have done wrong. My sin is bare before You and before me, and I cannot hide my failure from You. So I confess my guilt. Regret consumes me. Forgive me for my sins and wash me clean by the blood of the Lamb.

SEEK HIS STILLNESS

Confess your sins to the Lord, naming them specifically. Then receive His gracious forgiveness, and rest in His loving presence.

TRUST HIS FAITHFULNESS

Lord, I don't deserve Your forgiveness or restoration, but You are compassionate and kind, slow to anger, and abounding in steadfast love. Thank You for restoring me to fellowship. Set my feet on the path of Your commands, and help me walk in Your Spirit, no longer satisfying the desires of the flesh. You alone can do this, and I trust You.

For Further Prayer and Study

Psalms 32:5; 51:7 • Ecclesiastes 7:3 • Romans 8:18 • 2 Corinthians 7:9–10

SORROW

*"My life is consumed by anguish and my years by groaning;
my strength fails because of my affliction."*

PSALM 31:10

RECITE GOD'S GOODNESS

O God who sees and knows me, not a tear streaks my face without Your knowing it, and not a sob escapes without Your hearing it. If anyone knows what it's like to be burdened by sorrows, it's You, the Man of Sorrows. Thank You that I can find comfort and refuge in You.

EXPRESS YOUR NEEDINESS

Lord, I feel worn out from grief and sorrow. Whom have I in heaven but You? Turn toward me, and be gracious to me. Listen closely to my cries for relief, and rescue me from a world of sorrows.

SEEK HIS STILLNESS

Express your sorrow to the Lord, through tears, sobs, moans, or even silence, knowing that God's Holy Spirit interprets even your groans before Him. Let it all out, and then be still with Him. Let His presence quiet you with His love.

TRUST HIS FAITHFULNESS

Lord God, You alone will free me from this place of sadness. You are my refuge and hiding place, and I entrust myself fully into Your loving and capable hands. I will rejoice in your faithful love, because You've seen my sorrow, You know my trouble, and You will lead me to a place of comfort and rest.

For Further Prayer and Study

Psalm 25:18 • John 11:35 • Romans 8:26–27

SYMPATHY

"You, Lord, hear the desire of the afflicted; you encourage them, and you listen to their cry."

PSALM 10:17

RECITE GOD'S GOODNESS

Compassionate Lord, You are the One who hears our cries; Your ear is bent low to listen to the one who calls out to You. You created us with the capacity to feel care and concern for others who are suffering, and You generously provide us with people to walk with us through our hardest moments. How good You are!

EXPRESS YOUR NEEDINESS

Father God, my heart is heavy for my dear friend who is experiencing trouble. Be near them. Let them become aware of Your loving presence surrounding them this very moment. Help me know when to speak and what to say, and when to be silent in quiet empathy. Fill me with Your love overflowing toward them.

SEEK HIS STILLNESS

How is God calling you to love your friend today? Quiet your heart, listen to His voice, and then commit to obey right away.

TRUST HIS FAITHFULNESS

You, Lord God, are so faithful to use broken people like myself to be Your hands and feet to a broken world. You breathe courage and hope into the hearts of the sorrowful. You come quickly to their aid and save them, as only You can. I praise You, and I trust You with my friend's situation today.

For Further Prayer and Study

Exodus 22:23 • Psalm 9:12 • Revelation 21:4

DISTRESSED

"Why, my soul, are you downcast? Why so disturbed within me?
Put your hope in God, for I will yet praise him, my Savior and my God."

PSALM 42:5

RECITE GOD'S GOODNESS

O God who hears my prayers, even when I don't see You or feel You, You are always with me. You are constant and true, never abandoning the work of Your hands. Your goodness doesn't depend on my faithfulness but on Your own faithful character. You are good, and You are kind. That is who You are.

EXPRESS YOUR NEEDINESS

In my distress, I cry out to You. Answer me, O Lord God! Despite my emotions to the contrary, help me believe that You are my ever-present helper. In the dark night of my soul, God, give me eyes of faith to see You as my light and my salvation. Like the psalmist, I want to preach good news to my soul.

SEEK HIS STILLNESS

Take a few moments to become aware of God's loving presence surrounding you this very moment. Can you sense His light penetrating the darkness?

TRUST HIS FAITHFULNESS

In my heartache, I will wait on You. God, I hope in You. I trust in You. When my burdens weigh me down, I will choose to focus on Your past faithfulness and remember how You've always been faithful. I'm waiting to see Your faithful love, Lord, for I will yet praise You.

For Further Prayer and Study

Psalms 25:5; 38:6; 42:1–43:5 • Matthew 26:38 • Hebrews 12:11–12

CELEBRATORY

"Praise the LORD. . . . *Praise him for his acts of power; praise him for his surpassing greatness. . . . Let everything that has breath praise the* LORD."

PSALM 150:1-2, 6

RECITE GOD'S GOODNESS

Lord, You are great and worthy to be praised. You have done wonderful things in my own life, and my soul knows them well. I praise You for Your acts of power and Your magnificent greatness! I rejoice in You, my King!

EXPRESS YOUR NEEDINESS

Lord, open my eyes to see the wonderful things that You have done! Make my spirit quick to recognize Your hand at work in my life. Put a song of praise on my lips that my soul would rise to You in worship every moment of my life.

SEEK HIS STILLNESS

Allow your heart to respond to God's greatness and goodness however you feel led. Then be still in God's loving presence. Is there anything He wants to say to you?

TRUST HIS FAITHFULNESS

From the time I was in my mom's uterus, You knew me, You loved me, and You saw all the days of my life. You are the God who has never left me, because Your own faithfulness has bound You to me for all eternity. God, I trust You. There's no one else in this world that I trust or love more than You!

For Further Prayer and Study

Psalm 119:18 • 2 Corinthians 6:10 • Philippians 4:4–8

CONTENTED

"Yes, my soul, find rest in God; my hope comes from him. Truly he is my rock and my salvation; he is my fortress, I will not be shaken."

PSALM 62:5–6

RECITE GOD'S GOODNESS

Lord God, You alone are my rock, my shelter, the One I run to when the ground beneath my feet quakes. You are the safe place where my soul can finally breathe at ease. In You, I can rest secure because You are an impenetrable fortress. You are my defender, so I will always be secure.

EXPRESS YOUR NEEDINESS

Lord, though I've experienced Your protection on so many occasions, I'm still slow to run to You. Forgive me. Set my heart on a course that is set toward You, not just when I'm in trouble, but when things go well too. I want to rest in You alone.

SEEK HIS STILLNESS

Spend some time now resting in God, your Fortress. Let your soul breathe contentedly as He surrounds you with His loving presence. Is there anything He wants to say to you?

TRUST HIS FAITHFULNESS

Truly, my soul finds rest in You alone. You are my salvation; the One I can always count on. My feet are planted on solid ground when I'm with You because I trust You.

For Further Prayer and Study

Matthew 6:25–33 • 2 Corinthians 12:10 • Philippians 4:12–13 • 1 Timothy 6:6–7

DELIGHTED

"Then my soul will rejoice in the LORD and delight in his salvation."

PSALM 35:9

RECITE GOD'S GOODNESS

O Lord God, You are so good! My soul delights in You alone! I rejoice in You, the God of my salvation! For You have done great things for me. Who is like You, Lord? You rescue the poor and needy—You pour out Your blessings on Your children. I praise You!

EXPRESS YOUR NEEDINESS

You heard me when I cried out to You! You bent low and listened to my prayer of desperation, even when I couldn't sense Your presence. I bless Your holy name! May I not forget Your kindness. Help me dwell here, in the green pastures of thanksgiving, and remember all Your benefits.

SEEK HIS STILLNESS

Sit quietly before the Lord, taking a few deep breaths and resting in His loving presence. How has He proven His goodness to you lately, specifically? Who would be encouraged to hear of His faithful love today?

TRUST HIS FAITHFULNESS

All my life long, I will declare Your praises, Lord! I will proclaim Your powerful work in my life. You have been gracious and compassionate, slow to anger, and great in faithful love. You are good to everyone, and Your compassion rests on all You have made. I praise You, Lord! And I trust in You alone.

For Further Prayer and Study

Psalms 16:11; 37:3–4; 145:1–12 • Habakkuk 3:18 • 1 Thessalonians 5:16

GLAD

"I will be glad and rejoice in you; I will sing the praises of your name, O Most High."

PSALM 9:2

RECITE GOD'S GOODNESS

O Lord of my Exceeding Joy, You are a just God who rules rightly and compassionately. You are clothed with wisdom and righteousness, and all Your ways are perfect. You are good and You do only good. All the works of Your hands praise You, God, and I join them in singing Your praises too.

EXPRESS YOUR NEEDINESS

Father, there's so much that exceeds my comprehension, but occasionally You give me glimpses into how You're working all things for good. Expand my capacity to see and understand You, Lord. Help me to more fully surrender to You, God. Thrill me with Your presence. I want more of You, God.

SEEK HIS STILLNESS

Take a few moments to become aware of God's loving presence surrounding you this very moment. Is there anything He wants to say to you?

TRUST HIS FAITHFULNESS

Lord God, I thank You with all my heart. Indeed, You have done great things, and You're not finished yet. As I look back on my own life, I can see the thread of Your faithfulness, just as You've been faithful from the garden of Eden and will continue to be into eternity. Lord God, You are magnificent, and I trust You!

For Further Prayer and Study

Psalm 8:9 • Proverbs 31:25 • Matthew 25:21–23 • Romans 12:1–2

HOPEFUL

*"May your unfailing love be with us, L*ord*, even as we put our hope in you."*

PSALM 33:22

RECITE GOD'S GOODNESS

O Divine Redeemer, I will sing joyfully to You, and with my whole heart I will praise You! You are faithful in all You do, and the whole earth is full of Your unfailing love. Because of Your compassion, we are not consumed; Your merciful love is renewed every morning!

EXPRESS YOUR NEEDINESS

Lord, were it not for Your unfailing love, I would feel utterly hopeless. May Your goodness and mercy follow me all the days of my life. I know I need You. My soul clings to You, and Your right hand upholds me. So I put all my hope in You alone.

SEEK HIS STILLNESS

Quietly rest in God's loving presence, and let Him quiet you with His love. Is there anything He wants to say to you?

TRUST HIS FAITHFULNESS

Lord God, I wait for You in quiet expectation. My help and my salvation come from You, so I trust in Your holy name. No matter how long it takes to see the fulfillment of Your promises, my heart will rest and rejoice in You.

For Further Prayer and Study

Lamentations 3:22–23 • Psalms 23:6; 62:5; 63:8 • Joel 2:23 • Luke 1:46–55

OPTIMISTIC

*"Though an army besiege me, my heart will not fear;
though war break out against me, even then I will be confident."*

PSALM 27:3

RECITE GOD'S GOODNESS

Lord God Almighty, on my own I can do nothing. But with You by my side, there's nothing I cannot do. You are the One who sustains me, the very breath of Your nostrils animating me. It is in You that I live and move and have my being, so there's nothing that I fear.

EXPRESS YOUR NEEDINESS

It's so tempting to rely on my own understanding, my own strength, and my own record of achievements. But the truth is that, without You, I am nothing. Guard me from trusting in my abilities, my bank account, or my health. Only You are trustworthy; my confidence rests in You alone.

SEEK HIS STILLNESS

Visualize the challenges surrounding you these days, and picture God surrounding you with His protective presence. Take a few deep breaths as you rest in Him right now.

TRUST HIS FAITHFULNESS

Lord, You are my God. What could anyone do to me? You are the One who loves me and holds me. What failure could touch me? There's nothing that will separate me from Your love, so the pressure is off. I can rest in You. I can work with You. I can love in You. You are enough.

For Further Prayer and Study

Psalm 3:6 • Habakkuk 3:17–19 • Romans 8:31–39

PEACEFUL

"In peace I will lie down and sleep, for you alone, Lord, make me dwell in safety."

PSALM 4:8

RECITE GOD'S GOODNESS

You are the God of peace. In You alone I trust, and my heart rests securely. You created all things, and in You they hold together—so You're the One who restores perfect harmony where the enemy sows fear and discord. You have power over all creation.

EXPRESS YOUR NEEDINESS

Lord God, in the midst of relational difficulties, debilitating illnesses, financial crises, and so many other storms of life, I need Your peace. When my thoughts are jumbled and fear creeps up my throat, I will trust in You alone. When I toss and turn in the middle of the night, I will trust in You alone. Perfect peace is found only in You.

SEEK HIS STILLNESS

Take a few moments to lie on a bed or on the floor, and slow your breathing. Become aware of God's loving presence speaking peace over your life, over your body, over your future. Is there anything you want to say to Him?

TRUST HIS FAITHFULNESS

Eternal God, You put my life back together so I can rest peacefully in You. You, Jesus, are the Prince of Peace, and You restored peace wherever You went. Because of You, I have peace with the Father and can now help bring peace to my surroundings. I trust in You alone.

For Further Prayer and Study

Numbers 6:26 • Psalms 3:5; 16:9 • Nahum 1:7 • John 14:27; 16:33

RELIEVED

"God is our refuge and strength, an ever-present help in trouble."

PSALM 46:1

RECITE GOD'S GOODNESS

O Great God, when trouble seems near, You are nearer still. So I have nothing to fear. You are my refuge, a safe place to hide. You are my strength, always ready to help. Whom shall I fear? You are for me, so no one and nothing can separate me from Your love!

EXPRESS YOUR NEEDINESS

Lord, I confess that any other refuge I sometimes run to is like a straw hut against the gales of this world's troubles. Only You keep me safe. Forgive me for the times I make You my last resort instead of my first appeal. When I run to You, I am safe.

SEEK HIS STILLNESS

Picture God's presence as a mighty and impenetrable fortress. When have you found refuge in Him? How has He proven Himself faithful in times of trouble? Be still with Him now, and rest in His loving presence.

TRUST HIS FAITHFULNESS

Never once did You abandon me, even when I deserved it. You have proven Yourself more than enough whenever I run to You. Your faithful love endures any challenge that comes my way. I praise You, God! Because of You, I can face life's troubles fearlessly, for You are the One who fights for me. I trust You.

For Further Prayer and Study

Deuteronomy 4:29–31 • Psalms 37:39; 61:3 • Lamentations 3:55–57 • Joel 3:16

AWE

"Let all the earth fear the LORD; let all the people of the world revere him."

PSALM 33:8

RECITE GOD'S GOODNESS

Supreme Lord God, You are the almighty One who is worthy of all praise. Let all who serve you celebrate Your rule with wonder and awe. You are holy, holy, holy—the whole earth is full of Your glory, and all Your creation stands in awe of You, our Lord God.

EXPRESS YOUR NEEDINESS

To be honest, I find it hard to know how to fear You without becoming afraid of You, God. Teach me godly fear, acknowledging Your perfect holiness and sovereign rule and learning to respect and revere Your name. May I never become careless with You.

SEEK HIS STILLNESS

Wonder at the beauty and grandeur of God, quietly gazing out at the expansive sky. Allow reverential respect to humble you before Him, and just be still with Him. Is there anything He wants to say to you?

TRUST HIS FAITHFULNESS

Lord, when I become aware of Your majesty, I'm humbled by the realization that I don't often give You the proper respect You deserve. Lord, change my heart. Help me revere Your name. I trust You to transform me into one who worships You in Spirit and in truth.

For Further Prayer and Study

Deuteronomy 6:13 • Psalm 2:11 • Isaiah 18:3–4 • Micah 1:2–4 • Revelation 4:6–11

WONDER

*"Satisfy us in the morning with your unfailing love, that we may sing
for joy and be glad all our days. . . . May your deeds be shown to your servants,
your splendor to their children."*

PSALM 90:14, 16

RECITE GOD'S GOODNESS

Lord God, You are just amazing! Morning by morning, You fill me with your
faithful love and mercy. I am overcome by Your love and kindness toward me.
You put a song of praise on my lips and a melody of celebration in my heart.
You are altogether beautiful, majestic, and worthy of my praise.

EXPRESS YOUR NEEDINESS

Lord, You've been so faithful toward me all my life. I ask that You'd reveal Your
splendor to my loved ones as well. May they come to discover Your matchless
glory through Your faithful deeds in their own lives. Only You can satisfy, and I
want that not just for me, but for my children and their children for generations
to come.

SEEK HIS STILLNESS

*Allow your soul to make music to the King until you've exhausted your song. Then sit
quietly in wonder and admiration of His glory, and let God quiet you with His love.*

TRUST HIS FAITHFULNESS

Great is Your faithfulness, dear God. Even in my hardest moments, You never
abandoned me. The works of Your hands all around me, and even within me,
reveal Your beauty and majesty. I will always trust You.

For Further Prayer and Study

1 Chronicles 16:24 • Job 37:5 • Psalms 72:18; 98:1 • Luke 5:26 • Romans 11:33–36

BETRAYED

"My companion attacks his friends; he violates his covenant.
His talk is smooth as butter, yet war is in his heart."

PSALM 55:20–21

RECITE GOD'S GOODNESS

Unchangeable God, You listen to my prayer. You see what is hidden and discern the thoughts of every human heart. I cry out to You alone. I have no one else to turn to. I am poor and needy, but You are rich in mercy and compassionate in love.

EXPRESS YOUR NEEDINESS

Father God, this hurts. I had expected this person to love me and stay by my side, yet they took advantage of my trust and turned on me. I don't even have words to describe the depth of pain and brokenness. How could this happen?

SEEK HIS STILLNESS

Bring your pain, anger, and betrayal before the Lord, and talk with Him about the specifics. Then rest in His presence, and let Him quiet you with His love.

TRUST HIS FAITHFULNESS

Lord God, I cast my burdens on You because Your shoulders are broad enough to carry all my pain. You alone will carry me and sustain me. Even if my friends and family members abandon me, You will never leave me because I am Yours. Thank You for Your steadfast love. I didn't earn it. I don't deserve it. But You freely give it. I trust in You alone.

For Further Prayer and Study

Psalms 31:14–15; 55:1–23 • Matthew 20:17–19 • Acts 12:1–19

OUTRAGED

"Refrain from anger and turn from wrath; do not fret—it leads only to evil. For those who are evil will be destroyed, but those who hope in the LORD will inherit the land."

PSALM 37:8-9

RECITE GOD'S GOODNESS

Lord of All Being, because of Your mercy we are not consumed by Your anger. You continue to forgive all who turn to You, so I come to You now in my outrage. Thank You for being a safe place to open my heart and process my anger.

EXPRESS YOUR NEEDINESS

Lord, when I see the wickedness around me, I'm consumed with rage. My emotions threaten to get the better of me, so teach me to turn to You in my fury. Keep me from doing evil in my frustration. Help me wait on You and trust that You will do what is right in Your way and Your time.

SEEK HIS STILLNESS

Ask God to reveal the source of your rage. Sit quietly with Him. Is there anything He wants to say to you?

TRUST HIS FAITHFULNESS

The truth is that the evil residing in a murderer is the same sin crouching at my heart, seeking to devour me. Where I feel self-righteous, help me humble myself and wait patiently for You. You will be proved right when You speak and blameless when You judge. My hope is in You alone.

For Further Prayer and Study

Genesis 4:7; 6:3-8 • Psalm 51:4 • 1 Timothy 1:15 • 1 Peter 5:8

HUMILIATED

"The LORD is my light and my salvation whom shall I fear?
The LORD is the stronghold of my life—of whom shall I be afraid?"

PSALM 27:1

RECITE GOD'S GOODNESS

God of all Light and Truth, though You are the most powerful One in the universe, I never have to fear You. I praise You for being compassionate and kind. Unlike people in my life who have broken my trust, You are trustworthy and true. You never put me to shame. You are so, so good. I love You, Lord.

EXPRESS YOUR NEEDINESS

I don't know if I can take it anymore, God. You know the pain I've endured. You see how these evil-doers tear my dignity to shreds and leave me wounded and alone. Help me release them into Your hands, knowing that You will do what is right.

SEEK HIS STILLNESS

Picture the most recent incident of humiliation. Can you see Jesus with you, standing by your side? Take a few moments to become aware of God's loving presence surrounding you in this very moment.

TRUST HIS FAITHFULNESS

Jesus, You bore my pain and humiliation on the cross. You know what it's like to be stripped of dignity and publicly ridiculed, yet You conquered hatred with sin. Change my heart with Your love. Help me do good in the face of evil. I trust You to enact divine vengeance in Your perfect timing.

For Further Prayer and Study

Psalm 27:1–14 • Isaiah 53 • Matthew 5:43–48 • Romans 12:19

BITTER

"The face of the LORD is against those who do evil, to blot out their name from the earth."

PSALM 34:16

RECITE GOD'S GOODNESS

God of the Highest Heaven, You see how the innocent suffer, and You hear the cries of the afflicted. You are the judge of the living and the dead, and everything is laid bare before You. Nothing is hidden from Your sight. I praise You because You will not leave the wicked unpunished for their cruelty and sins. You will do what is right.

EXPRESS YOUR NEEDINESS

Lord, when I hear of hideous abuse and covered-up scandals, my heart cries out for these wrongs to be made right. When will You bring an end to this corruption? When will You bring shalom to this earth?

SEEK HIS STILLNESS

Bring your resentment before the Lord, and be honest with Him about the anger in your heart. Lament sin and brokenness. And then allow His loving, holy, and perfect presence to quiet your heart.

TRUST HIS FAITHFULNESS

Lord, You are patient and kind, righteous and just. Someday soon You will confront those who have done evil and wipe away the memory of their names when You wipe every tear from our eyes. But while there is still time, would You turn their hearts to repentance? Only You can do this.

For Further Prayer and Study

Deuteronomy 29:18–19 • Psalm 37:1–20 • Hebrews 12:14–15

ENVIOUS

"But as for me, my feet had almost slipped; I had nearly lost my foothold.
For I envied the arrogant when I saw the prosperity of the wicked."

PSALM 73:2–3

RECITE GOD'S GOODNESS

O God of All Truth, You are perfect in all Your ways. Where humans see only a sliver of the big picture, You are above all things and behold the whole realm of what is real, both what is seen and unseen. Wisdom and understanding belong to You alone. You are indeed good, and I praise You alone.

EXPRESS YOUR NEEDINESS

God, when others have what I want, I struggle with bitterness and resentment. It's tempting to compare and to cry "Not fair!" Forgive me, Father, for coveting. Help me humble myself before You and accept the portion You've given me.

SEEK HIS STILLNESS

Pause to consider the specific situations in which you're tempted to envy. What is the gift that you desire, and how is that longing a good thing? In what way is God inviting you to experience satisfaction of that desire in Him?

TRUST HIS FAITHFULNESS

Father, every good and perfect gift comes from You, and if You're withholding something, I will trust that You are doing what is best. Create in me a clean heart, O God, and renew a steadfast spirit within me. I want to be grateful for Your generous gifts and not begrudge Your goodness to others.

For Further Prayer and Study

Proverbs 14:30 • Galatians 5:19–21 • James 4:2–3

HOSTILE

"Do not fret when people . . . carry out their wicked schemes.
Refrain from anger and turn from wrath; do not fret—it leads only to evil."

PSALM 37:7–8

RECITE GOD'S GOODNESS

My Lord and Master, if anyone knows all the evil that's going on in this world, it's You. The fact that You do not destroy all of humanity right now is a testament to Your patience and mercy. You are not slow in executing justice, but rather You're compassionate, not wanting anyone to die in their sins. How good You are, Lord!

EXPRESS YOUR NEEDINESS

I confess that I'm not as patient when I see evil people flaunt Your mercy and prey on the vulnerable. It makes my blood boil when I think of how the powerful are abusing the innocent. O God, keep me from doing something foolish in my anger. Teach me how to submit my anger to You in righteousness.

SEEK HIS STILLNESS

Voice your frustrations to God, and then be still before Him. How is He inviting you to rest in the assurance of His sovereignty and power?

TRUST HIS FAITHFULNESS

Lord, I'm not the only person to witness atrocities, many done by those who claim Your name. Joseph, Moses, David, Elijah, Isaiah . . . so many godly people decried the evil in their world, but they rested in You. Help me trust that You will not leave the guilty unpunished. Help me wait for You.

For Further Prayer and Study

Psalm 139:19–22 • Romans 12:18 • James 3:14–16

FRUSTRATED

"Did I purify my heart and wash my hands in innocence for nothing?"

PSALM 73:13 CSB

RECITE GOD'S GOODNESS

Righteous and Holy God, I know that You are indeed good. You see when I get up and when I'm on my way, and nothing is hidden from Your sight. You, Lord, know all things, and You guide me in the way I should go. You are the strength of my heart and my portion forever.

EXPRESS YOUR NEEDINESS

Lord, I sometimes get so frustrated! I'm irritated when people get away with crimes committed in plain daylight. How long will You leave the wicked unpunished? When will You finally bring justice for the victims of oppression? Lord God, You see it all . . . do something!

SEEK HIS STILLNESS

Take a few moments to become aware of God's presence with you, His right hand holding you, His counsel guiding you. What does He want to say to you?

TRUST HIS FAITHFULNESS

On my own, I'm ignorant and foolhardy. I want to take justice into my own hands. But when I come into Your presence, God, I'm reminded that You are sovereign over all, and You will make all things right in Your perfect timing. I have no one else to rely on in heaven or on earth but You, so I trust You, God.

For Further Prayer and Study

Psalms 73; 137:4–6 • Romans 12:19 • Hebrews 10:30–39

ANNOYED

*"L*ORD*, don't I hate those who hate you, and detest those who rebel against you?"*

PSALM 139:21 CSB

RECITE GOD'S GOODNESS

Fountain of All Good, You are the One who created us all in Your image. You've placed eternity in our hearts, and have breathed Your own breath into our lungs. Every person I meet is a testament to Your creative majesty. How good of You to make us for Yourself!

EXPRESS YOUR NEEDINESS

The honest truth is that I get annoyed with people—all kinds of people—from corrupt politicians to slow grocery clerks, from unethical coworkers to whining children. Some days, it's all I can do to keep from yelling at everyone. Not just people who hate you, but even innocent bystanders. The real problem is me and the sin that still controls me. Expunge self-righteous anger and indignation from me, and purify my heart.

SEEK HIS STILLNESS

Recall to mind the faces of those who have annoyed you over the last 24 hours. Can you see the image of God in them? Can you sense the love of God extending toward them? Be still before the Lord, and let Him lead you in His everlasting way.

TRUST HIS FAITHFULNESS

God, Your gaze penetrates even the trickiest annoyances. Search me, God, know me; test me and lead me. I trust You to continue sanctifying me so that I look more and more like Jesus each day.

For Further Prayer and Study

Deuteronomy 32:35 • Psalm 37:1–21 • 1 Thessalonians 4:9–12 • James 1:19

OFFENDED

"While they curse, may you bless; may those who attack me
be put to shame, but may your servant rejoice."

PSALM 109:28

RECITE GOD'S GOODNESS

God of my Salvation, You are slow to anger and abounding in steadfast love. What You bless remains blessed, and what You curse will forever be cursed. I praise You that I am safe in Your love and that no one can turn Your love from me.

EXPRESS YOUR NEEDINESS

Father, I confess that some people just rub me the wrong way. It seems like they're purposefully trying to annoy me, and I have a hard time loving them. Help me not take to heart all the things they say; help me overlook offenses instead of letting them fester and lead to bitterness.

SEEK HIS STILLNESS

Who has wronged you recently? Take a few moments to talk with God about them, and ask Him to give you a forgiving heart. Then release them to God, and let His peace fill you.

TRUST HIS FAITHFULNESS

Lord, I want my heart to be soft toward You and toward others. Help me not hold on to grudges, but to display Your lovingkindness even toward people who I don't think deserve it. I don't deserve Your love, yet You love me still. So I will rejoice in You, and trust You all day long.

For Further Prayer and Study

Psalms 37:10–11; 119:165 • Ecclesiastes 7:21–22 • 1 Corinthians 13:5 • Hebrews 13:1

JUDGMENTAL

*"Search me, God, and know my heart; test me and know my anxious thoughts.
See if there is any offensive way in me, and lead me in the way everlasting."*

PSALM 139:23-24

RECITE GOD'S GOODNESS

All-Searching God, You know all things. You know my thoughts even before
I become aware of them. You discern motives and intentions even when I'm
unsure of what's in my own heart. Thank You that even the revelation of sin is
a gift because it leads to repentance and life.

EXPRESS YOUR NEEDINESS

When I see others commit wrongs, I'm quick to condemn them, without
considering my own shortcomings and sin. I want Your divine justice on others
but Your mercy on myself. Forgive me Lord, for my prideful attitude. Help me
humble myself before You.

SEEK HIS STILLNESS

*Take a few moments to allow God's Spirit to search your heart and reveal anything
that needs to be confessed or corrected. Then become aware of God's love and
forgiveness extended toward you in Jesus Christ.*

TRUST HIS FAITHFULNESS

Lord God, You are the One who will judge all people. You are just and fair,
and You will not let the guilty go unpunished. When I see others do wrong,
help me trust that You will do what is right. Thank You for Your mercy in Jesus
toward all who believe in You.

For Further Prayer and Study

1 Samuel 16:7 • Matthew 7:1–6 • John 8:7 • Romans 14:4

AFRAID

*"When I am afraid, I put my trust in you.
In God, whose word I praise—in God I trust and am not afraid."*

PSALM 56:3-4

RECITE GOD'S GOODNESS

Father of Mercies, I praise You for Your constant presence. You are powerful and reign supreme over all the details of my life. There's nothing that escapes Your notice, and nothing is out of Your control. You alone are a strong tower in my time of trouble, and I trust You!

EXPRESS YOUR NEEDINESS

When I am afraid, when I feel like I can't breathe because of the worries that suffocate my soul, help me turn my gaze from the circumstances around me and fix my eyes on You. Give me a heart of faith to believe that You will work all things together. But even more than that, make me aware of Your very presence with me.

SEEK HIS STILLNESS

Take a few moments to become aware of God's loving presence surrounding you this very moment.

TRUST HIS FAITHFULNESS

I will trust in You, God. You have never abandoned me in my time of need. So I can trust You and praise You because You keep me secure. After all, what's the worst that can happen? You keep my eternity and my salvation safe in Your loving hands. I will trust You and not be afraid.

For Further Prayer and Study

Psalms 23:4; 34:4-5 • Matthew 8:25-27; 10:29-32 • Luke 14:27

CONFUSED

"Show me your ways, LORD, teach me your paths. Guide me in your truth and teach me, for you are God my Savior, and my hope is in you all day long."

PSALM 25:4–5

RECITE GOD'S GOODNESS

Lord, all Your ways are righteous, and You alone are good. You are the truth, the light, and the way of salvation. There is salvation in no other name under the sun but Yours, and in Your goodness, You've given us Your Word so that we may know You.

EXPRESS YOUR NEEDINESS

I feel ignorant and stupid, like I should know the way forward, but I don't. Teach me what I cannot see. Show me the way I should go. Through Your Holy Spirit within me, guide me in all truth, so that all I say and do will please You.

SEEK HIS STILLNESS

Close your eyes, take a few deep breaths, and sit quietly with the Lord, your Shepherd. Is there anything He wants to say to you?

TRUST HIS FAITHFULNESS

With You as my Good Shepherd, I can walk securely, knowing You will lead me on the right path. The boundaries You've set for me keep me in green pastures; I trust You to lead me out of confusion and into clarity that I may know and do Your will. My hope is in You, Lord.

For Further Prayer and Study

Job 34:32 • Psalm 43:3 • John 16:13

ANXIOUS

"I lift up my eyes to the mountains—where does my help come from?
My help comes from the LORD, the Maker of heaven and earth."

PSALM 121:1–2

RECITE GOD'S GOODNESS

My Maker and Helper, You hear me when I cry out to You. You are the One who comes quickly to my rescue. Thank You for being close to me when I'm troubled. You alone can quiet me with Your presence; Your light dispels my darkness.

EXPRESS YOUR NEEDINESS

Lord, when terror and doom suffocate the life out of me, would You lift me out of the pit of despair? Help me fix my attention on You instead of on the surrounding circumstances. Help me remember how You've been faithful in the past and trust You to be my helper even now.

SEEK HIS STILLNESS

Take a few moments to become aware of God's loving presence surrounding you this very moment. Let Him quiet your anxious thoughts with His lovingkindness.

TRUST HIS FAITHFULNESS

Lord, You have always been faithful. Never once have you abandoned me. I need only to become more aware of Your constant presence by my side. When worries fester within me, help me cast my cares on You, knowing that You've always cared for me. I trust You to take care of these situations and to fill me with Your peace.

For Further Prayer and Study

Deuteronomy 31:6 • Proverbs 3:23–24 • Luke 14:27

WORRIED

"Cast your cares on the LORD and he will sustain you;
he will never let the righteous be shaken."

PSALM 55:22

RECITE GOD'S GOODNESS

Precious Father, thank You for being close to me when I'm worried. You hear me when I cry out to You, and You always answer me. You never let go of me, even when trouble surrounds me. Your saving help is my shield, and Your right hand sustains me.

EXPRESS YOUR NEEDINESS

Lord, I bring my worries to You. All the jumbled thoughts and the what-ifs, all the fears of falling short. Speak Your peace over my thoughts and calm my anxious heart as I cast all my cares on You.

SEEK HIS STILLNESS

Imagine holding a specific worry in your hands. Now palms down, place it into God's outstretched hands and, palms up, receive what He has to give you in exchange: peace for anxiousness; generous provision for financial woes; sustaining life for sickness. Repeat the palms down–palms up prayer until you have no worries left to give and you've received all God has to give you. Then rest in God's loving presence.

TRUST HIS FAITHFULNESS

Great is Your faithfulness, Father. There's no worry that escapes Your notice, and nothing is outside the realm of Your power and provision. You will keep me in perfect peace, so I rest in You today.

For Further Prayer and Study

Psalm 18:35 • Matthew 6:25–34 • 1 Peter 5:7

INSECURE

"How long must I wrestle with my thoughts and day after day have sorrow in my heart?"

PSALM 13:2

RECITE GOD'S GOODNESS

Almighty God, where I am weak, You are strong. Where I'm uncertain, You are sure. Where I am fearful, You are fearless. You are gracious and compassionate, Father, and I worship You.

EXPRESS YOUR NEEDINESS

I'm pummeled by fear and anxiety, never sure if I'm on solid footing in my relationships, in my job, in my finances, even in my standing with You. God, guard me from the enemy's lies that seek to torment me. Reassure me of what is true in You, and help me rest in You.

SEEK HIS STILLNESS

Take a few moments to become aware of God's loving presence surrounding you this very moment, strengthening you and filling you.

TRUST HIS FAITHFULNESS

Lord, You've promised to never leave me nor abandon me. Even if all my worst fears came true, You would still hold me in Your loving embrace because that is who You are. I put my whole trust in You, Lord; You keep me secure.

For Further Prayer and Study

Psalms 3:3–4; 42:4; 55:2 • Hebrews 13:5 • 1 John 4:18–19

UNEASY

"Let the morning bring me word of your unfailing love, for I have put my trust in you. Show me the way I should go, for to you I entrust my life."

PSALM 143:8

RECITE GOD'S GOODNESS

Father of Mercies, each morning I wake up to Your unfailing love, new every morning, sustaining my every breath. You're the One I rely on. Thank You that I can always turn to You. You've placed Your own Spirit within me and have promised to guide me, so I praise You in advance for how You will work.

EXPRESS YOUR NEEDINESS

Lord, I thought I was doing the right thing, but it turns out I may be wrong. I don't know what to do anymore. I'm jumpy, second-guessing myself. So I need You. Give me clear direction. Show me the way to go, the right decision to make. I need You, God.

SEEK HIS STILLNESS

Quiet your heart as you sit before the Lord, allowing Him to direct your thoughts. Is there anything He wants to say to you?

TRUST HIS FAITHFULNESS

Lord, when I am afraid, I hide in You. When I am anxious, I turn to You. When I feel uneasy, I entrust my life to You. Here I am, ready and wanting to do what is right. Lead me as only You can, Lord. I trust in You with my whole life.

For Further Prayer and Study

Psalms 5:11–12; 56:1–2 • Philippians 4:6 • 2 Timothy 1:7

WORTHLESS

"For you created my inmost being; you knit me together in my mother's womb."

PSALM 139:13

RECITE GOD'S GOODNESS

Creator and Sustainer of my life, You are the artist who beautifully shaped me, body and soul, while I was still in my mother's womb. Even there You saw me and knew me completely. All Your works are marvelous! I worship You in humble adoration!

EXPRESS YOUR NEEDINESS

Even though I know all that, I still sometimes feel worthless. I see others who are prettier, smarter, and kinder, and wonder why You even made me. Teach me how to think rightly about myself, to see myself as You see me. You created me in Your image and then bought me with the precious blood of Jesus. Help me remember that You are the One who defines me as valuable, not because of anything I've done, but because of all You've done for me.

SEEK HIS STILLNESS

Take a few moments to become aware of God's loving presence surrounding you this very moment.

TRUST HIS FAITHFULNESS

You're not finished with me yet, so I can be okay with being a work-in-progress. Lord, I trust You to continue shaping me into the image of Jesus and reminding me that I am valuable because of the priceless sacrifice of Jesus on my behalf. So I can rest in Him.

For Further Prayer and Study

Job 10:11 • Psalms 8:4–6; 119:73 • Isaiah 44:2, 24 • Jeremiah 1:5

DISMAYED

"From the ends of the earth I call to you, I call as my heart grows faint;
lead me to the rock that is higher than I."

PSALM 61:2

RECITE GOD'S GOODNESS

Mighty God, You are my rock of refuge, my strong fortress who saves me. You alone see all things as they are, so I know that I can run to You in my trouble. You hear my call no matter how faint my whisper. You are the One I trust.

EXPRESS YOUR NEEDINESS

I'm intimidated by what's before me. I don't think I can do this on my own. In fact, I know that I can't do this on my own. I need You, God. Come quickly to my rescue. Help me in this time of need.

SEEK HIS STILLNESS

Picture yourself running through a hailstorm into a strong tower. Feel the relief of finding refuge, the joy of catching your breath. How is God offering to be your refuge right now? Sit quietly with Him, and let Him quiet your soul.

TRUST HIS FAITHFULNESS

You, my Rock and my Redeemer, are the One I hide in when I'm dismayed. You will plant my feet securely when I feel like I'm standing in quicksand. Lead me by Your gentle truth. Show me the way I should go because I trust in You.

For Further Prayer and Study

Joshua 1:9 • Psalms 6:2; 31:2 • Isaiah 41:10 • Matthew 11:28-30

INADEQUATE

"How priceless is your unfailing love, O God!
People take refuge in the shadow of your wings."

PSALM 36:7

RECITE GOD'S GOODNESS

I love You, Lord, so much! You never leave me or turn away from me. Your faithful love extends higher than the sky above, and Your judgments are deeper than the ocean. You are good and You are kind, and You're abundant in grace when I stumble and fail.

EXPRESS YOUR NEEDINESS

There are times like today when I feel so deficient in my relationships, in my work, and in my ability to do what's required of me. When I fail, I feel like a failure, and it's a quick downward spiral from there. Let Your priceless love rescue me from the pit of despair. Bring me refreshment in Your presence.

SEEK HIS STILLNESS

Take a few moments to become aware of God's loving presence surrounding you this very moment. Hide under the shadow of His wings, and let Him quiet you with His love.

TRUST HIS FAITHFULNESS

Lord God, You preserve my life according to Your lovingkindness. You give me a seat at Your table because You delight in me; You satisfy me with Your own presence. In my inadequacy, I cling to You and Your right hand sustains me. Thank You for spreading your faithful love over me. I trust You.

For Further Prayer and Study

Matthew 10:29 • Romans 5:8 • 2 Corinthians 3:5; 12:9–10 • Philippians 1:6; 4:13

NERVOUS

"Those who know your name trust in you, for you, Lord,
have never forsaken those who seek you."

PSALM 9:10

RECITE GOD'S GOODNESS

Compassionate Lord, You are a refuge for all those who trust in You. No matter what's happening in my world today, You remain powerful, almighty, and in control. You never abandon those who seek You, so I can rest completely in You.

EXPRESS YOUR NEEDINESS

God, I'm nervous about what I'm facing right now. I don't know how it's going to turn out, and I'm afraid I'm going to do or say the wrong thing—and if not me, then someone else will. Calm my anxious heart; help me rest in the knowledge that You are in control. You've got this.

SEEK HIS STILLNESS

Find a comfortable position, and breathe in deeply, becoming aware of God's loving presence surrounding you. Place your hand on your heart, and sense His peace that passes all understanding guarding you this very moment. Is there anything you want to say to Him or that He is saying to you?

TRUST HIS FAITHFULNESS

Father God, I will rejoice and be glad in You because You will save me from my fears and worries. When I call on You, You will answer me and rescue me from all my troubles. I trust in You, God, and I rest in You today.

For Further Prayer and Study

Deuteronomy 4:31 • Psalms 70:4; 91:14 • Philippians 4:7

BORED

*"Blessed is the one . . . whose delight is in the law of the LORD,
and who meditates on his law day and night."*

PSALM 1:1–2

RECITE GOD'S GOODNESS

Heavenly Father, every good and perfect gift comes from You, and You give generously to all who ask without finding fault. Every gift says something about the giver—how marvelous and wonderful You prove Yourself to be!

EXPRESS YOUR NEEDINESS

I confess that I'm bored right now: bored with my work, with my relationships, with my life circumstances. I wish things were more exciting. But most likely, the problem is not with things outside me, but within me. Help me see the many blessings You've given me with fresh eyes; I want to delight in Your Word, in Your provision, in who You are. Thrill me with You, God!

SEEK HIS STILLNESS

Become aware of God's blessings all around you, even His own loving presence within you.

TRUST HIS FAITHFULNESS

You are preparing for us blessings and riches that no eye has seen and no ear has heard, and I can't wait for what You've prepared for those who love you! But in the meantime, I trust You to teach me contentment with what You've given me, and more than that, to fill me with joy in Your presence. I will delight in You and rest in Your unending blessings here and now.

For Further Prayer and Study

Psalms 1:1–3; 16:11; 21:6; 36:5–10 • Matthew 25:34 • 1 Corinthians 2:9 • James 1:12

DISAPPOINTED

"May my prayer reach your presence; listen to my cry."

PSALM 88:2 CSB

RECITE GOD'S GOODNESS

O Lord my Lord, You are the God of my salvation. My hope rests in You alone. When others disappoint me, I know that You will never disappoint. When I spread out my hands to You, You hear my cry and come close to me. You have never let me down, Lord. I can trust in You.

EXPRESS YOUR NEEDINESS

On days like today—whether I fail to meet other people's expectations or they fail to meet mine—I'm faced with human limitations. I'm not perfect and other people aren't perfect either. Help me take the pressure off myself to be what only You can be to others. And help me release them from that same expectation.

SEEK HIS STILLNESS

Take a few moments to become aware of God's loving presence surrounding you this very moment. Is there anything He wants to say to you?

TRUST HIS FAITHFULNESS

When I am disappointed, I can still trust in You. You meet me in my place of sadness, and You lift my gaze toward Your perfect love. Your faithful love for me is great, and You rescue me from despair and disillusionment. I can rest in the assurance of all You are and will always be.

For Further Prayer and Study

Psalms 86:11–12; 88:1–8 • Isaiah 55:8–9 • 1 Peter 5:6–7

WEAK

"Have mercy on me, LORD, for I am faint."

PSALM 6:2

RECITE GOD'S GOODNESS

Sustainer of All Things, You are the One who holds me and heals me. You are close to the brokenhearted, and you bandage up the wounded. You are great, awesome, and powerful—infinite in Your understanding and limitless in Your compassion.

EXPRESS YOUR NEEDINESS

I need You, God. I am weak, and my strength is failing. On my own, I can do nothing. Be quick to come to my rescue. Bend low and save me, God, for I put my hope in You alone.

SEEK HIS STILLNESS

Meditate on the truth that God gives power to the faint and increases strength to the one who has none. Be still before God as you draw strength from His endless reserve of strength.

TRUST HIS FAITHFULNESS

Lord God, when I am weak, Your strength is magnified in me. You strengthen my hands and straighten my back. You prepare me for each next step, and You fill me with Your Spirit's power. You give me both the desire and the ability to do what pleases You.

For Further Prayer and Study

Psalm 147:3 • Isaiah 40:29 • 2 Corinthians 12:9

BUSY

"Some trust in chariots and some in horses,
but we trust in the name of the LORD our God."

PSALM 20:7

RECITE GOD'S GOODNESS

Sovereign Lord God, I praise You for being the lover of my soul. You love me just the way I am, not because of how much I accomplish but because of what You've accomplished on my behalf in Jesus.

EXPRESS YOUR NEEDINESS

God, I confess that on days like today, I feel too rushed even to pray. There's so much to do and not enough time. It's days like today when I need to be reminded that the most important thing I can do is just to be with You. Establish Your work in my heart, so that I can discern the work that's important to Your heart.

SEEK HIS STILLNESS

Find a quiet place and take a deep breath, slowly inhaling through your nose and exhaling through your mouth. Is there anything God wants to say to you? Be still enough to listen . . . and wait on Him.

TRUST HIS FAITHFULNESS

Lord, You're not impressed with how many things I get done in a day or how many people are impressed by my productivity. Rather, You value those who fear You and put their hope in Your faithful love. So I'm choosing to trust You today, to slow down and rest in You. All will be well, because You are in control.

For Further Prayer and Study

Psalms 23:1–3; 147:10–11 • Luke 10:38–42 • John 17:4 • 2 Timothy 4:7–8

STRESSED

*"Have mercy on me, my God, have mercy on me, for in you I take refuge.
I will take refuge in the shadow of your wings until the disaster has passed."*

PSALM 57:1

RECITE GOD'S GOODNESS

O Lord my Strength and Shield, You are a refuge for me when I'm stressed.
When I cry out to You, You hear me and come to my rescue. Thank You for
being a gracious God, rich in mercies and abounding in steadfast love.

EXPRESS YOUR NEEDINESS

It all just seems too much right now, Lord. I can't handle it. It's beyond my
ability to cope. Hide me in the shelter of Your wings. Put Your protective cover
over me, and let me catch my breath.

SEEK HIS STILLNESS

*Picture giant wings enveloping you, completely protecting you from everything that's
stressing you out right now. What does it feel like? Can you breathe more deeply?
Be still with God, and rest in His loving presence for a few moments longer.*

TRUST HIS FAITHFULNESS

You are my strength, always helping when I trust in You. I will thank You for
Your faithfulness, God. Never have you left me to fend for myself. You've always
come quickly to my rescue, so I rest in You now.

For Further Prayer and Study

Psalms 9:9; 14:5–6; 28:7 • Isaiah 41:10 • Philippians 4:12–13

OVERWHELMED

"In the morning I lay my requests before you and wait expectantly."

PSALM 5:3

RECITE GOD'S GOODNESS

Father of Mercies, You never tire of hearing from Your children. Thank You for inviting me to come to You day after day, hour after hour, and welcoming me with open arms. Your compassion knows no limits.

EXPRESS YOUR NEEDINESS

I'm feeling overwhelmed with all I have to do today and all I left undone yesterday. Looking at my list, there just isn't enough time to do it all. Help me distinguish the work You've given me to do from the tasks that I and others have added on. I lay everything before You and wait to see what You say.

SEEK HIS STILLNESS

Bring your actual to-do list (or your planner, your inbox, or whatever is causing you overwhelm) before the Lord. Ask Him to give you clarity and direction. Is there anything God is saying to you in the stillness?

TRUST HIS FAITHFULNESS

Lord, You promise that if I lack wisdom and ask You for it, You'll graciously give it to me. So I'm asking, and believing, that You will guide me today in all wisdom and understanding. Bring clarity where there is confusion, and help me lay aside any expectations that are not from You. I want to please You today because I love You.

For Further Prayer and Study

Psalm 43:3–5 • Romans 8:15–17 • Hebrews 4:15–16 • James 1:5

SLEEPY

"I lie down and sleep; I wake again, because the LORD sustains me."

PSALM 3:5

RECITE GOD'S GOODNESS

Supreme Ruler of the visible and invisible world, You never fall asleep, nor do You become distracted or inattentive. I praise You that I can rest in peace knowing that You continue to keep the world spinning, and nothing is outside the realm of Your control

EXPRESS YOUR NEEDINESS

As I lay down tonight, give me rest in my body and refreshment in my soul. Quiet my thoughts and help me let go of all worries so that I may ease into peaceful sleep. And because I'm acutely aware of my failures today, forgive me, merciful Father, for Christ's sake.

SEEK HIS STILLNESS

Breathe in deeply as you feel the weight of your body sink into the mattress. Picture God's presence surrounding you as you ease into sleep, keeping you safe until you awake.

TRUST HIS FAITHFULNESS

As I lay my head on the pillow, You are with me. And when I awake—whether in the middle of the night or in the streams of the morning sun—You are still with me. You are faithful, Lord God, so I rest in You now.

For Further Prayer and Study

Leviticus 26:6 • Psalms 18:7–9; 139:18 • Mark 4:38–40

SLEEPLESS

"In peace I will lie down and sleep, for you alone, LORD, make me dwell in safety."

PSALM 4:8

RECITE GOD'S GOODNESS

Limitless God, You created us to require sleep each night that our bodies may be refreshed and restored. Your designs are perfect, and Your plans are good. So even though I'm struggling to sleep right now, I know You will provide.

EXPRESS YOUR NEEDINESS

Lord, look upon my tossing and turning. My mind is racing with all I've done or have left undone, and my failures are constantly before me. Fear and regrets consume me, stealing what little peace I have. I need You, God. Quiet my mind with Your peace so that I can fall asleep.

SEEK HIS STILLNESS

One at a time, grab hold of each thing that's worrying you, and then place it before Jesus. Keep laying your burdens there until there's a stack before Him. Now open your hands and receive His peace, knowing that He will handle all you've entrusted to Him. Breathe deeply as you continue this exchange, until you feel held by His love.

TRUST HIS FAITHFULNESS

When I'm afraid, I will trust in You. When I'm worried, I will trust in You. When I'm tired, I will trust in You. When I'm in pain, I will trust in You. You are enough for all my needs, so I rest in You tonight.

For Further Prayer and Study

Leviticus 26:6 • Numbers 6:25–26 • Job 11:18 • Isaiah 26:3 • Philippians 4:7

SHAME

"My face is covered with shame at the taunts of those who reproach and revile me, because of the enemy, who is bent on revenge."

PSALM 44:15-16

RECITE GOD'S GOODNESS

Father of Mercies, You are holy, perfect in all Your ways. Nothing impure could ever come into Your presence, so You made a way for Your children to be washed clean by the blood of Jesus. I praise You, Father, for Your matchless grace in Jesus!

EXPRESS YOUR NEEDINESS

Most days, it's my own conscience that condemns me. It's Satan, the accuser, who flings insults at me, and despair threatens to overwhelm me. I'm mortified by the hideousness of my own sin. Make me quick to run to the cross of Jesus and confess my brokenness, receive Your forgiveness, and claim His righteousness.

SEEK HIS STILLNESS

Picture God washing the shame and guilt of sin away, and wrapping you in a robe of righteousness that belongs to Jesus. Be still with Him, rejoicing in His salvation.

TRUST HIS FAITHFULNESS

If anyone had reason to disapprove of me, it would be You. But because of the precious sacrifice of Jesus, Satan's taunts can't touch me. Were it not for Your tender mercy in Jesus, everything my enemy says about me would be true. But because of Jesus, I have nothing to be ashamed of. Thank You, God!

For Further Prayer and Study

Romans 3:23-24 • 1 Corinthians 1:30 • Ephesians 1:7-14 • 1 John 1:7-10

TEMPTED

"I said, 'I will watch my ways and keep my tongue from sin;
I will put a muzzle on my mouth.'"

PSALM 39:1

RECITE GOD'S GOODNESS

God of All Good, You are holy in all Your ways, and I praise You for the work
that You are doing in my life to sanctify me and make me into the image of Jesus.
Thank You that no temptation comes against me that You haven't already prepared
me for and for which you have prepared a way of escape. You are so good!

EXPRESS YOUR NEEDINESS

God, what I want to do right now is not loving You or loving others, but merely
fulfilling my own selfish wants. Give me the strength to turn away from this
temptation and obey You instead. Guard me from sin or even flirting with the
possibility of sinning.

SEEK HIS STILLNESS

Take a few deep breaths and close your eyes. What is the escape plan God is
revealing to you? Physically distance yourself from temptation right now. Yes, this
very moment. Now look back and reflect on how God has delivered you. Is there
anything He wants to say to you?

TRUST HIS FAITHFULNESS

Lord, thank You for Your salvation. Your mercy is enough to cover any sin, but
Your grace is strong enough to keep me from sin. You have proven Yourself
faithful once again. Thank You. I can rest in Your deliverance now.

--- *For Further Prayer and Study* ---

Psalm 119:9 • 1 Corinthians 10:13 • Titus 2:11–14

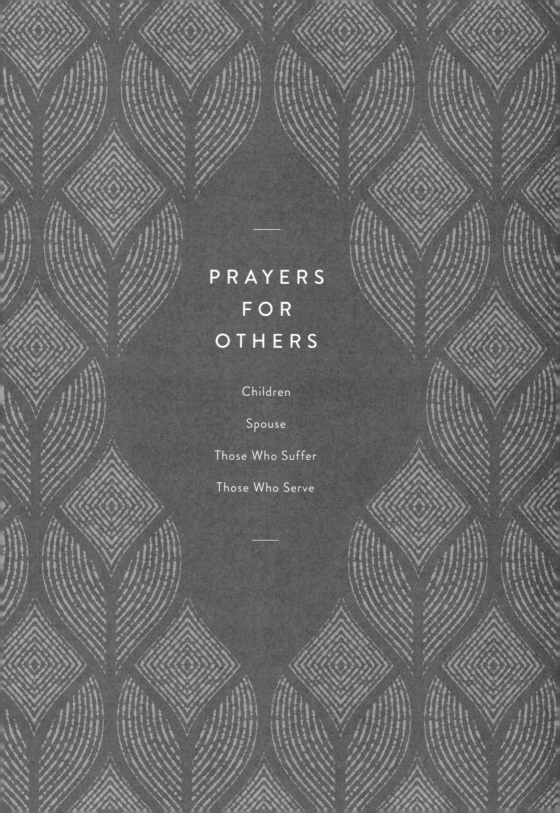

—

PRAYERS
FOR
OTHERS

Children

Spouse

Those Who Suffer

Those Who Serve

—

SALVATION

"The same Lord is Lord of all and richly blesses all who call on him,
for, 'Everyone who calls on the name of the Lord will be saved.'"

ROMANS 10:12-13

RECITE GOD'S GOODNESS

O Gracious God, You made us for Yourself, and my child will be restless
until he finds his rest in You. You promise that everyone who calls on Your
name will be saved. How kind of You to seek and to save those who are lost,
including my child.

EXPRESS YOUR NEEDINESS

Lord, pour out Your Spirit on my child, that he would turn from his sin and
repent. Bring him to a saving knowledge of Jesus Christ, and give him the
assurance of eternal forgiveness. Fill him with the joy of your salvation and the
celebration of new life.

SEEK HIS STILLNESS

Rest in the assurance that your heavenly Father loves your child even more than you
do, and He will seek him out as a lost lamb, inviting him to join His fold.

TRUST HIS FAITHFULNESS

Thank You, Father, that I can trust You with my child's salvation. I believe that
You are working on his heart even now, to soften his heart to respond to You.
You will be faithful to complete the good work You've started in him.

--------- *For Further Prayer and Study* ---------

Isaiah 44:3 • Luke 19:9–10 • Acts 16:31 • Romans 10:9

HUNGER AND THIRST FOR GOD

"He has filled the hungry with good things."

LUKE 1:53

RECITE GOD'S GOODNESS

All-Loving Father, You created my child for Yourself, and only in You will she find the satisfaction her heart is searching for. You bless those who hunger and thirst for You and promise to satisfy them with Yourself. You are so good to offer Yourself to us generation after generation!

EXPRESS YOUR NEEDINESS

Guard my child from addictions and idols that would draw her heart away from You, and give her an insatiable desire for You. Fill her with a hunger for Your Word, that she would feast on the bread of life all her days.

SEEK HIS STILLNESS

Bring any specific worries or concerns about your child before the Lord; entrust her into His loving care, and then rest completely in God's presence.

TRUST HIS FAITHFULNESS

Lord God, You promise to fill the hungry with good things. So I trust that when my child will draw near to You, You will draw near to her as well. May she sense Your loving presence with her all the days of her life.

For Further Prayer and Study

Proverbs 4:23 • Matthew 5:6; 6:33; 7:9–11 • James 4:8

HUMILITY

*"Humble yourselves, therefore, under God's mighty hand,
that he may lift you up in due time."*

1 PETER 5:6

RECITE GOD'S GOODNESS

Sovereign Lord, thank You for choosing the weak things of this world to shame the strong. I'm so grateful that You show off Your strength and Your power in those who are humble and dependent on You.

EXPRESS YOUR NEEDINESS

Help my child accept and embrace his desperate need for You; give him grace to not exaggerate his own importance, but to see himself as servant to all, so that he may receive grace upon grace. Keep him from arrogance and hastiness; grant him a willing and humble spirit to sustain him as he serves those around him.

SEEK HIS STILLNESS

Ponder the humility of Jesus, who let go of the glories of heaven to become human, suffering and dying for our sins. What do you want to say to Him? And is there anything that He wants to say to you?

TRUST HIS FAITHFULNESS

Lord, You have promised that Your grace is sufficient and Your power is made perfect in weakness. May my child's words, his actions, and his entire life be an outpouring of Your grace, giving life to those around him.

For Further Prayer and Study

2 Corinthians 12:9 • Philippians 2:1–11 • Colossians 4:6 • 1 John 3:3 • James 4:6

HEALTH TO DO GOOD WORKS

"From birth I have relied on you; you brought me forth
from my mother's womb. I will ever praise you."

PSALM 71:6

RECITE GOD'S GOODNESS

Almighty God, You are the One who knit my child while she was still in my womb. Before breath filled her lungs, You knew each day that You'd allotted for her, as well as every cold or fracture or infection she'd endure. Thank You for knowing her and loving her so well.

EXPRESS YOUR NEEDINESS

Keep my child healthy and strong so that she can do the good works You prepared for her to walk in before the creation of the world. Just as Jesus came not to be served but to serve, help her to give her life to serving others with Your love.

SEEK HIS STILLNESS

In your mind's eye, scan your child from head to toe, and entrust each part of her body and soul to God's loving care. Then rest in His tender provision.

TRUST HIS FAITHFULNESS

God, I trust You to grow my daughter in wisdom, in stature, and in favor before You and others. Thank You for being trustworthy; no matter what ailments come my child's way, I can trust You to love her and provide for her better than I ever could.

For Further Prayer and Study

Isaiah 40:31 • Matthew 20:28 • Luke 2:52; 8:48 • Ephesians 2:10 • Colossians 1:29

WISDOM AND INTEGRITY

*"Brothers and sisters, stop thinking like children.
In regard to evil be infants, but in your thinking be adults."*

1 CORINTHIANS 14:20

RECITE GOD'S GOODNESS

Lord God, You are the fountain of all wisdom; thank You for sharing that
wisdom with those who fear Your name. You are so good to generously give
wisdom without finding fault!

EXPRESS YOUR NEEDINESS

Teach my child to fear you, and fill him with all wisdom and discernment in his
life choices and friendships. Help him choose his friends wisely and surround
himself with those who love You, that they may encourage each other in love
and good deeds. Give him a sharp mind and discerning spirit, tempered with
innocence and integrity that he may walk securely in Your presence.

SEEK HIS STILLNESS

*In which specific areas of your child's life does he require wisdom and integrity
right now? Bring them before the Lord, and then rest in the assurance that He will
continue doing His good work in your child's life.*

TRUST HIS FAITHFULNESS

Lord God, as I look back on my own life, I see so many situations where You gave
me wisdom and courage to do the right thing. You've never failed me, and I know
You will prove Yourself faithful in my child's life as well. I trust in You alone.

For Further Prayer and Study

1 Kings 3:9–12 • Proverbs 1:7; 10:9 • Matthew 10:16 • James 1:5

DIVINE PROTECTION

"But the Lord is faithful, and he will strengthen you and protect you from the evil one."

2 THESSALONIANS 3:3

RECITE GOD'S GOODNESS

God of Heaven's Armies, You are the One we trust in. You are a shield around me and my family, my glory, and the lifter of my head. Because of Jesus, nothing plotted against us will stand. I praise You!

EXPRESS YOUR NEEDINESS

Protect my child from evil men who seek to harm her; guard her from the hands of the wicked and from those who plan to ensnare her. When I'm tempted to worry about what could happen to her, remind me that You hide Your beloved in the shadow of Your wings.

SEEK HIS STILLNESS

As you send your child into the world, far from where you can protect her, picture God Himself surrounding her with His own presence. Allow His presence to comfort your heart and bring rest to your soul, even now.

TRUST HIS FAITHFULNESS

I trust that You will be my child's refuge and strength, a very present help in her time of trouble. I praise You that Jesus has already won the battle against the enemy of our souls, so nothing can stand against You and those You protect! I trust You, God!

For Further Prayer and Study

Psalms 46:1; 90:1–5; 140:1–5 • 1 Corinthians 15:57 • Ephesians 6:12

MARRIAGE AND SEXUALITY

"My beloved is mine and I am his."

SONG OF SOLOMON 2:16

RECITE GOD'S GOODNESS

Precious Father, I praise You that You hold my children's futures in Your hands. You know every detail of their lives, including who and when they will marry. What a gift You've given us, to share the joys and sorrows of life with another human! You are so good!

EXPRESS YOUR NEEDINESS

Help my children trust You with their single years, staying focused on pleasing You in body and spirit and enjoying this season of life. Guard them from people who would use and abuse them, and keep them steadfast in You until they find a godly spouse who will love them and devote themselves to their marriage. May they and their spouses find joy and satisfaction in loving and serving one other, and may they find great delight in their marriage bed.

SEEK HIS STILLNESS

Take a few moments to become aware of God's loving presence surrounding you, your children, and their (future or current) spouses this very moment.

TRUST HIS FAITHFULNESS

How generous of You, God, to make marriage a living metaphor of the beautiful relationship that You have with Your church. I trust You to work that kind of beautiful marriage for my children, so that all who see them long to have that kind of a relationship with You too.

For Further Prayer and Study

Psalm 139:16 • Song of Solomon 5:16 • 1 Corinthians 7:34 • Ephesians 5:21–32

BOLDNESS AND STEADFASTNESS

*"Be strong and courageous. Do not be afraid; do not be discouraged,
for the LORD your God will be with you wherever you go."*

JOSHUA 1:9

RECITE GOD'S GOODNESS

Lord Jesus, what You bless remains blessed, and Your presence assures us of
victory in the end. You have placed Your own Spirit within Your children—a
spirit of power, of love, and of self-control. I praise You for Your victory over
the enemy of our souls. You alone are worthy!

EXPRESS YOUR NEEDINESS

Help my children stand boldly for righteousness and justice, even in the face
of temptation, mockery, and persecution. May they not shrink back and be
destroyed by the pleasures this world offers, but may they draw their strength
from You with feet firmly planted on the gospel of salvation.

SEEK HIS STILLNESS

*Imagine your child wearing the armor of God (see Ephesians 6:10–20), and pray
through each part of battle gear. Then rest in the peace of the Lord Jesus Christ, who
alone claims victory.*

TRUST HIS FAITHFULNESS

Thank You, God, that You invite us to pray bold and big prayers for our
children. I trust You to transform my children's timidity into boldness, their fear
into courage, and their doubt into faith. You alone can accomplish this, and I
trust You.

For Further Prayer and Study

Romans 14:4 • 1 Corinthians 10:13; 15:58 • 2 Timothy 1:7 • Hebrews 10:39

BODY IMAGE AND BEAUTY

*"The Lord does not look at the things people look at.
People look at the outward appearance, but the Lord looks at the heart."*

1 SAMUEL 16:7

RECITE GOD'S GOODNESS

Creator God, You knit my children together in my womb; before I even knew they existed, You were fashioning the cells that make them who they are today. How marvelous are Your works! I praise You, God!

EXPRESS YOUR NEEDINESS

Help my children see Your beautiful workmanship when they look in the mirror. Override false stereotypes on how they should look, and empower my children to celebrate Your creativity in the diversity of human bodies. Teach them to look past outward appearances and recognize the beauty of kind souls, and so may they radiate with joy from within.

SEEK HIS STILLNESS

What part of your child's body do they most struggle with? Entrust that aspect of your child's physical appearance to the Lord, and then ask Him to help you and your child see themselves as God sees them.

TRUST HIS FAITHFULNESS

Lord Most High, may Your face shine on my children, and may their faces radiate the beauty of being in Your presence. You are the One who brought them from death to life, so I trust that You will make them a fragrance of life and the sweet aroma of Christ among those who are being saved.

For Further Prayer and Study

Psalm 139:13–16 • Proverbs 31:25 • 2 Corinthians 2:15–16; 3:18 • 1 Peter 3:3–4

SIBLING FRIENDSHIPS

"How good and pleasant it is when God's people live together in unity!...
For there the LORD bestows his blessing, even life forevermore."

PSALM 133:1, 3

RECITE GOD'S GOODNESS

God of Blessing, You are the One who created my family, and You brought each of us together into this unit. I praise You for each of my children, and for how they each reflect your image in such a unique way!

EXPRESS YOUR NEEDINESS

Father, would You grow my children to become devoted to each other in affectionate love? May they seek not only their own interests, but also the interests of each other. Help them want to serve and honor one another in love.

SEEK HIS STILLNESS

How is God calling you to model patience and love in your relationships with them in this season? Is there anything God wants to say to you?

TRUST HIS FAITHFULNESS

I long for nothing more than to see my children grow up loving You and loving each other. God, I trust that You will continue to mature my children. May they grow up to become friends, and may their children know Your blessing in a united family life.

For Further Prayer and Study

Romans 12:9–10, 16; 15:5 • Philippians 2:2 • Colossians 3:14 • 1 Peter 3:8–9

WHOLEHEARTED LOVE

"'Love the Lord your God with all your heart and with all your soul and with all your mind.' This is the first and greatest commandment."

MATTHEW 22:37-38

RECITE GOD'S GOODNESS

Precious Lord, You created my spouse for Yourself, and You delight in their wholehearted devotion to You. How kind of You to dwell in the hearts of those who belong to You!

EXPRESS YOUR NEEDINESS

God, give my spouse a heart that hungers and thirsts to know You more. May they bow their knees in service and worship to You alone. Fill their heart with Your great love so that it overflows into the lives of those around them. Make them quick to forgive others, as You have forgiven them that they may extend Your mercy and kindness to all who they meet today.

SEEK HIS STILLNESS

Take a few moments to become aware of God's loving presence surrounding you, your spouse, and your family this very moment. Is there anything He wants to say to you?

TRUST HIS FAITHFULNESS

Lord God, I am certain that I will see Your continued goodness toward my spouse and my family, so I wait for You. I rest in Your strength, and my heart is courageous, and I wait to see what You will do.

For Further Prayer and Study

Psalms 27:13–14; 95:6 • Proverbs 4:23 • Jeremiah 24:7 • Matthew 5:6 • Ephesians 4:32

* This prayer is inspired by Andrew
Murray's book Absolute Surrender.²

ABSOLUTE SURRENDER*

*"Then I heard the voice of the Lord saying, 'Whom shall I send?
And who will go for us?' And I said, 'Here am I. Send me!'"*

ISAIAH 6:8

RECITE GOD'S GOODNESS

Fountain of Life and Source of Love and Blessing, the whole universe is filled
with Your goodness. You delight in communicating Yourself "to every child
who is prepared to receive" You,³ promising unspoken blessings to all who
surrender themselves completely to Your loving care.

EXPRESS YOUR NEEDINESS

Sovereign Lord, I ask that You would work in my spouse's heart an absolute
surrender to You and Your purposes for their life. Make them moldable in
Your capable hands that they would let You work in them all that You want to
accomplish and that they would do all that You want them to do.

SEEK HIS STILLNESS

*This very moment, God desires to strengthen both you and your spouse in your inner
person in order to fill you with His mighty power. Surrender yourself completely to
Him, and rest in His loving presence.*

TRUST HIS FAITHFULNESS

You know my spouse intimately, even better than I know them myself, so I
entrust them into Your loving care. Lead them to deny themselves moment by
moment that You would dwell in their heart through faith.⁴ Only You, Lord,
can accomplish this, and I trust You to do it.

For Further Prayer and Study

John 6:44 • Ephesians 3:16–17 • Colossians 2:7

FRIENDSHIP AND FUN

"Two are better than one, because they have a good return for their labor:
If either of them falls down, one can help the other up."

ECCLESIASTES 4:9–10

RECITE GOD'S GOODNESS

Holy Triune God, just as You exist in eternal unity within the divine Godhead, Father, Son, and Holy Spirit, so You created us for community. I praise You for creating us with the capacity for human friendships that we may share the joys and sorrows of life with one another.

EXPRESS YOUR NEEDINESS

Lord God, surround my spouse with friends who will stir one another on toward love and good deeds. May they refuse to gossip, harm their neighbors, or speak evil of their friends. Rather, let them sharpen each other in righteousness, doing what is right and living in harmony with all around them. Lord, let the counsel of my spouse's friends be heartfelt, as sweet as perfume and incense.

SEEK HIS STILLNESS

Quietly reflect on God's faithful love toward your spouse, specifically in their relationships. Take a few moments to become aware of God's loving presence surrounding both of you this very moment.

TRUST HIS FAITHFULNESS

Lord God, I trust You to bring godly friends into my spouse's life who will encourage and direct them to do this. I cannot force these relationships to happen, but You can accomplish what seems impossible. I trust You.

For Further Prayer and Study

Psalm 15:3 • Proverbs 27:9, 17 • Romans 15:2, 5

MARITAL PLEASURE AND INTIMACY

*"May you rejoice in the wife of your youth. A loving doe, a graceful deer—
may her breasts satisfy you always, may you ever be intoxicated with her love."*

PROVERBS 5:18–19

RECITE GOD'S GOODNESS

Beloved God, You created man and woman in Your own image and declared them
"very good." It was Your delight to design husbands and wives to find joy and pleasure
in sexual intimacy with one another. What an incredible gift You've given us!

EXPRESS YOUR NEEDINESS

Creator God, may our affections be only for one another, so that we would find
satisfaction in our intimate moments. Help us protect our marriage bed and
guard against anything that would taint our unity. Give us hearts to serve each
other well, so we may increasingly enjoy the pleasures of physical, emotional,
and relational intimacy.

SEEK HIS STILLNESS

*Ponder the mystery that the sexual union of believers in the covenant of marriage
somehow reflects the beauty of Christ and His church. In what ways does your
marriage reveal aspects of this divine union? Sit quietly in God's presence, and let
Him lead you in a deeper understanding of His love.*

TRUST HIS FAITHFULNESS

Lord God, we haven't done this marriage thing perfectly, but I trust that You
will continue to bring healing to our sexual wounds and harmony to our sexual
union. You've given us a priceless gift, and I thank You.

For Further Prayer and Study

Genesis 2:24–25 • Song 1:2; 4:5 • Hebrews 13:4

WISDOM AND DISCERNMENT

"If any of you lacks wisdom, you should ask God, who gives generously to all without finding fault, and it will be given to you."

JAMES 1:5

RECITE GOD'S GOODNESS

Father God, You are such a generous heavenly parent, giving wisdom and discernment to all who ask You sincerely. How good You are!

EXPRESS YOUR NEEDINESS

Lord, give my spouse wisdom and understanding, so that they may discern what is best and so be pure and blameless for the day of Christ. Surround them with godly people who will bring them up, and grant them a humble heart to receive instruction and add to their learning. In all their decisions, may they hear Your voice behind them, telling them the way they should go.

SEEK HIS STILLNESS

God is able to keep His children from stumbling and to present them before His glorious presence without fault and with great joy. What does that say about God? Take a few moments to become aware of God powerfully working in you and your spouse this very moment.

TRUST HIS FAITHFULNESS

Lord God, just as You poured Your love into my spouse's heart, I believe that they will continue to abound still more and more in knowledge and depth of insight. You will keep them until the day of Christ. I trust You.

For Further Prayer and Study

Proverbs 1:5; 4:5; 13:20 • Isaiah 30:21 • Philippians 1:9–10 • Jude 24

FAVORED SKILL

"Do you see someone skilled in their work? They will serve before kings; they will not serve before officials of low rank."

PROVERBS 22:29

RECITE GOD'S GOODNESS

Glorious God, what a privilege that we get to participate with You in the work You're doing in the world. Thank You for the way that You have equipped my spouse with specific skills so that they can help provide for our family.

EXPRESS YOUR NEEDINESS

Lord, empower my spouse to work with all their heart, remembering that they're working for You, not human employers. Help them pay careful attention to their own work so that they may be satisfied with a job well done. Guard them from comparing themselves to anyone else, and grant them a financial reward for their diligence, so that we may have an abundance from which to bless others.

SEEK HIS STILLNESS

Ponder how you have seen God work in your spouse's life and how you've seen them work for God. Then rest in the assurance that God is not finished with you yet.

TRUST HIS FAITHFULNESS

Lord, may your favor rest on my spouse, establishing the work of their hands. I trust that You will be with my spouse so they will succeed at everything they do as they serve You in the workplace.

For Further Prayer and Study

Genesis 39:2 • Psalm 90:17 • Proverbs 28:19 • Colossians 3:23 • Galatians 6:4
1 Corinthians 15:58

A GENEROUS HEART

"Those who give to the poor will lack nothing."

PROVERBS 28:27

RECITE GOD'S GOODNESS

Lord God, You own the cattle on a thousand hills. Everything in this whole world belongs to You, and You generously grant us a portion of it during our lifetime to steward well what You have entrusted to us. How good You are!

EXPRESS YOUR NEEDINESS

Lord God, grow in my spouse a generous heart. Grant them discernment in handling our finances so we may honor You in our giving, spending, and saving. Guard them from the love of money so that their heart would be devoted to You alone.

SEEK HIS STILLNESS

Ponder for a few moments: Which aspect of your personal finances is most challenging for you and your spouse? Do you believe that God can bring peace in this area of your lives? Declare your trust in Him, and then rest in His loving care for you.

TRUST HIS FAITHFULNESS

Father God, You are the One who has faithfully provided for us all the days of our lives. Never once have we gone hungry because You generously met all our needs. I trust You in this area too: that You will unite us in the stewarding of our resources and we would honor You with our money.

For Further Prayer and Study

Proverbs 3:9; 28:27 • Luke 16:13 • 1 Timothy 6:18 • 1 Peter 4:10

STRENGTH AND HEALTH

"He trains my hands for battle; my arms can bend a bow of bronze."

PSALM 18:34

RECITE GOD'S GOODNESS

Lord God, You are my spouse's strength and shield, and You cover them with Your own presence. You train and strengthen them, and You keep them safe from all harm.

EXPRESS YOUR NEEDINESS

Almighty God, keep my spouse safe from harm and healthy in their body, so they may accomplish the good works You've prepared for them to do. Make them a good steward of their physical body, offering it as a living sacrifice to You, so they may love You with all their heart, soul, mind, and strength.

SEEK HIS STILLNESS

Think about which aspects of your spouse's health you tend to worry most about, then entrust those specific things into God's hands, resting completely in your heavenly Father's tender care.

TRUST HIS FAITHFULNESS

Heavenly Father, whatever my spouse's ailments and health challenges, I choose to entrust my spouse into Your caring hands. All their days are written in Your book, so I know You will help them in their time of need. Your faithful promises are our armor and protection. I trust You with every day You've given us to live together, in sickness and in health, until the end of our days.

For Further Prayer and Study

Psalms 16:1; 28:7; 91:4; 144:1 • Romans 12:1–2 • 1 Corinthians 6:12

*This prayer is inspired by the
prayer of Scottish evangelist
Duncan Matheson's: "Lord, stamp
eternity upon my eye-balls."*

ETERNAL PERSPECTIVE*

"Set your minds on things above, not on earthly things."

COLOSSIANS 3:2

RECITE GOD'S GOODNESS

Everlasting Father, You have set eternity in our hearts. Thank You for calling my spouse from death into glorious life, and that we will share eternity together in union with You.

EXPRESS YOUR NEEDINESS

Lord, "stamp eternity"[5] onto my spouse's eyes, that they would fix their gaze not on the visible and temporary things around them, but on the invisible, eternal, and transcendent realities of Your kingdom. Through Your Holy Spirit, do a powerful work of renovation on their heart, enabling them to gain Your perspective on the things of this world, and so live and love like Jesus.

SEEK HIS STILLNESS

Reflect on the past 24 hours. Consider the ways your spouse has shown the love of Jesus in their actions. Thank God for that specific work in their life, and then rest in the knowledge that He will continue that good work.

TRUST HIS FAITHFULNESS

Lord Jesus, I trust that You will keep my precious beloved's spirit and soul and body safe in Your loving care until the day of Your return. As they live, may they honor You; and if You delay Your return and they die, may that also be in a way that glorifies You.

For Further Prayer and Study

Matthew 25:21–23 • Romans 12:1–2; 14:8 • 2 Corinthians 4:18

LEGACY OF INTEGRITY

"I urge you to live a life worthy of the calling you have received."

EPHESIANS 4:1

RECITE GOD'S GOODNESS

Dear heavenly Father, how kind You are to call us Yours, welcoming us into Your heavenly family, not on the basis of our own merits, but because of the priceless gift of Jesus! I praise You for all You've done in my spouse's life so far!

EXPRESS YOUR NEEDINESS

Lord, help my spouse walk faithfully before you all the days of their life. Guard them from gazing at worthless distractions; preserve their life according to Your Word. In all they do, may they set an example of honesty and honor, so that those who'd oppose them find nothing bad to say.

SEEK HIS STILLNESS

Consider your spouse's plans for the day, and entrust each item on the calendar to God's capable care. Then rest in God's presence, knowing that He will care for your loved one.

TRUST HIS FAITHFULNESS

Searcher of hearts, I trust You to empower my spouse to conduct themselves in a manner worthy of You that they would leave a legacy of integrity for our children and grandchildren and generations to come. May they be such a pleasing aroma of Christ in this world that those interacting with them today will ask about the source of their hope. May my spouse then share boldly about their eternal calling in Jesus.

For Further Prayer and Study

1 Kings 9:4 • Psalms 25:21; 119:37 • Proverbs 11:3 • 2 Corinthians 1:12; 2:15 • Titus 2:7–8

*These prayers can be prayed
any time of year but can provide
guided prayer during Advent.*

THOSE WHO ARE SICK

*"Heal me, LORD, and I will be healed; save me and I will be saved,
for you are the one I praise."*

JEREMIAH 17:14

RECITE GOD'S GOODNESS

Creator of Heaven and Earth, You are the One who made us and sustains us—every cell in our bodies must submit to Your sovereign will. One word from You and the sick are healed and the dead come to life! Nothing is impossible with You!

EXPRESS YOUR NEEDINESS

Lord, like the friends of the paralytic lowered through the roof, I bring to You my friend who's battling this sickness. I cannot help her, but You can. Do what only You can do, Lord. Bring healing to her body, health to her bones, peace to her heart, and restoration to her soul.

SEEK HIS STILLNESS

Picture yourself carrying your friend to Jesus. Imagine His response to her . . . to you. What does God want to say to you? Let His presence flow over you and fill you with His peace.

TRUST HIS FAITHFULNESS

Lord God, You who know the very number of hairs on our heads—help us trust You even in these unexpected times. You know how much we long for physical healing, but we trust You to do what is best. May Your will be done in our lives here on earth, as it is in heaven.

For Further Prayer and Study

Psalms 20:1–2; 41:3 • Luke 5:17–26 • 2 Corinthians 4:16–19 • James 5:14–18 • Revelation 21:4

GRIEVING THE DEATH OF AN UNSAVED FRIEND

"Will not the Judge of all the earth do right?"

GENESIS 18:25

RECITE GOD'S GOODNESS

O heavenly Father, when we don't know what to do, we cast ourselves on You. You are good, and You do what is good. You are righteous in all Your ways, and I rest in You.

EXPRESS YOUR NEEDINESS

Lord, we grieve the loss of this friend, who did not appear to have a relationship with You. My heart is heavy with sorrow. Give me and their loved ones an extra dose of strength for today and hope for tomorrow. Help us trust You completely, believing that You always do the right thing.

SEEK HIS STILLNESS

Quiet your heart in God's presence, and allow His love to envelope you like a balm for your soul. Is there anything He wants to say to you?

TRUST HIS FAITHFULNESS

Lord, You are the sovereign judge, full of grace and mercy to all who call on You. Your justice was satisfied by Jesus' death on the cross for our sins—His righteousness given to undeserving people—and it's in Your justice and mercy that I now rest.

For Further Prayer and Study

Deuteronomy 32:4 • Psalm 119:68 • Nehemiah 9:33 • John 16:22 • Revelation 21:4

187

FAMILY OF A SUICIDE VICTIM

"My God turns my darkness into light."

PSALM 18:28

RECITE GOD'S GOODNESS

Lord God, You are the Light of the world. Even the darkness is not as gloomy or hopeless with You. Thank You for keeping me going even as we mourn the loss of our friend to suicide. In our place of desperate need, You have been near, and I praise You.

EXPRESS YOUR NEEDINESS

Lord God, we need You. O how desperately we need You to be close to us right now. Wrap Your arms of tender mercy around us, especially around the immediate family of the one we lost. Help us in our weakness. Bring comfort, peace, and hope as only You can.

SEEK HIS STILLNESS

Sit quietly in God's presence, resting in the knowledge that the Spirit is interceding for you with wordless groans. There's no need to force words if none come to mind. Just be with your heavenly Father, and let Him comfort you with His love.

TRUST HIS FAITHFULNESS

Even darkness is as light to You, Lord, so I run to You. Hide me in the shelter of Your wings. Send forth Your love and Your truth to pull us out of the fog of despair and set our feet on the solid ground of Your loving faithfulness. We trust You.

For Further Prayer and Study

Psalm 139:12 • Matthew 5:4 • Romans 8:26–27 • 2 Corinthians 1:3–4 • Revelation 7:16–17

PARENTS WHO HAVE LOST A CHILD

"You keep track of all my sorrows. You have collected all my tears in your bottle.
You have recorded each one in your book."

PSALM 56:8 NLT

RECITE GOD'S GOODNESS

Heavenly Father, You see our pain and keep track of our sorrows. In Your
goodness, You stay close to the brokenhearted and surround us with Your love.
Thank You for Your presence in my friends' lives as they mourn the loss of their
child.

EXPRESS YOUR NEEDINESS

Lord, what can I say? We're devastated, but the surviving family most of all.
Wipe their tears. May Your Spirit bring them comfort in their loss, Your very
presence their guide through this dark valley of death. Surround them with the
body of Christ to weep with them and carry them and serve them, that they
would sense the comfort of Your love in very practical ways.

SEEK HIS STILLNESS

Take a few moments to become aware of God's loving presence surrounding you this
very moment.

TRUST HIS FAITHFULNESS

Truthfully, our hearts revolt at the pain that death inflicts on this world. Lord,
I yearn for the day that Your resurrection power will annihilate sin and death
once and for all. Come quickly, Lord Jesus. We wait for You!

For Further Prayer and Study

Psalm 46:1 • Isaiah 41:10 • Philippians 4:19 • 1 Peter 5:7 • Revelation 21:4

INFERTILITY AND MISCARRIAGE

"The Lord is close to the brokenhearted and saves those who are crushed in spirit."

PSALM 34:18

RECITE GOD'S GOODNESS

O Lord, no pain escapes Your notice, no cry is too faint to be heard by You. You are close to our grieving friends right now and promise never to abandon them. You are able to provide the comfort they so desperately need.

EXPRESS YOUR NEEDINESS

As my friends grieve their loss and go through stages of numbness and pain, continue to be their strength and comfort. Bring healing to both body and soul through Your supernatural presence and peace; may their hearts not become bitter with loss.

SEEK HIS STILLNESS

Take a few moments to become aware of God's loving presence surrounding you this very moment. See Him holding the unborn child in His tender care.

TRUST HIS FAITHFULNESS

Amid mourning a life unlived and a family member unmet, yet already so loved, fill our hearts with the hope of Your resurrection. You are the One we cling to in our sorrow. We trust You to redeem this pain for our good and Your glory.

For Further Prayer and Study

Psalm 46:1–10 • John 14:19 • 1 Peter 5:7 • Revelation 21:4

LABOR AND DELIVERY

*"From birth I have relied on you; you brought me forth from
my mother's womb. I will ever praise you."*

PSALM 71:6

RECITE GOD'S GOODNESS

O Giver of Life, You are our Creator and sustainer. Thank You for this small life that You've formed in my friend's womb. All her days are already known to You, and she is already loved by You. What a delight to see new life coming into the world!

EXPRESS YOUR NEEDINESS

Lord, I ask for Your protection and strength over this dear mama. Give her energy to labor well; give her endurance when she feels like giving up; give her courage when she faces transition. Protect both mama and baby through this delivery. May we see them and rejoice in Your good work!

SEEK HIS STILLNESS

Take a few moments to become aware of God's loving presence surrounding you, your mama friend, and the baby this very moment. Rest in His goodness.

TRUST HIS FAITHFULNESS

Lord God, You have been faithful from generation to generation, and I know You will be faithful in this birth as well. Thank You for the privilege of participating with You in the process of creating and bringing life into the world. You have been so good to watch over this pregnancy, and I trust You with its fulfillment in the birth of this new baby.

For Further Prayer and Study

Psalms 22:9–10; 139:1–12 • Isaiah 40:11; 46:3

YOUNG MOTHERS

*"He tends his flock like a shepherd: He gathers the lambs in his arms
and carries them close to his heart; he gently leads those that have young."*

ISAIAH 40:11

RECITE GOD'S GOODNESS

Gentle and Good Shepherd, You tenderly care for those who care for others.
Thank You for being close to those who need You most and for Your special
care for young mamas. How kind You are!

EXPRESS YOUR NEEDINESS

Lord, I bring to You today my young mother friend. You know her needs better
than I do. Give her energy amid the exhaustion. Grant her joy despite the daily
challenges. Help her cherish these moments with her littles, and may they grow
to know Your loving care because of her own.

SEEK HIS STILLNESS

*As you entrust your mother friend to the Lord, pause to ponder how God wants to
gently lead you as well. Whether you've grown weary of nurturing others, or your
own arms have longed for such opportunities, rest in God's loving presence.*

TRUST HIS FAITHFULNESS

Thank You, Lord, that You are the One we can turn to when our arms grow
heavy and our hearts are weary. You love our loved ones even more than we do,
and we can trust You to provide everything we need. I love You, Lord!

For Further Prayer and Study

Genesis 16:7–13 • Deuteronomy 26:19 • Psalms 28:9 • Isaiah 49:10 • Micah 5:4 • John 10:11

AGING PARENTS

*"Even to your old age and gray hairs I am he, I am he who will sustain you.
I have made you and I will carry you; I will sustain you and I will rescue you."*

ISAIAH 46:4

RECITE GOD'S GOODNESS

Creator God, You loved my parents before they were born, and all their days were known to You. I praise You that You've foreseen all their health challenges and difficulties, and You promise to provide for all their needs from Your glorious riches in Christ Jesus.

EXPRESS YOUR NEEDINESS

Lord, it's hard to see the people who've cared for me now needing to be cared for. Help me honor and serve them without resentment, as I would serve You. Be near them as their bodies grow frail and their minds age. Be their ever-present help, and reassure them of their continued worth, even in old age.

SEEK HIS STILLNESS

Sit in the presence of the One with whom a thousand years is like a day. Allow His constant, loving presence to fill you with all you need for this moment.

TRUST HIS FAITHFULNESS

I trust You, Lord, to sustain my parents today, even as You did from their very first breath, and as You will do to their last. Grant me joy in serving and loving them today.

For Further Prayer and Study

Leviticus 19:32 • Psalm 92:12–14 • 1 Corinthians 1:8–9 • Philippians 4:19 • 2 Peter 3:8

STRAYING CHILDREN

"What do you think? If a man owns a hundred sheep, and one of them wanders away, will he not leave the ninety-nine on the hills and go to look for the one that wandered off?"

MATTHEW 18:12

RECITE GOD'S GOODNESS

Ever-Present Lord, You know this child's comings and goings—nothing is hidden from Your sight. Yet You do not judge harshly as our sins deserve, but rather You go looking for the one who's wandered off. How good You are!

EXPRESS YOUR NEEDINESS

Lord, I find myself wondering: Do I speak? Do I keep silent? How do I continue expressing love without condoning sin? Give me wisdom to love this child as You do. And give them no rest until they return to You with all their heart.

SEEK HIS STILLNESS

Picture the Gentle Shepherd pursuing your child who has strayed. How does He look at this wandering lamb? How does He look at you and the other sheep who have remained with the flock? Allow His patient love to envelope you and fill your heart this very moment.

TRUST HIS FAITHFULNESS

Father, I trust You to do the work that only You can do. Help me continue to faithfully pray for this child and leave an open door for when You bring them home.

For Further Prayer and Study

Psalms 27:14; 34:4 • Isaiah 43:5–6 • Luke 15:1–32; 19:10 • Acts 17:27 • 3 John 1:4

ESTRANGED FAMILY MEMBERS

"While he was still a long way off, his father saw him and was filled with compassion for him; he ran to his son, threw his arms around him and kissed him."

LUKE 15:20

RECITE GOD'S GOODNESS

Heavenly Father, thank You for showing such compassion and mercy to those who come back to You. When I wandered astray, You received me with open arms too. I praise You that no one is too far gone that Your mercy can't reach them!

EXPRESS YOUR NEEDINESS

O Lord, You know I love this family member, but for so many reasons we are estranged. Search our hearts and reveal any sin that needs to be confessed. Show us the way to walk in, and give us wisdom for how to interact with one another. Turn our hearts toward forgiveness, and bring restoration in Your perfect timing.

SEEK HIS STILLNESS

Picture the prodigal's father: standing, watching, waiting. How does that reflect God's posture toward His wandering children? How might He be calling you to adopt the same posture in this relationship?

TRUST HIS FAITHFULNESS

Lord, when I don't know what to do, I will trust in You. I desire unity, but I fear previous toxicity. Lead us, Lord. I give myself wholly to You, trusting that You will perfect Your love in me and knowing I can trust You with my loved one too.

For Further Prayer and Study

Matthew 12:15–20 • Luke 15:11–32 • Hebrews 12:14 • 1 Corinthians 15:58

DIVORCED FRIENDS

*"And God is able to bless you abundantly, so that in all things at all times,
having all that you need, you will abound in every good work."*

2 CORINTHIANS 9:8

RECITE GOD'S GOODNESS

O Love Beyond Compare, You created marriage, and You care about this
broken relationship even more than I do. In Your goodness, continue to show
mercy and kindness even in the midst of this divorce, for Your steadfast love
endures forever.

EXPRESS YOUR NEEDINESS

Lord, I don't know all the details of what my friend is going through, but
You do. Be their shelter, their safe place in this time of need. Bring healing,
forgiveness, and repentance, so both spouses may seek You with all their hearts.
Provide for the children, and let them know You're still near and You still hear
their prayers.

SEEK HIS STILLNESS

*Take a few moments to become aware of God's loving presence surrounding you—
and your divorced friends—this very moment.*

TRUST HIS FAITHFULNESS

Lord, You have been our God from generation to generation, so we can trust
You. When my friend doubts whether You'll provide for their needs, reassure
them of Your steadfast love and mercy. You see. You know. You will provide
because You are faithful. We trust You.

For Further Prayer and Study

Psalm 23:1 • 2 Corinthians 9:8 • James 1:19

NEIGHBORS IN NEED

"Love your neighbor as yourself."

MARK 12:31

RECITE GOD'S GOODNESS

Lord Jesus, You let go of the glories of heaven and came to earth to live among us, to do life with us, so that You may bring us into perfect relationship with You. You are the very best neighbor.

EXPRESS YOUR NEEDINESS

Precious Jesus, please deepen my love for my neighbors, for each family surrounding this place I call home. Help me see them with Your eyes and become intentional in reaching out with Your love. Soften my heart to hear and respond as Your Spirit moves in my neighborhood.

SEEK HIS STILLNESS

In your mind's eye, scan your neighborhood, pausing at each home to lift the names of those who live around you to the One who sees what's happening behind closed doors. Is there anything God wants to say to you?

TRUST HIS FAITHFULNESS

You've called Your people to be shining lights in the darkness, and that is my desire: that my home would be a beacon of light in my neighborhood, welcoming all who need refuge, a listening ear, and the hope of the gospel. Would you accomplish this, as only You can? I know You will.

For Further Prayer and Study

Matthew 5:14; 6:33; 9:36–38 • John 1:14 • Philippians 2:3–15

LOST SOULS

"For the Son of Man came to seek and to save the lost."

LUKE 19:10

RECITE GOD'S GOODNESS

O Lord Jesus, how compassionate You are to go out of Your way to encounter those who have wandered astray. You gently call those who've turned their backs, and You gladly receive all those who turn to You.

EXPRESS YOUR NEEDINESS

Gracious Lord, have mercy on my friends who do not yet know You. Cause their hearts to thirst for something more, to yearn for the living God. Make their hearts sensitive to Your Spirit calling to them, and place godly believers in their path to share the good news of Jesus in a winsome and understandable way.

SEEK HIS STILLNESS

Picture Jesus seeking out your friend as they go about their daily life. Rest in His abundant love and compassion for your unsaved friend . . . and for you as well.

TRUST HIS FAITHFULNESS

Thank You, Lord Jesus, that You desire all people to repent and turn to You. You care about my friend even more than I ever could. Give me opportunities to share Your love in practical ways, and help me trust and obey when You call me to say or do something outside my comfort zone. Save them, Lord, and use me however You see fit.

For Further Prayer and Study

Genesis 45:15 • Matthew 18:12–14 • Luke 19:1–10 • 1 Peter 5:7 • 2 Peter 3:9

THE OPPRESSED

"I have indeed seen the misery of my people. . . . I have heard them crying out because of their slave drivers, and I am concerned about their suffering. So I have come down to rescue them."

EXODUS 3:7–8

RECITE GOD'S GOODNESS

Heavenly Father, You lean down from on high and observe the misery of the oppressed. You see, hear, and care for each human bearing Your image. You're near to the brokenhearted, and Your arm reaches out to rescue those in need.

EXPRESS YOUR NEEDINESS

Almighty God, listen to the pleas of those who suffer under brutal regimes, heartless traffickers, and radical terrorists. Rescue victims from their living nightmares. Let Your justice break through like mighty waters, and may Your salvation bring hope like the light of dawn.

SEEK HIS STILLNESS

Ponder the words "I am concerned about their suffering." Whose suffering have you passed by lately? As you sit quietly with God, how is He inviting you to be His hands and feet today?

TRUST HIS FAITHFULNESS

Lord Jesus, You proclaimed liberty to the captives and freedom to the oppressed, and You continue working through Your powerful Spirit in us. So stir Your people to compassion, and move us to rescue victims from oppression until You return and restore all things to eternal glory.

For Further Prayer and Study

Psalms 18; 37:6; 102 • Jeremiah 22:3 • Amos 5:24 • Matthew 25:35–40 • Luke 4:18–19

THE PERSECUTED

"Continue to remember those in prison as if you were together with them in prison, and those who are mistreated as if you yourselves were suffering."

HEBREWS 13:3

RECITE GOD'S GOODNESS

Precious Jesus, You are the head of the church, so when one part of the body suffers, You also enter into our suffering with us. Thank You for bearing our own wounds in Your body, for being ever close to those who are mistreated and maligned for Your name. You never leave us or forsake us.

EXPRESS YOUR NEEDINESS

Lord, as my brothers and sisters face persecution for their allegiance to You, I ask that You would strengthen them with Your divine power, helping them rely on You alone. Give them the right words at the right time, and strengthen their faith in You.

SEEK HIS STILLNESS

Sit quietly with Jesus, who Himself is experiencing the pain and suffering of those who are persecuted. Ask Him: "What do You want me to know about my persecuted brothers and sisters?" And wait patiently for His response.

TRUST HIS FAITHFULNESS

God of all comfort, even though I feel powerless to help my spiritual siblings around the world, I trust that You are moving in response to prayer even now. Turn their suffering into a witness to Your worthiness that even their oppressors may trust in You as their Lord and Savior.

For Further Prayer and Study

Matthew 25:31-46 • John 15:18-21; 17:14 • 2 Corinthians 4:8–12 • Ephesians 6:19–20
2 Timothy 3:12

MEDICAL STAFF

"He went to him and bandaged his wounds, pouring on oil and wine.
Then he put the man on his own donkey, brought him to an inn and took care of him."

LUKE 10:34

RECITE GOD'S GOODNESS

O Great Physician, thank You for the doctors, nurses, and medical staff to whom You've given great wisdom and skill in order to bring healing to our bodies. We praise You for advances in medical technology and access to urgent care. What a gift!

EXPRESS YOUR NEEDINESS

Lord, work through this medical staff to bring Your divine healing. Give them endurance and perseverance when they grow weary. Enhance their natural skills, and grant them supernatural wisdom when making decisions concerning treatment and care.

SEEK HIS STILLNESS

Imagine Jesus ministering healing through the doctors' and nurses' hands. See Him reaching out and touching the sick with His healing power. Let His love quiet your heart.

TRUST HIS FAITHFULNESS

Lord, human life in this fallen world is so frail, and You know every day allotted to each person. Give us compassion and tender hearts toward one another; continue sustaining this medical staff with Your faithful love and presence, even if they're unaware of it. You're the One who works healing and restoration, and we trust You.

For Further Prayer and Study

Psalm 30:2 • Isaiah 53:4–5 • Matthew 25:44 • Luke 10:30–35 • Galatians 6:10

NATIONAL LEADERS

*"I urge, then, first of all, that petitions, prayers, intercession and thanksgiving
be made for all people—for kings and all those in authority,
that we may live peaceful and quiet lives in all godliness and holiness."*

1 TIMOTHY 2:1-2

RECITE GOD'S GOODNESS

Supreme Ruler of the Universe, dominion belongs to You alone. You are always
in control, and Your reign will endure forever!

EXPRESS YOUR NEEDINESS

Lord, bless our president and cabinet, congressional representatives and
senators, Supreme Court justices, and other national leaders. Set before us
rulers of honesty and integrity, who will lead our country with wisdom and
discernment. Give them humble hearts, a desire to seek justice, and a drive to do
what is good. Empower them to pass and enforce laws that keep us at peace and
protect the weak. Surround them with godly counselors who point them to You.

SEEK HIS STILLNESS

*Focus your heart on the reality that our God reigns no matter what today's headlines
say. Let His presence quiet your heart and give you rest.*

TRUST HIS FAITHFULNESS

You, Jesus, are the King of kings and the Prince of Peace, and someday soon,
You will bring Your reign on earth. What a glorious day that will be! Until then,
help me live at peace with all people and rest in Your faithful love.

For Further Prayer and Study

1 Kings 8:28 • Psalm 22:28 • Proverbs 21:1 • Daniel 2:21 • Micah 6:8 • Revelation 11:15

LOCAL COMMUNITY LEADERS

"Submit yourselves for the Lord's sake to every human authority."

1 PETER 2:13

RECITE GOD'S GOODNESS

Your throne, O Lord God, will endure forever, no matter what's happening on the political scene today. You're the One who reigns, and Your kingdom will come on earth someday soon. I praise You!

EXPRESS YOUR NEEDINESS

Lord, I pray for our mayor, city council, county commissioners, police chiefs, judges, and all who serve in our local communities. Give them humble hearts to serve in their places of leadership. Guard them from corruption, and keep their hearts free of greed and arrogance. Grant them wisdom and discernment, and help our local church seek ways to work together to seek the flourishing of our local community, so that we may live peacefully with one another.

SEEK HIS STILLNESS

Imagine God's light penetrating the darkness through each individual believer in their sphere of influence. How is God moving in your local community? Be still with Him as you ponder His mighty work.

TRUST HIS FAITHFULNESS

Lord, I entrust my future and the future of our community to You. I know that You are in control, and You will direct our leaders as You choose. You're a good Father and a powerful God, so I rest in You.

For Further Prayer and Study

Psalm 45:6 • Daniel 7:14 • Romans 13:1–7 • Hebrews 1:8 • 1 Peter 2:13–25 • Revelation 1:6

CHURCH LEADERS

"Be shepherds of God's flock that is under your care, watching over them—
not because you must, but because you are willing, as God wants you to be;
not pursuing dishonest gain, but eager to serve."

1 PETER 5:2

RECITE GOD'S GOODNESS

You, Jesus, are the head of Your church. I praise You that You continue to
shepherd us through our local church leaders. You have been so good to
provide all we need!

EXPRESS YOUR NEEDINESS

Lord, I pray for the pastor, elders, deacons, Sunday school teachers, and other
staff who serve in my local church. Give them undivided hearts to love You
above all, humility to die to self, and wisdom to equip the saints for Your work
in our communities. Protect them from the temptations of greed, pride, power,
and illicit sex. Grant them endurance and joy in their ministry to be faithful to
the end.

SEEK HIS STILLNESS

Sit quietly with God. Is there anything He wants to say to you?

TRUST HIS FAITHFULNESS

Lord Jesus, You're committed to purifying Your people for Yourself, so I entrust
my church's leadership to You. Give me the grace to joyfully submit to them
and encourage them, confident that You will accomplish Your work in our local
communities and around the world.

For Further Prayer and Study

1 Corinthians 9:24–27 • Galatians 6:9 • Ephesians 4:11–16 • Colossians 1:9–18
Titus 2:11–15 • Hebrews 12:1–3

SCHOOLTEACHERS

*"Let us not become weary in doing good, for at the proper time
we will reap a harvest if we do not give up."*

GALATIANS 6:9

RECITE GOD'S GOODNESS

O God of All Grace, thank You for giving us teachers in our schools who can
help me educate my children. What a blessing to partner with other adults in
training up my children.

EXPRESS YOUR NEEDINESS

Lord, please fill my children's teachers with sincere kindness and sacrificial love.
Give them patient endurance when faced with a difficulties and disruptions,
and help them keep going on the hard days. Fill them with your wisdom to
know how to handle disciplinary issues, and surround them with believers who
can encourage them to continue in good works and love.

SEEK HIS STILLNESS

*Picture God present in the classroom with your child and their teacher. How does
His presence with them invite you to rest in His peace?*

TRUST HIS FAITHFULNESS

Gracious God, when I disagree with school policies or how a teacher handled
a situation, help me trust You first and foremost. Show me the next right steps
for my family, and fill me with peace as I make educational choices. Ultimately,
You're the One working all things for good, and I trust You with my children
and their schoolteachers.

For Further Prayer and Study

Psalm 32:8 • Proverbs 1:2–4; 31:26 • Luke 6:40 • 1 Corinthians 13:4–7

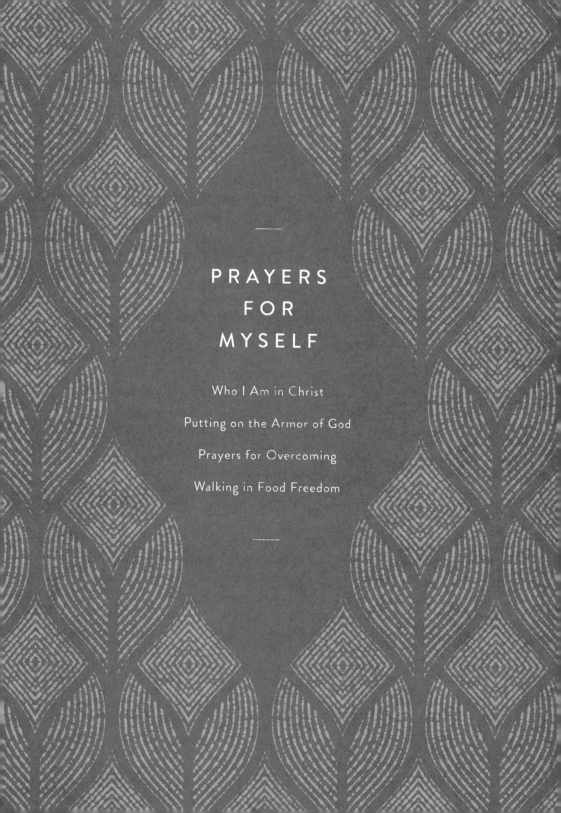

PRAYERS
FOR
MYSELF

Who I Am in Christ

Putting on the Armor of God

Prayers for Overcoming

Walking in Food Freedom

IN CHRIST, I AM DEARLY LOVED

"[You are] God's chosen people, holy and dearly loved."

COLOSSIANS 3:12

RECITE GOD'S GOODNESS

Loving Lord, how gracious You are to extend Your love to me in Christ! I praise You for Your never-ending, steadfast love that continues to pursue me day after day and for Your personal love, not just toward the whole world, but me! Wow!

EXPRESS YOUR NEEDINESS

Lord, open the eyes of my heart to grasp the enormity of Your love for me! "Jesus loves me" is a truth I've heard since I was young; let it never become shallow or empty. Help me grasp just how precious I am to You, and how great is Your love toward me!

SEEK HIS STILLNESS

Take a few moments to let the reality sink in that you are fully known by God and fully loved. Let His presence quiet you and His compassion give your soul rest today.

TRUST HIS FAITHFULNESS

Lord God, thank You that in Christ I am dearly loved. I can't quite wrap my mind around the reality that You delight in me. You rejoice over me! You call me Your prized possession . . . and You really mean it! Those are not empty words, but an expression of Your true heart toward me in Christ. I rejoice in You, heavenly Father!

For Further Prayer and Study

Psalm 149:4 • Zephaniah 3:17 • John 15:9–17 • James 1:17–18

IN CHRIST, I AM CHOSEN

"But you are a chosen people, a royal priesthood, a holy nation, God's special possession."

1 PETER 2:9

RECITE GOD'S GOODNESS

Lord of Heaven and Earth, I praise You that in Christ I am chosen to be Yours—not because of anything I have done but because of Your own great tender mercy. You knew me before I was even born and called me for a specific purpose. How wonderful are Your ways!

EXPRESS YOUR NEEDINESS

Lord, when I feel left out or ignored by others, help me remember that You chose me from the beginning of the world, and You are the One who gives me significance. When I'm discouraged, remind me that You formed me before I was born and called me for a specific purpose. I am Yours.

SEEK HIS STILLNESS

Quiet your heart in God's presence, becoming aware of His great love for you. What does it feel like to be chosen? Is there anything you want to say to God?

TRUST HIS FAITHFULNESS

Lord God, it's my delight to declare how excellent You are! I didn't choose You, but You chose me, and made me part of Your royal priesthood, a holy nation, a purchased people. You don't give up on Your chosen ones, so help me continue to trust You.

For Further Prayer and Study

Psalm 139:13 • Romans 8:33 • Ephesians 1:4 • Colossians 3:12 • 2 Timothy 1:9

IN CHRIST, I AM REDEEMED

"For he has rescued us from the dominion of darkness and brought us into the kingdom of the Son he loves, in whom we have redemption, the forgiveness of sins."

COLOSSIANS 1:13–14

RECITE GOD'S GOODNESS

Gracious Redeemer, how wonderful You are and how great Your riches of grace toward us! While we were yet your enemies, You rescued us out of Satan's kingdom and transferred us into Jesus' kingdom! You freely forgave all my sins. I praise You!

EXPRESS YOUR NEEDINESS

Lord, so many days I live as if the kingdom of darkness still has a claim on me. Help me live into the reality that I am Your redeemed! You've pulled me out of the world—now continue pulling the world out of me. I want to live as one who belongs to You.

SEEK HIS STILLNESS

Visualize God's extraction mission, plucking you out of the domain of darkness and tenderly placing you in His kingdom of light. What does that say about God? What do you want to say to Him?

TRUST HIS FAITHFULNESS

Christ Jesus, in You and because of You, I am dead to sin and live in unbroken relationship with You, belonging to Your kingdom forever and ever. I am Yours, and my soul rejoices in Your redemption!

For Further Prayer and Study

Romans 3:24; 6:11 • Ephesians 1:7; 2:5–6 • Colossians 2:12

IN CHRIST, I AM A CHILD OF GOD

"See what great love the Father has lavished on us, that we should be called children of God! And that is what we are!"

1 JOHN 3:1

RECITE GOD'S GOODNESS

O heavenly Father! How kind of You to not only forgive and redeem me but to adopt me into Your own family. You are mine and I am Yours, and nothing can separate me from You again. I praise You!

EXPRESS YOUR NEEDINESS

Lord God, help me live as a child of the King, with the full implications of that relationship. Bring a deeper awareness that I am a joint-heir with Christ to all the riches of glory. May that reality transform the way I plan my day, how I spend my time, and what I hope for my life.

SEEK HIS STILLNESS

Let this reality sink in to the depths of your being: in Christ, you are a child of God. Sit with your heavenly Father, and just be still in His presence.

TRUST HIS FAITHFULNESS

Lord God, those who are born of You cannot be overcome by the evil one, because You always defend and protect Your own. I am Your child! What an incredible privilege You've given me. My soul praises You and rejoices in You!

For Further Prayer and Study

Romans 8:17 • Galatians 4:7 • Ephesians 3:6 • Titus 3:7 • 1 John 3:1; 5:18

IN CHRIST, I AM A NEW CREATION

*"Therefore, if anyone is in Christ, he is a new creation.
The old has passed away; behold, the new has come."*

2 CORINTHIANS 5:17 ESV

RECITE GOD'S GOODNESS

Blessed Creator, I praise You for bringing me from death to new life in You.
Through Your Spirit, You are renewing me into the image of Jesus. How
wonderful are Your works, O Lord! My soul knows this well.

EXPRESS YOUR NEEDINESS

Help me remember that I've been crucified with You, so selfishness, pride,
greed, gluttony, hatred, and all sinful longings are dead to me. Empower me
each day to put on my new self and step into my new identity in Christ, which
is continually being renewed day by day.

SEEK HIS STILLNESS

*Ponder the wonder of how God delicately crafted you before your birth. How much
more is He tenderly re-creating you into a new person? Sit with Him, and allow your
soul to respond to Him in love.*

TRUST HIS FAITHFULNESS

Lord God, I praise You that someday soon You will renew all of heaven and
earth because You always finish what You start. Thank You that You will fully
free me from the battle with my flesh so that I can finally embody the person
You've always created me to be. I can't wait for that day!

For Further Prayer and Study

Psalm 139:13–18 • Jeremiah 1:5 • Romans 6:6 • Colossians 3:10 • 1 Peter 1:23

IN CHRIST, I AM A CITIZEN OF HEAVEN

*"But our citizenship is in heaven.
And we eagerly await a Savior from there, the Lord Jesus Christ."*

PHILIPPIANS 3:20

RECITE GOD'S GOODNESS

Lord of All Heaven, You reign over all the world, and You've welcomed me into Your heavenly kingdom as my home. What an incredible privilege! Because of Your great love, I am no longer a foreigner or a stranger to You, but part of Your family. You are so *so* good!

EXPRESS YOUR NEEDINESS

Lord, help me keep my heavenly citizenship at the core of my identity, before my allegiance to a country or a community. When political intrigues beguile me, remind me that I am an ambassador of Christ, called to love all people of all parties and all nations.

SEEK HIS STILLNESS

Take a few moments to become aware of God's loving presence surrounding you this very moment.

TRUST HIS FAITHFULNESS

In Christ Jesus, I am a citizen of heaven, and when this world and all its nations pass away, You, Jesus, will reign as King of kings and Lord of lords forever and ever. Your kingdom come, Lord, Your will be done on earth as it is in heaven!

For Further Prayer and Study

1 Corinthians 6:19 • 2 Corinthians 5:20 • Ephesians 2:19

IN CHRIST, I AM RICHLY CARED FOR

"And my God will meet all your needs according to the riches of his glory in Christ Jesus."

PHILIPPIANS 4:19

RECITE GOD'S GOODNESS

Thank You, heavenly Father, for knowing me so personally that not even a hair on my head goes unnoticed. You are so loving and kind, and You delight in providing every need for Your children. I praise You!

EXPRESS YOUR NEEDINESS

When I face financial, physical, relational, and emotional needs that seem too big for me, help me trust that You will abundantly provide all I need. Help me seek first Your kingdom and Your glory, resting in the truth that You will take care of the rest.

SEEK HIS STILLNESS

Sit quietly with the God who takes care of the birds and the flowers and richly promises to provide for your every need. What area of your life do you need to entrust to His loving care? Make your needs known to Him, and rest in His loving presence.

TRUST HIS FAITHFULNESS

You own the cattle on a thousand hills, and all the universe belongs to You, so nothing is too difficult or intimidating for You. You've always provided faithfully in the past, and I trust that You will give me everything I need today and tomorrow too.

For Further Prayer and Study

Psalm 23:1 • Luke 12:22–31 • 2 Corinthians 9:8 • Ephesians 3:20 • 2 Peter 1:3–4

IN CHRIST, I AM HOLY AND BLAMELESS

*"For he chose us in him before the creation of the world
to be holy and blameless in his sight."*

EPHESIANS 1:4

RECITE GOD'S GOODNESS

Holy and heavenly Father, how good You are to wash me clean of all my sins through the blood of Jesus! Thank You for setting me apart to be Yours, and committing to the process of sanctification so that I may be holy and blameless in Your sight. Such love is too wonderful for me!

EXPRESS YOUR NEEDINESS

Lord, when Satan tempts me to despair because of the sin that so easily entangles me, help me remember that Jesus Christ is my righteousness, and You call me holy—not because of my own good deeds but because of His perfect sacrifice. Help me live as Your holy one today.

SEEK HIS STILLNESS

Take a few moments to become aware of God's Spirit making you holy right now. Be still with Him, and bask in His lovingkindness.

TRUST HIS FAITHFULNESS

Lord God, You've set me apart before the creation of the world, and You make me faultless and above reproach in Christ Jesus. You have started this work in me, and You will be faithful to complete it. I praise You and rejoice in Your salvation!

For Further Prayer and Study

Psalm 103:12 • Romans 6:11; 8:1–2 • 2 Corinthians 5:21 • Hebrews 8:12 • 1 Peter 1:16

IN CHRIST, I AM GOD'S WORKMANSHIP

*"For we are his workmanship, created in Christ Jesus for good works,
which God prepared beforehand, that we should walk in them."*

EPHESIANS 2:10 ESV

RECITE GOD'S GOODNESS

Master Craftsman, You knit me together in my mother's womb. I praise You
for continuing to shape me into a human who reflects Your love and Your light
to the world—making me the person You've always intended me to be. How
incredible You are!

EXPRESS YOUR NEEDINESS

Lord, honestly, I'm tempted to give up when I see myself struggling with the
same old sins. Create in me a clean heart, O God, and renew a steadfast spirit
within me! Make me aware of the work You're doing in my life, and make me
quick to walk in the good works You've prepared for me!

SEEK HIS STILLNESS

*Looking back on the past few years, where do you see God's transforming work in
your life? Pause to praise Him, and listen to His rejoicing over you in love.*

TRUST HIS FAITHFULNESS

Lord God, thank You for not leaving me in my sin. Rather, You commit to
sanctifying me and making me more like Jesus through Your powerful Spirit at
work in me. I surrender to You, opening my whole life to Your work in me.

For Further Prayer and Study

Isaiah 43:7 • 1 Corinthians 6:11 • Ephesians 4:24 • Philippians 1:6 • Titus 2:14

IN CHRIST, I AM MORE THAN A CONQUEROR

"In all these things we are more than conquerors through him who loved us."

ROMANS 8:37

RECITE GOD'S GOODNESS

Precious King Jesus, You have overcome the world through Your sacrificial love on the cross, and You generously share Your victory with us. I praise You that nothing can stand against those You've redeemed by Your own blood. In You, I am more than a conqueror. I praise You!

EXPRESS YOUR NEEDINESS

More days than not, I feel defeated. Remind me that I'm not defined by my feelings or emotions, because You give me victory, and no matter how fierce the struggle I'm engaged in right now. Help me be transformed by the renewal of my mind into what is true in Christ Jesus.

SEEK HIS STILLNESS

Picture Jesus, enthroned on high, placing a crown of victory on your head. What will you do next? Savor the Savior, and let your heart respond to Him in quiet adoration.

TRUST HIS FAITHFULNESS

Because of You, Jesus, I am more than a conqueror, and I will overcome the enemy of my soul by the blood of the Lamb and the word of my testimony. Only You, Jesus—only You reign victorious. Thank You for inviting me to share in Your victory.

For Further Prayer and Study

1 Corinthians 15:57 • Romans 8:2 • Hebrews 2:14–15 • Revelation 12:11

THE CALL TO ENGAGE

"Finally, be strong in the Lord and in his mighty power. Put on the full armor of God, so that you can take your stand against the devil's schemes."

EPHESIANS 6:10-11

RECITE GOD'S GOODNESS

Almighty God of the Universe, thank You for inviting us to stand strong in You. You clothe us with Your righteousness and You prepare us for battle with Your own armor. I praise You, for You've already won the battle against the enemy.

EXPRESS YOUR NEEDINESS

Most days, I'm completely unaware of the battle that's raging around me. Forgive me, Lord, for being asleep to the spiritual warfare that's happening. Teach me how to put on Your full armor in Christ Jesus and to stand in Your power and not my own.

SEEK HIS STILLNESS

Take your stand in God's presence, allowing His power to fill you and overflow all around you. Where in your life might He be calling you to stand against the enemy?

TRUST HIS FAITHFULNESS

You, Jesus, reign supreme over all the universe and over the spiritual battles the devil is fighting right now. Thank You for the reassurance that I don't have to fear him or his schemes. I trust in Your steadfastness because You are invincible, and Yours is the victory forever!

For Further Prayer and Study

Colossians 1:15-16 • Romans 6:5-10; 8:37 • Ephesians 1:1-14

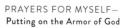
THE REAL ENEMY

"For our struggle is not against flesh and blood, but against the rulers, against the authorities, against the powers of this dark world and against the spiritual forces of evil in the heavenly realms."

EPHESIANS 6:12

RECITE GOD'S GOODNESS

Lord of Immortality, Yours is the power and authority over all of heaven and earth. I praise You that Satan has no power except what You've sovereignly allowed him to have—for a purpose, for a season.

EXPRESS YOUR NEEDINESS

Lord, make me quick to always turn to you when I sense Satan's intrusion in my life. He is the real enemy, not people I disagree with around me. Give me boldness to reject his purposes in this battle. In the name of Jesus, I command every wicked spirit to leave my presence and go where the Lord Jesus sends them.

SEEK HIS STILLNESS

Find your rest in God's presence, remembering that the battle belongs to the Lord. Be still with Him, and let Him refresh you by His Spirit.

TRUST HIS FAITHFULNESS

Lord Jesus, You've united me with You, so I submit myself to Your purposes in these trials and spiritual battles. I want Your will to be done, and I want to profit and learn from all You have for me in this experience. Yours is the victory. I trust in You alone.

For Further Prayer and Study

1 Corinthians 1:30 • 2 Corinthians 12:6–9 • Ephesians 4:27 • Hebrews 2:14–15

THE ARMOR OF GOD

*"Therefore put on the full armor of God, so that when the day of evil comes,
you may be able to stand your ground, and after you have done everything, to stand."*

EPHESIANS 6:13

RECITE GOD'S GOODNESS

All-Sufficient King, You resisted the enemy's temptations in the wilderness and
beyond, and You are able to help me stand in Your victory today. Thank You for
equipping me with Your very own armor. How generous You are!

EXPRESS YOUR NEEDINESS

I confess that I'm wholly preoccupied with the wrong things most of the time.
Give me Your perspective, and help me put on Your armor. Imprint on my soul
the urgency of this spiritual battle, so that I may stand my ground—not in my
own power or cunningness, but in You alone.

SEEK HIS STILLNESS

*Take a few moments to become aware of God's loving presence surrounding you and
filling you with everything you need for this battle. Is there anything you want to say
to Him?*

TRUST HIS FAITHFULNESS

Lord, though I don't know much about putting on Your armor, I trust that
You will teach me and guide me in all knowledge and holiness. You're the One
who started this work, and You will be faithful to complete it—and keep me
standing through the power of Your Holy Spirit in me. I trust You.

For Further Prayer and Study

Matthew 4:1–11 • John 16:7–11 • Ephesians 1:18–23; 5:15–20

THE BELT OF TRUTH

"Stand firm then, with the belt of truth buckled around your waist."

EPHESIANS 6:14

RECITE GOD'S GOODNESS

You, Jesus, are the truth, and You've generously given us access to the truth through the Scriptures. Thank You for giving us weapons infused with divine power to demolish the enemy's strongholds. You are so good to us!

EXPRESS YOUR NEEDINESS

Lord Jesus, make me aware of Satan's ploys to deceive me and my family, and help me discern truth from the lies of the enemy that I may take captive every thought that holds itself up against the knowledge of God and make it obedient to Christ.

SEEK HIS STILLNESS

Invite God's Spirit to search you and reveal any areas where deception has crept in. Sit quietly with Him, and allow His truth to illuminate your understanding.

TRUST HIS FAITHFULNESS

Lord, I've buckled the belt of truth around my waist and embrace You as the ultimate truth. Guide me in Your truth, and by Your Spirit, help me walk in obedience to Your Word that I may never give the enemy a foothold. Thank You for providing me the belt of truth; I receive it gladly.

For Further Prayer and Study

John 1:14; 14:6; 17:17 • 1 Corinthians 2:10–14 • 2 Corinthians 10:4–6

THE BREASTPLATE OF RIGHTEOUSNESS

"With the breastplate of righteousness in place."

EPHESIANS 6:14

RECITE GOD'S GOODNESS

Righteous Lord Jesus, thank You for clothing me with Your own righteousness. When Satan stands to accuse me before the Father, You, Jesus, act as my advocate because of Your own sacrifice on my behalf. How good You are!

EXPRESS YOUR NEEDINESS

Lord God, make me quick to abandon any attempts at self-righteousness and, instead, throw myself on the mercy of Jesus Christ. Where I have sinned and turned against You, forgive me, and cleanse me through the precious blood of Jesus. Sanctify me by Your truth, and help me live in Your righteousness alone.

SEEK HIS STILLNESS

Take a few moments to become aware of God's righteousness filling you because of Jesus. Where is He calling you to live that out through faith and love? Be still with Him as you worship Him in silent adoration.

TRUST HIS FAITHFULNESS

Lord, I put on the breastplate of righteousness, remembering that I'm no longer condemned because You have set me free from the law of sin and death. I am free! And I'm forever grateful. I trust You with all my heart as I continue to wage this battle through Your power and Your Spirit alone.

For Further Prayer and Study

Isaiah 59:15–17 • Zechariah 3:4 • Romans 8:1–2 • 2 Corinthians 5:21 • Philippians 3:8–9

THE SHOES OF PEACE

"And with your feet fitted with the readiness that comes from the gospel of peace."

EPHESIANS 6:15

RECITE GOD'S GOODNESS

Prince of Peace, You preached the good news of Your coming kingdom here on earth, bringing restoration and flourishing to all who believed. Thank You for taking sin's punishment on the cross so that we wouldn't ever experience God's wrath or punishment. You've brought us peace with the Father, and I praise You!

EXPRESS YOUR NEEDINESS

Lord God, though chaos rages around me and anxiety threatens to overwhelm me, guard my heart and mind in Christ Jesus with Your perfect peace. Protect me from the attacks of the enemy and teach me to turn to You with all my needs. Make me quick to obey You fully at all times, so that Your peace may reign in my life.

SEEK HIS STILLNESS

With quiet surrender, give your whole self to God, waiting in His presence until His peace floods your inner being and replaces all anxiety and worry.

TRUST HIS FAITHFULNESS

Lord God, I step into the shoes of peace You've given me to wear. Thank You for commissioning me as Your ambassador and calling me to walk in You, so that the fullness of Your peace may glorify God in me wherever my feet step.

For Further Prayer and Study

John 14:27 • Romans 5:1; 16:20 • Philippians 4:6–9

THE SHIELD OF FAITH

*"In addition to all this, take up the shield of faith, with which you can
extinguish all the flaming arrows of the evil one."*

EPHESIANS 6:16

RECITE GOD'S GOODNESS

My Shield and Protector, thank You for the gift of faith to turn to You when
Satan flings his fiery darts my way. You are my God—I will not be shaken. You
are my confidence—I will not be afraid.

EXPRESS YOUR NEEDINESS

Lord, remind me of my daily dependence on You. Help me each day put on
Your armor as a reminder that my protection and deliverance come from You
alone. I can't fight this battle on my own. But with You by my side, I will stand
my ground.

SEEK HIS STILLNESS

*Take a few moments to become aware of God's protective presence surrounding you
and shielding you from the enemy this very moment. Just rest in His loving presence.*

TRUST HIS FAITHFULNESS

Lord God, I take up the shield of faith, believing that You are who You say You
are and You will do what You said You would do. Where the enemy intends to
kill, I rejoice in Your promise to defend and strengthen. Thank You for Your
faithfulness to protect my life with Your very own.

For Further Prayer and Study

Genesis 15:1 • Deuteronomy 33:29 • Psalm 5:12 • Proverbs 30:5 • James 1:2–4
1 Peter 1:6–7

THE HELMET OF SALVATION

"Take the helmet of salvation."

EPHESIANS 6:17

RECITE GOD'S GOODNESS

Lord Jesus, salvation is found in no one else but You. When I was helpless and desperate, You saved me and brought me into Your family. I praise You for how graciously You continue rescuing me when I cry out to You.

EXPRESS YOUR NEEDINESS

Lord Jesus, protect my mind from any thought distortions or lies planted by the enemy. Help me guard my media consumption and discern through Your Spirit what is truthful and life-giving from what is poisonous and deceptive. Help me meditate on Your truth and think Your thoughts, having the mind of Christ.

SEEK HIS STILLNESS

Ask the Holy Spirit to help you reflect on the last time you were you attacked by the enemy, perhaps in the last few days. How is He inviting you to rest in His salvation, both now and in future attacks?

TRUST HIS FAITHFULNESS

Lord Jesus, I put on the helmet of salvation, acknowledging that You're the One who guards my mind with Your own presence. Give me a desire to memorize Your Word, and activate it over my mind to protect me from sin. Thank You for always being faithful. I rejoice in Your victory over the enemy.

For Further Prayer and Study

Psalm 119:11 • Matthew 1:21 • Acts 4:12 • Romans 8:6–7; 12:1–2 • 1 Corinthians 2:16

THE SWORD OF THE SPIRIT

"Take . . . the sword of the Spirit, which is the word of God.
And pray in the Spirit on all occasions with all kinds of prayers and requests."

EPHESIANS 6:17–18

RECITE GOD'S GOODNESS

You, Jesus, are the Word of God in human flesh. Thank You for filling us with Your Spirit that we may defeat the enemy's designs against our lives and our loved ones.

EXPRESS YOUR NEEDINESS

Lord Jesus, give me an urgent desire to know Your Word and to apply it to my life. Just as You battled Satan in the wilderness, so teach me to correctly handle the word of truth.

SEEK HIS STILLNESS

The psalmist praises God for training his hands for war and his fingers for battle (see Psalm 144:1–2). How has God equipped you already with the sword of the Spirit, and how is He calling you to better train with Him in this area? Sit quietly with Him as you listen for His guidance and leading.

TRUST HIS FAITHFULNESS

Lord Jesus, I take up the sword of the Spirit in my hand. I praise You for defeating the enemy, and thank You for the right to appropriate Your victory even now as I'm praying in Your Spirit.

For Further Prayer and Study

Matthew 12:29 • 2 Corinthians 10:3–4 • 2 Timothy 2:14–16

THE WEAPON OF PRAYER

"With this in mind, be alert and always keep on praying for all the Lord's people."

EPHESIANS 6:18

RECITE GOD'S GOODNESS

Lord of All Heaven, thank You for giving us heavenly weapons with divine power to demolish strongholds. Truly, You've given us everything we need for a life of victory in You. You have overcome, and because of You, I have hope each day until I see You face-to-face.

EXPRESS YOUR NEEDINESS

Lord, make me aware of my desperate need for ongoing prayer. Enlarge my field of prayer and teach me how to engage in spiritual battle for my spouse, my children, and all those You've given to me. Give me boldness to pray in the Spirit at all times, whether or not I'm aware of the enemy's schemes.

SEEK HIS STILLNESS

Envision yourself putting on each of the piece of the armor of God, starting with the belt of truth and ending with the sword of the Spirit. Let His presence bring you a reassurance of His victory, and rest in Him right now.

TRUST HIS FAITHFULNESS

Thank You precious Jesus for the assurance that when we call on You in our day of need, You will deliver us so that we may glorify You. You've already won the battle, so I rejoice in You. I stand in Your victory as I continue waiting on You!

For Further Prayer and Study

Psalm 50:15 • Luke 18:1–8 • 1 Thessalonians 5:16–18

*As you rest in God's power to
overcome your addiction, consider also
reaching out to a friend, counselor,
or medical professional and receiving
God's help through them.*

OVERCOMING ADDICTION*

*"But this happened that we might not rely on ourselves but on God, who raises the dead.
He has delivered us from such a deadly peril, and he will deliver us again.
On him we have set our hope that he will continue to deliver us."*

2 CORINTHIANS 1:9–10

RECITE GOD'S GOODNESS

O Holy God, my Creator and my King, You part the seas and protect through
fires, raising the dead and bringing new life—nothing is too difficult for You. I
believe in You, and I praise You!

EXPRESS YOUR NEEDINESS

Lord God, I'm praying against anything that has set itself up against the
knowledge of You in my life, stealing my focus and my joy: Lord, break the
power of this addiction and the allure of sin in my life.

SEEK HIS STILLNESS

*Sit quietly before the Lord and invite Him to reveal where you've been ignoring the
Spirit's call to turn from sin. Ask Him to empower you to be quick to obey and walk
with Him in the newness of life.*

TRUST HIS FAITHFULNESS

Lord God, only You bring freedom, so help me continue relying on You and
Your work in my life instead of my own self-help ways. I believe that You will
guide me to those who can help and that you will completely deliver me from
the bondage of sin because I have set my hope in You alone.

For Further Prayer and Study

Psalms 119:45 • Isaiah 43:15–16 • John 8:32 • 2 Corinthians 3:17 • Galatians 5:1, 13

OVERCOMING SPIRITUAL APATHY

"Create in me a pure heart, O God, and renew a steadfast spirit within me."

PSALM 51:10

RECITE GOD'S GOODNESS

Mighty God, Your kingdom is an everlasting kingdom, and Your dominion endures throughout all generations. You are God, and I am not, so You deserve all honor and praise.

EXPRESS YOUR NEEDINESS

O God, my heart feels cold and indifferent toward You. Change my heart! Cause me to turn away from distractions that have dulled my spiritual senses. Help me seek You with all of my heart. Stir my affections and my devotion for You, and grant me a hunger and thirst for righteousness that I may drink from Your river of delights. Thrill me, God, with Your presence, that I would lose my appetite for anything but You.

SEEK HIS STILLNESS

Be still before God, breathing deeply as you become aware of His loving presence. What does He long to say to you?

TRUST HIS FAITHFULNESS

Your love, O Lord, reaches to the heavens. You are trustworthy in all Your promises and loving to all You have made. I trust You to cause my heart to long for You. I believe that You will revive me again that I may celebrate Your abundant goodness and joyfully sing of Your righteousness.

For Further Prayer and Study

Psalms 36:5–9; 145:13 • Isaiah 55:2–3 • Jeremiah 2:12–13 • Matthew 5:6; 6:33

OVERCOMING TEMPTATION

"No temptation has overtaken you except what is common to mankind.
And God is faithful; he will not let you be tempted beyond what you can bear.
But when you are tempted, he will also provide a way out so that you can endure it."

1 CORINTHIANS 10:13

RECITE GOD'S GOODNESS

Heavenly Father, You are my loving God and my fortress, my stronghold and
my deliverer. You are my shield in whom I take refuge because You will crush
the enemy who comes against me. I praise You alone!

EXPRESS YOUR NEEDINESS

Lord, this temptation I'm facing seems too powerful for me, as if I can't resist
it much longer. Help me recognize the way of escape You've prepared for me,
and make my feet quick to run away. Guard me from flirting with temptation
or testing my resilience. Let me run in the path of Your commands for You have
set my heart free.

SEEK HIS STILLNESS

Close your eyes and take a few deep breaths. Where has God given you a way out?
Be quick to obey, running to safety, and then take a few moments to be still with God,
your rescuer.

TRUST HIS FAITHFULNESS

Lord, when I cry out to You in distress, You answer me and set me free. I praise
You for always being faithful to rescue me from temptation, and deliver me
from evil. Yours is the victory forever!

For Further Prayer and Study

Psalms 119:32; 144:2 • Matthew 4:1–11 • 2 Peter 2:9

OVERCOMING GENERATIONAL SIN

*"Through Christ Jesus the law of the Spirit who gives life has set you free
from the law of sin and death."*

ROMANS 8:2

RECITE GOD'S GOODNESS

God of All Love, You do not hold our ancestors' sins against us, but invite each
person to experience the truth that sets us free! Whom You set free is free
indeed, and no force can stand against Your Word. I praise You!

EXPRESS YOUR NEEDINESS

Lord Jesus, You have come to set the captives free, so I pray for generational
strongholds to be broken in Jesus' name. May Your healing power enable me
and my family to walk in the newness of life, free from the curses of sin and
death.

SEEK HIS STILLNESS

*Sit quietly with Jesus and consider: Is there any area where you have allowed sin to
reign in your life? Invite Him to search you and bring freedom and victory over sin
today.*

TRUST HIS FAITHFULNESS

Lord Jesus, I count myself dead to sin and present myself to You. Thank You for
Your great and precious promises of forgiveness, freedom, and life in You alone.
I believe that Your every promise is yes and amen, and I lay claim to them in my
life. Help me walk in Your Spirit's freedom today.

For Further Prayer and Study

Leviticus 26:40–42 • Psalm 79:8–9 • Isaiah 54:17 • Luke 4:18 • Romans 6:11–14
James 5:16

OVERCOMING PRIDE

"'God opposes the proud but shows favor to the humble.' Humble yourselves, therefore,
under God's mighty hand, that he may lift you up in due time."

1 PETER 5:5–6

RECITE GOD'S GOODNESS

Divine Majesty, who is like You, who sits enthroned on high and stoops down
to give grace to the humble? In Your goodness, You shower the humble with
Your favor.

EXPRESS YOUR NEEDINESS

Lord Jesus, help me acknowledge Your greatness and humble myself before
You. Empty me of pride and vain conceit; kill any selfish ambition within me.
Fill my soul with sincere love and admiration of You that I may be caught up in
Your beauty and reflect the likeness of Christ as I bear Your image.

SEEK HIS STILLNESS

Ponder John the Baptist's words about Jesus: "He must become greater; I must
become less" (John 3:30). What would it look like for Jesus to become greater in your
life? How would pursuing His greatness allow your soul to rest in His presence?

TRUST HIS FAITHFULNESS

In Your great love, Jesus, You humbled Yourself to death on the cross; it's
Your humility that led to my salvation. I give myself wholly to Your meek and
humble Spirit. Guide me always by Your humility, and lead me in the joy of
Your salvation that my life may bear much fruit for Your glory alone.

For Further Prayer and Study

Psalm 113:5–6 • Proverbs 3:34 • Matthew 23:12 • Philippians 2:1–11 • James 4:10
1 Peter 3:8

OVERCOMING DESPAIR

*"For our light and momentary troubles are achieving for us an eternal glory
that far outweighs them all. So we fix our eyes not on what is seen, but on what is unseen
since what is seen is temporary, but what is unseen is eternal."*

2 CORINTHIANS 4:17–18

RECITE GOD'S GOODNESS

O Father of Mercies, I love You because You hear my voice and You pay
attention to my cry for mercy. You are gracious and righteous, full of
compassion and love.

EXPRESS YOUR NEEDINESS

Lord, this hardship doesn't feel light or temporary—it feels soul-crushingly
permanent. Help me lift my gaze from these troubles and fix my eyes on Jesus.
Make me more like Jesus in the midst of this hardship, and turn what the
enemy meant for evil into my good and Your glory.

SEEK HIS STILLNESS

Fix your eyes on Jesus as you seek His stillness. Let Him quiet you with His love.

TRUST HIS FAITHFULNESS

Thank You for turning Your ear to me and saving me from the cords of anguish
and despair that entangle me. When You speak, all creation obeys. I believe that
Your Word will not return to You empty, but will accomplish the purpose for
which You sent it. So I trust in You, Lord.

For Further Prayer and Study

Genesis 50:20 • Psalms 27:4–5; 116:1–7 • Isaiah 55:11–12 • Romans 8:28

OVERCOMING FEAR

"Don't be afraid; just believe."

MARK 5:36

RECITE GOD'S GOODNESS

Eternally Merciful God, You bend low to hear the cries of those who call to you. Thank You for being a very present help in my time of need. You've always been near when I called out to You! How good You've been to me, Lord!

EXPRESS YOUR NEEDINESS

Lord, in this moment when fear seems to overcome me and paralyze me in its grip, I will put my trust in You. Help me declare Your lovingkindness over my life even when my heart can only see danger. Through Your Spirit's work in me, help me overcome my fear with faith in Your awesome power and might.

SEEK HIS STILLNESS

Take a few moments to sit quietly with the Lord, who has the power to turn any curse into a blessing because of His great love (see Deuteronomy 23:5). What might He want to do in your life today?

TRUST HIS FAITHFULNESS

Faithful God, I put my trust in You; what can man do to me? You will not take Your love from me nor will You betray Your own faithfulness. Your hope does not disappoint me because You have poured out Your love into my heart by Your Holy Spirit. So I will see the day of Your salvation, and I will rejoice in Your deliverance.

For Further Prayer and Study

Psalms 46:1; 56:3; 89:33–34 • Romans 5:5 • 2 Timothy 1:7

OVERCOMING DOUBT

"I do believe; help me overcome my unbelief!"

MARK 9:24

RECITE GOD'S GOODNESS

Three-in-One God, You alone are God, and there is no other. No one can fathom Your mysterious ways or probe Your limits, almighty One. I am humbled by Your majesty, and praise You for Your steadfast love!

EXPRESS YOUR NEEDINESS

Lord, I humbly and honestly cry out to you: help me overcome my unbelief! Grow the tiny seed of faith in my heart so that my soul would swell[3] with faith in You. I do believe! May Your Word dwell in me richly and bear much fruit of repentance.

SEEK HIS STILLNESS

Sit quietly before the God of the universe and allow His loving presence to work in your heart an ever-increasing faith and trust in Him.

TRUST HIS FAITHFULNESS

Lord, though I have not seen You, I truly do love You, and I want to believe in You more and more that I may be filled with an inexpressible and glorious joy. Only You can accomplish this, and I trust that You delight in those who come to You with simple and childlike faith. So here I am. Have Your way in me.

For Further Prayer and Study

Job 11:7–9 • Isaiah 45:5 • Mark 5:36 • John 5:38; 20:31 • Hebrews 12:1–2 • 1 Peter 1:8

OVERCOMING SHAME

"This is how we know that we belong to the truth and how we set our hearts at rest in his presence: If our hearts condemn us, we know that God is greater than our hearts, and he knows everything."

1 JOHN 3:19-20

RECITE GOD'S GOODNESS

O Lord my Lord, You are slow to anger and abounding in steadfast love. You have forgiven my sin and given me Jesus' perfect righteousness. I praise You!

EXPRESS YOUR NEEDINESS

Lord God, help me fight this shame with the truth of Your complete forgiveness in Jesus. Free me from guilt and oppression, for there is no condemnation for those who belong to You. Remind me that no one can bring charges against those You've justified in Jesus. How great is Your love!

SEEK HIS STILLNESS

Take a few moments to rest your heart in God's presence, aware that God is greater than your heart, your emotions, and anything that threatens to come against you. Wait patiently on Him. Is there anything He wants to say to you?

TRUST HIS FAITHFULNESS

When the enemy reminds me of my past failures, help me recall to mind Your great love and forgiveness. You are faithful to complete the work of sanctifying me and making me more like Jesus, and I will rejoice in Your salvation.

For Further Prayer and Study

Exodus 34:6 • Psalms 34:5; 103:12 • Micah 7:19 • Romans 8:1-2, 28-39 • 1 John 1:9

OVERCOMING INSECURITY

"'Though the mountains be shaken and the hills be removed,
yet my unfailing love for you will not be shaken nor my covenant of peace be removed,'
says the Lord, who has compassion on you."

ISAIAH 54:10

RECITE GOD'S GOODNESS

O Lord of Immortality, the whole earth is filled with Your glory! You are good, and Your love endures forever. I praise You that nothing can separate us from Your love for us in Christ Jesus!

EXPRESS YOUR NEEDINESS

Lord, I am not worthy of being called by You, but You chose me, Christ Jesus, anyway. May Your unfailing love bring me comfort, and Your steadfastness replace my insecurity with a strong sense of Your presence.

SEEK HIS STILLNESS

Rest for a few minutes in the presence of the One whose unfailing love will never be removed from you, though the mountains be shaken and the hills be moved.

TRUST HIS FAITHFULNESS

Lord Jesus, You chose me knowing all my flaws and failures, because You want to display Your glory and power through my weaknesses. You will be faithful to Your promises, so I trust and rejoice in You today.

For Further Prayer and Study

Psalm 119:64, 76 • Romans 8:38–39 • 1 Corinthians 1:27 • 2 Corinthians 12:9
1 John 3:19–20

CRAVING WHAT TRULY SATISFIES

"Come, all you . . . who have no money, come, buy and eat!
Come, buy wine and milk without money and without cost. Why spend money
on what is not bread, and your labor on what does not satisfy? Listen, listen to me,
and eat what is good, and you will delight in the richest of fare."

ISAIAH 55:1–2

RECITE GOD'S GOODNESS

Heavenly Father, You are so good to generously give us everything we need.
Money could never buy salvation or sanctification. When I was poor and
needy, You turned toward me and generously poured out the riches of heaven
in Christ Jesus. I love You, Lord God!

EXPRESS YOUR NEEDINESS

I foolishly turn to the fridge, the drive-thru, and other numbing distractions,
but the truth is they'll never truly satisfy. Forgive me, Lord. None of those can
fix my spiritual hunger or my hurt. Only You can satisfy, so teach me to hunger
for You alone.

SEEK HIS STILLNESS

Take a few moments to become aware of God's loving presence surrounding you this
very moment.

TRUST HIS FAITHFULNESS

Despite people's idolatrous hearts throughout history, Your faithful love calls us
back to Yourself, to feast on You alone. When I turn to You, You delight me as
with the richest of foods. You are enough, God, and You will always satisfy.

For Further Prayer and Study

John 7:37–39 • Romans 12:1–3 • 1 Corinthians 6:19–20 • 1 Peter 1:18–19

HUNGRY FOR GOD

"Blessed are those who hunger and thirst for righteousness, for they will be filled."

MATTHEW 5:6

RECITE GOD'S GOODNESS

How kind of You, Lord, to speak blessing over those who seek You! You are the One who feeds my hungry soul; You satisfy me with as with the richest of foods! Every good and perfect gift comes from You, and You never send Your hungry children away empty. I praise You!

EXPRESS YOUR NEEDINESS

Father, I confess that I don't really feel a deep hunger or thirst for You. Awaken my spiritual appetite. Cause me to desire You more than I crave my next sugar high or salty fix. Change my heart, my taste buds, and my eating habits. Make me wholly Yours.

SEEK HIS STILLNESS

Sit quietly with the Lord, the One who promises to satisfy the hungry with good things. Is there anything He wants to say to you?

TRUST HIS FAITHFULNESS

Merciful God, I know I can't do this on my own, so I praise You in advance for the ways that You will stir up my hunger for You. Thank You for not just causing spiritual hunger but for meeting it, and not just a little, but abundantly. You satisfy. You fill. You are enough.

For Further Prayer and Study

Psalms 22:26; 63:5; 107:8–9 • Luke 1:53 • John 6:1–58

FEASTING ON THE BREAD OF LIFE

"For the bread of God is the bread that comes down from heaven and gives life to the world.... I am the bread of life. Whoever comes to me will never go hungry."

JOHN 6:33, 35

RECITE GOD'S GOODNESS

O Precious Bread of Life, You are the One that our souls are hungry for, and You give Yourself freely to us. You are so good, for when I ask for daily bread You don't give me stones, but You give Your very self. Day by day, You satisfy my hungry soul with the Bread of Life. I worship You!

EXPRESS YOUR NEEDINESS

Lord Jesus, You've given me daily nourishment in the Word of life. Help me open Your Word each day and feast on the Bread of Life. I want to learn daily dependence on You.

SEEK HIS STILLNESS

Meditate on the Bread of Life, as He invites you to receive the gift that He offers you. What do you want to say to Him? And is there anything that He wants to say to you?

TRUST HIS FAITHFULNESS

Just as You generously provided daily manna for the Israelites in the wilderness, so in Jesus You daily provide for all my spiritual needs too. When I'm tempted to turn to food for comfort or distraction, help me instead to turn to You. Only You can satisfy. I trust You.

For Further Prayer and Study

Deuteronomy 8:2–5 • John 6:35 • Philippians 4:19

TASTING THE GOODNESS OF GOD

"Taste and see that the LORD is good."

PSALM 34:8

RECITE GOD'S GOODNESS

O Life-Giving God, You invite us to feast our souls on You, to find our satisfaction in You. Those who seek You lack no good thing because You generously give us all good things, even Your very self. You are generous. You are good. I worship You.

EXPRESS YOUR NEEDINESS

I confess that I often lose my appetite for spiritual food. I become so engrossed with my next meal that I forget You prepare a table of spiritual delicacies in Your presence. Make Your Word set to my taste, even sweeter than my favorite treat. Turn my appetite away from the temporal and toward the eternal.

SEEK HIS STILLNESS

Imagine the Lord's banquet laid out for you, your gracious host inviting you to sit at the table with Him, and enjoy His presence. What does He want to say to you? And how have you tasted His goodness in your life?

TRUST HIS FAITHFULNESS

Lord God, I want to taste of Your goodness over and over again. Help me see opportunities to turn from empty calories and feast instead on Your Word. Cause me to crave pure spiritual milk; fill me in personal ways that food never could. Only You can do this, and I trust You.

For Further Prayer and Study

Psalms 34:8–10; 119:103 • Hebrews 6:4–5 • 1 Peter 2:2–3

DIVINE DIETICIAN

*"His divine power has given us everything we need for a godly life through
our knowledge of him who called us by his own glory and goodness."*

2 PETER 1:3

RECITE GOD'S GOODNESS

Giver of All Good Things, You don't hold out on Your children. You've given
me everything I need to live a life that honors You. You've called me for Your
own glory, and in Your goodness, You pour out more and more of Yourself in
me. Thank You! I worship You alone!

EXPRESS YOUR NEEDINESS

Lord, I confess that when it comes to bringing my eating habits under control,
I often feel overwhelmed. I cannot. But You can. Be my Divine Dietitian.
Through Your power, break the stronghold of food fixation in my life that I may
walk in freedom and fullness in Jesus.

SEEK HIS STILLNESS

*Ponder what would change if you lived and ate under God's divine power and
direction in your life. What is God inviting you to, this very moment? Answer His
call, and then be still with Him.*

TRUST HIS FAITHFULNESS

Lord, when I was lost, You found me. When I was broken, You healed me.
When I was enslaved, You freed me. And when I was disheartened, You
revived me. You have given me great and precious promises, and I trust You
to complete Your work of transformation in me.

───── *For Further Prayer and Study* ─────

Romans 8:28–30 • 1 Peter 1:5 • 2 Peter 1:3–8 • Jude 24–25

A SPIRIT OF SELF-DISCIPLINE

"For the Spirit God gave us does not make us timid,
but gives us power, love and self-discipline."

2 TIMOTHY 1:7

RECITE GOD'S GOODNESS

All-Powerful and Sovereign God, in Your goodness, You've opened the riches of heaven to us, but more than that, You placed Your very Spirit within us. Thank You that I don't have to wrestle through this life alone. I have You. And You are enough.

EXPRESS YOUR NEEDINESS

Self-discipline is so very hard for me. I'd rather pander to my own cravings than regulate my appetites. Forgive me, Lord. I bring myself under Your authority and ask that Your Spirit would produce in me Your love, Your power, and Your control.

SEEK HIS STILLNESS

Take a few moments to abide in God's loving, powerful, and directive presence. What does He want to say to you? Be still with your good heavenly Father.

TRUST HIS FAITHFULNESS

Where I am powerless, You are powerful. You can do so much more than I could even imagine. So help me abide in You and surrender to Your work of sanctification in my life. I submit to Your Spirit of discipline to teach me self-discipline. Food is only one aspect that needs brought under Your authority. I need a wholehearted renovation. Thank You for doing Your perfect work in me.

For Further Prayer and Study

Luke 24:49 • Romans 8:15 • Galatians 5:22–23

EATING FOR GOD'S GLORY

"So whether you eat or drink or whatever you do, do it all for the glory of God."

1 CORINTHIANS 10:31

RECITE GOD'S GOODNESS

Lord God, in Your lovingkindness You've graciously given us a wide variety of delicious foods to nourish our bodies and delight our taste buds. You are so creative and generous! Thank You for inventing food. Your plans are wonderful and Your ideas are always good!

EXPRESS YOUR NEEDINESS

Lord, I confess that it's easy to view food as the enemy, as if it's somehow my meal's fault that I'm overweight or obsessed or otherwise struggling with food. Teach me how to view food as a good gift from You and to eat in a way that points to Your goodness. I need Your help.

SEEK HIS STILLNESS

Picture yourself at your next meal: What does it look like to eat in a way that glorifies God? Why do you think He even cares about this? Allow His presence to bring peace in this area of your life, and commit your meals to Him.

TRUST HIS FAITHFULNESS

There's so much conflicting information when it comes to "the right way" to eat, and Lord, I just want to please You. I want to do what's right by You. Would You lead me in this? I trust You to continue working healing and freedom in the area of food in my life.

For Further Prayer and Study

Zechariah 14:21 • Colossians 3:17 • 1 Peter 4:11

LIVING FREE INDEED

"So if the Son sets you free, you will be free indeed."

JOHN 8:36

RECITE GOD'S GOODNESS

O Great God, You rescued me from slavery to sin and set me free by the precious blood of Jesus! You call me a child of God! You have set my heart free to run in the path of Your commands. I praise You, God, that what You set free is free indeed, and nothing can enslave me again.

EXPRESS YOUR NEEDINESS

Forgive me for the times that I choose to return to a life of sin—it has only led to death and dead ends. Let me not use freedom as an excuse to sin, but rather experience the fullness of life that You offer me. Help me lay aside every hindrance and entangling sin habit, and run freely with my eyes on Jesus.

SEEK HIS STILLNESS

Reflect on the last 24 hours. Where have you become entangled in sin, and how does Jesus want to free you to live for Him? Confess your sin to Jesus, receive His forgiveness, and experience His liberating grace.

TRUST HIS FAITHFULNESS

You have set me free; now teach me how to live free. Where the enemy has come to steal, kill, and destroy, You've brought freedom and fullness of life. Because You have liberated me, Jesus, I am really and unquestionably free. I want to live free indeed, so please lead me in Your freedom.

For Further Prayer and Study

John 8:32 • Romans 6:17–18; 8:1–2 • Hebrews 12:1–4

NO LONGER MASTERED BY CRAVINGS

*"'I have the right to do anything,' you say—but not everything is beneficial.
'I have the right to do anything'—but I will not be mastered by anything."*

1 CORINTHIANS 6:12

RECITE GOD'S GOODNESS

Blessed God, You have been so good toward me to set me free from sin and
death. You alone have the power to transform the parts of me that still turn to sin
and make me wholeheartedly devoted to You alone. Thank You for placing Your
Spirit of discernment within me. You give me all I need, for You are enough.

EXPRESS YOUR NEEDINESS

I get in this weird head space where what's off-limits becomes attractive,
tempting me to compromise. Your Word says that a person is a slave to
whatever has mastered them. I don't want to be mastered by my cravings,
but by Your Spirit alone. Help me take every thought captive to obey You.

SEEK HIS STILLNESS

*Take a few moments to reflect on how God has provided and protected you through
His own presence. Then be still with Him.*

TRUST HIS FAITHFULNESS

You, Lord God, have always been faithful to provide a way out of every
temptation. So I trust You to continue leading me through Your Spirit
of wisdom. You lead me as a loving and gentle Master; I follow You
wholeheartedly today.

--- *For Further Prayer and Study* ---

Psalm 36:9 • John 8:44 • Romans 14:12 • 2 Corinthians 10:5 • 2 Peter 2:19

IMMEDIATE OBEDIENCE

"For the grace of God has appeared . . . It teaches us to say 'No' to ungodliness and worldly passions, and to live self-controlled, upright and godly lives in this present age."

TITUS 2:11-12

RECITE GOD'S GOODNESS

Father God, Your grace is such a gift, not only covering my sins and offering salvation, but even coaching me to resist sinful habits. Thank You for not leaving me to struggle on my own. You've given me everything I need for a life of victory in Jesus!

EXPRESS YOUR NEEDINESS

Honestly, even when Your Spirit prompts me to say no, I still flirt with temptation, longing to indulge my impulses. Forgive me. Transform me. Make sin so distasteful that I'll be quick to obey You. Keep my feet on the path of Your commands, for You alone set my heart free.

SEEK HIS STILLNESS

Picture the last time you faced temptation. Where was God's grace urging you to say no, and how did you respond? Become aware of His presence indwelling you and calling you to a life of immediate obedience.

TRUST HIS FAITHFULNESS

On my own, I am lost without You. But Your grace is greater than my past failures and stronger than my current temptations. Jesus, You have overcome sin and death, and in You I can live a victorious life that reflects Your coming kingdom here on earth. I trust You to teach me immediate obedience.

For Further Prayer and Study

John 14:15 • Titus 2:11–14 • 1 Peter 4:2 • Revelation 12:11

FULLY SATISFIED

*"I will praise you as long as I live, and in your name I will lift up my hands.
I will be fully satisfied as with the richest of foods;
with singing lips my mouth will praise you."*

PSALM 63:4–5

RECITE GOD'S GOODNESS

Lord of All, if I lived to be five hundred, I'd never exhaust Your goodness toward me. From the moment I met You, You've shown Your lovingkindness toward me. When I turn to You, You always fill me with good things, and I praise You, Lord! There is nothing on earth that I desire more than You.

EXPRESS YOUR NEEDINESS

I want to be fully satisfied with You. I want to long for You more than my favorite foods, more than the very best meal. Cause me to turn from distractions that numb my appetite for You; I want to hunger for You alone.

SEEK HIS STILLNESS

Take a few moments to become aware of God's loving presence surrounding you this very moment. How has He satisfied your deepest needs with His very self?

TRUST HIS FAITHFULNESS

You satisfy me each morning with Your unfailing love. Never once have you turned me away empty-handed. Because You are my loving Shepherd, I lack nothing; no good thing do you withhold from me. You've been faithful all my life, and I trust You to fully satisfy me all my days.

For Further Prayer and Study

Psalms 23:1; 63:1–5; 73:25–26; 90:14 • Matthew 7:9–11 • John 6:35

LIFE TO THE FULL

"The thief comes only to steal and kill and destroy;
I have come that they may have life and have it to the full."

JOHN 10:10

RECITE GOD'S GOODNESS

Thank You, Precious Jesus, that where the enemy intends to harm, You heal.
Where the enemy steals, You restore. Where the enemy kills, You bring life.
And not just a meager life of eking out an existence, but life abundantly . . .
life to the full with You. You are my Good Shepherd, and I praise You!

EXPRESS YOUR NEEDINESS

I'm easily deceived by the enemy as he leads me astray with lies and
temptations. Protect me from his prowling threats. Help me recognize his
schemes and stand against Him with the sword of Your Spirit in my hand.
Make me quick to see through his lies and conquer through Your truth.

SEEK HIS STILLNESS

Picture the Good Shepherd standing between you and the enemy's threat. Allow His
presence to comfort you, His peace to fill you, and His love to surround you. Just rest
with your Good Shepherd.

TRUST HIS FAITHFULNESS

You loved me to the death, Lord Jesus, so I can trust You with my life. I know
that I don't face temptations alone because You are always with me. Though I
face a crafty enemy, You are greater, and Your goodness and mercy will follow
me all the days of my life.

For Further Prayer and Study

Psalm 23 • Ephesians 6:10–18 • 1 Peter 5:8

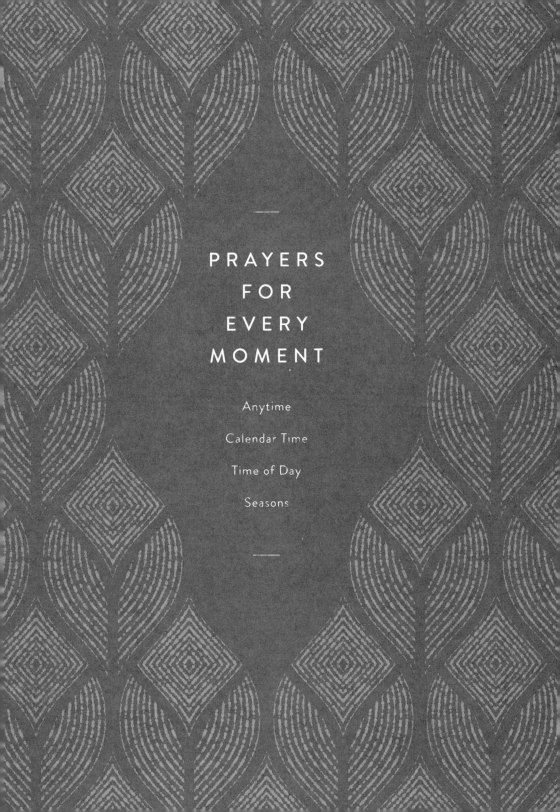

PRAYERS FOR EVERY MOMENT

Anytime

Calendar Time

Time of Day

Seasons

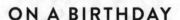

ON A BIRTHDAY

*"Take delight in the L*ORD*, and he will give you the desires of your heart.*
*Commit your way to the L*ORD*; trust in him . . ."*

PSALM 37:4-5

RECITE GOD'S GOODNESS

Everlasting Father, how marvelous You are in all Your works! Thank You for
creating this child of Yours, Your handiwork and masterpiece.

EXPRESS YOUR NEEDINESS

Lord, help [the birthday person] delight themselves in You; with everything in
them, may they bless Your holy name. Shape the desires of their heart to long
for the things You long for, and lead them in Your paths of life. May You fill
them with joy in Your presence all the days of their life, and may they find rest
for their souls in You.

SEEK HIS STILLNESS

Sit quietly before the Lord, picturing Him tenderly holding and guiding the
birthday person throughout every significant event over the course of their life.
Be still with Him, and let His compassionate care quiet you with reassurance of
His love for you too.

TRUST HIS FAITHFULNESS

Heavenly Father, how great is the love You have lavished on us to be called
Your children! I entrust this child of Yours into Your loving care, knowing that
whatever good or hard things they face this year, You are always with them.

For Further Prayer and Study

Numbers 6:24-26 • Psalms 20:4; 27:4-7; 90:12 • Ephesians 2:10 • Jude 24

WHEN LEAVING ON A TRIP

*"The LORD will keep you from all harm—he will watch over your life;
the LORD will watch over your coming and going both now and forevermore."*

PSALM 121:7-8

RECITE GOD'S GOODNESS

Ever-Watchful God, Your eyes roam the earth, and there's nowhere in all of
creation that I could go and be out of Your sight. How mighty and majestic is
Your name in all the earth!

EXPRESS YOUR NEEDINESS

Lord, You know every inch of my route, from the moment I step out of my
door until I arrive safely to my destination. Just as You attended the Israelites
in the wilderness journeys, so be with me in my travels, watching over me and
protecting me with Your presence.

SEEK HIS STILLNESS

*Pause to envision your route—all your connections and stopping points, and
envision God with you in each of those places. Then be still, surrendering your fears
and anxieties to Him, and rest in His protection.*

TRUST HIS FAITHFULNESS

Lord, no matter what happens on this trip, I will trust that You hold me
securely in Your hands, and nothing will touch me outside of Your sovereign
control. Remind me as I journey that I am a pilgrim on this earth, and use this
trip to revive my desire to see You in paradise.

For Further Prayer and Study

Exodus 13:21 • Deuteronomy 28:6 • Psalm 121:7-8 • Proverbs 3:23, 26 • James 4:13–15

GOODBYES

*"Now may the Lord of peace himself give you peace at all times
and in every way. The Lord be with all of you."*

2 THESSALONIANS 3:16

RECITE GOD'S GOODNESS

Heavenly Father, thank You for the gift of time and friendship with this sweet child of Yours. I praise You for bringing them into my life for this season, and I'm thankful for Your presence that will continue to be with us even as we say goodbye.

EXPRESS YOUR NEEDINESS

As we leave each other today, I pray Your blessing and continued protection of this dear person. May they come to know Your peace and presence in such a personal way, and may they continue to experience Your Spirit's work in their lives. Bring comfort where there may be loneliness, and cause Your people to surround them with Your love.

SEEK HIS STILLNESS

Hold this person in your thoughts as you sit quietly with Jesus. Are there any words of encouragement that He places on your heart for you to share with them?

TRUST HIS FAITHFULNESS

Thank You, Lord God, for beginning a good work in Your child. I entrust them into Your loving care, knowing that You will complete what You started and anticipating the day we will once be reunited with great rejoicing and worship at what You have done in both our lives.

For Further Prayer and Study

Deuteronomy 31:8 • Psalms 37:23; 121:1–8 • Ephesians 6:23–24

RUNNING LATE

"Teach us to number our days, that we may gain a heart of wisdom."

PSALM 90:12

RECITE GOD'S GOODNESS

O God of my Beginning and End, thank You for watching over me both in my coming and in my going. Thank You for keeping me safe this far.

EXPRESS YOUR NEEDINESS

I'm running late right now, and it's causing me anxiety and worry. I confess that I could have planned better to avoid feeling rushed, but here I am now. Teach me to number not only my days but also my hours and minutes so I can live wisely. Help me learn from this experience. Please give me peace in this moment, and use this situation to grow me more into the image of Jesus.

SEEK HIS STILLNESS

Take a few deep breaths and quiet your heart in God's presence. Consider how He might use all things—even your tardiness—for His glory and your continued transformation into Christlikeness.

TRUST HIS FAITHFULNESS

Lord God, whether I'm on time or late to where I need to go, thank You that You are always faithful. You're never slow in keeping Your promises; instead, You are patient and kind, and You long to be gracious to us. I will trust You with the outcome of my travels, knowing that You will work all things for good.

For Further Prayer and Study

Deuteronomy 28:6 • Psalms 39:4; 121:7–8 • Proverbs 16:9 • 2 Peter 3:9

CLEANING THE HOUSE

"I will sprinkle clean water on you, and you will be clean;
I will cleanse you from all your impurities."

EZEKIEL 36:25

RECITE GOD'S GOODNESS

O Living God, thank You for giving me a home that provides both shelter and comfort to me and my family. You are so good to generously provide for my every need!

EXPRESS YOUR NEEDINESS

Lord, help me delight in cleaning my house, even if I'm tempted to grumble at the futility of it all. I want to serve You with gladness and do these chores with joy in my heart.

SEEK HIS STILLNESS

As you clean each room, pause to allow the Lord to reveal to you what He wants to clean in your own heart. Perhaps you'll recall conversations in that space that prompt you to repent, or maybe God wants to reveal specific ways to love in that space that you wouldn't have thought of on your own. Then sit quietly with Him, and rest for a few moments in His presence before moving on.

TRUST HIS FAITHFULNESS

Lord, thank You that what You clean sparkles like new, and what You forgive is cleansed forever. Thank You for being faithful to use even a task as mundane as housecleaning to bring me greater joy and peace in You. I love You!

For Further Prayer and Study

Psalm 51:2 • Matthew 23:25–26 • Hebrews 9:14 • 1 John 1:9

BEFORE APOLOGIZING

"Let us therefore make every effort to do what leads to peace and to mutual edification."

ROMANS 14:19

RECITE GOD'S GOODNESS

Loving Savior, You know all things, and my heart is laid bare before You.
Thank You for not condemning me for my sins, but offering forgiveness and
restoration whenever I humbly come to You with a broken and contrite heart.

EXPRESS YOUR NEEDINESS

Lord, grant me the humility to acknowledge my wrongdoing to the one whom
I've offended. Give me courage to speak the truth without embellishing it or
excusing my sin. Soften their heart, that they would extend grace, mercy, and
forgiveness. Restore our relationship, and help me sin no more.

SEEK HIS STILLNESS

*Consider what fears grip your heart ahead of this apology. Picture God's comforting
Spirit guiding you into this difficult conversation, and His sustaining presence with
you even if the worst case scenario were to happen. Then become aware of His
sufficient grace and love enveloping you right now. Just be still in His loving presence.*

TRUST HIS FAITHFULNESS

Lord, I don't know how this conversation will go, but I'm obeying Your impulse
to repent and ask for forgiveness. I trust You with the outcome, knowing that
no matter what happens, You will be faithful to continue loving me, and You
will never leave me.

For Further Prayer and Study

Psalm 51:17 • Proverbs 15:1 • Luke 17:3–4 • 2 Timothy 2:14, 23–24 • Titus 3:1–2

WELCOMING GUESTS

"They broke bread in their homes and ate together with glad and sincere hearts."

ACTS 2:46

RECITE GOD'S GOODNESS

Precious Immanuel, You who took on human flesh and spent countless hours around tables, I praise You for the gift of friendship and hospitality.

EXPRESS YOUR NEEDINESS

Lord, as I prepare to open my home for guests, please prepare my heart to serve with gladness. Let me lay aside my worries about how the meal turns out or how my home looks, and help me focus instead on welcoming these beloved children of Yours just as they are, with any burdens they're carrying. May we be refreshed by one another's presence as we break bread together, and may our friendships deepen as the hours carry on.

SEEK HIS STILLNESS

Sit quietly with God and allow Him to wrap you in His loving presence. Then ask Him to open your eyes and heart to see each guest and serve them with His divine love.

TRUST HIS FAITHFULNESS

Lord, You know my hesitations and hang-ups about hospitality, how terrible I can be at small talk, and how worried I am about what others think. I entrust all these concerns to You, believing that You will use this small offering of hospitality for Your kingdom and glory.

For Further Prayer and Study

Leviticus 19:33–34 • Luke 14:12–14 • 1 Timothy 5:10 • Titus 1:8 • 1 Peter 4:8–9

WAITING IN LINE

"Wait for the LORD; be strong and take heart and wait for the LORD."

PSALM 27:14

RECITE GOD'S GOODNESS

Timeless and Glorious God, thank You that even when life doesn't move at the pace I'd like it to, You are never hurried or rushed. I praise You for always being with me, even in this seemingly interminable wait.

EXPRESS YOUR NEEDINESS

Lord, I confess my annoyance at this slow-moving line. Forgive me for seeing the people around me as impediments instead of image-bearers. Use this frustration to reveal the work You have yet to do in my heart, and help me slow down my pace that I may be fully present in this moment.

SEEK HIS STILLNESS

Take a few deep breaths and look around you. Try to discern the people you're seeing with the eyes of your heart. Who may the Lord prompt you to pray for? Who could use an encouraging smile or affirmation? Be present in this moment with the Spirit of Jesus as your guide.

TRUST HIS FAITHFULNESS

Lord, You don't waste any opportunity to sanctify me, do You? Thank You for Your faithfulness! Continue to form in me the image of Jesus during this pilgrimage on earth, causing me to remember that just as I will soon be at the end of my waiting, so too I will soon see You face-to-face.

For Further Prayer and Study

Psalms 27:13–14; 40:1 • Lamentations 3:25 • Luke 18:1 • James 5:7–8 • 2 Peter 3:9

BALANCING THE BUDGET

"Keep your lives free from the love of money and be content with what you have, because God has said, 'Never will I leave you; never will I forsake you.'"

HEBREWS 13:5

RECITE GOD'S GOODNESS

Giver of All Good Things, You graciously provide everything I need exactly when I need it. You are generous and kind, and I know that You always take care of me.

EXPRESS YOUR NEEDINESS

Lord, I want to steward my resources wisely and honor You in my spending and financial investments. Guard my heart from greed and dishonest gain, and help me store my treasures in eternity, not in temporal things. Remind me that all I have is Yours, and You are mine, so I never have to worry about tomorrow.

SEEK HIS STILLNESS

Today's Scripture connects financial contentment with an awareness of God's presence. Consider how God has provided for you in the past month, and how He's present with you this very moment, and be still in His loving presence.

TRUST HIS FAITHFULNESS

Creator God, I want to live a simple life within my financial means so that I may save for hard times and generously bless others with the resources You've entrusted to me. And when unforeseen events threaten my budget, I trust that You will provide for all my needs according to Your riches in Christ Jesus.

For Further Prayer and Study

Psalm 50:7–15 • Matthew 6:1–4, 19–24 • Luke 14:28 • Philippians 4:19

WEEKEND REST

*"This is what I have observed to be good: that it is appropriate for a person
to eat, to drink and to find satisfaction in their toilsome labor under the sun
during the few days of life God has given them—for this is their lot."*

ECCLESIASTES 5:18

RECITE GOD'S GOODNESS

Everlasting Creator, I bless You for the rhythm of our days. You have set limits
for time and space that we may remember who You are and who we are not.
Every good and perfect gift comes from You, including this time to rest and be
refreshed.

EXPRESS YOUR NEEDINESS

Lord, when I work, help me be fully present at the task at hand and work with
all my strength. And when I come to a break, help me leave behind the cares of
my labor to rejoice in the simple pleasures of life.

SEEK HIS STILLNESS

*Come to Jesus with all your burdens now, and rest in His loving presence. Practice
intentionally pausing throughout your weekend to become aware of His Spirit within
you, delighting as you rejoice in His creation.*

TRUST HIS FAITHFULNESS

Lord, I trust You with the course of my life, for all my days are already written
in Your book. So grant me the serenity to enjoy my life as I actually experience
it today, not as I wish it were, that my soul may rise in worship to You.

For Further Prayer and Study

Psalm 139:16 • Matthew 6:25–34; 11:28–29 • James 1:17

NEW YEAR'S DAY

"In their hearts humans plan their course, but the LORD establishes their steps."

PROVERBS 16:9

RECITE GOD'S GOODNESS

Sovereign Lord, thank You for bringing me into a new year. My heart sings to You a new song, praising Your name, for You have done great and marvelous things this past year, and You will continue to be faithful in the year to come.

EXPRESS YOUR NEEDINESS

Lord, I have high hopes for this coming year, but I can do nothing on my own. Help me live in complete dependence on Your Spirit within me. Reveal to me more of Yourself this year, that I may delight in Your love.

SEEK HIS STILLNESS

Reflect on the past year, pausing to consider where you have most strongly sensed God's presence and where you have seen Him working in a powerful way. As you consider the coming year, commit your plans and goals to Him, and then sit quietly in His presence, just basking in His love for you.

TRUST HIS FAITHFULNESS

Father of lights, this new year is a gift from You, and You are faithful to watch over me every day. Wherever I go, You are already there, so no matter the heartaches and hardships that may await me this year, I trust in Your compassionate mercy and constant presence to lead me all the days of my life.

For Further Prayer and Study

Psalms 20:4; 23; 39:4; 90:12; 96:1–3; 121:7–8 • John 10:27–30 • James 1:17

ASH WEDNESDAY

"For dust you are and to dust you will return."

GENESIS 3:19

RECITE GOD'S GOODNESS

How humbling, O Lord, to remember that I am but dust. You are the creator God, the almighty One who breathed life into dust—breath of Your breath, moving in me, animating me, energizing me. You are my life.

EXPRESS YOUR NEEDINESS

Most days I try to escape reminders of my mortality, my frailty. Give me humility and sober judgment to remember that someday my body will return to the dust. I confess my pride and my arrogance to You: the ways I seek to elevate myself above my fellow humans. Forgive me. Create in me a clean heart, O God, and renew a steadfast spirit within me.

SEEK HIS STILLNESS

Breathe deep, and stand bare before the Lord. He sees you. He knows you. And He loves you just as you are. Is there anything He wants to say to you?

TRUST HIS FAITHFULNESS

Lord God, I am not worthy of Your love or consideration. But You are faithful and kind, and You've glorified dust with Your own breath. Anything good in me comes from You—it's the work of Your Spirit in me. Just as You breathed life into Adam's nostrils, so You, Jesus, breathed the Spirit over Your disciples. And now that same Spirit resides in me. Thank You for Your faithfulness to the work of Your hands.

For Further Prayer and Study

Genesis 2:7 • Psalm 146:4 • 1 Corinthians 15:47 • Hebrews 9:27–28

MAUNDY THURSDAY

"It was just before the Passover Festival. Jesus knew that the hour had come for him to leave this world and go to the Father. Having loved his own who were in the world, he loved them to the end . . . and began to wash his disciples' feet."

JOHN 13:1, 5

RECITE GOD'S GOODNESS

Precious Jesus, how great is Your love—that You would lower Yourself to a servant's task, loving your disciples to the very end. Yet Your love extended past washing feet to laying down Your own life on the cross. What costly love to the very last drop.

EXPRESS YOUR NEEDINESS

Lord Jesus, there remains still too much pride in me, too much ambition and arrogance, making me resist such humble service. If You, my Lord and master, humbly bowed in service others, may I eagerly follow Your example.

SEEK HIS STILLNESS

Ponder Jesus' sweet love compelling Him to humble servitude unto death. Abide in His love for you, and then rest in the presence of a being whose very essence is self-giving love.

TRUST HIS FAITHFULNESS

Lord Jesus, You were so secure in Your Father's love and Your identity with Him that no task was too menial or lowly for You. Your love compels me to trust my whole self to You alone; let me seek not to be served but to serve. Here I am.

For Further Prayer and Study

Matthew 20:20–28 • Luke 7:44–50 • Philippians 2:1–11 • 1 Thessalonians 4:11–12

GOOD FRIDAY

*"So the soldiers took charge of Jesus. . . . They crucified him, and with him two others—
one on each side and Jesus in the middle. . . . Later, knowing that everything had now been
finished . . . Jesus said, 'It is finished.' With that, he bowed his head and gave up his spirit."*

JOHN 19:16-30

RECITE GOD'S GOODNESS

O Savior of Sinners, what great love You displayed in your death! It was not
nails that pinned You there, nor the soldier's pointed spear, but love that held
You on that cross!

EXPRESS YOUR NEEDINESS

I kneel before the cross, acknowledging that it was my heinous sin, my
miserable guilt, and my vile iniquity that caused You to be made a curse for me.
May I never become glib about what You endured, but may Your sacrifice make
You all the more precious to me, my Savior.

SEEK HIS STILLNESS

*Throughout history, forgiveness of sin always required a sacrifice of blood. Ponder the
infinite value of the blood of the incarnate Son of God poured out for your sin, and
rest in the forgiveness He secured for you at the cross.*

TRUST HIS FAITHFULNESS

Precious Jesus, You conquered evil by letting it conquer You on the cross,
gaining victory over the world through an act of self-giving love. So You are
worthy of all my praise and adoration, and I will trust and worship You forever
and ever.

For Further Prayer and Study

Isaiah 53:1–12 • Hebrews 9:22; 12:1–2 • 1 Peter 1:18–20

RESURRECTION SUNDAY

"Why do you look for the living among the dead? He is not here; he has risen!"

LUKE 24:5–6

RECITE GOD'S GOODNESS

King Jesus, You are the resurrection and the life! Blessed are You, my Lord and Savior, for conquering death with Your resurrection life! You are worthy of all my praise!

EXPRESS YOUR NEEDINESS

Much like the women at the tomb, I too search for the living among the dead, and sometimes even live as one whose only life is here on earth. Forgive me. Make me more aware of Your resurrected life in me, that I may be influenced in all ways by Your resurrection power and my unswerving destiny with You.

SEEK HIS STILLNESS

Scripture says that Jesus endured the cross and scorned its shame for the joy of spending eternity with His redeemed and resurrected people—and that includes you. Allow the joy of His resurrection to cause your heart to soar in joyful worship and rest in quiet adoration.

TRUST HIS FAITHFULNESS

Lord Jesus, because You live, I also will live with You in a resurrected body forever and ever. You have given me new birth into a living hope through Your resurrection from the dead, so I live for you alone.

For Further Prayer and Study

Matthew 28:5–6 • Luke 24:1–12, 36–47 • John 11:25–26; 20:1–18 • 2 Corinthians 5:14–15
Hebrews 12:1–3 • 1 Peter 1:3 • Revelation 20:6

*Historically, the church observes Jesus' ascension to the Father in heaven forty days after the day of His resurrection.

PRAYERS FOR EVERY MOMENT—
Calendar Time

JESUS' ASCENSION*

"When he had led them out to the vicinity of Bethany, he lifted up his hands and blessed them. While he was blessing them, he left them and was taken up into heaven."

LUKE 24:50–51

RECITE GOD'S GOODNESS

Majestic Jesus, You secured our salvation by taking on human flesh, and now You're seated on high at the Father's right hand, in Your rightful place of glory and supreme authority. I praise You for finishing the work of salvation by triumphing over all demonic powers.

EXPRESS YOUR NEEDINESS

Lord Jesus, You are the founder and perfecter of our faith, and I admit there's so much more perfecting that needs to take place in my life. I submit myself wholly to You, asking that Your Spirit take control of me.

SEEK HIS STILLNESS

Because Jesus is seated at the Father's right hand, He makes requests for all believers. Be still before the Lord, and let Jesus intercede on your behalf.

TRUST HIS FAITHFULNESS

Lord Jesus, help me rest in the reality of Your exalted position at the Father's right hand so that I gain courage and boldness as Your witness in life and death. Thank You for the promise of future glory and eternal life with You. So whatever may come, I fully trust in You.

For Further Prayer and Study

John 14:1–4 • Acts 1:4–11; 7:55–56 • Romans 8:34 • Ephesians 1:18–23; Hebrews 1:3–4

**Historically, the church observes
Pentecost fifty days after Jesus'
resurrection (ten days after Jesus'
ascension) to celebrate the gift of the
Holy Spirit to all who believe.*

PENTECOST*

*"When the day of Pentecost came . . . They saw what seemed to be tongues of fire
that separated and came to rest on each of them. All of them were filled with
the Holy Spirit and began to speak in other tongues as the Spirit enabled them."*

ACTS 2:1, 3–4

RECITE GOD'S GOODNESS

Spirit of God, You turned chaos into created order, bringing life from the grave
and beauty from destruction. It is You who wooed me to Yourself and now
infuses me with Your own presence! How wonderful You are!

EXPRESS YOUR NEEDINESS

Spirit of Jesus, make me more aware of Your presence living in me, moving me,
energizing me, and sustaining me. There's still much fear within, so empower
me to preach Your name through my love and my words—my life, a fragrant
aroma to You.

SEEK HIS STILLNESS

*Allow the presence of Jesus within you to lead you in a place of quiet trust and
courageous living. How is He inviting you to more fully abide in Him that He may
bear fruit in your life?*

TRUST HIS FAITHFULNESS

Holy Spirit, I offer myself wholeheartedly to You: a living sacrifice, a dwelling
place, a temple for You. Teach me and guide me that I may labor with You until
Your kingdom comes on earth as it is in heaven.

For Further Prayer and Study

John 14:15–26; 15:26–16:15 • Acts 1:8; 2:1–21 • Galatians 5:22–23 • 1 Corinthians 6:19–20

THANKSGIVING

"Give thanks to the LORD, *for he is good; his love endures forever."*

PSALM 107:1

RECITE GOD'S GOODNESS

Bountiful Father, You created the heavens and the earth and have generously given us all things. Thank You for satisfying us with good things and for renewing Your mercies and love toward us each day.

EXPRESS YOUR NEEDINESS

Lord, make my heart tender to recognize how You've provided in both times of plenty and in need. Guard me from pride and arrogance so that I will never forget You are the One who gives both daily bread and daily strength. I need You. And You have always been enough.

SEEK HIS STILLNESS

Look around you and thank God for every blessing your gaze falls upon, extending your thankfulness in concentric circles to the surrounding people and places. Let your soul soar with thanksgiving, then be still with the giver of every perfect gift.

TRUST HIS FAITHFULNESS

Heavenly Father, we will never exhaust the riches of Your glories in heaven. Thank You for pouring out Your goodness day after day. As I look at the challenges in the days and weeks ahead, I will choose to trust that You will continue to provide in the future just as You have in the past. My soul rests in You, my Savior, my God, and my loving Father.

For Further Prayer and Study

Deuteronomy 8:1–20 • Psalms 103:1–4; 107:9 • 2 Corinthians 9:15 • James 1:17–18

THE BEGINNING OF ADVENT

"A voice of one calling: 'In the wilderness prepare the way for the LORD;
make straight in the desert a highway for our God.'"

ISAIAH 40:3

RECITE GOD'S GOODNESS

My Precious Jesus, I praise You for disrobing Yourself of heavenly glory and taking on human flesh to come to earth to save us. How great is Your love for us!

EXPRESS YOUR NEEDINESS

Lord, at the beginning of this Advent, help me prepare my heart to celebrate the miraculous joy of Your birth. In the midst of busy holiday activities, let me make space to sit quietly with You and rejoice in the coming of Your salvation.

SEEK HIS STILLNESS

Bring your holiday expectations, your lengthy to-do list, and all your hopes for this season before the Lord, and lay them all at His feet. Then sit quietly with Him, asking for grace to see what opportunities He has prepared for you to find rest in Him this coming month.

TRUST HIS FAITHFULNESS

Lord, just as You kept Your promise to come as our Savoir—born as a baby in a manger—so You promise to come again as victorious King—riding a white horse in majesty. You were faithful to keep Your first promise, and You will certainly be faithful to come again. Come quickly, Lord Jesus! May your bride be found ready and awaiting Your return!

For Further Prayer and Study

Luke 1:26–80 • 1 Peter 3:15 • Revelation 19:11–16; 22:12–21

CHRISTMAS MORNING

"Today in the town of David a Savior has been born to you; he is the Messiah, the Lord."

LUKE 2:11

RECITE GOD'S GOODNESS

What joy You've brought to the world, Jesus, in visiting us to bring salvation to all who believe! I praise You, Word of God, for becoming flesh and dwelling among us that we may dwell with You forever!

EXPRESS YOUR NEEDINESS

Lord, I confess that I'm quick to forget the wonder of Your birth and find myself seeking elation in the consumerist holiday trappings that surround me. Fill my soul with the joy of Your salvation, and allure my heart with the wonder of Your great love made manifest in Your humble birth.

SEEK HIS STILLNESS

Slowly read through one of the passages suggested below, picturing yourself kneeling in the muddy straw at the manger scene long ago. Worship Jesus in humble adoration at the extravagant display of His love, then be still, basking in His loving presence— then, today, and for all eternity to come.

TRUST HIS FAITHFULNESS

Heavenly Father, what can I say in the face of such love? You did not spare Your own Son; You gave Him up for us all, not just to a smelly manger, but to a scornful cross. Thank You for grace upon grace in Jesus. You are my everything, and I adore You.

For Further Prayer and Study

Isaiah 9:6–7 • Matthew 1:18–24 • Luke 1:26–38; 2:1–15 • John 1:1–18

FIRST THING IN THE MORNING[2]

"This is the day the LORD has made; let's rejoice and be glad in it."

PSALM 118:24 CSB

RECITE GOD'S GOODNESS

Good morning, Lord! Thank you for a new day. Thank You that Your compassion is renewed every morning. Great is Your faithfulness and Your steadfast love, O Lord! I don't know all that is going to happen today or how much I'll get done, but You do. So I give this day to You.

EXPRESS YOUR NEEDINESS

Fill me with Your Holy Spirit, Father. Energize me for Your work, because You know how tired these bones are. Awaken me to the wonder of Your salvation, and quicken my spirit to the reality of Your work in my life. Help me cease striving and trust that You will give me all I need today to do the work You've given me to do.

SEEK HIS STILLNESS

Review the day's tasks point by point with the Lord. Ask Him to make any adjustments to your agenda, and then rest quietly for a few moments in His presence.

TRUST HIS FAITHFULNESS

As I step into my day, I declare Your sovereignty over every area of my life. I entrust myself to You and ask that You use me however You see fit. This day is Yours. My body is Yours. My mind is Yours. Everything I am is Yours. May You be pleased with me today.

For Further Prayer and Study

1 Chronicles 16:11 • Psalm 143:8 • Isaiah 50:4–5 • Lamentations 3:22–23 • Mark 1:35

STARTING YOUR WORK DAY*

"Whatever your hand finds to do, do it with all your might."

ECCLESIASTES 9:10

RECITE GOD'S GOODNESS

My Loving Master, You are the first to have worked, creating this universe and everything around us, even humanity in Your own image. Thank You for the opportunity to partner with You in the work that You are doing in the world. You pour out Your blessings day after day.

EXPRESS YOUR NEEDINESS

Father, help me today to work faithfully in the tasks You've given me to do. Give me a heart to love and serve You and those around me, rather than seeking my own glory. I need Your wisdom, diligence, humility, and focus. Let all that I do be done in love.

SEEK HIS STILLNESS

As you sit quietly with God, consider whether you're naturally bent toward hyper-productivity or laziness. What would it look like today to work with all the energy of Christ working in you?

TRUST HIS FAITHFULNESS

Lord God, as I entrust myself fully to Your work in me, help me patiently accept the result of my efforts today, whether fruitful or frustrating. You are the One who will work all things together for good. I rest in Your finished work, Jesus, and Your sufficient grace for my life.

For Further Prayer and Study

Matthew 25:14–30 • Ephesians 2:4–10 • Colossians 1:29; 3:23–24

MIDDAY GRACE

"From the rising of the sun to the place where it sets,
the name of the LORD is to be praised."

PSALM 113:3

RECITE GOD'S GOODNESS

God of All Grace, how good You are to have sustained me this far into my day!
You are worthy of all my praise!

EXPRESS YOUR NEEDINESS

Show me where I have been prickly or selfish or proud this morning that I may
repent and seek reconciliation. Reveal to me when I've been anxious or fearful
that I may more fully rely on You. Help me walk humbly before You and slow
down to experience Your presence with me, instead of rushing through my day.

SEEK HIS STILLNESS

*Pause to look back on the last few hours: Where have you experienced God's warmth
and kindness leading you to love? As you look ahead: Where will you need to rely on
God's strength and faithfulness to get you through today's challenges? Talk with Him
about your pondering, and commit yourself to the Lord.*

TRUST HIS FAITHFULNESS

Lord, I'm setting my mind on things above, where Christ, who is my life, is
seated at Your right hand. I lean on You in my weaknesses, and may I rejoice at
Your power at work in me today. Great is Your faithfulness, O God!

For Further Prayer and Study

2 Corinthians 12:9 • Ephesians 3:20–21 • Colossians 3:1–4

MEAL TIME

*"Taking the five loaves and the two fish and looking up to heaven,
he gave thanks and broke the loaves."*

MATTHEW 14:19

RECITE GOD'S GOODNESS

I bless You, Father, giver of all good things. You make the grass grow for animals
to eat; You bring food from the earth that nourishes our bodies. You satisfy us
with good things, so we bless You today for this food.

EXPRESS YOUR NEEDINESS

Lord, just as You created us dependent on daily food, so we also depend on
You and Your Word for daily nourishment. We don't live on bread alone but on
every word that comes from Your mouth. Help us hunger and thirst for You as
much as we hunger for our next meal.

SEEK HIS STILLNESS

*Quietly consider God's goodness and generosity in providing you food for each meal
for days and months and years on end. Then sit quietly for a few moments in joyful
adoration and blessing.*

TRUST HIS FAITHFULNESS

Thank You, God, that I don't have to wonder where my next meal will come
from. You provide generously for me and my family day after day. We receive
this food with thankful hearts. May it nourish our bodies and energize us for
the work You've given us today.

For Further Prayer and Study

Deuteronomy 8:3 • Psalm 104:14–15, 27–31 • Matthew 4:4 • 1 Timothy 4:5

BEDTIME PRAYER

"When you lie down, you will not be afraid; when you lie down, your sleep will be sweet."

PROVERBS 3:24

RECITE GOD'S GOODNESS

Lord God, thank You for Your sustaining grace, bringing me to the end of my day. You were faithful and good all day long, and my soul praises You!

EXPRESS YOUR NEEDINESS

Lord, Your love sustains me both when I'm awake and when I'm asleep. Help me fall asleep quickly and deeply, and restore my weary body that I may wake up with joy and renewed strength tomorrow.

SEEK HIS STILLNESS

Look back on the past 24 hours and consider where you felt God's Spirit prompting you, moving you, correcting you, or working through you. What sins must you confess, and what needs have you encountered that you might intercede for? Name them all, and lay them to rest in God's loving hands. Then breathe deeply, in and out, as you allow God's presence to quiet your heart and mind and prepare you for sleep.

TRUST HIS FAITHFULNESS

Lord, as I close my eyes to sleep, grant me rest for my body and also for my mind and soul. I entrust all my cares to You, knowing that You will sustain me. I rest in Your comfort and love tonight.

For Further Prayer and Study

Psalms 3:5; 4:8 • Mark 4:38–39 • Philippians 4:6–7

A PRAYER FOR THE MIDDLE OF THE NIGHT

*"He will not let your foot slip—he who watches over you will not slumber;
indeed, he who watches over Israel will neither slumber nor sleep."*

PSALM 121:3-4

RECITE GOD'S GOODNESS

Almighty God of the Universe, You've watched over me from the day of my
birth, and You're holding me even now. Thank You for Your constant presence
and protection. You have been so so good to me!

EXPRESS YOUR NEEDINESS

Lord, I'd rather be sleeping right now, but instead I'm awake. Help me release
any worries or frustration and find my rest in You alone. If You've woken me
with a purpose, for prayer or vigil or service, help me do so in Your power and
strength. But if not, please let me fall back asleep quickly so that my body and
mind may be refreshed for tomorrow's work.

SEEK HIS STILLNESS

*Take deep breaths, picturing God's loving arms holding you in a tender fatherly
embrace. Picture yourself resting your head on His shoulder, and just be still with Him.*

TRUST HIS FAITHFULNESS

Heavenly Father, You know the cares that have woken me in the middle of the
night. I entrust them back into Your caring hands, knowing that You never
sleep, even when I do. I love You too, Lord. I love You and I trust You with my
whole life.

For Further Prayer and Study

Psalms 23; 46:1-2 • John 14:27 • 1 Peter 5:7

SPRINGTIME AND NEW LIFE

"The desert and the parched land will be glad; the wilderness will rejoice and blossom. Like the crocus, it will burst into bloom; it will rejoice greatly and shout for joy."

ISAIAH 35:1–2

RECITE GOD'S GOODNESS

O Heavenly Father, Your sun rises and Your grace rains down on both the righteousness and the unrighteous. How good You are to thrill us all with tender new signs of life every springtime. My heart rejoices in You!

EXPRESS YOUR NEEDINESS

As You resurrect flowers, trees, and creative possibilities, creator God, breathe hope into my spirit as well. After a spiritual winter that feels like dormancy and death, prune back any area of my life that displeases You so that I may bear more abundant and sweet fruit for You this year.

SEEK HIS STILLNESS

Look out your window and survey the signs of springtime: budding leaves, emerging flowers, the trill of birds. Sit quietly with the Father and ponder: What does He want to prune to bring a spiritual springtime in your life?

TRUST HIS FAITHFULNESS

Gracious Gardener, You remain committed to bringing peace, security, and abundance in Your coming kingdom. As I abide in You this spring, may Your resurrection power work mightily in my life and in Your church, that Jesus may soon return to great shouts of joy.

For Further Prayer and Study

Hosea 6:3 • Psalm 1:3 • Isaiah 43:18–20; 44:1–4 • Matthew 6:28–29 • John 15:1–8

SUMMERTIME AND SWEET LABOR

*"As long as the earth endures, seedtime and harvest, cold and heat,
summer and winter, day and night will never cease."*

GENESIS 8:22

RECITE GOD'S GOODNESS

Creator God, You set the world into motion and gave us seasons that we may
steward creation and care for it, providing for our families by the work of our
hands. Thank You for inviting me to co-labor with Your Spirit at work in the
world.

EXPRESS YOUR NEEDINESS

Lord, sometimes my work feels more like a curse than a blessing, especially in
the summer heat when I just want to rest. Teach me to balance my productivity
with rest, so that I would not forget that my paycheck and my abundance come
from You.

SEEK HIS STILLNESS

*What would it look like to work for God rather than a human supervisor? Sit
with your creator God, and let His presence fill you with His joy, His strength, His
creativity, and His rest.*

TRUST HIS FAITHFULNESS

Lord God, You provide my every need, so I trust You with my employment,
my bank balance, my vacation, or the lack of those things. I trust You to give me
exactly what I need, when I need it, and that You will use this summer for my
good and Your glory.

For Further Prayer and Study

Genesis 1:27–28 • Proverbs 30:8–9 • Jeremiah 17:8 • 1 Corinthians 15:58
Colossians 3:23–24

FALL TIME AND HARVEST

*"The harvest is plentiful but the workers are few.
Ask the Lord of the harvest, therefore, to send out workers into his harvest field."*

MATTHEW 9:37-38

RECITE GOD'S GOODNESS

Creator God, You generously supply an abundant harvest each year that we would have food on our tables and sufficient supplies to see us through the year. Your love endures forever, and I'm reminded just how much I have to be thankful for each fall season.

EXPRESS YOUR NEEDINESS

Lord God, though the leaves may fall and flowers shrivel and the grass wither, Your Word and Your kingdom endure forever. Open my eyes to see the spiritual harvest Jesus was talking about, and make me willing to serve Your kingdom however You see fit.

SEEK HIS STILLNESS

God promises that we will reap a harvest if we do not give up. Where in your life have you grown weary of doing good? Sit with the Lord and listen to what He's calling you to tend and where He is preparing a harvest.

TRUST HIS FAITHFULNESS

Heavenly Father, You've promised that those who sow with tears will reap with songs of joy, carrying sheaves of abundant harvest with them. I trust You for an abundant spiritual harvest in our generation. Bring Your revival among us, and let us live to see Your return!

For Further Prayer and Study

Psalms 126:5-6; 136:25-26 • Isaiah 40:8 • Matthew 6:25-27, 33 • Galatians 6:9
James 5:7-8

WINTERTIME AND REST

"He spreads the snow like wool and scatters the frost like ashes."

PSALM 147:16

RECITE GOD'S GOODNESS

Lord, how creative You are to have invented an infinite number of snowflakes, each unique and beautiful in design, each speaking to the beauty of its Creator!

EXPRESS YOUR NEEDINESS

When the natural world around me rests in the garb of snow and ice, help me also slow down and rest. Just as a season of dormancy is vital to an abundant harvest in the year to come, help me grasp the importance of slowing down, stopping the hustle, and resting in You.

SEEK HIS STILLNESS

Take a few moments to consider the wonder of a world in which atmospheric conditions obey God's every word. What does that say about God? Sit for a few moments with Him, perhaps looking out the window, and rest in His loving presence.

TRUST HIS FAITHFULNESS

Lord, though some days feel like winter will last forever, You are always faithful to breathe the warm spring breezes that melt the ice. Help me savor each season on this earth as a reflection of Your sovereign control of the universe, and rest in the assurance that You will accomplish all You've promised to do.

For Further Prayer and Study

Job 37:6–7 • Psalm 147:16–18 • Proverbs 31:21 • Isaiah 55:10–11

HOUSE
PRAYERS[1]

FRONT PORCH

"You are the light of the world. A town built on a hill cannot be hidden."

MATTHEW 5:14

RECITE GOD'S GOODNESS

Author of All Good Things, You give us homes to dwell in, shelters over our heads, and a safe place to call our own. How good You are!

EXPRESS YOUR NEEDINESS

Lord, may our home be a shining light, a city on a hill in the middle of our neighborhood. Cause us to see opportunities to love our neighbors in many little (and big) ways, that the name of Jesus would become precious to each family living on this street.

SEEK HIS STILLNESS

Consider the ways God is inviting you to embody the love of Jesus in your neighborhood: What relationships is He calling you to invest in? What neighbors need to be invited to walk through your front door?

TRUST HIS FAITHFULNESS

Lord Jesus, just as You let go of the glories of heaven to dwell among us— to pitch Your tent here with us—so I trust that You will make Your presence known in our neighborhood through us. I give You every interaction in our driveway, our front yard, our front porch, and when opening our front door. May I speak, act, live, and love empowered by Your Spirit and for Your glory, in our home, our neighborhood, and beyond.

For Further Prayer and Study

Deuteronomy 28:6 • Luke 10:25–37 • John 1:1–14 • Romans 13:8–10
Hebrews 13:1–3

LIVING ROOM

"By wisdom a house is built, and through understanding it is established; through knowledge its rooms are filled with rare and beautiful treasures."

PROVERBS 24:3-4

RECITE GOD'S GOODNESS

Triune God, You live in perfect harmony within Father, Son, and Holy Spirit, and You've given us the gift of relationships and friendships even within our home. Thank You for each of my family members and for the years You've given us to live together.

EXPRESS YOUR NEEDINESS

Lord, I pray that we would lay aside distractions so we may truly see one another and be seen, and rest in being loved and known exactly as we are. May these walls witness joy, life, and abundance. Lord God, protect my children from sibling rivalries and envy. May they find in each other a lifelong companion and together create wonderful memories of laughter and of a good life lived in a home that is under Your authority and protection.

SEEK HIS STILLNESS

Lie down on the couch and be still with God, listening to His presence delighting over you with singing, and let His love quiet your heart.

TRUST HIS FAITHFULNESS

Lord, I trust Your protection from any enemy scheme that would bring discord and disunity and disquiet into my family. Cause Your presence to rest over this space that we may truly be refreshed in our relationships with one another.

For Further Prayer and Study

Job 8:21 • Psalm 133:1 • John 10:10 • Philemon 7 • 1 John 4:21

KITCHEN

"And if anyone gives even a cup of cold water to one of these little ones who is my disciple, truly I tell you, that person will certainly not lose their reward."

MATTHEW 10:42

RECITE GOD'S GOODNESS

Heavenly Father, You created us and sustain us by the very impulse of Your love. Thank You for generously providing not just daily bread but an abundance of supplies in our fridge and pantry. Thank You for Your generous provision!

EXPRESS YOUR NEEDINESS

Fill my heart with joy and gladness as I chop vegetables, stir stews, bake bread, or wash dishes. May I do all these menial chores with love, serving You in my kitchen. Give me wisdom to prepare healthy meals that will fuel our bodies for all the good works You've prepared for us from eternity.

SEEK HIS STILLNESS

Consider the people you serve here, recognizing God's image in each of them. Let His presence energize you for the ongoing task of feeding your family each day with joy and gladness.

TRUST HIS FAITHFULNESS

Gentle Shepherd, You prepare a table for me in the presence of my enemies, and You knelt low to wash Your disciples' feet. As I do these small daily chores, continue to do a bigger work in my heart, transforming me into a humble servant like You.

For Further Prayer and Study

Psalm 23:5 • Matthew 6:25–34 • Ephesians 2:10 • Colossians 3:23–24

DINING ROOM

"The Son of Man came eating and drinking, and they say, 'Here is a glutton and a drunkard, a friend of tax collectors and sinners.' But wisdom is proved right by her deeds."

MATTHEW 11:19

RECITE GOD'S GOODNESS

Dear Lord Jesus, thank You for modeling radical hospitality by welcoming all kinds of people to share meals with You. You feasted on good food and drink with a grateful heart, and You promise that where two or three are gathered in Your name, You are also with us.

EXPRESS YOUR NEEDINESS

Precious Jesus, as we linger over food and drink at this table, bind us together in love and unity. May our meals be punctuated with uproarious laughter and insightful connections as we fellowship with friends old and new.

SEEK HIS STILLNESS

Think back on memorable meals you've shared with your own family and friends around this table. How is God's Spirit inviting you to widen your circle of hospitality? Who would He have sitting in these chairs next?

TRUST HIS FAITHFULNESS

King Jesus, with every meal around this table, may our hearts be stirred with longing for the great supper of the Lamb. Until then, continue to work the fruit of Your Spirit in our hearts even as we spend time together in this space made sacred by Your presence.

For Further Prayer and Study

Luke 19:1–10 • Galatians 5:22–23 • Colossians 4:6 • Revelation 19:6–9

BEDROOM

"In vain you rise early and stay up late, toiling for food to eat—
for he grants sleep to those he loves."

PSALM 127:2

RECITE GOD'S GOODNESS

O Life-Giving God, thank You for giving us a safe and quiet place to lay down our heads at night and sleep in peace. You're the One who gives sleep to our bodies and rest for our souls, and I praise You for taking such good care of us.

EXPRESS YOUR NEEDINESS

Lord, help me steward my evenings well, putting away distractions that keep me from an early bedtime. Please protect me from sleepless nights, tossing and turning with worries. May our marriage bed be a place of joy, love, and intimacy that we may glimpse the beauty and love of Jesus for His bride.

SEEK HIS STILLNESS

Picture Jesus in the boat in the midst of a raging storm, sleeping soundly and securely, unafraid of the winds and the waves because He rested in His Father's love and care for Him. Meditate on that picture, and be still with Him.

TRUST HIS FAITHFULNESS

You, Jesus, who spoke peace over the winds and the waves, thank You for always keeping watch over us, for You neither slumber nor sleep. So I entrust You with my nights, trusting that You will give me the rest my body needs.

For Further Prayer and Study

Psalm 4:8 • Matthew 8:20 • Mark 4:38–40 • Hebrews 13:4

KIDS' ROOMS

"I have no greater joy than to hear that my children are walking in the truth."

3 JOHN 4

RECITE GOD'S GOODNESS

Heavenly Father, what a privilege to raise up the next generation of servant leaders as we parent our children in this home.

EXPRESS YOUR NEEDINESS

Lord God, give me wisdom and discernment to disciple each of my children in love and grace, redeeming my sincere but flawed efforts. Continue pursuing each of them with Your love until they surrender wholly and completely to You. Grow them in healthy bodies, in wise minds, and in humble service, that they would love You and delight in You with every fiber of their being all the days of their lives and love others well.

SEEK HIS STILLNESS

Rest in the assurance that your beloved children are in God's hands, and He loves them more than you can fathom. Let His peace guard your heart and mind from all the what-ifs so that you can rest in His loving presence.

TRUST HIS FAITHFULNESS

Lord, thank You for entrusting our children to us for this short season. So I entrust them into Your care, and thank You that You will be faithful to complete the good work in them long after they leave our home and that Your Spirit will go with them, and You will continue Your sanctification until we are all with You in paradise.

For Further Prayer and Study

Isaiah 40:11; 46:4 • Matthew 7:11 • Luke 2:52

GUEST ROOM

"Do not forget to show hospitality to strangers, for by so doing some people have shown hospitality to angels without knowing it."

HEBREWS 13:2

RECITE GOD'S GOODNESS

Creator God, how good You are to give Your people enough resources so that no one should ever hunger, thirst, or lack for shelter. You own the world and allow us to steward this small space in it.

EXPRESS YOUR NEEDINESS

Lord, I admit I'm kind of nervous to open my home to strangers, but I want us to be sensitive to Your Spirit's leading and quick to obey. Open our hearts, and guide us to those whom You would have us bless this way. May this space become a place of grace and rest and refreshment for all who stay here.

SEEK HIS STILLNESS

Ponder what it would have been like to host Jesus and His disciples during one of His many trips through Judea. What conversations would you have had with Paul and Timothy around your table? Who might God's Spirit be prompting you to open your home to in the near future, providing a blessing not just to them—but to you as well?

TRUST HIS FAITHFULNESS

Lord, I want to join the ranks of those who opened their homes to prophets, apostles, and even Your own Son. So I entrust myself, my family, and our home to You. Here we are. Your will be done.

For Further Prayer and Study

Genesis 18 • Job 31:21 • Matthew 25:35 • Romans 12:13

BATHROOM

"Cleanse me with hyssop, and I will be clean; wash me, and I will be whiter than snow."

PSALM 51:7

RECITE GOD'S GOODNESS

Gracious God, thank You for the gift of running water and indoor plumbing. So many people don't have these simple basics, so I'm grateful for the privilege of turning on the tap to have access to clean water.

EXPRESS YOUR NEEDINESS

As I spend time in this bathroom, may I never take this space for granted, but may even brushing my teeth cause my heart to turn in worship to You. As I look in the mirror, guard me from comparison or discontentment, as I remember that You've knit me together wonderfully. Help me rest in this body You've given me to embody. As I cleanse and care for my body, so cleanse my soul of any impurities.

SEEK HIS STILLNESS

If you routinely take your phone with you into the bathroom, start a new habit of leaving your phone at the door, and allow your bathroom breaks to be a time of quiet and stillness. Be present with your thoughts and with the Lord who never leaves you.

TRUST HIS FAITHFULNESS

Thank You, Lord, for Your goodness! Thank You for the privilege of modern conveniences. I trust that You will continue to work in my heart joy and gratitude and contentment each day as I prepare for the day ahead.

For Further Prayer and Study

Psalm 139 • Ezekiel 36:25 • 1 Thessalonians 5:8

LAUNDRY ROOM

*"Clothe yourselves with the Lord Jesus Christ, and do not think
about how to gratify the desires of the flesh."*

ROMANS 13:14

RECITE GOD'S GOODNESS

King of Glory, just as You clothe the flowers of the field in all their radiant
splendor, so You graciously provide for all our needs, including clothes to wear,
homes to live in, and strength to keep up with the endless piles of laundry.

EXPRESS YOUR NEEDINESS

Lord God, I want to be humble and quick to serve in the unseen places of my homes.
As I wash clothes, remind me of my own need to be cleansed by Your precious
blood. As I fold and put away clothes, help me clothe myself with You, putting on
Your love, Your grace, and Your compassion toward my family and neighbors.

SEEK HIS STILLNESS

*As you do the laundry, take time to confess any sins that may have accumulated in
your heart, with the assurance that He is faithful and just to forgive and cleanse us
from all unrighteousness. Then as you handle each item of clothing, ask God's Spirit
to lead you in praying for that person.*

TRUST HIS FAITHFULNESS

Thank You, God, for the guarantee that You cleanse me of all my sins, You wash
me by the precious blood of Jesus; You clothe me in the righteousness of Jesus.
You are so, so good to me.

For Further Prayer and Study

Isaiah 1:16–18; 61:10 • Matthew 6:26–30 • John 1:29 • Romans 13:14 • Colossians 3:14–17

BACKYARD

"The LORD will guide you always; he will satisfy your needs in a sun-scorched land and will strengthen your frame. You will be like a well-watered garden, like a spring whose waters never fail."

ISAIAH 58:11

RECITE GOD'S GOODNESS

My Glorious Creator, You are the One who blesses us with all good things, satisfying all our needs abundantly. Thank You for a green space to relax with my family after a long day of work.

EXPRESS YOUR NEEDINESS

Cause my heart to slow down and relish the beauty and the joy of Your goodness in the little things. Help me put away distractions and be present with the people You've placed in my life. Make me like a well-watered garden, fruitfully reproducing all You've planted within me.

SEEK HIS STILLNESS

Step outside and soak in creation's worship of God's glory. Sit with Him, and let the grandeur of His glory humble you in quiet rest.

TRUST HIS FAITHFULNESS

Lord God, just as all of creation groans awaiting Your return to re-create heaven and earth, so I also await You with eager expectation. Until then, I entrust my life, my work, my rest and recreation, my relationships, and my fruitfulness to You. You will be faithful in all these things. And I love You too.

For Further Prayer and Study

Genesis 1:26–2:8 • Nahum 1:3 • Psalms 1; 19:1 • Romans 8:19–23 • Hebrews 4:9–11

TREASURING
GOD'S
WORD

LISTEN TO HIM!

"This is my beloved Son, with whom I am well-pleased. Listen to him!"

MATTHEW 17:5 CSB

RECITE GOD'S GOODNESS

O Son of God, You are worthy of all my praise and adoration, because You are perfect in every way. You are the Word of God in human form, living among humans to reveal the Father to us. Thank You for making clear how the Father loves us through Your love toward us.

EXPRESS YOUR NEEDINESS

Help me listen to You, Jesus. Forgive me for filling my life with so much noise—allowing the chatter of news anchors, talk show hosts, politicians, and even Christian celebrities to fill my days. Show me how to quiet down so I can hear Your voice, like a sheep following her shepherd's call. I want Your Word to be the loudest in my heart.

SEEK HIS STILLNESS

Quiet your heart and thoughts and listen. What is Jesus saying to you right now? What next step of obedience is He calling you to take?

TRUST HIS FAITHFULNESS

Father God, You were pleased to reveal Yourself throughout the ages through prophets and miracles, but in Jesus, Your fullest revelation came to all who believe, made clear by Your indwelling Spirit. Thank You that when I ask to hear You more clearly, You will act because this prayer pleases You. I trust You to make me sensitive to Your voice and quick to listen.

For Further Prayer and Study

Matthew 3:17 • John 1:1–18; 10:27–30 • Galatians 1:16 • James 1:19

PRECIOUS TREASURE

"I have treasured the words from his mouth more than my daily food."

JOB 23:12 csb

RECITE GOD'S GOODNESS

Giver of All Good Things, Your Word is more precious than gold, more delightful than chocolate or croissants. When You speak, the universe listens and immediately obeys. How wonderful are Your revelations in Scripture. How incredible that I'll never exhaust the riches of Your Word!

EXPRESS YOUR NEEDINESS

Even as I pray those words, I realize that some of them ring hollow. I want that to be true of me. I want to cherish Your words and to delight in Your revelation, but how often I'm bored instead. Forgive me! Stir in me a wonder and delight for Your Word!

SEEK HIS STILLNESS

Reflect on your heart attitudes and actions toward God's Word this past month. Ask Him: "Is there an invitation You have for me here? Something You would have me do? Learn? See? Say? Become?" Then sit quietly with Him as He leads your heart.

TRUST HIS FAITHFULNESS

You have been so good to reveal Yourself to humans. How good You are to preserve your Word like an inheritance from generation to generation. I also pray for those brothers and sisters around the world who do not have their own copy of the Bible—would You move to place Your Word in their hands?

For Further Prayer and Study

Psalms 12:6–7; 19:10; 119:72 • Proverbs 8:10 • Matthew 5:18 • John 1:1–3

PONDERING HIS PROMISES

"Mary was treasuring up all these things in her heart and meditating on them."

LUKE 2:19 CSB

RECITE GOD'S GOODNESS

Everlasting Father, You give wonderful gifts to Your children, revealing Yourself to those great and small. In my own life, I can look back and see Your goodness and Your mighty power in so many ways! I praise You!

EXPRESS YOUR NEEDINESS

As I reflect on Mary treasuring Your acts of divine love in her life, I realize how often I forget Your goodness toward me. Forgive me for being quick to move on, for taking Your answers to prayers for granted. Open my eyes to see the wonderful works of Your hand, and help me ponder and meditate on Your faithfulness—in my life, in Your Word, and throughout the generations.

SEEK HIS STILLNESS

Be still with the Lord, and allow Him to bring to mind His acts of faithful love toward you personally and in your family history.

TRUST HIS FAITHFULNESS

You always keep Your promises, Lord, and You were faithful to fulfill Your promise of a Messiah, even through an unsuspecting young girl. What a good God You are! Thank You for how You've worked in and through me, though I don't deserve it. You are faithful and good, and I trust You!

For Further Prayer and Study

Psalm 77:11–13 • John 5:39 • Colossians 1:15 • 2 Timothy 3:16 • Hebrews 1:1–14

LED BY THE LIGHT

"Send your light and your truth; let them lead me."

PSALM 43:3 CSB

RECITE GOD'S GOODNESS

Eternal Light who sees and moves forever, You hear us when we cry out to You. Thank You for being close to the brokenhearted and quick to rescue the lost. You are so good to illuminate my path through Your Word. You are my light and my salvation!

EXPRESS YOUR NEEDINESS

As the psalmist prayed, so I too recognize my desperate need for Your light and truth. In the situations I'm facing right now, I need Your wisdom and guidance. Open my eyes to understand Your Word as I read Scripture, and lead me through Your Spirit.

SEEK HIS STILLNESS

Tell God specifically what challenges you're facing, and then be still, receiving His light and truth. If He brings a Bible verse to mind, look it up, and then continue being still with Him, allowing Him to lead you.

TRUST HIS FAITHFULNESS

You've never withheld Yourself from those who seek You with their whole hearts. You sent Your light in Jesus, the Light of the world, and You will continue to lead me all the days of my life. Thank You for being faithful and kind to show me the way I should go today. I trust You.

For Further Prayer and Study

Psalms 25:5; 27:1; 119:18 • John 8:12; 12:35–36, 46 • 1 John 1:5–7

ALL MY DAYS

"From infancy you have known the sacred Scriptures."

2 TIMOTHY 3:15 csb

RECITE GOD'S GOODNESS

O God who knit me together, You reveal Yourself from generation to generation! How good You are to seek us out from our youth. Thank You for those faithful older women and men who have pointed me to You. All my days have been held in Your hand, and all my steps have been ordained by You. I praise You, Father!

EXPRESS YOUR NEEDINESS

As I consider my own children, my heart longs for them to know You and love You all the days of their lives. Help me be faithful to teach them Your Word and to remain consistent in exposing them to Your truth in a gentle and loving way.

SEEK HIS STILLNESS

Cast your worries for your children upon God and become aware of His great care for you and them. Rest in His loving presence.

TRUST HIS FAITHFULNESS

One generation will declare Your lovingkindness to the next, and I will do my part to tell my children and grandchildren of Your faithful love. But only You can turn their hearts toward You. I trust You to work through my imperfect efforts. I trust You to nurture the seed planted in their early years to bear much fruit through Your Spirit in them.

For Further Prayer and Study

Deuteronomy 4:6–9; 6:1–9 • 1 Samuel 2:18 • Psalms 139:16; 145:4 • Matthew 13:8

BLESSED TO READ AND KEEP

"Blessed is the one who reads aloud the words of this prophecy, and blessed are those who hear the words of this prophecy and keep what is written in it."

REVELATION 1:3 CSB

RECITE GOD'S GOODNESS

O God of Unsearchable Greatness, I praise You for revealing Your glory in Christ Jesus! Thank You for giving us Your Word, and You declare a blessing over us when we read of and cherish Your return. How good You are to us!

EXPRESS YOUR NEEDINESS

To be honest, I'm frequently confused by the difficult passages of the Bible, and I feel like I need a theology degree to understand it all. Sometimes it feels like there's no point in reading certain sections. Would You help me see Jesus on every page of my Bible?

SEEK HIS STILLNESS

Quiet your heart and become aware of God's loving presence surrounding you, filling you with wisdom and understanding.

TRUST HIS FAITHFULNESS

God, thank You that You reward those who diligently seek You, and as I continue to read Your Word, You will open it to me and reveal new wonders of who You are and how You've called me to live. You are faithful to lead me into a deeper knowledge and love of You each time I read Your Word.

For Further Prayer and Study

Psalm 119:18, 129 • Luke 6:46–49; 11:28 • John 5:39; 14:21 • Hebrews 4:12
Revelation 22:7

EAGERNESS TO EXAMINE

"They received the word with eagerness and examined the Scriptures daily to see if these things were so."

ACTS 17:11 CSB

RECITE GOD'S GOODNESS

You are so good, Father, to provide spiritual teachers to explain Your truths and a community of believers to open Your Word and discuss it together. Thank You for the gift of a Bible in my hands and for the privilege of reading and examining it for myself. How generous You are!

EXPRESS YOUR NEEDINESS

I'm sometimes too lazy to read the Bible for myself, relying on others to tell me what it says. Forgive me for disregarding such great a gift! Fill me with an eagerness to study Scripture. Give me a holy curiosity to search Your Word each day. Make me a lifelong student of You.

SEEK HIS STILLNESS

Receive God's forgiveness and sit quietly with Him. How is He leading you?

TRUST HIS FAITHFULNESS

For millennia You promised a rescuer, sending prophets to remind Your people of Your plan, recording Your words so each generation could read and hope. And when Jesus came, He perfectly fulfilled Your promises, clearly revealing Himself to be Your Son. How good and faithful You were to the Jewish people then, and You continue to be for us today, as we await Jesus' return to finish what He started. You're coming soon, Jesus, and I'm waiting for You.

For Further Prayer and Study

Deuteronomy 29:29; 30:20; 32:46–48 • John 5:39; 6:63 • 1 Thessalonians 1:4–6

SPEAK . . . I'M LISTENING

"Speak, for your servant is listening."

1 SAMUEL 3:10 CSB

RECITE GOD'S GOODNESS

Eternal Word, how good You are to make Yourself known to Your people! You are not a distant God, leaving us to wonder about You. Rather, You delight in revealing Yourself to those who love You. Thank You for speaking to me through Your Word and Your Spirit.

EXPRESS YOUR NEEDINESS

Lord, I confess that I'm often too busy to stop and listen to what You're trying to say to me. I rush from one thing to the next, hoping that "someday" I'll have the luxury of slowing down. Forgive me. Help me quiet my soul each day to listen to what Your Spirit is speaking to me.

SEEK HIS STILLNESS

Take a few deep breaths and quiet your soul. Then sit quietly and allow God to speak to you, if He desires.

TRUST HIS FAITHFULNESS

From the beginning of time, You spoke to Your created humans many times and in many different ways, finally giving us Your ultimate Word-become-flesh in Jesus. And now, through Your indwelling Spirit, You are faithful to speak, to lead, and to guide me through Your gentle nudges—in Scripture and in spirit. I trust You to continue speaking, leading, and guiding me today.

For Further Prayer and Study

Psalm 25:14 • Matthew 11:25–26 • Luke 10:21–22 • 1 Corinthians 2:9–13
Hebrews 1:1–4

PERFECT RENEWAL

"The instruction of the LORD is perfect, renewing one's life."

PSALM 19:7 CSB

RECITE GOD'S GOODNESS

O Spirit who refreshes my soul, You are perfect in all Your ways; I praise You for giving me Your perfect Word in my hands. Thank You for reviving and re-energizing me with hope, faith, love, and joy when I open Your Word. You are so good, Lord, to give us everything we need for a life that pleases You!

EXPRESS YOUR NEEDINESS

When I am weary and exhausted, revive me according to Your Word. When I feel like I have nowhere to go, lead me to the chapter and verse that will offer rest for my soul. When I am poor and needy, depleted of my own resources, refill me with Your riches revealed in Scripture.

SEEK HIS STILLNESS

Quietly become aware of God giving you everything you need as you rest in His loving presence.

TRUST HIS FAITHFULNESS

Thank You that in every situation You give me exactly what I need when I come to You. You are faithful to provide specific instruction in Your Word through Your Spirit; no matter what trouble I'm facing, You provide insight and direction and lead me in the path I should go. You have always been faithful, and Your goodness and mercy will accompany me all my days.

For Further Prayer and Study

Deuteronomy 4:6–9 • Psalms 23:3–6; 40:16–17; 119:25–48 • James 1:25 • 2 Peter 1:3–4

ALL DAY LONG

"How I love your instruction! It is my meditation all day long."

PSALM 119:97 CSB

RECITE GOD'S GOODNESS

Gentle Companion and Guide, I praise You because You are always with me, constantly bringing to mind fragments of Scripture that relate to the circumstances I'm facing. How I love You! And how I love Your Word!

EXPRESS YOUR NEEDINESS

Lord, how many times have I ignored Your instruction? Too many to count. Forgive me for my disobedience. Make me quick to listen and quick to obey. Cause my spirit discomfort until I walk in the path of Your commands. Send Your love and Your light to lead me all my days until I finally come face-to-face with You, the Lover of my soul.

SEEK HIS STILLNESS

Pause to ponder today's verse, and allow God's Spirit to continue forming your heart to conform to His as you rest in His loving presence.

TRUST HIS FAITHFULNESS

From morning to evening and every moment in between, You are faithful to guide me through Your Spirit bringing Your Word to mind. Just as the pillar of cloud by day and fire by night, so Your Word is my compass and Your Spirit my constant companion. You are always with me.

For Further Prayer and Study

Deuteronomy 5:31–33 • Psalm 119:32–35 • John 14:25–27; 16:13 • 1 John 2:27

DESIRING THE WORD

*"Like newborn infants, desire the pure milk of the word,
so that by it you may grow up into your salvation."*

1 PETER 2:2 CSB

RECITE GOD'S GOODNESS

O God of my Delight, You don't leave us as You found us, but through Your
Spirit, You transform us into the image of Your Son. Thank You for providing
daily sustenance through Your pure Word. Thank You for how You've been
growing me into a spiritually mature person who images Christ in this world.

EXPRESS YOUR NEEDINESS

Like an infant desperate for her next meal, make me desperate for Your Word.
May not a day go by that I don't nourish myself with Scripture. Stir in me an
appetite for spiritual things, a hunger and a thirst for righteousness that can
only be satisfied in You. May I crave You more than anything else in this world.

SEEK HIS STILLNESS

*Turn your attention to delight in God's presence with you right here, right now,
feeding you through His Word. What would it look like for you to enjoy God as much
as (or even more than) your favorite food?*

TRUST HIS FAITHFULNESS

Lord God, thank You for providing the means for daily spiritual growth. I'm
so grateful that You are transforming and maturing me in Jesus. You Yourself
establish me, strengthen me, and support me through Your Word. May You
receive all glory and honor forever.

For Further Prayer and Study

Deuteronomy 8:3 • Psalm 81:10 • Matthew 5:6 • John 6:33–35 • Hebrews 5:11–14

STORED IN MY HEART

"The instruction of his God is in his heart; his steps do not falter."

PSALM 37:31 CSB

RECITE GOD'S GOODNESS

O Spirit of God, Your Word is my light and a lamp, always showing me the next right step. Thank You for helping me recall Scripture when I need it most. You make my steps secure because You are always with me, so what shall I fear?

EXPRESS YOUR NEEDINESS

When it comes to my failure to memorize Scripture, I blame a faulty memory or lack of time. But honestly, there are times I just don't desire Your Word that much. I need Your help. Cause me to yearn for Your Word. Give me divine insight into how I can work this habit into my daily rhythm, so I can store Your truth in my heart.

SEEK HIS STILLNESS

Reflect on a time when God brought Scripture to mind at the exact moment you needed it. How did He make it happen? Sit quietly with Him, basking in His love for you.

TRUST HIS FAITHFULNESS

Every good thing comes from You, Lord. The desire to memorize Scripture, the discipline to work at it, and the ability to recall it—it all comes from You! I trust You will make me someone who cherishes Your Word in my heart. On my own, I know I'd fail, but when I rely on You, I will never be disappointed.

For Further Prayer and Study

Deuteronomy 6:6 • Psalm 119:11 • Matthew 28:20 • John 5:39

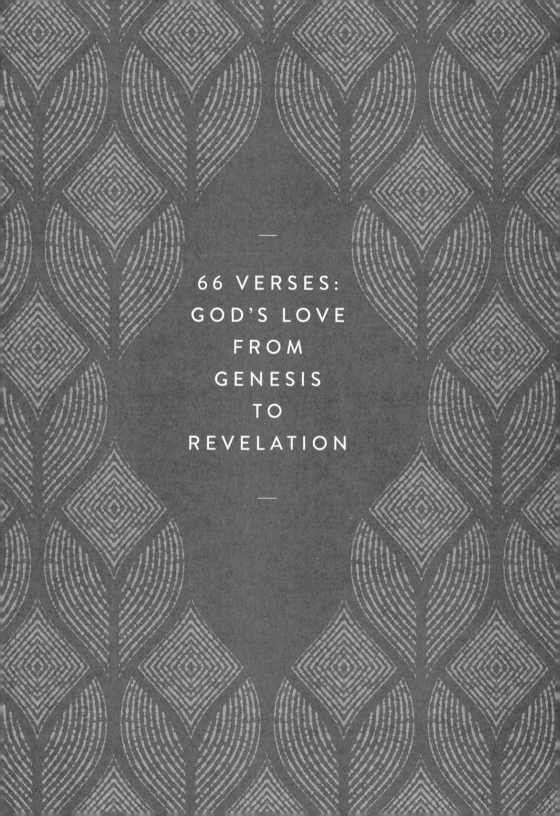

66 VERSES:
GOD'S LOVE
FROM
GENESIS
TO
REVELATION

GENESIS

"God saw all that he had made, and it was very good indeed."

GENESIS 1:31 CSB

RECITE GOD'S GOODNESS

Creator God, You are good, and everything You do is good. Although You are self-sufficient, You made the world and everything in it for Your own sheer pleasure and delight . . . and You created us to be in relationship with You. What a gift You've given us to be Your creation!

EXPRESS YOUR NEEDINESS

When I look at the world around me, and even at my own reflection in the mirror, I often fail to see the good You've made. Give me eyes to see the world as You see it. Give me a heart to believe that You will finish the good work that You've started on this earth and in my life.

SEEK HIS STILLNESS

If possible, get outside and look at nature. Take a few deep breaths as you become aware of God's creative presence and power all around you.

TRUST HIS FAITHFULNESS

Although sin and death have marred Your beautiful creation, Jesus, You came to restore life to this broken world. And someday soon You will make everything new, as through Your Spirit You are making me new. I trust You.

For Further Prayer and Study

Philippians 1:6 • James 1:17 • Revelation 21:5

EXODUS

*"I am the LORD your God, who brought you out of the land of Egypt,
out of the place of slavery."*

EXODUS 20:2 CSB

RECITE GOD'S GOODNESS

God of my Salvation, I praise You because You are powerful! No power or politician can stand against You. When Your people were enslaved in Egypt, You heard their cries, and Your compassion moved You to action. How awesome are Your works!

EXPRESS YOUR NEEDINESS

Just like the Israelites were enslaved, so I also feel enslaved by the sins that master me. Forgive me my willful return to sinful habits; I don't want to be mastered by my impulses or desires. I feel as if I'm a slave to sin, but help me believe that You are powerful to save me from its grip, and You have set me free!

SEEK HIS STILLNESS

Quiet yourself and imagine God breaking the chains of sin that hold you captive, just as He freed the Israelites. What is God trying to say to you through this passage?

TRUST HIS FAITHFULNESS

O God, You were faithful to free Your people and lead them into the Promised Land. In Jesus, You've freed us from the power of sin and death, and through Your Spirit, You are leading us toward our heavenly Promised Land with You. On this long journey of life, I trust You.

For Further Prayer and Study

Exodus 3:7–10 • Psalm 18 • John 8:36 • Romans 6:5–7; 8:2 • Galatians 5:1

LEVITICUS

"You are to be holy to me because I, the LORD, am holy, and I have set you apart from the nations to be mine."

LEVITICUS 20:26 CSB

RECITE GOD'S GOODNESS

You are holy, holy, holy, O Lord God Almighty. The whole earth is filled with Your glory! You've set us apart to be a people of Your very own, to bear Your image in the world. Thank You for calling me to Yourself and including me in Your family.

EXPRESS YOUR NEEDINESS

In light of Your holiness, my own sin is hideous. Forgive me for coddling sinful habits and refusing to turn from them, even once You've revealed them to me. Wash me clean of my sins, and purify me from everything vile and base that keeps me from being completely Yours.

SEEK HIS STILLNESS

Meditate on God's holiness. What thoughts come to mind as you consider His perfection and radiant glory?

TRUST HIS FAITHFULNESS

You sent Your Holy One to bear the punishment for our rebellion against You. Where the law and commands failed in me, You, Jesus, fulfilled the law and offered us Your holiness. Thank You, God, that I no longer have to fear condemnation. I trust You to continue making me holy.

For Further Prayer and Study

Psalm 51:10–12 • Isaiah 64:6 • Matthew 5:19 • Romans 7:12; 8:1–4 • Galatians 3:21–23

NUMBERS

*"The Lord is slow to anger and abounding in faithful love,
forgiving iniquity and rebellion."*

NUMBERS 14:18 CSB

RECITE GOD'S GOODNESS

Compassionate Lord, You are so wonderful! You are patient, putting up with our wandering hearts. You are bountiful in love, faithful to Your promises. And when we turn to You, You are gracious to forgive us and cleanse us from all sin. What an incredible God You are! I praise You!

EXPRESS YOUR NEEDINESS

God, I confess my distorted view of You, unconsciously whittling You into a glorified superhero or an egotistical, capricious, and absent deity. Forgive me for my carelessness. Help me grow in my knowledge and love for You as You have revealed Yourself in Scripture.

SEEK HIS STILLNESS

Kneel before our wonderful God and quietly meditate on His splendor. Be silent before Him, and allow His loving presence to envelop you like a parent's warm embrace.

TRUST HIS FAITHFULNESS

From the garden of Eden to the final chapter of Revelation, You have revealed Yourself to be trustworthy, loving, and true. You never change; from generation to generation You remain faithful. I trust You to continue broadening my understanding and love for You as I seek Your face each day.

For Further Prayer and Study

Exodus 34:4–7 • Psalm 145:8 • 1 John 1:5–10

DEUTERONOMY

"Know that the LORD your God is God, the faithful God who keeps his gracious covenant loyalty for a thousand generations with those who love him and keep his commands."

DEUTERONOMY 7:9 CSB

RECITE GOD'S GOODNESS

Covenant-Keeping God, You remain faithful to Your promises even when we are faithless. Your steadfast love does not depend on our behavior but Your own unchanging character. I praise You for being faithful and true in my own life too, just as You've been throughout history.

EXPRESS YOUR NEEDINESS

Reading this verse, I'm aware that my own love for you is often lacking, and Your commands often seem too taxing. Forgive me for the ways I've failed to love You and keep Your commands. Set my heart on honoring You in all I do and reflecting Your character to those around me.

SEEK HIS STILLNESS

Reflect on how God has shown His gracious faithfulness in your own life. Sit quietly with Him, and allow Him to shape your heart and affections.

TRUST HIS FAITHFULNESS

My greatest desire is that my own children would walk in close relationship with You all the days of their lives. May Your favor be upon my children and grandchildren and the generations to follow them. May they love You and experience Your covenant love. I trust You to do this.

For Further Prayer and Study

1 Kings 8:23 • Nehemiah 1:5 • Psalm 108:4 • Isaiah 49:7

JOSHUA

"Haven't I commanded you: be strong and courageous?
Do not be afraid or discouraged, for the Lord your God is with you wherever you go."

JOSHUA 1:9 CSB

RECITE GOD'S GOODNESS

O God who conquers all, my hope and strength are found in You alone! You commissioned Joshua and the Israelites to conquer the land You'd given them, to face their battles with the assurance that Your presence would give them victory. I praise You for giving me that same presence through Your Spirit in me.

EXPRESS YOUR NEEDINESS

I confess that many days I feel overwhelmed and alone. When I face depression, disease, desperation, loneliness, financial worries, sinful habits, or broken relationships, help me remember that You are with me.

SEEK HIS STILLNESS

Ponder what battles you're fighting in your life right now, and acknowledge God's presence with you in the middle of those hard situations. God never leaves your side.

TRUST HIS FAITHFULNESS

When I feel alone, I will trust in You, God. You allow me to face hardship in my life so that I can learn to depend on You and not my own strength. I choose to believe that when I feel weak, I get to experience Your strength because of Jesus within me. So I trust You with every situation I face today. You are enough.

For Further Prayer and Study

Deuteronomy 31:6 • Joshua 10:8 • Psalm 23:4 • Isaiah 41:10

JUDGES

"In those days, there was no king in Israel; everyone did whatever seemed right to him."

JUDGES 21:25 CSB

RECITE GOD'S GOODNESS

Blessed God, You love us enough to give us the freedom to choose: Will we love and obey You, or will we reject You and go our own way? Yet even when Your people rebelled and turned away, You did not reject or abandon them.

EXPRESS YOUR NEEDINESS

O God, I confess that sometimes I just want to do whatever I want to do. I feel like Your laws and commands are a burden, like they're limiting my freedom and enjoyment. Help me instead to delight in Your commandments and see them as an invitation to experience life with You.

SEEK HIS STILLNESS

Quiet your heart in God's presence and ask Him to show you in what ways you've turned away from Him in the last 24 hours. Confess those specific sins, and receive His forgiveness, as you turn toward His embrace.

TRUST HIS FAITHFULNESS

Even when we are faithless, You remain faithful, for You cannot deny Yourself. Time after time, humans turned from You, yet You continued pursuing a relationship with us. And in Jesus, You've provided an everlasting King who will reign forever. Thank You for your gracious lovingkindness. I trust You, and I surrender completely to You today.

For Further Prayer and Study

Psalm 1:1–6 • 2 Timothy 2:13 • 1 John 5:3

RUTH

"The women said to Naomi, 'Blessed be the LORD, who has not left you
without a family redeemer today. May his name become well known in Israel.'"

RUTH 4:14 CSB

RECITE GOD'S GOODNESS

All-Seeing Lord, You do not despise the cries of a broken heart. You care about
the widow, the childless, the poor, the marginalized, and the despised. You lift
up the downtrodden and fill the hungry with good things.

EXPRESS YOUR NEEDINESS

Help me rejoice with those who rejoice and mourn with those who mourn.
Guard me from trying to solve problems in my own wisdom, and help me trust
that You are faithful in all things.

SEEK HIS STILLNESS

Close your eyes and take a few deep breaths, asking God to bring to mind a friend
you can celebrate with and one you can grieve with. In both good and bad news,
picture God's presence right there with that person in a tangible way through you.
What is God calling you to do?

TRUST HIS FAITHFULNESS

God, not only did you provide an heir for Naomi and Ruth, but through him,
You also provided a royal line through David and eventually King Jesus for all
people. You make beautiful things out of brokenness, and You are faithful to
Your promises even when I don't see what You're doing. I can trust You today.

For Further Prayer and Study

Psalms 107:9; 145:13; 147:6–16 • Romans 12:15 • 1 Corinthians 1:9; 10:13
2 Corinthians 1:18

1 SAMUEL

"But the LORD told them, 'Listen to the people and everything they say to you. They have not rejected you; they have rejected me as their king.'"

1 SAMUEL 8:7 CSB

RECITE GOD'S GOODNESS

What an awesome gift You offered Your people, God, that You Yourself would be their king! You have always desired a relationship with us, and through Your Son and Your Spirit, you continue to seek us and love us.

EXPRESS YOUR NEEDINESS

God, I also grow discontented like the Israelites when I see others' highlight reels. Too often I listen to what the world says I need instead of celebrating all You've given me. Turn my eyes, my ears, and my heart away from celebrities, sports figures, and social media influencers toward You alone.

SEEK HIS STILLNESS

Quietly consider: In what areas of your life are you listening to other voices instead of God's? Imagine His still small voice drowning out the cacophony of competing sounds around you, and just be quiet with Him.

TRUST HIS FAITHFULNESS

In Your faithfulness, You did not reject Israel, even though they rejected You. But You provided King Jesus, who welcomes everyone into the family of God. And You've promised that when Jesus returns, we will be Your people, and You will be our God—a long desire finally fulfilled. I can't wait for that day!

For Further Prayer and Study

Jeremiah 30:22 • Romans 11:1–6 • Revelation 19:16

2 SAMUEL

*"Your house and kingdom will endure before me forever,
and your throne will be established forever."*

2 SAMUEL 7:16 CSB

RECITE GOD'S GOODNESS

O Covenant-Keeping God, what David could have never imagined, You
provided—not because he deserved it, but because it delighted You to
work through him. You are the God who works through the insignificant to
accomplish Your plan in the world.

EXPRESS YOUR NEEDINESS

Like David, I too often have such a small view, focusing on my daily to-do list
and pressing needs, forgetting that You are doing a greater work around the
world and in me. Lift my gaze to You, God, and change my view so I can see the
eternal work You're doing right in the midst of the temporal surrounding me.

SEEK HIS STILLNESS

*Take a few moments to be still with the God who is at work around the world and at
work in your life as well.*

TRUST HIS FAITHFULNESS

Even when David broke Your covenant, You continued to keep Your promises
to him. And in Your faithfulness, You provided a line of royal descendants from
David to rule the land of Israel; and in Jesus, You've provided an eternal King who
will reign forever. You alone are trustworthy. God, I trust You.

For Further Prayer and Study

2 Samuel 7 • Psalm 89 • Luke 1:31–33

1 KINGS

"When all the people saw it, they fell facedown and said,
'The LORD, he is God! The LORD, he is God!'"

1 KINGS 18:39 CSB

RECITE GOD'S GOODNESS

O Lord of Cloud and Fire, You alone are God! And You are so patient to draw our wandering hearts back to Yourself. You are a jealous God, desiring that we worship You alone because You know that nothing else will fill the void in our hearts that is meant for You.

EXPRESS YOUR NEEDINESS

God, You know my heart is prone to wander. How quickly I get distracted by little idols that offer little satisfaction, everything from TV shows to ice cream cartons, shopping sprees to online games. Turn my heart from worthless things to worship You alone.

SEEK HIS STILLNESS

Bring to mind those "little idols" that take your time and attention, and become aware of God's presence. What is He calling you away from that you might find greater satisfaction in Him? Turn from worthless things to find God's love and forgiveness filling you this very moment.

TRUST HIS FAITHFULNESS

Even though we might not see fire coming down from heaven these days, I can look back on my life and see You tenderly and powerfully calling me back to You. You are so faithful. Thank You! I trust You to satisfy my deepest needs.

For Further Prayer and Study

1 Kings 18 • Psalms 119:37; 135:15–18 • James 4:8

2 KINGS

*"For the sake of his servant David, the L*ORD *was unwilling to destroy Judah."*

2 KINGS 8:19 CSB

RECITE GOD'S GOODNESS

O Heavenly Father, like a loving parent with a rebellious son, You showed such patience toward the Israelites. You corrected and rebuked, encouraged and disciplined, bearing with Your people though their sin broke Your heart. How good You are!

EXPRESS YOUR NEEDINESS

Though it's easy to judge the Israelites for their idolatry and disobedience, I confess the same waywardness causes me to grow bored in my prayer life, distracted with my Bible reading, and halfhearted in my obedience. Forgive me, Lord. Grow in me a desire and devotion that can only come from You!

SEEK HIS STILLNESS

Take a few deep breaths and be still before God, becoming aware of His patient love drawing you close to Himself.

TRUST HIS FAITHFULNESS

Lord God, though Your people abandoned You to worship other gods, You remained faithful to Your covenant promise to David. Yet because of their continued failure, You sent Your Son, Jesus, to provide a way to be in relationship with You forever—not through my own faithfulness, but through Yours alone.

For Further Prayer and Study

Deuteronomy 4:31 • 2 Samuel 7 • 1 Kings 8 • Galatians 4:4–7

1 CHRONICLES

*"Yours, LORD, is the greatness and the power and the glory and the splendor
and the majesty, for everything in the heavens and on earth belongs to you.
Yours, LORD is the kingdom, and you are exalted as head over all."*

1 CHRONICLES 29:11 CSB

RECITE GOD'S GOODNESS

Truly, You are the great and awesome One, worthy of all my praise and
adoration. You alone are King of the universe, and all creation bows to worship
You. How good it is to acknowledge Your sovereignty and control, especially in
a world that often feels so out of control.

EXPRESS YOUR NEEDINESS

Help me remember today that You are seated on Your throne, and nothing happens
in the world or in my life that escapes Your notice. Fill my heart with praise. May I
be quick to rest in Your goodness, instead of becoming anxious or fearful.

SEEK HIS STILLNESS

*Read the key verse again, and then quiet your heart before the King of the universe.
Picture Him on His heavenly throne, exalted above every living thing, and bow
your face to the ground in humble worship. Let His greatness fill your heart with
tranquility.*

TRUST HIS FAITHFULNESS

Mighty God, thank You that I don't have to fear what will happen today or
tomorrow or next year. You are not only powerful, but You are also good, and I
can trust Your faithfulness in my life. There's nothing You, my God, cannot do!

For Further Prayer and Study

Nehemiah 9:6 • Matthew 6:13 • Revelation 5:13

2 CHRONICLES

"If ... my people, who bear my name, humble themselves, pray and seek my face, and turn from their evil ways, then I will hear from heaven, forgive their sin, and heal their land."

2 CHRONICLES 7:13–14 csb

RECITE GOD'S GOODNESS

You are the sovereign One, and You do whatever You please. It pleases You to continue pursuing a relationship with humans, even though we're so fickle. Thank You for hearing my prayers, forgiving my sins, and bringing healing in my life.

EXPRESS YOUR NEEDINESS

As I reflect on my own life, I see this cycle repeating itself: times of humbly walking with You and times of pridefully walking away from You. Yet, You never give up. Create in me a heart that will not stray from You, a heart that seeks Your face each moment of my life.

SEEK HIS STILLNESS

Be aware of God's loving presence with you right now. He's listening to you.

TRUST HIS FAITHFULNESS

On my own, I'd continue to stumble and fall, but You've placed Your own Spirit in me to transform me into the person You've created me to be: one who loves You and loves others. You will be faithful to complete the work You've started in me and in all Your people.

For Further Prayer and Study

Psalm 51:10–12 • Micah 6:8 • James 4:6–8

EZRA

"They sang with praise and thanksgiving to the LORD:
'For he is good; his faithful love to Israel endures forever.'"

EZRA 3:11 CSB

RECITE GOD'S GOODNESS

Truly, You are good and faithful, not just to Israel, but to everyone who calls on Your name. When Your people turned to You, repentant in exile, You brought them back into the Promised Land and protected them while they built a temple of worship. Everything good that we accomplish comes from You, and You deserve our praise forever.

EXPRESS YOUR NEEDINESS

Open my eyes to see Your hand at work around me and in me, and make me quick to praise You for everything You're doing. Fill my heart with praise and thanksgiving, and may a song of worship always be on my lips.

SEEK HIS STILLNESS

Continue praising God for how He has worked in your life, joining your voice to countless faithful men and women who have worshiped Him throughout the ages. Then be still, and allow His goodness to quiet your heart.

TRUST HIS FAITHFULNESS

You have done great things, God, and in Israel's history You have revealed Your faithful character time and time again. In my own life, I can recognize events that can only be explained by Your hand at work in my life. Thank You for being the God who is trustworthy and true. I can trust You.

For Further Prayer and Study

Psalm 136 • Joel 2:32 • James 1:17–19

NEHEMIAH

"Please, Lord, let your ear be attentive to the prayer of your servant and to that of your servants who delight to revere your name. Give your servant success today, and grant him compassion in the presence of this man."

NEHEMIAH 1:11 csb

RECITE GOD'S GOODNESS

O God who hears my prayers: You see, You hear, You know. And You care. You care about the big events in our lives and the tiniest details, and You know which little moments will actually define the course of our lives. Nothing is too big or small for You.

EXPRESS YOUR NEEDINESS

Like Nehemiah before the pagan king, I also find myself powerless in certain situations, whether at work or at home. Lord God, look upon me and be gracious to me. Grant me compassion and success in these moments.

SEEK HIS STILLNESS

Tell God about those specific situations that weigh heavy on your heart, no matter how many or few, how big or small they seem. Then silently rest in His presence, allowing His Spirit to assure you that God sees, hears, and knows, and He will provide.

TRUST HIS FAITHFULNESS

God, You are so faithful and kind. You did provide success for Nehemiah, and through his obedience You built up Jerusalem's defenses once again, bringing Your salvation to all people around the world. You are able to do much more than I can ask or imagine, and I trust You.

For Further Prayer and Study

Genesis 16 • Nehemiah 1 • Ephesians 3:20

ESTHER

"If you keep silent at this time, relief and deliverance will come to the Jewish people from another place, but you and your father's family will be destroyed. Who knows, perhaps you have come to your royal position for such a time as this."

ESTHER 4:14 CSB

RECITE GOD'S GOODNESS

O Supreme Moving Cause, You raise kings and queens and depose them, reigning over all. Yet, You are intimately invested in the most unknown person's life as well. I praise You that You formed every part of me, and You have a good plan for my life.

EXPRESS YOUR NEEDINESS

Forgive me for being so absorbed with my own agenda that I forget that You have invited me to partner with You in Your good work around the world. I submit my plans to You. I surrender my life to You. Lead me through Your Spirit.

SEEK HIS STILLNESS

Picture yourself picking up your planner or journal and handing it to the Lord. Allow Him to write your story for His glory, and then rest in the confidence that your life is in good hands with Him.

TRUST HIS FAITHFULNESS

Just as You used Esther to preserve Your exiled people, so You've continued to use surrendered women and men to accomplish Your work. I join myself to Your people throughout history, trusting You to be faithful today as You have always been.

For Further Prayer and Study

Psalms 139:13; 143:10 • Daniel 2:21 • Ephesians 2:8–10

JOB

"I know that my Redeemer lives, and at the end he will stand on the dust."

JOB 19:25 CSB

RECITE GOD'S GOODNESS

Eternal and Immortal God, I praise You for being my Redeemer! You paid the price for my life through Jesus' death and included me in the people You ransomed to be Your very own. Thank You for the goodness and mercy You've shown me in great and small ways.

EXPRESS YOUR NEEDINESS

Forgive me, Lord, for defining myself by my bank account, my social media following, my weight on the scale, or any other made-up marker. I am Yours. You live, and my life is hidden in Christ, kept safe and secure by You. Help me renew my mind with eternal truths instead of temporary trends.

SEEK HIS STILLNESS

Take a few deep breaths, setting your mind on Christ. What thoughts pop up to distract you? Gently observe them, then bring them to the Lord, and refocus your attention on Him. Be still, and allow His presence to quiet your mind with His love.

TRUST HIS FAITHFULNESS

God, You are the living One, and in Jesus You have conquered sin's hold on humanity and death's hold on the world. And one day soon You will return to finish what You've started. In the end, You will stand victorious, so I entrust myself to Your loving care today.

For Further Prayer and Study

Job 19 • Mark 10:45 • John 16:33 • Romans 12:1–2 • Colossians 3:2–4 • Titus 2:11–14

PSALMS

*"The LORD is gracious and righteous; our God is compassionate.
The LORD guards the inexperienced; I was helpless, and he saved me."*

PSALM 116:5–6 CSB

RECITE GOD'S GOODNESS

O Gracious and Righteous God, You are compassionate to Your people, treating us not as our sins deserve but according to Your lovingkindness shown to us in Jesus. Thank You for guarding us against all evil and preserving us for Yourself.

EXPRESS YOUR NEEDINESS

Forgive me, Lord, for forgetting all the ways You've shown Your goodness and mercy toward me all the days of my life. Soften my heart to respond to Your movements in my life with praise and adoration. Help me be quick to recognize Your compassion, protection, and provision in the mundane moments of my life.

SEEK HIS STILLNESS

Read the key verse several times, meditating on one word at a time. What does God want to say to you? Rest quietly in the presence of the God who cares for you so personally.

TRUST HIS FAITHFULNESS

When I was lost in my sin, I didn't know I needed You. But in Your compassionate love, You rescued me, just as You've rescued Your people throughout history. From the garden of Eden until now, You continue to be faithful, gracious, compassionate, and kind. I rest in You with my whole heart.

For Further Prayer and Study

1 Samuel 2:9 • Psalms 78:38–39; 91:11 • Colossians 3:1–4

PROVERBS

*"The fear of the Lord is the beginning of knowledge;
fools despise wisdom and discipline."*

PROVERBS 1:7 CSB

RECITE GOD'S GOODNESS

Sovereign Creator and Sustainer, You deserve all my honor, reverence, and awe.
I praise You for freely giving wisdom to all who humbly ask of You, and I thank
You for disciplining those You love. It has never felt good in the moment, but
I know You mean it for good.

EXPRESS YOUR NEEDINESS

Forgive me, Lord, for the times I've treated You cavalierly, as if we were peers.
Forgive me for not giving You the proper reverence You deserve. Strip me of
all pride. Help me honor You as the One who is high and lifted up, that I may
humble myself before You.

SEEK HIS STILLNESS

*As you enter into God's presence, consider the posture of your heart. Take a few
moments to contemplate God's holiness and splendor, and if possible, fall to your face
in humble and quiet adoration.*

TRUST HIS FAITHFULNESS

Thank You! Because of Jesus, we do not have to fear You, nor be terrorized by
Your holiness; rather, we can approach Your throne of grace with confidence.
When I acknowledge my dependence on You, You are faithful to fill me with
wisdom, knowledge, and practical skills to live in Your world.

For Further Prayer and Study

Proverbs 16:6; 19:23 • Isaiah 50:10 • Romans 8:28–30

ECCLESIASTES

*"When all has been heard, the conclusion of the matter is this:
fear God and keep his commands, because this is for all humanity."*

ECCLESIASTES 12:13 csb

RECITE GOD'S GOODNESS

Lord God, You are the One who holds all wisdom and knowledge and power in
Your hands, and You've invited us to live in ways that image You in the world. Thank
You for providing us with everything we need to live in this world: not just Your
laws and commands, but Your very Spirit living in us, leading and directing us.

EXPRESS YOUR NEEDINESS

Forgive me for living life as if I'm the one who is in control. Help me see my life
as under Your dominion; show me how to revere and honor You, and how to
take the next right step in each situation. Where life feels complicated, quiet the
noise so I may hear Your voice.

SEEK HIS STILLNESS

*Sit with the One who holds your life, and ask Him: "What would You like me to pay
attention to in these moments?" Listen carefully as He directs your thoughts, and
follow Him in prayerful conversation.*

TRUST HIS FAITHFULNESS

From the beginning of time, You have created humans to be in relationship with
You and to rule the world with You. What a privilege! When humans corrupted
their power, You sent Jesus into the world as the perfect human to reconcile us
with You for all eternity. You are trustworthy, God! I praise You today.

For Further Prayer and Study

Deuteronomy 10:12 • Ecclesiastes 3:14; 12:1–14 • Micah 6:8

SONGS OF SONGS

"A huge torrent cannot extinguish love; rivers cannot sweep it away."

SONG OF SONGS 8:7 CSB

RECITE GOD'S GOODNESS

Creator of Love and Lover of our souls, I praise You for revealing the extent of Your love to us in Christ Jesus, who laid down His own life for us while we were yet sinners. What great love! It's too marvelous for me to comprehend!

EXPRESS YOUR NEEDINESS

It's easy to become so familiar with the phrase "Jesus loves me." Forgive me for growing bored with Your phenomenal love. Open the eyes of my heart that I may begin to grasp the enormity of Your love for me in Christ Jesus. And fill me up with Your love that it would overflow to those around me.

SEEK HIS STILLNESS

Be still. Just be in God's loving presence, and let Him quiet you with His love.

TRUST HIS FAITHFULNESS

I was not worthy of Your love—am not still—yet Jesus' display of love gives me value and worth. And it's not because we loved You, but because You loved us and made us Your own. What grace! What a privilege! You've loved me at my worst, and You continue loving me, so that hell would have no power over me and I may love others with Your same love. I will trust in Your love.

For Further Prayer and Study

John 15:13 • Romans 5:8 • 1 Corinthians 13 • 1 John 4:9–10

ISAIAH

"Do not fear, for I have redeemed you; I have called you by your name; you are mine."

ISAIAH 43:1 CSB

RECITE GOD'S GOODNESS

All-Searching God, You see and know each one of us by name, and You brought salvation to the world through Your chosen people, the Israelites. Thank You for Your faithful love throughout generations, and I praise You that nothing stood in the way of Your redemptive work through the Messiah Jesus.

EXPRESS YOUR NEEDINESS

It's easy to read a verse like this and focus on myself, but help me remember that all of Scripture points to You, Lord. You are the Redeemer. You are the One who calls. You are the Creator and owner of all creation. You are the Father. You are love. Create in me a humble heart that is quick to worship and exalt You alone.

SEEK HIS STILLNESS

Take a few moments to wonder at God's incredible love to include you in His family. What does that say about God? Sit with Him in quiet contemplation.

TRUST HIS FAITHFULNESS

Because of Your great love, I have nothing to fear. Because You have chosen me, I belong to You. Because of Your rescue in Jesus, I am Yours. And You are mine. Not because I deserve it, but because You are faithful. So, I bring to You those big concerns in my heart that suddenly seem much smaller now: I trust You.

For Further Prayer and Study

Psalm 139:13–16 • Jeremiah 1:5 • Romans 8:29; 9:25

JEREMIAH

*"'This is the covenant I will make with the house of Israel after those days'—
the LORD's declaration. 'I will put my teaching within them and write it on their hearts.
I will be their God, and they will be my people.'"*

JEREMIAH 31:33 CSB

RECITE GOD'S GOODNESS

You, Lord, keep Your promises to Your people, despite our wandering hearts.
In Your goodness, You provided an eternal covenant that is written on hearts,
not on tablets of stone, and You've written Your covenant on my heart as well.
I praise You for being our God; we are Your people forever.

EXPRESS YOUR NEEDINESS

How kind of You, LORD God, to continue pursuing Your people after they've
turned against You time after time. Forgive me too for wandering from You
even though You've always been faithful. Cause my heart to follow You all the
days of my life.

SEEK HIS STILLNESS

*Quietly reflect on God's faithful love toward you in specific ways. Then sit with Him
in silence, allowing His loving presence to envelop you.*

TRUST HIS FAITHFULNESS

You are the covenantal God who keeps His promises, from Noah to Abraham
to the Israelites at Sinai to David and now to us. Jesus, You opened Your family
to all who call on Your name. I can't wait for the day when You return to once
again be our God here on earth as in heaven.

For Further Prayer and Study

Genesis 28:15 • Ezekiel 36:26 • Romans 2:14–16 • Hebrews 8:10

LAMENTATIONS

"Because of the LORD's faithful love we do not perish, for his mercies never end.
They are new every morning; great is your faithfulness!"

LAMENTATIONS 3:22-23 CSB

RECITE GOD'S GOODNESS

O Merciful God, how great is Your love! Your mercy is renewed every morning, even this day as I arose out of bed. I praise You that Your lovingkindness is inexhaustible, renewed day by day like a mountain spring of fresh water. I'm so grateful that Your mercies never end. You are worthy of all my worship, O King of my heart!

EXPRESS YOUR NEEDINESS

Apart from Your grace, we all deserve eternal separation from You because of our sin. Remind my heart how great is Your love and patience, Lord. Guard me from using Your grace as an excuse to sin; rather, let Your grace lead me to repentance and greater dependence on You.

SEEK HIS STILLNESS

Read over the verses a few times, allowing each word to impress itself on your heart. Then sit quietly with the Lord, and allow His presence to fill you with hope and joy.

TRUST HIS FAITHFULNESS

Your greatest display of love is revealed at the cross. For He who knew no sin became sin so that in Him we might become Your righteousness. How great is Your love! How great is your faithfulness. You are good. You are loving. You are kind. And I trust You with my whole heart.

For Further Prayer and Study

Psalm 78:38 • Isaiah 33:2 • Hebrews 10:23

EZEKIEL

"I will give you a new heart and put a new spirit within you;
I will remove your heart of stone and give you a heart of flesh."

EZEKIEL 36:26 CSB

RECITE GOD'S GOODNESS

Compassionate Lord, You have loved us with an everlasting love, giving us
a new heart and a new spirit that come from You. Thank You for giving us
everything we need for life and godliness. I praise You!

EXPRESS YOUR NEEDINESS

I confess that even though You've given me a new heart, my old nature still
wants to go the old way. Forgive me, Lord. Soften my heart that I may be tender
and responsive to You. Make me sensitive to Your Spirit's leading, always quick
to listen and obey.

SEEK HIS STILLNESS

Quiet yourself and feel the rhythmic beating of your heart. With every beat, become
aware of the Holy Spirit in You, in your spiritual "heart," and be still in His presence.

TRUST HIS FAITHFULNESS

From the garden to the wilderness, one generation after another hardened their
hearts toward You. And I'm no better. On my own, I'd be hopelessly lost, but
because of Your great love, I have hope that I can indeed learn to live in a way
that truly honors You. I give myself to You today, Lord. Have Your way in me.

For Further Prayer and Study

Psalm 51:10 • Ezekiel 11:19 • John 14:15–17 • 2 Corinthians 5:17 • 2 Peter 2:3–4

DANIEL

*"For his dominion is an everlasting dominion,
and his kingdom is from generation to generation."*

DANIEL 4:34 CSB

RECITE GOD'S GOODNESS

O Sovereign King of the Universe, nothing escapes Your notice. You humble the proud, but give grace to the humble. Though the nations rage, You reign from Your throne forever. Whom shall I fear?

EXPRESS YOUR NEEDINESS

I have made You too small and believed the enemy's lies that You are unable to help, uninterested in details, unavailable to listen. Yet You are near to the brokenhearted, and You hear those who cry out to You. I believe! Help my unbelief.

SEEK HIS STILLNESS

Bring to mind recent headlines, the ones that cause anxiety and sleepless nights. Feel God's loving presence, not just surrounding you, but filling you, obliterating the darkness with His light. Be still with Him.

TRUST HIS FAITHFULNESS

O God, You created this world, and You continue to rule it. You have never left Your people, and You will not abandon us now. From the first page of Genesis to the last page of Revelation, You are faithful. So no matter what happens today, I trust You, and I will rest in Your sovereignty.

For Further Prayer and Study

Psalms 102:24–27; 145:13 • Jeremiah 10:10 • Daniel 4 • Luke 1:32–33; 18:14

HOSEA

*"For I desire faithful love and not sacrifice,
the knowledge of God rather than burnt offerings."*

HOSEA 6:6 CSB

RECITE GOD'S GOODNESS

Divine Love, You created us to be in relationship with You, to know You and love You and be loved by You. What a gift! What a simple command. What freedom from the long list of things I impose on myself for self-improvement and self-betterment. Thank You for Your everlasting love and for choosing me to be Your loved one.

EXPRESS YOUR NEEDINESS

Even though this is simple, I find it's not easy. To my dismay, I find myself loving other things more than You, seeking my fulfillment and satisfaction in lesser things, so that I have no appetite or desire for You. Forgive me, Lord. I offer myself as a living sacrifice, set apart to be Yours alone. I want to want You more.

SEEK HIS STILLNESS

Become aware of God's presence around you and within you, filling you with His love. Sit quietly with Him, content to just be with Him.

TRUST HIS FAITHFULNESS

You desire faithful love because You are faithful love. When I despair of loving You as I ought, remind me that You are still working in me, and You will be faithful to complete the good work You have started. I trust You to transform me into the loving person You've created me to be.

For Further Prayer and Study

1 Samuel 15:22 • Isaiah 1:10–17 • Matthew 9:13; 12:7

JOEL

*"Tear your hearts, not just your clothes, and return to the LORD your God.
For he is gracious and compassionate, slow to anger, abounding in faithful love,
and he relents from sending disaster."*

JOEL 2:13 csb

RECITE GOD'S GOODNESS

Gracious God, merciful and compassionate, You long for us to return to You, and You always receive those who come in brokenness and desperate need. What love! What compassion! Thank You for welcoming me this way.

EXPRESS YOUR NEEDINESS

So here I am, confessing that I need You. Pierce my heart over the sins that I continue to commit, the ways that I fail to love You and love others. Break my heart for what breaks Yours. Wash me and make me white as snow. Show mercy and compassion to me, and change me.

SEEK HIS STILLNESS

Reread today's verse, slowly pondering each word. Then sit with the Lord in silence. Is there anything He wants to say to you?

TRUST HIS FAITHFULNESS

Though You'd have every reason to destroy humanity, Your steadfast love calls us to repentance. You've never turned anyone away, and You won't start now. Thank You that I can always approach Your throne of grace with confidence, assured that I will find forgiveness and mercy. You are faithful, and I love You.

For Further Prayer and Study

Exodus 34:6 • Job 1:20 • Isaiah 57:15 • Hebrews 4:16

AMOS

"But let justice flow like water, and righteousness, like an unfailing stream."

AMOS 5:24 CSB

RECITE GOD'S GOODNESS

O Just and Gracious God, You hear the cries of the oppressed and bend low to lift them up. You stand against the proud who trust in themselves and rescue the vulnerable and marginalized. I praise You that You see, You hear, and You act.

EXPRESS YOUR NEEDINESS

O God, I've focused on my own wish list at the expense of those suffering around me. I've selfishly let others fend for themselves when I could extend my hand and alleviate their pain. Forgive me. Help me see what You're calling me to do and obey Your call with courage and grace.

SEEK HIS STILLNESS

Jesus said that out of the hearts of those who believe in Him will come streams of living water. Picture that stream flowing into your home and your neighborhood, joining other streams to form a river of justice that floods your community with God's righteousness. What changes would such a river bring? Be still, and let God work in your heart what He wants to change in and through you.

TRUST HIS FAITHFULNESS

O Living Water, You will return as King, bringing justice that shines like the noonday sun. Until that day, show me how You want me to become Your agent of restoration in this broken world. And let Your righteousness begin with me.

For Further Prayer and Study

Psalms 33:4; 37:6 • Isaiah 45:8, 61:8 • Jeremiah 22:3 • John 7:37–39

OBADIAH

"The kingdom will be the LORD's."

OBADIAH 21 csb

RECITE GOD'S GOODNESS

King of the Universe, You will soon return to the earth to set all things right. You will finish the battle against sin and darkness, and You will reign forever and ever. I praise You, Lord, for the battle is already decided and the victory is Yours!

EXPRESS YOUR NEEDINESS

Over and over again in the Bible this theme of Your kingship and rulership appears, reminding us to fix our eyes not on what is seen but on what is unseen. Your kingdom, though not visible, is real, and Your victory, though not completed right now, is certain. Give me eyes to see the world as You would have me see. Fill my heart with faith to believe the unseen.

SEEK HIS STILLNESS

Take a few moments to quiet your heart before our King as you sit with the question: "King Jesus, what do You have for me to do today? How may I participate with You in Your kingdom work?"

TRUST HIS FAITHFULNESS

Through every personal storm, national crisis, and international scramble, You still reign supreme. From the moment You put this world into motion to the moment You finally set it right, You have been watching and waiting and working. Help me trust You completely, for You are ever faithful and true.

For Further Prayer and Study

Psalms 22:28; 47:9 • Zechariah 14:9 • Luke 17:21 • Revelation 11:15

JONAH

*"I knew that you are a gracious and compassionate God, slow to anger,
abounding in faithful love, and one who relents from sending disaster."*

JONAH 4:2 CSB

RECITE GOD'S GOODNESS

Lord of the Land and the Sea, You are indeed gracious—showing mercy to
those who deserve none; and compassionate—showing concern for those who
are but dust. Thank You for being quick to forgive and slow to become angry,
Your faithful love overflowing to all who find refuge in You.

EXPRESS YOUR NEEDINESS

Like Jonah, I'm quick to judge whether others deserve Your mercy, forgetting
that I don't deserve it either. I seek Your justice toward those who've offended
me, but I plead Your grace on myself. Forgive me. Help me humble myself and
not think of myself more highly than I ought.

SEEK HIS STILLNESS

*Quiet yourself before the Lord and ponder: Who have you deemed unworthy of
God's mercy? Allow His Spirit to lead you into repentance, and receive His full
pardon and forgiveness.*

TRUST HIS FAITHFULNESS

God of all grace, I entrust to You this person/people who seem so far removed
from You, and I ask that You would lead them to repentance. Soften their hearts
to seek Your mercy, and soften my heart to intercede for them. May they taste
and see that You are good, and may I live to see the day of their salvation.

For Further Prayer and Study

Deuteronomy 4:31 • Numbers 14:18 • Psalms 86; 103:8 • Philippians 2:1–11

MICAH

"Mankind, he has told each of you what is good and what it is the LORD requires of you: to act justly, to love faithfulness, and to walk humbly with your God."

MICAH 6:8 CSB

RECITE GOD'S GOODNESS

O Eternal God, You are just, loving, faithful, and good, so when You ask the same of us, You're inviting us to bear Your image in the world. Thank You for the privilege of reflecting Your own character to a dying and desperate world.

EXPRESS YOUR NEEDINESS

Honestly, I totally fail in living out this verse: I act unjustly toward fellow humans, I'm unfaithful in my relationships, and I'm prideful and arrogant, seeking my own good instead of others'. Forgive me, Lord. Renew a steadfast spirit within me. Grow me in Christlikeness.

SEEK HIS STILLNESS

Invite God's Spirit to change your heart, and then sit quietly with Him, becoming aware of His loving presence indwelling you this very moment.

TRUST HIS FAITHFULNESS

Though this simple command has proven so difficult for me and every other human, You, Jesus, were exactly this kind of person. You lived a perfect life yet died a sinner's death so that we might gain Your righteousness. And through Your Spirit in us, You are making us into people who live and act and speak like You. Do Your work in me, Lord. Here I am.

For Further Prayer and Study

Deuteronomy 10:12–13 • Psalm 51:1–10 • Isaiah 1:17; 57:15 • Galatians 5:22–23

NAHUM

"The LORD is good, a stronghold in a day of distress;
he cares for those who take refuge in him."

NAHUM 1:7 CSB

RECITE GOD'S GOODNESS

Sovereign Stronghold, You are good and You do only good. Thank You for being a safe place I can run to in my sorrow. Thank You for showing kindness toward all those the world has forgotten. No one is unknown to You.

EXPRESS YOUR NEEDINESS

God, in those moments when I am overcome with sadness and distress, when I feel my world crashing down around me, or I'm simply numb toward my surroundings, You are the God who shields and protects me. I need You. Only You. And You are enough.

SEEK HIS STILLNESS

Whether you're having a good day or a bad day, run to God as your shelter now. Feel your racing heart slow down as you catch your breath in the shadow of His wings. Let Him quiet you with His love and surround you with His presence.

TRUST HIS FAITHFULNESS

O God of all ages, You have been a shelter for Your people from the beginning. When Jacob ran away from his brother Esau, when the Israelites fled the Egyptians, when David hid from Saul . . . You were faithful. And in Christ Jesus, Your bountiful love still extends to all people who run to You. You are good and faithful and kind. I rest in You.

For Further Prayer and Study

Psalms 1:6; 27:1; 61:1–3 • Jeremiah 33:11 • Acts 17:27

HABAKKUK

"Yet I will celebrate in the LORD; I will rejoice in the God of my salvation!
The LORD my Lord is my strength; he makes my feet like those of a deer
and enables me to walk on mountain heights."

HABAKKUK 3:18-19 CSB

RECITE GOD'S GOODNESS

God my Savior, You hear me when I call, strengthening me in dangerous places.
You are worthy of my praise and adoration because You have shown Your
goodness in my own life. I rejoice in You!

EXPRESS YOUR NEEDINESS

When I feel shaky in my family relationships, my job situation, my finances, or
my personal sanctification, help me trust in You alone. When my world feels dark
and I feel lonely, fill my heart with hope that I will yet praise You. And when You
prove faithful once again, make my heart quick to acknowledge Your deliverance.

SEEK HIS STILLNESS

Take a few moments to become aware of God's loving presence surrounding you,
and reflect on a past situation when God was with you in a precarious place.

TRUST HIS FAITHFULNESS

When the Israelites felt alone and abandoned because of their sinful idolatry,
You were still with them, precious Lord. You never left them, because You
always keep Your promises. And You've never left my side, because You are
always faithful. Whatever worries I'm facing today, God, I choose to trust You
with my whole heart. You are my God.

For Further Prayer and Study

Exodus 15:2 • Isaiah 61:10 • Philippians 4:4

ZEPHANIAH

"The LORD your God is among you, a warrior who saves. He will rejoice over you with gladness. He will be quiet in his love. He will delight in you with singing."

ZEPHANIAH 3:17 CSB

RECITE GOD'S GOODNESS

O God of the Highest Heavens, this verse seems too good to be true! You, mighty and majestic, long to be with Your people. You, reigning in power on Your throne, also rejoice in Your own. How great is Your love, O God! How good You are!

EXPRESS YOUR NEEDINESS

I get so caught up in my busy schedule that I forget about Your presence. Forgive me for being so rushed that I rarely quiet my heart to be with You. I need You today. Would You help me slow down now? Would You help me find moments in my day to rest in You and just be with You?

SEEK HIS STILLNESS

Sit with the Heavenly Warrior who delights over you, and ask Him: "Where has my time with You grown stale? What's one way You'd like to refresh our time together next?" Listen to His voice, and be quick to do as He leads.

TRUST HIS FAITHFULNESS

What reassurance that You are the faithful One of Israel: as you were yesterday, so you are today and You will be forever. Thank You for loving me as You've loved Abraham, David, and Your own disciples. Nothing can separate me from Your love in Christ Jesus, so I rest fully in You today.

For Further Prayer and Study

Job 33:26 • Psalms 18:19; 149:4 • Joel 2:21 • John 15:9–17 • Romans 8:31–39

HAGGAI

*"'The final glory of this house will be greater than the first,' says the LORD of Armies.
'I will provide peace in this place'—this is the declaration of the LORD of Armies."*

HAGGAI 2:9 CSB

RECITE GOD'S GOODNESS

Glorious and Exalted God, how kind of You to speak to Your rebellious people through Your prophets. And so You speak to me through Your Spirit and Your Word, calling me to repentance, reminding me of Your love, reassuring me of Your presence. Thank You!

EXPRESS YOUR NEEDINESS

Just as the Jews needed to rebuild the temple and worship You in purity, so I need to repent and obey. I confess my sins to You now. [Take a moment to name them.] Purify me through the blood of Jesus. Fill me with Your presence; I dedicate my body as a temple of Your Spirit.

SEEK HIS STILLNESS

Become aware of God's loving presence surrounding you and filling you now with "peace in this place," just as His glory filled the temple in the days of Solomon.

TRUST HIS FAITHFULNESS

When You return, Jesus, You will stand in the temple as the Prince of Peace, and all nations will see Your glory. I can't wait to see this promise fulfilled on Your holy mountain! Until then, help me trust and obey You today in all I do.

For Further Prayer and Study

1 Kings 8:10–11 • Psalm 85:9 • Isaiah 9:6; 66:18 • Romans 12:1–3 • 1 Corinthians 3:16

ZECHARIAH

*"I will refine them as silver is refined and test them as gold is tested.
They will call on my name, and I will answer them.
I will say, 'They are my people,' and they will say, 'The LORD is our God.'"*

ZECHARIAH 13:9 CSB

RECITE GOD'S GOODNESS

Faithful Lord, You never abandon Your people. Though Israel's rejection opened up our inclusion into Your family, You will cause their hearts to eventually turn back to You in the end. Thank You for including me in Your family, and I praise You for being a God who never gives up.

EXPRESS YOUR NEEDINESS

I confess it's tempting to read a verse like this and try to apply it immediately to my life. Teach me instead to read Scripture as pointing to You. Train me to look for Your character and Your attributes on every page.

SEEK HIS STILLNESS

Take a few moments to reflect on what God is revealing to you about Himself through this passage, and be quiet as you become aware of His very presence with you this very moment.

TRUST HIS FAITHFULNESS

Heavenly Father, just as You are faithful to Your promise to Abraham, Isaac, and Jacob, so You are faithful to Your covenant promise to us in Christ Jesus. Never once have You turned away from those who belong to You, and You're not going to start now. So I trust You today.

For Further Prayer and Study

Genesis 28:15 • Leviticus 26:12 • Psalms 86:7; 94:14 • Jeremiah 29:12

MALACHI

*"But for you who fear my name, the sun of righteousness
will rise with healing in its wings."*

MALACHI 4:2 csb

RECITE GOD'S GOODNESS

O Sweet Jesus, You bore our sins, our wounds, and our diseases in Your body on the cross that we may be healed in You. Thank You for sympathizing with our weaknesses. Thank You for defeating sin and death through Your resurrection!

EXPRESS YOUR NEEDINESS

You know every ache and pain I face each day, and You give me the strength to carry on. Give me that strength today. Bring healing to my body where there is brokenness, and give me faith to believe that You will restore me to full health in Your timing—if not on this side of eternity, then when You return to set all things right.

SEEK HIS STILLNESS

Take a few moments to call to mind the many times Jesus healed those who were brought to Him. Picture yourself coming to Him now, and just be still before Him.

TRUST HIS FAITHFULNESS

Even though all creation groans while sin and death still ravish this world, I praise You that You will soon bring an end to devastation, and You will bring healing to those who trust in You. You will wipe every tear from our eyes and there will be no more sickness or death. Wow, Lord! I can't wait for that day. I trust You now.

For Further Prayer and Study

Psalm 121 • Hebrews 4:15–16 • Revelation 21:4

MATTHEW

*"From then on, Jesus began to preach,
'Repent, because the kingdom of heaven has come near.'"*

MATTHEW 4:17 CSB

RECITE GOD'S GOODNESS

Precious Jesus, You didn't come preaching fire and brimstone, but repentance, hope, and restoration. I praise You for bringing Your kingdom here on earth and inviting me to be a part of it. Thank You, thank You!

EXPRESS YOUR NEEDINESS

Make me quick to hear Jesus' words and obey. Help me continue to turn from any hint of sin or compromise in my life. I want Your kingdom of light to shine brightly in my life. Give me courage as Your ambassador to call out to my own friends, family, and neighbors, inviting them to be reconciled to You.

SEEK HIS STILLNESS

Take a few moments to picture God's kingdom of light penetrating the darkness, all over the world, and in your home . . . your neighborhood . . . your workplace. Be still before God, and let His light fill you.

TRUST HIS FAITHFULNESS

O God, after hundreds of years of silence, Jesus' voice rings loud and clear: "Turn back. God's kingdom is near." When the people didn't listen to the prophets, You sent Your own Son! Thank You, God! You are not slow in keeping Your promises, but You want everyone to repent. Help me trust Your timing. You are always faithful.

For Further Prayer and Study

Luke 5:32 • Romans 2:4 • 2 Peter 3:9 • 1 John 1:9

MARK

*"For even the Son of Man did not come to be served, but to serve,
and to give his life as a ransom for many."*

MARK 10:45 CSB

RECITE GOD'S GOODNESS

Humble Jesus, how breathtaking is Your love! You let go of heaven's glories and angels' ministrations to become like one of Your created beings. And You came not to sit in a palace but to serve the lowest among us. What grace! What mercy! What love! Thank You.

EXPRESS YOUR NEEDINESS

As I reflect on Your humility, my own pride seems grossly out of place. Forgive me for thinking myself better than my coworkers, my fellow church-goers, and my own family members. Empty me of selfish ambition or vain conceit. Do whatever it takes to form in me the humility of Christ my master and Lord.

SEEK HIS STILLNESS

Call to mind the image of Jesus washing His disciples' feet. Be still before Him. What is He trying to say to you?

TRUST HIS FAITHFULNESS

O Jesus, how different Your mission on earth would've been had You sought Your own interests! Yet because You let go of heaven's glories to serve us, the cross became Your throne of exaltation. And now You are seated at Your Father's right hand, high and lifted up. So I trust You'll continue working in me Your humility that I may be Your faithful servant.

For Further Prayer and Study

John 16:33 • Romans 8:32 • Galatians 6:9 • Philippians 2:1–11

LUKE

"For the Son of Man has come to seek and to save the lost."

LUKE 19:10 CSB

RECITE GOD'S GOODNESS

Precious Jesus, You didn't have to show such love and compassion. But like a good shepherd, You go after those who are lost. For this reason, You came to the earth as a human—to seek out those who have strayed and welcome us back into the fold of God's family. Such marvelous grace! May it never become old or familiar to me.

EXPRESS YOUR NEEDINESS

Too often I fail to recognize my own lostness apart from You. I try to forge my own path and determine my own destiny, believing the mantras of self-sufficiency. Forgive me, Lord. Help me humbly acknowledge that without You, I'd be lost. I need You every day.

SEEK HIS STILLNESS

Take a few moments to become aware of God's loving Spirit seeking you in the place you've wandered and guiding you back into His presence. Be comforted by His love.

TRUST HIS FAITHFULNESS

Just as You've sought and saved me, and countless others who have trusted in You, so I can entrust my loved ones to You. I bring to You my children, my spouse, my family members, friends, coworkers, and neighbors. [Pause to say their names.] You love them and care for them more than I do, so I trust You to seek them, find them, call them to Yourself, and save them.

For Further Prayer and Study

Psalm 23 • Ezekiel 34:12–16 • John 10:1–21

JOHN

*"In the beginning was the Word, and the Word was with God,
and the Word was God. He was with God in the beginning."*

JOHN 1:1–2 csb

RECITE GOD'S GOODNESS

O Life-Giving God, existing from before time began, You are limitless and beyond comprehension; yet You revealed Yourself to us in Jesus. Your Word enfleshed in bodily form walked among us, displaying Your love in a way we could see, touch, and understand. I praise You, God, for the gift of Your Son.

EXPRESS YOUR NEEDINESS

I confess that I can't quite grasp the concepts of coexistence, eternity, the Trinity. These truths seem beyond my comprehension, so help me appreciate the beauty of these mysteries, and may they make You more precious to me.

SEEK HIS STILLNESS

Take a few moments to become aware of God's eternal communal presence surrounding you and filling you through His Spirit.

TRUST HIS FAITHFULNESS

O God, because You are so much bigger than I can comprehend, I can rest in Your power and supremacy. And because You deigned to come to earth in the form of a human, I can rest in Your love and compassion. I trust in Your faithful and powerful love, and my heart rejoices in Your salvation.

For Further Prayer and Study

Genesis 1 • Galatians 4:4–5 • Hebrews 1:1–2

ACTS

"But you will receive power when the Holy Spirit has come on you, and you will be my witnesses in Jerusalem, in all Judea and Samaria, and to the ends of the earth."

ACTS 1:8 CSB

RECITE GOD'S GOODNESS

Powerful God, You didn't abandon us when Jesus returned to Your right hand, but You sent Your own Spirit to dwell within us. Thank You for the privilege of partnering with You in the work You're doing in the world.

EXPRESS YOUR NEEDINESS

Most days, I feel like I'm living in my own power and strength, instead of relying on Your Spirit to empower me. Forgive me. Remind me to seek You first and entrust to You my work each day, so that I might be a witness to Your Name, not my own.

SEEK HIS STILLNESS

Quiet your heart before God. Become aware of His presence and power in you through His Spirit. Then give Him the details of your day, and wait quietly for His input and direction.

TRUST HIS FAITHFULNESS

You have been so faithful to bring us back into relationship with You—through Jesus' sacrifice on the cross and Your Spirit dwelling in us. And one day soon, Your glory will once again dwell among us in the new creation. Thank You for allowing me to be a part of Your big story. I trust You today.

For Further Prayer and Study

Psalm 46 • Matthew 6:33 • Hebrews 11:6

ROMANS

"For all have sinned and fall short of the glory of God;
they are justified freely by his grace through the redemption that is in Christ Jesus."

ROMANS 3:23-24 csb

RECITE GOD'S GOODNESS

You alone are glorious, holy, majestic, and awesome in power. And You made a way, through Jesus, for us to be pardoned of our sin and made right with You. What amazing grace! I praise You, God, for Your infinite love.

EXPRESS YOUR NEEDINESS

How quickly I forget my helplessness apart from You. Remind me of the beauty of the gospel, and imprint on my soul an eternal gratitude for Your grace toward me in Christ Jesus. Even today, may You become ever more precious to me.

SEEK HIS STILLNESS

Quiet your mind and your heart as you rest in God's loving presence. Ask Him:
"Is there anything You want to show me about my life, my heart, or my relationship
with You and others?" Then sit quietly with Him as you allow His Spirit to lead you.

TRUST HIS FAITHFULNESS

Long ago, You required sacrifices for people to enter Your holy presence. But because of Jesus, we can come to You anytime, anywhere—His blood covers our sins once and for all. God, You were faithful to deliver us from sin, and You will continue to keep Your promises this hour, this day, and into eternity.

For Further Prayer and Study

2 Corinthians 12:9 • Ephesians 2:8 • Hebrews 4:6

1 CORINTHIANS

*"God is faithful; you were called by him into fellowship with his Son,
Jesus Christ our Lord."*

1 CORINTHIANS 1:9 CSB

RECITE GOD'S GOODNESS

Heavenly Father, You indeed are faithful and true. In Your perfect timing,
You sent Your Son into the world to bring us into close relationship with You.
You called us, You pursued us, You made a way for us. I praise You!

EXPRESS YOUR NEEDINESS

Though You are faithful, I'm not always faithful, just like the first believers
in Corinth. Forgive me for my fickle heart, for my wandering devotion. You
are the One who called me, and You are the One who will make me stand
blameless before You. I need You in my life!

SEEK HIS STILLNESS

*Take a few moments to become aware of God's faithful work in your life over the
years, and His loving presence with you right this moment.*

TRUST HIS FAITHFULNESS

God, I praise You that You're building for Yourself a new temple, a body of
believers in whom Your Spirit dwells. It's not just me—it's many together who
are being made one. So as You began this work, I trust You to fulfill it and to
bring close fellowship even among the people of my local church. As the Father
and Jesus and the Spirit are One, so help us be one in You.

For Further Prayer and Study

Deuteronomy 7:9 • 2 Timothy 2:13 • Hebrews 10:23

2 CORINTHIANS

"But he said to me, 'My grace is sufficient for you, for my power is perfected in weakness.' Therefore, I will most gladly boast all the more about my weaknesses, so that Christ's power may reside in me."

2 CORINTHIANS 12:9 CSB

RECITE GOD'S GOODNESS

How kind of You, Lord, to take the weak things of the world and to shame the strong. You showcase Your power in me despite my imperfections. Thank You for grace upon grace.

EXPRESS YOUR NEEDINESS

So often I try to highlight my strengths and hide my weaknesses. There's so much I want to change about myself, so many ways to improve, but on my own, I'm powerless. I surrender these weaknesses to You; may Your power be on full display in my life.

SEEK HIS STILLNESS

Bring to mind those weaknesses that most frustrate you and surrender them into God's powerful hands. Then rest quietly in His loving presence.

TRUST HIS FAITHFULNESS

It's never been about me, has it? My life, my story, this world, all of history . . . it's all about You. Your power, Your glory, Your kingdom, forever and ever. Thank You for the privilege of being a part of what You're doing in the world. I can't wait to see what You do today and in the weeks to come through my surrendered life. I trust You.

For Further Prayer and Study

Isaiah 40:29–31 • John 1:16 • Romans 3:23–24; 8:28 • 1 Corinthians 2:5

GALATIANS

*"I do not set aside the grace of God,
for if righteousness comes through the law, then Christ died for nothing."*

GALATIANS 2:21 CSB

RECITE GOD'S GOODNESS

Glorious God, You showered us with the riches of Your grace, holding nothing back. Thank You for Jesus' perfect life, death, and resurrection. Because of Him, I can come to You freely today.

EXPRESS YOUR NEEDINESS

Much like the Galatians, I often turn to my own list of dos and don'ts in my self-righteousness. Purge any pride, selfish ambition, or vain conceit from my heart, and help me fully embrace Your grace—free, unmerited, unearned grace.

SEEK HIS STILLNESS

Identify any anxiety in your heart, and bring it before God. Allow His grace and His great love in Jesus to quiet you and restore peace to your heart.

TRUST HIS FAITHFULNESS

All throughout history, You promised a rescuer who would undo the effects of sin from the garden of Eden. And in Jesus, Your promises proved true. God, I trust that You will complete the work of righteousness in my life, not through my own efforts, but as I submit to Your Spirit at work in me.

For Further Prayer and Study

Romans 8:32 • 2 Corinthians 1:20 • Ephesians 2:7 • Philippians 2:1–11

EPHESIANS

"For you are saved by grace through faith, and this is not from yourselves;
it is God's gift—not from works, so that no one can boast."

EPHESIANS 2:8-9 CSB

RECITE GOD'S GOODNESS

Compassionate God, You saved me not because of anything I've done but because of Your loving generosity toward me! Thank You for choosing me. What a wonderful and undeserved gift!

EXPRESS YOUR NEEDINESS

I'm embarrassed to admit how often I see myself as the hero of my own story. I've tried to play a part in my own saving, but I can't. In my helplessness, You swooped down and rescued me. Forgive me for any remnants of pride left in me. May Your grace lead me to repentance and humility.

SEEK HIS STILLNESS

As you reflect on today's key verse, what do you feel God is saying to you? And is there anything else that you want to say to Him?

TRUST HIS FAITHFULNESS

O God, I need You, not just for my salvation from sin, but every day, for every breath of my life. And truly, You are enough. You are more than enough to meet my every need. I can trust You, not just for my eternal security, but for every moment from now until I see You face-to-face.

For Further Prayer and Study

Psalm 18:16 • Isaiah 46:4–13 • John 15:16 • 1 Peter 2:9

PHILIPPIANS

"For me, to live is Christ and to die is gain."

PHILIPPIANS 1:21 CSB

RECITE GOD'S GOODNESS

Generous Lord, how much joy I've found in Your presence, how much peace in knowing Christ Himself is in me! Through Your Spirit, You fill us with all the fullness of Christ Jesus, holding nothing back. What an incredible gift You've given us!

EXPRESS YOUR NEEDINESS

I want to be so wrapped up in You, my identity so closely tied to Yours, that my life is not my own. I confess that I still sometimes see areas of my life as "sacred" and other areas as "secular," when there is no such division with You. You live in me, and I in You. May I live with no fear of death and die with no fear of a life poorly lived.

SEEK HIS STILLNESS

Take a few moments to become aware of God's presence filling you through His Spirit, from the top of your head to the soles of your feet. Christ in you, the hope of glory.

TRUST HIS FAITHFULNESS

Because of Jesus, I have joy for today and hope for tomorrow. Thank You, God, that I am never alone because Christ is in me through His Spirit. What beautiful union with You! What perfect harmony in Your love! I rejoice in Your promise of redemption, eagerly awaiting the fulfillment of Your promises of restoration.

For Further Prayer and Study

Habakkuk 3:18 • Romans 12:12 • Galatians 2:20 • Philippians 4:4

COLOSSIANS

"He is before all things, and by him all things hold together."

COLOSSIANS 1:17 csb

RECITE GOD'S GOODNESS

Sovereign Commander of the Universe, how incredible You are! You existed with the Father before time began, and by Your word all things sprang into existence. Through You everything lives and moves and has its being, and You hold the universe together!

EXPRESS YOUR NEEDINESS

All creation bows before You in proper acknowledgment of Your Lordship and dominion, but I find myself otherwise preoccupied. Forgive me, Lord Jesus, for those times when I try to rule a little world of my own making. I come under Your Lordship and rulership and acknowledge that You alone are Master and King.

SEEK HIS STILLNESS

Recall to mind the scene where Jesus calms the winds and the waves with just a few words. The disciples were terrified. What things in your life feel like they're falling apart? Bring it under Jesus' Lordship, and rest in Him as He speaks peace over your life.

TRUST HIS FAITHFULNESS

When I am afraid, I will trust in You, Jesus. You are the Creator and Sustainer, from the moment this world began with the breath of Your voice to the moment You return to re-create heaven and earth—and every moment in between. You are holding this universe together and You hold my life together. I trust You.

For Further Prayer and Study

Psalm 145 • John 1:1–5 • Acts 17:28 • Romans 10:9 • Revelation 21:1–4

1 THESSALONIANS

*"Rejoice always, pray constantly, give thanks in everything;
for this is God's will for you in Christ Jesus."*

1 THESSALONIANS 5:16–18 CSB

RECITE GOD'S GOODNESS

God of my Praise, I will tell of Your faithfulness, for You have dealt
compassionately with me. If I had a thousand tongues to sing for all eternity, still I
would not exhaust Your praise. You are so good, and Your mercies endure forever!

EXPRESS YOUR NEEDINESS

You've made Your will so clear: You want me rejoice always, pray constantly,
and give thanks in everything. But I fail in each of these. Forgive me. Transform
my heart to live in a way that honors You.

SEEK HIS STILLNESS

*Allow God to raise your heart in soaring praise for His presence, His provision, and His
promises in your life. Then be still before Him, and let Him quiet you with His love.*

TRUST HIS FAITHFULNESS

You've always been faithful, Lord, not just throughout the pages of my Bible,
but throughout the years of my own life. You who provided an heir for
Abraham, a wife for Isaac, and an abundant income for Jacob will provide all
my needs according to Your riches in Christ Jesus. I know that because You
gave Your own Son. So how can I not sing Your praise? O Lord, I trust in You
with all my heart!

For Further Prayer and Study

Psalms 71:15–24; 126:2; 145:8 • Luke 18:1–8 • Philippians 4:4, 19

2 THESSALONIANS

"May the Lord direct your hearts to God's love and Christ's endurance."

2 THESSALONIANS 3:5 CSB

RECITE GOD'S GOODNESS

O Faithful Lord, You strengthen the hearts of those who trust in You. I praise You for filling my heart with Your love. In Your presence, my heart is neither half full nor half empty but filled to overflowing with Your love.

EXPRESS YOUR NEEDINESS

Lord, I grow discouraged sometimes when it seems like I struggle with the same sins day after day. Other times I wonder if I'm making a difference in the lives of my spouse and children. Lord, would You help me continue to trust and obey You?

SEEK HIS STILLNESS

Take a few moments to become aware of God directing your heart back to His love, as today's key verse says. How does Christ's endurance compel you to a life of faithful obedience?

TRUST HIS FAITHFULNESS

Thank You, Jesus, for Your example of patient endurance in hardship. You were obedient to the point of death on a cross. My own hardships pale in comparison to what You endured. I praise You for being faithful to the end. You never gave up, and You won't give up now. Though this obedience in the same direction often feels like a long road, I trust You, precious Jesus.

For Further Prayer and Study

Psalms 28:7–8; 31:24 • Nehemiah 8:10 • Romans 5:3–4 • Colossians 2:10 • Hebrews 10:36

1 TIMOTHY

*"This saying is trustworthy and deserving of full acceptance:
'Christ Jesus came into the world to save sinners'—and I am the worst of them."*

1 TIMOTHY 1:15 CSB

RECITE GOD'S GOODNESS

O Gracious Lord, there's no molecule in me that remains untouched by Your grace, nor any part of me that has not experienced Your love. Thank You for seeking and saving the lost. You are worthy of my praise.

EXPRESS YOUR NEEDINESS

How quickly I try to hide my flaws, not just from others but even from You! But You know me completely, and there's nothing hidden from Your sight. Forgive me for pretending I'm better than I am. Help me be quick to acknowledge my sin and to humble myself before You, that I may receive Your mercy and grace.

SEEK HIS STILLNESS

Quiet your heart before the Lord and become aware of His great love and forgiveness toward you. What do you want to say to Him? Is there anything that He is saying to you?

TRUST HIS FAITHFULNESS

Thank You, God, that when I confess my sins, You are quick to forgive and cleanse me. You are faithful to wash away any stain, no matter how despicable. You have saved Your people, not because of our righteousness, but because of Your great love and faithfulness. My heart finds rest in You.

For Further Prayer and Study

Psalms 139:1–6; 145:1 • Luke 9:10 • 1 John 1:9–10 • Revelation 4:11

2 TIMOTHY

"All Scripture is inspired by God and is profitable for teaching,
for rebuking, for correcting, for training in righteousness,
so that the man of God may be complete, equipped for every good work."

2 TIMOTHY 3:16-17 CSB

RECITE GOD'S GOODNESS

How good You are, Lord, to not leave us wondering who You are, but to give us Your very Word that we may come to know You and love You! Thank You for placing Your own Spirit within us to teach us Your truth!

EXPRESS YOUR NEEDINESS

Lord, You know how much I need to be trained, corrected, taught, rebuked, and equipped. But I confess that I often grow bored with Scriptures. My appetite for Your Word is weak, and I find myself easily distracted and dissuaded. Forgive me. Give me a hunger for this bread of life!

SEEK HIS STILLNESS

Be still before God. Become aware of His loving presence surrounding you this very moment, working on your heart in response to your prayer.

TRUST HIS FAITHFULNESS

Mighty God, You've faithfully preserved Your Word throughout the generations. Now would You make me a faithful student of Scripture? My favorite shows and books will all fade into oblivion, but Your Word will endure forever. Thrill me with Your Word, faithful God.

For Further Prayer and Study

Matthew 5:18 • John 6:25–59 • Romans 8:32 • 2 Peter 1:3–5

TITUS

"He saved us—not by works of righteousness that we had done, but according to his mercy—through the washing of regeneration and renewal by the Holy Spirit."

TITUS 3:5 CSB

RECITE GOD'S GOODNESS

Precious Savior, how merciful You are—not to overlook my sin as if it hadn't happened, but to acknowledge it and cover it by Your own blood. You've washed me white as snow and continue to cleanse me through Your Spirit! O Your kindness and goodness know no limits! I praise You!

EXPRESS YOUR NEEDINESS

On my own, even my best behavior is failure before You. I confess that nothing good resides in me apart from You. Everything good and holy and admirable comes from You. I'm utterly lost without You. I need You, Lord.

SEEK HIS STILLNESS

Take a few moments to picture yourself on your very best day. Now picture your very worst day. Recognize that God's lovingkindness and mercy continue to be poured out on you, even in this very moment.

TRUST HIS FAITHFULNESS

Changeless God, You are who You say You are, and You will do what You say **You will do.** You fulfilled Your promise from long ago, saving us through Your precious Son, so I believe that You will finish the good work You've started—in my life and in the world.

For Further Prayer and Study

Romans 7:18–25 • Philippians 1:6 • Hebrews 10:22 • Jude 24–25 • 1 John 1:7–10

PHILEMON

*"For this reason, although I have great boldness in Christ to command you
to do what is right, I appeal to you, instead, on the basis of love."*

PHILEMON 8–9 csb

RECITE GOD'S GOODNESS

Loving Father, it's through You alone that we know what love is. You've placed
Your love in our hearts, and through Your Spirit, You continue to produce the
fruit of abiding in You, chief of which is love.

EXPRESS YOUR NEEDINESS

It's easier to follow a list of rules than it is to follow the way of love. Yet Your
command is straightforward: to love You wholeheartedly and to love others as
myself. Simple, but so hard, especially when I feel wronged. Teach me to love
like You love.

SEEK HIS STILLNESS

*Picture the person most difficult to love. Now picture Jesus Himself loving them,
a precious daughter or son, just as He loves you. Be still before Him, and allow
His love to fill you for this beloved child of His.*

TRUST HIS FAITHFULNESS

Any love in me comes from You, precious Jesus. So continue pouring Your love
in my heart, enlarging my capacity to love the unlovable. My own heart is fickle
and selfish, but I trust You to make me more and more like You. May others see
and marvel at Your love at work, for Your glory alone.

For Further Prayer and Study

Matthew 22:34–40 • Romans 5:8; 8:28–29 • 1 Corinthians 12:31–13:13

HEBREWS

"Let us run with endurance the race that lies before us, keeping our eyes on Jesus, the pioneer and perfecter of our faith. For the joy that lay before him, he endured the cross, despising the shame, and sat down at the right hand of the throne of God."

HEBREWS 12:1-2 CSB

RECITE GOD'S GOODNESS

O Author and Perfector of my Faith, You are worthy of all my praise and adoration. You persevered through the bitterness of the cross to Your glorious resurrection and ascension at the Father's right hand. I praise You because You didn't give up then, and You won't give up now.

EXPRESS YOUR NEEDINESS

Precious Jesus, I'm tired physically and spiritually. Despair ensnares me. Empower me to endure in suffering, to resist sin, and to keep my eyes on You until I finally see You face-to-face.

SEEK HIS STILLNESS

Be still before the Lord, and picture Him strengthening your tired hands and weak knees, making straight paths for your feet. Be still with Him, and let Him quiet you with His love.

TRUST HIS FAITHFULNESS

I've never had to endure to the point of death, but even now, many of my brothers and sisters are being persecuted for their faith. Dear Lord, be near them. Help them endure until You place a crown of victory on their heads. You are faithful and true, and we trust You.

For Further Prayer and Study

Deuteronomy 31:6 • Psalm 37:27–29 • Matthew 24:13 • Revelation 2:10; 19:11

JAMES

"Consider it a great joy, my brothers and sisters, whenever you experience various trials, because you know that the testing of your faith produces endurance. And let endurance have its full effect, so that you may be mature and complete, lacking nothing."

JAMES 1:2–4 CSB

RECITE GOD'S GOODNESS

Author of All Good Things, You turn the enemy's plans for evil into good. I worship You because death and despair will not have the final word—for You will reign in victory with the people You have redeemed as Your very own.

EXPRESS YOUR NEEDINESS

Give me eyes to see You in the midst of my suffering. Give me grace to cling to You in my hours of despair. Give me faith to rejoice that You will use the worst to bring me to maturity, completely satisfied in You alone.

SEEK HIS STILLNESS

Allow yourself to feel the full weight of sorrow and pain. Bring it to the Lord, and then be still. Picture Him by your side in your hardship, and let His presence in the darkness bring you comfort.

TRUST HIS FAITHFULNESS

O God, I praise You in the midst of my suffering, not because it is good, but because You are good, and You will work it for good, as only You can. So I trust You in the midst of this hardship. Have Your way in me.

For Further Prayer and Study

Genesis 50:20 • Psalm 146:10 • Romans 8:28–29 • Revelation 5:9–14

1 PETER

"Blessed be the God and Father of our Lord Jesus Christ.
Because of his great mercy he has given us new birth into a living hope
through the resurrection of Jesus Christ from the dead and into an inheritance
that is imperishable, undefiled, and unfading, kept in heaven for you."

1 PETER 1:3–4 CSB

RECITE GOD'S GOODNESS

Eternal God, You conquered sin and death, and You've graciously offered us a
share in Your heavenly inheritance. How good You are to the undeserving!
I praise You!

EXPRESS YOUR NEEDINESS

Help me cling to this living hope in You when I feel surrounded by darkness.
Reassure my heart that just as You are keeping this wonderful inheritance, so
You are keeping me safe and secure in Your powerful arms of love.

SEEK HIS STILLNESS

Ponder that image for a few moments: you yourself are being kept by God, a sheep
kept by the Shepherd, and no one can snatch you from the Father's hand. Rest in
His embrace. Let His loving presence quiet your anxious heart.

TRUST HIS FAITHFULNESS

O God, You've shown such great mercy—though we turned from You, You
adopted us into Your family. Adopted forever, with no fear of being disowned.
You are the One who holds on to Your own, and You will never let go. I trust You.

――――――――――――――― *For Further Prayer and Study* ―――――――――――――――

Psalm 16 • Proverbs 30:4 • Isaiah 41:10 • John 10:28–30; 11:25

2 PETER

"His divine power has given us everything required for life and godliness through the knowledge of him who called us by his own glory and goodness."

2 PETER 1:3 csb

RECITE GOD'S GOODNESS

Holy God, thank You for securing our holiness in Christ Jesus. Apart from You, I would be hopelessly lost in darkness and despair, but because of Your great grace, I can come to You with confidence.

EXPRESS YOUR NEEDINESS

Everything I need I already have in You, generously provided by You. Forgive me for believing the lie that I'm doomed to a life of defeat and sin. You've given me everything I need for a life that points to You. Help me live in dependence on You.

SEEK HIS STILLNESS

Take a few moments to become aware of God pouring out on you and in you everything you need for today, and just be still in His presence.

TRUST HIS FAITHFULNESS

You have not abandoned me to my own resources, but along with new life, You've also given me Your own Spirit of power, love, and self-control. You've given me all the riches of glory in Christ Jesus, even Your own presence in me. There's nothing I'll face today that You haven't already equipped and prepared me for, so I rest in You, Lord.

For Further Prayer and Study

Psalm 24:1 • Luke 11:13 • 1 Corinthians 2:12 • Romans 8:32; 11:36 • Hebrews 4:16

1 JOHN

*"I am writing to you, dear children,
because your sins have been forgiven on account of his name."*

1 JOHN 2:12

RECITE GOD'S GOODNESS

Heavenly Father, You are so kind! Not only did You provide salvation from sin and death in Christ Jesus, but You offer to continually forgive all our sins, each and every day, cleaning us from all the sinful habits and distractions that woo us from You. You are so good! Thank You that we can approach You with confidence. Thank You that we have nothing to fear with You!

EXPRESS YOUR NEEDINESS

You are holy and You are also good, and You've made a way, through the sacrifice of Jesus, to cover our sins whenever we confess them to You. I take time now to admit the sins that have accumulated in my life.

SEEK HIS STILLNESS

Voice your sins, asking God's Spirit to search your heart and lead you in repentance. Then thank God for His forgiveness, and allow His presence to reassure you of His great love.

TRUST HIS FAITHFULNESS

From that first sacrifice to make coverings for Adam and Eve to the ultimate sacrifice in Jesus, You have always provided a way for humans to be made right with You. And it's not our goodness that attracts You, but Your faithful love that never changes. Thank You, God. My soul finds rest in You alone.

For Further Prayer and Study

Psalms 62:1; 139:23–24 • John 14:6 • Titus 3:4–7 • 1 John 3:23

2 JOHN

"This is love: that we walk according to his commands.
This is the command as you have heard it from the beginning: that you walk in love."

2 JOHN 6 csb

RECITE GOD'S GOODNESS

You are the God of love. You define love, and through Your actions we learn what love is. How great is Your love toward us, that while we were still rebelling against You, You laid down Your life for our sins.

EXPRESS YOUR NEEDINESS

Your only command is simple, yet it's so hard: to love like You. In my fallen nature, I turn inwardly, loving myself, protecting myself, advancing myself. Forgive me, Lord. Fill me with Your Spirit, and kill any selfishness, pride, or envy in me. Teach me to love like You love.

SEEK HIS STILLNESS

Allow this command to become an invitation: walk into His presence, and allow His love to embrace you and fill you up.

TRUST HIS FAITHFULNESS

Your love, O Lord, never fails. You created us for love, You pursued us in love, You died for us in love, and You raised us up with You in love. And now You indwell us with Your love. You alone are pure love, and You're transforming us into a people of love. How great is Your love for us! If there's anyone worthy of my trust, it's You.

For Further Prayer and Study

Psalms 36:5; 136 • John 14:15 • Romans 5:8 • Ephesians 2:6–7 • 1 John 3:1

3 JOHN

"I have no greater joy than this: to hear that my children are walking in truth."

3 JOHN 4 csb

RECITE GOD'S GOODNESS

God of All Truth, I praise You because there is no lying or shifting with You. You define reality by Your Word, and I never have to fear that You'll deceive me. You are faithful and true, and every promise with You is "yes" and "amen." What a wonderfully reliable and trustworthy God You are!

EXPRESS YOUR NEEDINESS

Though I'd like to believe I'm always truthful, when I look more closely at my life, I recognize half-truths and exaggerations, convenient omissions and slight misdirection. Forgive me, Lord. Guard me from having anything to do with the father of lies. Put Your truth in my mouth, and may my actions match my words—Your Word in me.

SEEK HIS STILLNESS

As you quietly sit with the God of Truth, invite Him to search you completely, to bring to light any hidden darkness, and confess anything He reveals. Then be still. Be known. Be loved.

TRUST HIS FAITHFULNESS

Every promise You speak, You, God, always keep. You have always been faithful, even at great cost, from the garden to the cross and to this day. I want to walk with You in truth. Make me wholeheartedly committed to You!

For Further Prayer and Study

Deuteronomy 7:9 • Psalms 86:11; 119:43, 74, 114, 147; 139:12 • John 8:12 • James 1:17

JUDE

"Now to him who is able to protect you from stumbling and to make you stand
in the presence of his glory, without blemish and with great joy,
to the only God our Savior, through Jesus Christ our Lord, be glory, majesty,
power, and authority before all time, now and forever. Amen."

JUDE 24–25 CSB

RECITE GOD'S GOODNESS

O God who holds me secure, You rescued me and forgave me, and You're not
finished with me yet. I praise You, God! I praise You, Jesus! I praise You, Holy
Spirit!

EXPRESS YOUR NEEDINESS

Holy One, may I not get in the way of what You're trying to do in my life. Make
me quick to obey Your Spirit. I want to be holy. I want to bring You great joy!

SEEK HIS STILLNESS

Quiet your heart in God's presence, and allow Him to show you how He has been
making you holy. Do you see changes in your life over the last six months? Over the
past years? He is doing a good work in you. Rest in His loving presence.

TRUST HIS FAITHFULNESS

On my own, I'm prone to stumble and wander. But by Your grace, You are
keeping me and holding me; and when I come before Your throne, You will
make me stand. Not because of my own goodness or obedience, but because
of Your great love! I praise You, loving Father!

For Further Prayer and Study

Psalms 22:3; 37:23–24 • Matthew 11:28–30 • 2 Corinthians 12:9 • Revelation 4:11

REVELATION

"Then he said to me, 'It is done! I am the Alpha and the Omega, the beginning and the end.'"

REVELATION 21:6 CSB

RECITE GOD'S GOODNESS

O Author and Finisher of our Faith, You promise to make everything new and to bring to fruition the promises from long ago. I praise You because You will complete what You've started.

EXPRESS YOUR NEEDINESS

In this messy middle, help me believe what I cannot see. Though the world around me seems stuck in sin and despair, reorient my heart to await Your return, for You will finish Your rescue of all creation. Help me live confident of this truth. Help me rest in You when my soul grows weary.

SEEK HIS STILLNESS

Sit with Jesus, the Author and Finisher of your faith. If there's something you want to say to Him, then do so. But then sit quietly in His presence, and be comforted by His love.

TRUST HIS FAITHFULNESS

O Jesus, You are working in the world even now, right this minute. Though time seems slow, You are not slow in keeping Your promises. We're moving ever closer to Your return, and You're making things ready for the end. I want to be ready too. You've been faithful to keep all Your promises so far, and You will be faithful to the end. I trust in You with all my heart. Come quickly, Lord Jesus!

For Further Prayer and Study

Proverbs 3:5–6 • 2 Peter 3:9 • Jude 24–25 • Revelation 22:20

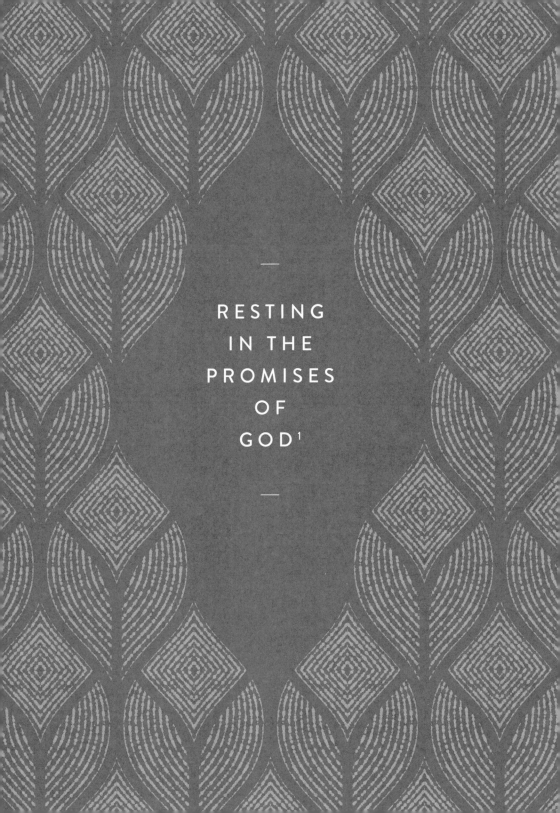

—

RESTING
IN THE
PROMISES
OF
GOD[1]

—

GOD PROMISES TO KEEP HIS PROMISES

*"For no matter how many promises God has made, they are 'Yes' in Christ.
And so through him the 'Amen' is spoken by us to the glory of God."*

2 CORINTHIANS 1:20

RECITE GOD'S GOODNESS

O God who hears my prayers, You promise good things to Your people, and You extend those promises throughout the generations for all who believe in You! How good You are to all who trust in You!

EXPRESS YOUR NEEDINESS

Lord, help me hold unswervingly to my hope in You, knowing that You are faithful to keep all Your promises. Cast all doubt or fear from my heart, and help me cling to Your Word. Grant me patience and endurance to wait on You when it seems like You're slow to act. I want to trust You with all my heart.

SEEK HIS STILLNESS

What promises of God are you clinging to today? Take a few moments to read the Scripture aloud, and add your vocal "Amen" to that, believing that it will be done to you according to His promise. Then be still before the Lord, and rest in His loving presence.

TRUST HIS FAITHFULNESS

Lord God, You are not like humans, who sometimes lie or change their minds. You are always faithful, and whatever You promise, that You will do. So I rest and rejoice in You today.

For Further Prayer and Study

Numbers 23:19 • Isaiah 30:18; 46:11 • Luke 1:38 • Hebrews 10:23

GOD PROMISES TO LISTEN TO OUR PRAYERS

"For the eyes of the Lord are on the righteous and his ears are attentive to their prayer."

1 PETER 3:12

RECITE GOD'S GOODNESS

Heavenly Father, I praise You that Your eyes are on me and Your ears are attentive to my prayers. Thank You for hearing me when I cry out to You and for coming close in my time of need.

EXPRESS YOUR NEEDINESS

God, grow in me a desire to always be in conversation with You about the things happening around me and within me. Make me be quick to pray at all times and in all moments, knowing that You listen to my every prayer.

SEEK HIS STILLNESS

Tell God all that's on your heart, and then be still with Him, knowing that He's listening.

TRUST HIS FAITHFULNESS

Lord God, thank You for Your promise to lean close and listen to my prayers. I'm so grateful that You want to hear from me, and I trust that You are listening, whether or not I feel Your presence. You will be faithful to do what You know is best, so I trust You with my prayers today.

For Further Prayer and Study

2 Chronicles 16:9 • Psalms 4:4; 34:17; 102:17 • 1 John 5:14

GOD PROMISES TO ANSWER OUR PRAYERS

"Therefore I tell you, whatever you ask for in prayer, believe that you have received it, and it will be yours."

MARK 11:24

RECITE GOD'S GOODNESS

All-Sufficient King, how kind You are to give us open access to You, granting us permission to make our requests known to You! Thank You for the assurance that You always answer our prayers.

EXPRESS YOUR NEEDINESS

Lord, increase my faith. I want to pray with this kind of assurance: that You always listen and always answer and always delight in giving Your children good gifts. Guide my requests so that they honor You, and grant me boldness to believe that You always hear and respond in love.

SEEK HIS STILLNESS

Take a few moments to make your requests known to God right now. What weighs heavy on your heart? Lay your burdens before the Lord, and then rest in His loving presence.

TRUST HIS FAITHFULNESS

Father, You've always been faithful, even when Your answers haven't matched my expectations. Thank You that I can trust You to give me the right thing at the right time in the right way.

For Further Prayer and Study

Isaiah 58:9; 65:24 • Jeremiah 33:3 • Matthew 7:7 • Mark 11:24 • John 15:7; 16:24

GOD PROMISES ETERNAL SALVATION TO ALL WHO BELIEVE IN HIM

*"For God so loved the world that he gave his one and only Son,
that whoever believes in him shall not perish but have eternal life."*

JOHN 3:16

RECITE GOD'S GOODNESS

Most Glorious God, how great is Your love for us in Christ Jesus that You would give Your only beloved Son to die for us! Thank You for Your precious gift of eternal salvation.

EXPRESS YOUR NEEDINESS

Lord, when discouragement makes me doubt my salvation, remind me that it's not my performance or religiosity that secured my salvation, but Your own grace that extended it freely to me. Assure me that no one and nothing can snatch me out of Your hand, and give me peace and security knowing that I am Yours.

SEEK HIS STILLNESS

Take a deep breath and rest in the awareness of God's loving presence surrounding you this very moment.

TRUST HIS FAITHFULNESS

Thank You, Father, that You chose me first, and those You've chosen for eternal life remain Yours forever. How great is Your love! How precious are Your promises! I rejoice in You, the God of my salvation!

For Further Prayer and Study

John 3:17 • Romans 10:9–10, 13 • Ephesians 2:8–9 • 1 Timothy 2:3–4 • Hebrews 6:18

GOD PROMISES FORGIVENESS TO ALL WHO CONFESS AND REPENT

"If we confess our sins, he is faithful and just and will forgive us our sins and purify us from all unrighteousness."

1 JOHN 1:9

RECITE GOD'S GOODNESS

Compassionate Lord, how good You are to offer us ongoing forgiveness and purification when we confess our sins to You! Thank You for Your unconditional forgiveness to all who repent!

EXPRESS YOUR NEEDINESS

Lord, I confess that confession is hard for me. Too often I go weeks or months without pausing to consider the sins that have accumulated in my soul. I know You offer forgiveness—help me develop the habit of regularly confessing my sins to You so that I may repent, be forgiven, and begin to see transformation in my life. May I no longer return to old patterns of sin but walk in the newness of life.

SEEK HIS STILLNESS

Spend time confessing all your sins that come to mind, then bask in the assurance of God's complete forgiveness. Just be still in His loving presence, and let Him quiet you with His love.

TRUST HIS FAITHFULNESS

Lord, what a great and precious promise of forgiveness! Thank You that I don't have to fear retaliation or rejection when I come to You in humble repentance. I love You, and I rejoice in Your forgiveness!

For Further Prayer and Study

Psalms 32:1–2; 51:7; 103:12 • Isaiah 43:25 • Ephesians 1:7 • Romans 8:33 • 1 John 1:9–10

GOD PROMISES TO ALWAYS LOVE US

"For I am convinced that neither death nor life, neither angels nor demons, neither the present nor the future, nor any powers, neither height nor depth, nor anything else in all creation, will be able to separate us from the love of God that is in Christ Jesus our Lord."

ROMANS 8:38–39

RECITE GOD'S GOODNESS

My Dear God, You have loved me with an everlasting love, and through Your lovingkindness, You've drawn me to Yourself. Thank You for Your great and precious promise that nothing in all creation will ever separate me from Your love in Christ Jesus my Lord!

EXPRESS YOUR NEEDINESS

Lord, help me walk in the path of Your commands to experience the fullest expression of Your love and grace in my life. Make any pseudo-loves of this world lose their shine as my heart becomes increasingly consumed with Your love for me.

SEEK HIS STILLNESS

Sit for a moment with the reality that God loved you from all eternity, even when you were at your most unlovable state. Allow yourself to rest completely in His love this very moment.

TRUST HIS FAITHFULNESS

Lord God, Your steadfast love endures forever, and Your loving mercies are renewed every morning. How great is Your faithfulness! Thank You for Your never-stopping, never-ending, always-chasing love.

For Further Prayer and Study

Psalm 136:26 • Zephaniah 3:17 • John 15:9–17 • Romans 8:38–39 • 1 Thessalonians 1:4

GOD PROMISES TO GIVE US HIS OWN SPIRIT

"This is how we know that we live in him and he in us: He has given us of his Spirit."

1 JOHN 4:13

RECITE GOD'S GOODNESS

How amazing You are, Lord God, that You would give us Your own Spirit to live in us, Your created humans! How wonderful are Your ways, O Lord! I praise You with my whole heart!

EXPRESS YOUR NEEDINESS

Lord, I want Your Spirit to have full reign in my heart. Help me not grieve Your Spirit through disobedience or quench it through distraction. I earnestly desire to be filled with all Your fullness, receiving everything You have to give me through Your Spirit.

SEEK HIS STILLNESS

Be still in God's presence, becoming aware of His indwelling Spirit filling you this very moment. What do you want to say to Him? Is there anything He wants to say to you?

TRUST HIS FAITHFULNESS

Lord, You promised thousands of years ago to pour out Your Spirit on Your own people, and You kept that promise through Jesus and the sending of Your Holy Spirit at Pentecost. Thank You for Your faithfulness!

For Further Prayer and Study

Isaiah 44:3 • Luke 11:13 • John 14:16–23 • Acts 1:8 • Galatians 4:6 • Ephesians 3:16–19
1 John 4:13

GOD PROMISES TO PROTECT US FROM EVIL

"But the Lord is faithful, and he will strengthen you and protect you from the evil one."

2 THESSALONIANS 3:3

RECITE GOD'S GOODNESS

Lord of Light, You have disarmed the powers of darkness and made a public spectacle of them at the cross. You, Jesus, conquered evil through Your death and resurrection, so You are able to rescue us from any evil attack.

EXPRESS YOUR NEEDINESS

Lord, deliver me and my loved ones from wicked and evil people. Stand against the spiritual powers of darkness that convene against us, and protect us through the precious blood of Jesus.

SEEK HIS STILLNESS

Ponder what areas of your life feel like they're under attack, and bring each one individually under God's authoritative protection. Then rest in His presence, knowing that you are safe in Him.

TRUST HIS FAITHFULNESS

You, Lord Jesus, freed me from the slavery of fear and death, rescuing me from the kingdom of darkness. And what You started, You will be faithful to complete to the end, protecting me from evil and bringing me into Your kingdom of light and life when You return again.

For Further Prayer and Study

Psalm 91:9–13 • Romans 8:38–39 • Colossians 2:15 • 2 Timothy 4:18 • Hebrews 2:14–15
1 John 5:18

GOD PROMISES TO ALWAYS BE WITH US

"And surely I am with you always, to the very end of the age."

MATTHEW 28:20

RECITE GOD'S GOODNESS

Ever-Near God, You are always everywhere in this world You created. Yet You are also personally present with me in this moment. Where could I go that You are not there? What an assurance of Your constant presence.

EXPRESS YOUR NEEDINESS

God, even though You're always with me, I'm not always aware of Your presence. When I feel alone and forgotten, remind me that You are with me and You never leave me. Increase my spiritual sensitivity that I would acknowledge Your presence with me always.

SEEK HIS STILLNESS

Take a few moments right now to close your eyes and become aware of God's presence filling you through His Spirit this very moment. No need to say or do anything—just rest in His loving presence.

TRUST HIS FAITHFULNESS

Lord, thank You that I could never escape Your presence—even if I wanted to—because You live in me through Your Spirit. What a profound and beautiful mystery! Christ in me, the hope of glory to come. I rejoice in You, Lord God. Thank You for Your unfailing love.

For Further Prayer and Study

Deuteronomy 31:6 • Joshua 1:9 • Psalm 139:7–12 • Isaiah 41:10 • Matthew 1:23 • Acts 1:8

GOD PROMISES TO FULFILL
HIS PLANS FOR US

"And we know that in all things God works for the good of those who love him,
who have been called according to his purpose. For those God foreknew
he also predestined to be conformed to the image of his Son."

ROMANS 8:28-29

RECITE GOD'S GOODNESS

Author of All Good Things, thank You for Your promise to always fulfill Your
plans for me, working all things for my good and Your glory. How kind of You
to choose me to be conformed into the image of Jesus!

EXPRESS YOUR NEEDINESS

God, I confess that my plans are often selfish, centered on my own pursuit of
greatness. Center my heart on You, that I would desire what You desire, and
that my plans would align with Yours. Let me not seek something that is not
honoring to You.

SEEK HIS STILLNESS

Take a few moments to rest in the knowledge that God is sovereign, and He will
always accomplish His will, no matter what obstacles may arise. You can rest in Him.

TRUST HIS FAITHFULNESS

How great is Your faithfulness, O God, that You continue to fulfill Your
promises even when I'm doubtful or weary. Thank You for using any means
necessary to shape me into the image of Jesus. I rest in Your faithfulness, O God.

For Further Prayer and Study

Psalm 138:8 • Isaiah 55:8–9 • Jeremiah 29:11 • Habakkuk 2:3 • Luke 1:38 • Romans 8:28

GOD PROMISES TO ALWAYS BE FOUND BY US

"From one man he made all the nations, that they should inhabit the whole earth. . . .
God did this so that they would seek him and perhaps reach out for him
and find him, though he is not far from any one of us."

ACTS 17:26–27

RECITE GOD'S GOODNESS

Blessed Father, how good You are to make Yourself found by those who seek You with their whole hearts! You do not play hide-and-seek with us; rather, You long to show Yourself gracious to us. I praise You!

EXPRESS YOUR NEEDINESS

Lord, stoke a longing in my soul to seek You all my days. Give me courage to ask and seek for more of You in my life. Help me search for treasures found only in You, and may You be more precious to me than any possession on earth.

SEEK HIS STILLNESS

Sit quietly with the Lord, knowing that He is near you—even within you. You do not have to chase Him down, but simply turn your heart toward Him, and receive His rest.

TRUST HIS FAITHFULNESS

Precious Lord, You are so faithful and kind to give us both the desire to reach out for You and the beautiful fulfillment of Yourself in response to our outstretched arm. Your steadfast love never changes, so I rejoice in You, my Savior and my God!

For Further Prayer and Study

Deuteronomy 4:29 • Lamentations 3:24–26 • Jeremiah 29:13–14 • Matthew 7:7
James 4:6–8

GOD PROMISES TO BEAR MUCH FRUIT IN US

"You did not choose me, but I chose you and appointed you so that you might go and bear fruit—fruit that will last—and so that whatever you ask in my name the Father will give you."

JOHN 15:16

RECITE GOD'S GOODNESS

Thank You, heavenly Father, for choosing me as one of Your own, destined to bear much fruit for Your kingdom and Your glory. How kind You are to fill me with Your own Spirit and produce Your divine fruit in my life.

EXPRESS YOUR NEEDINESS

Forgive me for getting sidetracked and using the resources You've given me for my own selfish gain. Help me produce much fruit through Your Spirit, and that I would present You a hundred-fold harvest at the end of time.

SEEK HIS STILLNESS

Consider God's promise of "fruit that will last." What would it look like to bear fruit that outlasts your lifetime and encourages generations to come? Be still, and rest in the presence of the One who can accomplish this great miraculous promise.

TRUST HIS FAITHFULNESS

Lord God, You are always faithful to Your promises; help me also to be faithful to abide in you, and faithfully steward what You've entrusted to me. May I someday hear You say, "Well done, good and faithful servant. Enter into the joy of your master!"

For Further Prayer and Study

Matthew 13:8; 24:45; 25:14–30 • John 15:1–16 • Galatians 6:9

GOD PROMISES HIS SPIRITUAL GIFTS ARE IRREVOCABLE

"God's gifts and his call are irrevocable."

ROMANS 11:29

RECITE GOD'S GOODNESS

Unchanging God, You work in marvelous and mysterious ways in this world, not least of which is gifting Your children with various spiritual manifestations of Your Spirit. I praise You for never withdrawing Your Spirit or Your gifts, but working in the body through all different kinds of people united by Your Spirit!

EXPRESS YOUR NEEDINESS

Lord, help me not neglect the spiritual gift You've placed within me, but help me serve those around me in love, encouraging and building them up. May I never wield my spiritual gift as a weapon or manipulate it for my own gain, but always place it in humble service of others for Your glory and fame.

SEEK HIS STILLNESS

Reflect on the past week and consider how God has worked through you by the power of His Spirit gifting you. Sit quietly with Him as you offer your body as a living sacrifice—ready to bestow on others whatever He gifts to you.

TRUST HIS FAITHFULNESS

Lord God, You were faithful to Israel and You are faithful to Your church, because You always keep Your promises. Thank You for giving me Your Spirit; I'm so privileged to receive Your gifts. I celebrate how You're using me already, and I trust You to continue working in me and through me by the power of Your Spirit.

For Further Prayer and Study

Romans 12:1–16 • 1 Corinthians 12:1–31 • Philippians 1:6

GOD PROMISES TO GIVE US HIS KINGDOM

"But seek his kingdom, and these things will be given to you as well.
Do not be afraid, little flock, for your Father has been pleased to give you the kingdom."

LUKE 12:31–32

RECITE GOD'S GOODNESS

Sovereign King, what an incredible promise You've given us, that we would be co-heirs with Christ to all the riches of Your coming kingdom! Such generosity is beyond my understanding. You have been so so good to me!

EXPRESS YOUR NEEDINESS

Lord, as I look around me at the stuff surrounding me, help me remember that this is not my treasure. Help me loosen my grip on the things of this world and take hold of my royal inheritance in Christ Jesus. Help me seek You and Your kingdom with everything I have in me.

SEEK HIS STILLNESS

Ponder in what ways does God desire to have His kingdom come on earth—in your life and your home—as it is in heaven right now? Be still with Him, and listen for His still, small voice.

TRUST HIS FAITHFULNESS

Lord, in the years I have left, help me fix my eyes on the things above: the promised kingdom and the coming King. May You become more precious to me than anything I may leave behind for Your sake. I can't wait to see You!

For Further Prayer and Study

Matthew 6:10, 20, 33; 19:29 • Romans 8:17 • Colossians 3:1–2

GOD PROMISES COMPLETE JOY IN HIS PRESENCE

"I have told you this so that my joy may be in you and that your joy may be complete."

JOHN 15:11

RECITE GOD'S GOODNESS

Lord Jesus, in Your presence is fullness of joy, the overwhelming pleasure of being alive in this world. How good You are to promise us unending joy with You!

EXPRESS YOUR NEEDINESS

Lord, when trials surround me, help me be quick to run to You, for You fill my heart with gladness. Help me cling to Your promise of eternal joy, not just in the future but in this moment here and now, a joy that no one can take from me. I want to rejoice in You always!

SEEK HIS STILLNESS

Consider the little things that bring you joy, from a baby's smile to a blooming flower and everything in between. How are each of these gifts revealing a greater truth about the giver? Be still with Him, and delight in His joy.

TRUST HIS FAITHFULNESS

Lord God, someday soon we will enter Zion with singing, and everlasting joy will crown our heads. Joy and gladness will overtake us, and sorrow and sighing will flee away, because You are making everything new. Like a bride awaiting her bridegroom, I wait for Your return, Jesus, with great joy and anticipation!

For Further Prayer and Study

Psalms 16:11; 21:6 • Isaiah 35:10; 55:12 • John 3:29 • Acts 2:25–28 • Romans 14:17
Philippians 4:4

GOD PROMISES PERFECT PEACE
(TO THOSE WHO TRUST HIM)

"I have told you these things, so that in me you may have peace.
In this world you will have trouble. But take heart! I have overcome the world."

JOHN 16:33

RECITE GOD'S GOODNESS

God of Grace, because You have overcome the world with its curse of sin
and death, we now have the promise of eternal peace with God and perfect
restoration of peace in the coming kingdom. How great and wonderful You are!

EXPRESS YOUR NEEDINESS

Lord, I lay before You now everything that has been causing me anxiety. No
matter what I worry about, You are greater, and so my soul can find rest in You
alone because You have given me Your perfect peace.

SEEK HIS STILLNESS

*Take a few moments to become aware of God's peace guarding your heart and your
mind in Christ Jesus. Just be still with Him, resting in His loving arms.*

TRUST HIS FAITHFULNESS

Precious Jesus, our peace came at great cost, for You were pierced for our sins
and bore our punishment that we may be reconciled to You. How faithful You
are to Your promises, stopping at nothing to secure the perfect peace for those
who trust in You!

For Further Prayer and Study

Isaiah 53:5 • John 14:27 • Romans 5:1 • Philippians 4:7

GOD PROMISES REST

"The promise of entering his rest still stands ... There remains, then,
a Sabbath-rest for the people of God; for anyone who enters God's rest
also rests from their works, just as God did from his."

HEBREWS 4:1, 9–10

RECITE GOD'S GOODNESS

How delightful You are, Lord God, that You provided us a way to rest from our work in Christ Jesus! Thank You that You will not turn away anyone who comes to Your weary or heavy-burdened, but welcome us with open arms.

EXPRESS YOUR NEEDINESS

Lord, I'm not very good at resting. It's like I'm addicted to hurry, and the few moments I could slow down, I spend instead restlessly scrolling a screen. Teach me how to truly rest in Your presence, today and every day.

SEEK HIS STILLNESS

Take a few moments to become aware of God's loving presence surrounding you this very moment. Taking deep breaths, identify any tightness or tension in your body, and feel yourself relax completely as you allow God to hold you in His loving arms.

TRUST HIS FAITHFULNESS

Truly, my soul finds rest in You alone, for You are my salvation. Just as You gave the Israelites rest from their enemies in the land of Canaan, so I trust You to give me rest in Your presence here and now and eternal rest in Your coming kingdom.

For Further Prayer and Study

Exodus 33:14 • Psalm 62:1 • Matthew 11:28–29 • Revelation 14:13

GOD PROMISES SPIRITUAL POWER

*"I pray that the eyes of your heart may be enlightened in order that you may know . . .
his incomparably great power for us who believe. That power is the same as
the mighty strength he exerted when he raised Christ from the dead."*

EPHESIANS 1:18–20

RECITE GOD'S GOODNESS

Almighty God, You are so generous to have given us Your own Spirit of power
within us! Lord, who is like You, awesome in power and mighty in strength?

EXPRESS YOUR NEEDINESS

Lord, give me strength when I am weary and increase my power when I am
weak. Help me realize that my weakness is actually an opportunity for You
to display Your great power at work in me. Make me quick to turn to You in
humble recognition of my need instead of trying to power through in my
own strength.

SEEK HIS STILLNESS

*Take a few moments to become aware of God's presence of love and power filling you
this very moment.*

TRUST HIS FAITHFULNESS

Lord God, You are the eternal Rock, and You will never fail. You've given me
not a spirit of timidity and fear, but a Spirit of power, love, and self-control.
Your joy is my strength, so I will rest today in Your mighty power within me.

For Further Prayer and Study

Isaiah 40:29 • Nehemiah 8:10 • 2 Corinthians 12:9 • Ephesians 6:10 • Philippians 4:13

GOD PROMISES COMPLETE SANCTIFICATION

*"Being confident of this, that he who began a good work in you
will carry it on to completion until the day of Christ Jesus."*

PHILIPPIANS 1:6

RECITE GOD'S GOODNESS

God Most High, You are holy in all Your ways, and You alone are powerful to
sanctify me through and through. How good You are to promise to finish what
You started in me!

EXPRESS YOUR NEEDINESS

Lord, continue purifying me, burning away the remnants of the world and
sinful flesh with Your purifying fire, no matter how painful it may seem in the
moment. I want to be a vessel of honor for You, set apart for Your righteous
works in this world by Your Spirit living in me.

SEEK HIS STILLNESS

*Ponder the reality that God is committed to finishing His work of sanctification in
your life. You need not try harder to be good, but only surrender to Him and rest in
the work He's already doing. So be still with Him, opening your heart to what He
may want to say to you even now.*

TRUST HIS FAITHFULNESS

Heavenly Father, I trust You to complete Your sanctification in me that I may
be mature and complete, not lacking anything, to the praise, glory, and honor
of Jesus Christ my Lord.

For Further Prayer and Study

John 17:18–19 • 1 Corinthians 1:8 • Philippians 1:9–10 • James 1:2–4 • 1 Peter 1:6–7
2 Peter 1:3–4

GOD PROMISES WISDOM TO THOSE WHO ASK

*"If any of you lacks wisdom, you should ask God, who gives generously
to all without finding fault, and it will be given to you."*

JAMES 1:5

RECITE GOD'S GOODNESS

Generous Lord God, You are the fountain of all wisdom, and from Your mouth
come knowledge and understanding. How precious is Your promise to share
Your wisdom with us!

EXPRESS YOUR NEEDINESS

Lord, if fearing You is the beginning of wisdom, then I want to learn what it
means to fear You. Help me always acknowledge Your sovereign control of the
world and humbly submit myself to Your reign. Increase my knowledge of You
and grant me supernatural understanding in my work and relationships.

SEEK HIS STILLNESS

*Pause to consider where you need God's wisdom in your life right now: What conversations
or decisions require good judgment or divine direction? Bring all those relationships before
the Lord, and rest in His wisdom freely and generously given to you today.*

TRUST HIS FAITHFULNESS

Lord God, wisdom and power, counsel and understanding belong to You alone,
and You are generous and kind to share Your knowledge and discernment with
me. Give me wisdom to discern where Your Spirit is leading and help me trust
You with the outcomes.

For Further Prayer and Study

Ecclesiastes 2:26 • Proverbs 2:6–7; 9:10 • Job 12:13 • Daniel 2:20–22 • 1 Corinthians 1:30

GOD PROMISES TO TEACH US THROUGH HIS WORD

"But the Advocate, the Holy Spirit, whom the Father will send in my name, will teach you all things and will remind you of everything I have said to you."

JOHN 14:26

RECITE GOD'S GOODNESS

My Divine Teacher, You are good and upright in all Your ways, and You guide the humble in what is right and teach us Your way. All Your ways are loving and faithful, so I praise You!

EXPRESS YOUR NEEDINESS

Lord God, I'm an eager student, ready to receive Your divine instruction through Your Spirit at work in me. Teach me Your ways as I study Your Word that I may walk in Your truth. Give me an undivided heart to be quick to obey Your every instruction.

SEEK HIS STILLNESS

The psalmist writes that "The LORD confides in those who fear him; he makes his covenant known to them" (Psalm 25:14). What might that look like in your life? Be still with Him, and wait upon the Lord.

TRUST HIS FAITHFULNESS

Lord, You promise to instruct and teach me in the way I should go, counseling me with Your loving eye on me. I rest in Your promise, trusting that You will teach me everything I need to know, leading me firmly on Your path, today and all the days of my life.

For Further Prayer and Study

Psalms 25:8–10, 12–14; 32:8 • Proverbs 15:33 • John 16:13 • Philippians 3:15
2 Timothy 3:16–17

GOD PROMISES TO GUIDE US THROUGH HIS SPIRIT

"He calls his own sheep by name and leads them out. When he has brought out all his own, he goes on ahead of them, and his sheep follow him because they know his voice."

JOHN 10:3-4

RECITE GOD'S GOODNESS

Lord Jesus, You are the Good Shepherd who tenderly guides His sheep through the dangers of life. You lead me to green pastures and make me lie down beside still waters. You restore my soul. You are so good!

EXPRESS YOUR NEEDINESS

Precious Shepherd, open my ears to hear Your voice guiding me in every moment and every decision. Make my spirit sensitive to Your leading, so that I would hear a whisper in my ear telling me which way to go.

SEEK HIS STILLNESS

Sit quietly with the One who knows you by name and guides you with His own presence. Let Him lead you now to a place of stillness and restoration, and just rest with Him.

TRUST HIS FAITHFULNESS

Lord God, thank You for not allowing me to stumble and bumble on my own; instead, You've been faithful to give me Your own Spirit to guide me in all truth. I trust You to show me the way all the days of my life.

For Further Prayer and Study

Psalms 13:1–3; 23; 48:14; 86:11; 139:9–10 • Isaiah 30:21 • John 14:26; 16:13

GOD PROMISES TO PROVIDE FOR US

"And my God will meet all your needs according to the riches of his glory in Christ Jesus."

PHILIPPIANS 4:19

RECITE GOD'S GOODNESS

Heavenly Father, You know all of my needs, and You generously provide everything I need, often before I even ask for it! How good You are to take care of me and my family. You are able to bless me abundantly in all things at all times. I praise You!

EXPRESS YOUR NEEDINESS

Lord, sometimes I hesitate to tell You my needs and desires because I don't want to treat You like a divine vending machine. Help me overcome my fear and learn how to humbly bring all my requests to You, trusting that if I'm doing it wrongly, You will gently and tenderly correct me.

SEEK HIS STILLNESS

Bring before the Lord now all your needs and desires. Place them before Him, and then rest in the assurance that He will take care of you.

TRUST HIS FAITHFULNESS

Truly, no good thing do You withhold from those who trust in You! So I place the weight of my entire being—all my future hopes, all my loved ones—into Your loving hands. I trust You, Lord God, with every atom of my being. You are good and You do only good. I rejoice in You!

For Further Prayer and Study

Leviticus 26:3–5 • Psalm 37:25 • Matthew 6:25–33 • Luke 12:30–32 • 2 Corinthians 9:8

GOD PROMISES TO REWARD FAITH

"And without faith it is impossible to please God, because anyone who comes to him must believe that he exists and that he rewards those who earnestly seek him."

HEBREWS 11:6

RECITE GOD'S GOODNESS

How kind of You, my God and heavenly Father, to reward all those who earnestly seek You! Unlike our human relationships rife with selfishness and fear, You generously pour out Your riches to all who believe in You. I praise You, Lord! Blessed be Your name!

EXPRESS YOUR NEEDINESS

Lord, as I read this verse I can't help but wonder if my faith pleases You. It seems like my faith is so small most days, hardly even the size of a mustard seed. So would You increase my faith? Would You help me believe You for big and bold things that only You can do in and through my life?

SEEK HIS STILLNESS

Rest in the promise that God rewards those who seek Him with their whole heart. What might that look like for you today?

TRUST HIS FAITHFULNESS

Lord, even the faith to believe in You is a gift from You; truly, I have nothing to offer of my own except my very self. So here I am. I trust You completely because You have always proven Yourself faithful. My soul rests in You, not for the promised reward, but for the joy of Your own presence.

For Further Prayer and Study

Matthew 17:20 • Mark 9:24, 41 • Colossians 3:23–24

GOD PROMISES ESCAPE FROM TEMPTATION

"Submit yourselves, then, to God. Resist the devil, and he will flee from you."

JAMES 4:7

RECITE GOD'S GOODNESS

Almighty God, You are my help and my salvation. I praise You for Your presence within me, for You are greater than my enemy, and You have overcome.

EXPRESS YOUR NEEDINESS

So Lord, give me eyes to see the escape route You've opened for me. Make me sensitive to Your Spirit prompting me toward obedience, and make my feet quick to run in the path of Your commands. Deliver me from evil; empower me to escape temptation; save me from sins that I'm aware of committing, and gradually convict me of sins I'm completely unaware of.

SEEK HIS STILLNESS

Be still before our Great High Priest, taking inventory of any area of your life that is not completely submitted to Him. Lift your hands in absolute surrender, and allow Him to quiet you with the assurance of His presence in your most difficult temptation.

TRUST HIS FAITHFULNESS

God, thank You for Your faithfulness to not allow me to be tempted beyond what I can bear. I'd prefer a life free of temptation, but while I live in this body, help me trust You to always provide a way of escape so that I can resist the devil. Then I will rejoice in Your deliverance, as I anticipate the day You will finally crush Satan under our feet.

For Further Prayer and Study

Psalm 37:39–40 • John 16:33 • Romans 16:20 • 1 Corinthians 10:13 • Hebrews 4:14–16
1 John 4:4

GOD PROMISES VICTORY OVER SUFFERING

"Blessed is the one who perseveres under trial because, having stood the test, that person will receive the crown of life that the Lord has promised to those who love him."

JAMES 1:12

RECITE GOD'S GOODNESS

Compassionate and Conquering Lord, if You are for me, who can be against me? Thank You for the reassurances of Your presence even in the darkest night and for the comfort of Your Spirit when I feel alone. You are good, and You are kind, and my lips will always praise You!

EXPRESS YOUR NEEDINESS

So Lord God, fight for me when I cannot. Strengthen me when I feel like I'm ready to collapse. Comfort me by Your Spirit, and empower me to not fear what I am about to suffer, but instead to cling to You in steadfast and immovable faith.

SEEK HIS STILLNESS

Bring an awareness of God's presence with you in your current trial, knowing that He is strengthening you this very moment. Take this time to rest in His presence.

TRUST HIS FAITHFULNESS

I cannot persevere in my own power, so I trust You to strengthen me to remain faithful even to the point of death, knowing that I would awake to see Your face, and all will be worth it in the end.

For Further Prayer and Study

Psalm 27:1–2 • Romans 5:3; 8:31 • James 1:12 • 1 Peter 1:4–7 • Revelation 2:10

GOD PROMISES ETERNAL LIFE

"I give them eternal life, and they shall never perish; no one will snatch them out of my hand. My Father, who has given them to me, is greater than all; no one can snatch them out of my Father's hand."

JOHN 10:28–29

RECITE GOD'S GOODNESS

Father God, You are greater than all, high and exalted as King of the universe. You are the Creator of life, and when You resurrected Jesus to eternal life, You graciously offered that same eternal life to all who believe in You. How great and precious is Your promise of life everlasting!

EXPRESS YOUR NEEDINESS

Lord God, help me live this day in light of eternity with You. Give me wisdom and patience to keep temporal annoyances in perspective, and grant me diligence and joy to serve with an eternity mindset.

SEEK HIS STILLNESS

Jesus said that eternal life is knowing Him (see John 17:3), because He is life (John 1:4). How is He inviting you to know Him and grow in this eternal life with Him on this side of eternity?

TRUST HIS FAITHFULNESS

Lord Jesus, nothing and no one can snatch Your people away, for You hold us firmly and securely—forever. Your almighty power brings me great comfort, so I rest in the assurance that You hold my eternity in Your hands.

For Further Prayer and Study

Matthew 25:46 • John 3:16–17; 6:39; 17:2–3

GOD PROMISES JESUS WILL RETURN SOON

"You too, be patient and stand firm, because the Lord's coming is near."

JAMES 5:8

RECITE GOD'S GOODNESS

Lord Jesus, I've never seen You face-to-face, but my heart knows You so well, and I rejoice with an inexpressible joy at the thought of seeing You soon! Thank You for Your promise to unite us with Yourself that we may be with You forever. What a glorious day that will be!

EXPRESS YOUR NEEDINESS

I confess that Your return is not top-of-mind most days. Impress on my soul a sense of expectation and excitement. Fill me with urgency to faithfully do the work You've called me to do, not out of fear, but out of sheer joy.

SEEK HIS STILLNESS

Spend time with Jesus, just being with Him, letting His presence guide you into what your time of stillness ought to look like today. Though He is untouchable, He is approachable through His Spirit in you. Relish His presence.

TRUST HIS FAITHFULNESS

King Jesus, if Your coming was considered "soon" two thousand years ago, how much more is it today! Whether I live to see Your return, or it's in my children's or grandchildren's generation, I trust You to keep Your promise, and I want to be found watching and waiting, ready for You with open arms!

For Further Prayer and Study

John 14:2–3, 28 • Acts 1:11 • 1 Thessalonians 4:16–17 • Hebrews 9:28 • James 5:8
Revelation 1:7

GOD PROMISES TO RESTORE HEAVEN AND EARTH

"But in keeping with his promise we are looking forward to a new heaven and a new earth, where righteousness dwells."

2 PETER 3:13

RECITE GOD'S GOODNESS

Creator and Redeemer God, You first fashioned the heavens and the earth, and You are committed to restoring them to glory. Thank You for being a God who redeems, not discards, and in Your infinite creativity, You will make everything beautiful again.

EXPRESS YOUR NEEDINESS

Lord, while we await the (re)creation of the new heaven and earth, guard us from carelessness and entitlement, as if this earth was ours to trash because it will all burn. Give us wisdom and humility to see this world as Your creation, and to steward it well because it belongs to You.

SEEK HIS STILLNESS

Bring to mind the most beautiful places in nature that you've seen in your lifetime. What do they each say about our Creator? Be still with Him, and let His grandeur quiet your heart.

TRUST HIS FAITHFULNESS

Lord, as I look around this earth You created, there are still so many wondrous places I haven't yet visited, and they all tell of Your glory. I can't imagine the great and wonderful things You will create in the coming kingdom and all that You've prepared for those who love You.

For Further Prayer and Study

Isaiah 65:17; 66:22 • 1 Corinthians 2:9 • Hebrews 12:26–27 • 2 Peter 3:12–13
Revelation 21:1

GOD PROMISES TO AGAIN DWELL IN US

*"For we are the temple of the living God. As God has said:
'I will live with them and walk among them, and I will be their God,
and they will be my people.'"*

2 CORINTHIANS 6:16

RECITE GOD'S GOODNESS

What a great and precious promise You've given us, Lord God—that You will actually live with us and walk among us, as You did in the garden of Eden. Such proximity and generosity is too wonderful for me to comprehend.

EXPRESS YOUR NEEDINESS

Precious Jesus, when I think of the disciples walking with You those three years, actually seeing Your face and hearing Your laughter and experiencing Your physical touch, there's a deep longing within me for those things too.

SEEK HIS STILLNESS

Sit quietly with the Lord. What does He want to say to you? Is there anything you want to say to Him?

TRUST HIS FAITHFULNESS

You are altogether faithful and trustworthy, Lord God, and I can't wait for the day You will dwell with us in bodily form. Until then, help me represent You to people around me. I trust You with my relationships, my conversations, and my tasks today.

For Further Prayer and Study

John 1:10–14 • 1 Corinthians 2:8–10 • 1 Peter 1:4–5 • 2 Peter 1:10–11; 3:13
Revelation 21:1–6

WHERE DO WE GO FROM HERE?

YOU'VE FINISHED! Whether you've prayed through all 365 prayers, or you just thumbed through some of the prayers on your way to the back of this book, I hope the words of the psalmist in Psalm 62:1 have become your heart's anthem as well:

"Truly my soul finds rest in God."

Before you put this book down and move on to the next thing, take a few minutes to reflect on how you've grown in your prayer habit over the course of time.

What have you learned about God? (Journal your thoughts below.)

What did you learn about yourself?

How have you grown in your prayer habit?

What did you enjoy most about your Prayers of REST habit?

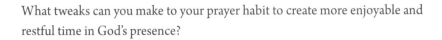

What tweaks can you make to your prayer habit to create more enjoyable and restful time in God's presence?

What would you like to say to God as you reflect on your seasons of Prayers of REST? In the space below, write a few words of worship, praise, gratitude, or rededication.

If you've felt your heart stirred by God to enjoy Him and rest in His presence, that's fantastic! I hope you take some time to celebrate with Jesus and with someone else who will cheer you on! Continue your daily Prayers of REST habit, either by starting this book over again with a friend, picking up a collection of prayers that address a current need, or using the REST prayer format to pray through a Bible reading plan (like one of the many found at *prayersofrest.com/resources*).

Next, connect with others in your local church and look for ways to serve and continue to grow in community. You can find more studies and devotionals for individual and group use at *asheritah.com*, including my 31–day *Bible and Breakfast* devotional and cookbook!

Last, I would love for you to share Prayers of REST with a few of your friends.

If you've found rest for your soul in God's presence over the last few weeks or months, wouldn't they want that too? What would it look like to invite another person or two into that experience with you?

Maybe you could bring a together a group of women to meet once a week for prayer, using the REST prayer format as a guide. Or perhaps you could invite a few young moms into your home to pray over your children once a month. Maybe you can invite friends from around the country to join you in a private Facebook group or via text message to pray together through a collection you've all agreed you need prayer in. I would love to hear about how you're using this book and prayer method to disciple others into God's kingdom! The possibilities are endless!

Whatever your next steps look like, I pray you will continue your daily Prayers of REST habit and develop new spiritual habits that help you enjoy Jesus more each day! And remember that the *Prayers of REST* podcast is just a click away, and it would be my joy to guide you into God's presence in these weekly 10-minute prayers. You can find the podcast at *prayersofrest.com*.

In closing, I hope you discover for yourself this truth about God penned by St. Augustine so long ago:

> *"You stir man to take pleasure in praising you,*
> *because you have made us for yourself,*
> *and our heart is restless until it rests in you."*[1]

May you always find your rest in God's presence.

Asheritah

CALENDAR INDEX

ACKNOWLEDGMENTS

I'M SO GRATEFUL for those precious women who joined me in the early days of the lockdown for daily prayer on Instagram. Your presence made me feel less lonely, your prayers bolstered me to keep going, and your testimonies affirmed that our God was indeed doing something bigger with this Prayers of REST than any of us could have imagined.

A big thank you to the *Prayers of REST* podcast listeners, who join together around the world to lift up our prayers to our Savior and God. Your prayers are a fragrant aroma before God's throne, and they're an unbelievable blessing to me. Thank you for letting me lead you in prayer each week through the podcast. I hope this book becomes a precious resource for times of prayer in between episodes.

Thank you, Pastor Mike, for generously giving your time and attention to reviewing the manuscript. Your keen eye and shepherd's heart make this book that much stronger. May it serve to resource the church and equip the saints.

As always, a giant shout out to Judy and the whole team at Moody Publishers. I'm so grateful to partner with you in the gospel. What a privilege it is to get to do this together!

Tawny, for all the texts and emails and phone calls, thank you. I wouldn't want to do this without you. (But still, remind me not do *this* again, okay?)

Kindra, thanks for your help gathering some of those cross-references, for managing my inbox while I focused on the deep work, and for filling in the gaps. I'm so grateful for you.

Handsome Man, it's your steadfast love and belief in me that kept me going day after day after long day, even when COVID unexpectedly burst into our home. What can I say? We make a great team.

Darling Carissa, Amelia, and Theo, the last 100 devotionals would have been a lot less fun without your help coloring in the bubbles! Thank you for your prayers, your cheers, and your cuddles. I just *love* being your Mama!

Precious Savior, *You know*. Thank You.

NOTES

Let's Get Started

1. This same survey found that only 2 percent of respondents are "very satisfied" with their prayer lives. "Infographic: How Is Your Prayer Life?" Crossway, November 2, 2019, https://www.crossway.org/articles/infographic-how-is-your-prayer-life/.

2. I was first introduced to this concept of practicing God's presence in college, when I picked up the booklet *The Practice of the Presence of God* by the seventeenth-century monk Brother Lawrence.

3. James Clear, "The Law of Least Effort" (essay), published in *ATOMIC HABITS: An Easy and Proven Way to Build Good Habits and Break Bad Ones* (London: Random House, 2019), 48, 151.

4. I'd always wanted to be the kind of person whose prayers were anchored in Scripture, but I didn't quite know *how* to do that until God led me to two books: *Praying God's Word: Breaking Free from Spiritual Strongholds* by Beth Moore (Nashville, TN: B&H Publishing Group, 2009) and *Face to Face: Praying the Scriptures for Intimate Worship* by Kenneth Boa (Grand Rapids, MI: Zondervan, 1997).

5. "Breathing more deeply allows for more carbon dioxide to enter your blood, which quiets down parts of the brain, like the amygdala, that handle your anxiety response. More carbon dioxide also helps synchronize your heartbeat and breathing." McKenna Princing, "This Is Why Deep Breathing Makes You Feel So Chill," Right as Rain by UW Medicine, June 4, 2018, https://rightasrain.uwmedicine.org/mind/stress/why-deep-breathing-makes-you-feel-so-chill#:~:text=Take%20longer%20breaths%2C%20counting%20to,your%20body%20feeling%20more%20relaxed.

6. Brother Lawrence explains the importance of this intentional reflection as follows: "We must know before we can love. In order to know God, we must often think of Him; and when we come to love Him, we shall then also think of Him often, for our heart will be with our treasure." Joseph de Beaufort, *The Practice of the Presence of God: Being the Conversations and Letters of Brother Lawrence* (Nicholas Herman of Lorraine), (United Kingdom: H.R. Allenson, 1906), 50.

7. I was struck by the lack of confession in my life—and how deeply this lack affected my relationship with Jesus—in the summer of 2020 when a friend put the book *Humility* by Andrew

Murray in my hands. He ends his chapter on humility and sin with this caution: "Being occupied with self, even having the deepest self-abhorrence, can never free us from self. It is the revelation of God . . . *it is only grace that works that sweet humility which becomes a joy to the soul as its second nature*" (italics added). I've since come to realize the utter necessity of regularly confessing not only my sin but also my need for God's grace and the wonder of His forgiveness to a thriving life of constant communion and communication with God. Andrew Murray, "Humility and Sin," in *Humility*, ed. Lore Ferguson Wilbert, *Read & Reflect with the Classics* (Nashville, TN: B&H Publishing, 2017), 66–69.

8. I first wrote this sentence in the introduction of my Advent devotional *Unwrapping the Names of Jesus* (Chicago: Moody, 2017).

9. BJ Fogg describes it this way: "Difficult behaviors require a high level of motivation. . . . When a behavior is easy, you don't need to rely on motivation. . . . A good tiny behavior . . . takes less than 30 seconds of effort [and] doesn't create pain or bad emotions." BJ Fogg, "Start Tiny," Tiny Habits, 2017, https://sites.google.com/view/learn-tiny-habits/3-start-tiny?authuser=0.

10. BJ Fogg calls this his "Tiny Habits recipe," and James Clear refers to this as "habit stacking" (Clear, 73–74).

11. James Clear explains: "Your brain is a reward detector. As you go about your life, your sensory nervous system is continuously monitoring which actions satisfy your desires and deliver pleasure. Feelings of pleasure and disappointment are part of the feedback mechanism that helps your brain distinguish useful actions from useless ones. Rewards close the feedback loop and complete the habit cycle" (Clear, 49).

12. I'm constantly coming up with new and creative ways to enjoy God's presence, and once again, behavior science helps us understand why this principle works, because "habits are a dopamine-driven feedback loop. When dopamine rises, so does our motivation to act" (Clear, 111).

Finding Quiet Rest

1. I find myself indebted to *Valley of Vision*, the collection of Puritan prayers, for helping me think creatively about ways to begin my prayers, addressing God in myriad ways based on His revealed attributes in Scripture.

The Simple Gospel

1. This collection on the names of Jesus is inspired by my Advent devotional *Unwrapping the Names of Jesus* (Chicago: Moody, 2017), and originally appeared as a mini-series on my *Prayers of REST* podcast in November 2020–January 2021. Listen to 10-minute prayer episodes based on each name included in this collection at prayersofrest.com.

2. This collection on the love of Jesus is inspired by my Lent devotional *Uncovering the Love of Jesus* (Moody, 2020), and originally appeared as a mini-series on my *Prayers of REST* podcast in February–March 2021. Listen to 10-minute prayer episodes based on this collection and more at prayersofrest.com.

The People of Jesus

1. This collection on the Fruit of the Spirit originally appeared as a mini-series on my *Prayers of REST* podcast in April–May 2021. Listen to the archived episodes at prayersofrest.com.

2. Tim Keller's sermon on the Beatitudes helped me better see how Jesus fulfilled all these aspects of a Kingdom-minded life, and how we can follow in His example. This sermon was preached at Redeemer Presbyterian Church on April 22, 2012 as part of the series "Savior and Teacher—A Study of Matthew," and was accessed via podcast on March 12, 2021.

Prayers for Others

1. I've learned so much about praying for my husband from *The Power of a Praying Wife* by Stormie Omartian (Harvest House, 1997), and while this collection is not based on that book, the way I pray for my husband has been deeply informed and shaped by that book.
2. This prayer is inspired by Andrew Murray's book *Absolute Surrender* (Nashville, TN: B&H Books, 2017).
3. Andrew Murray, *Absolute Surrender* (Nashville, NT: B&H Books, 2017), 4.
4. Ibid., 14.
5. This prayer is often attributed to Jonathan Edwards but has been cited as being spoken by evangelist Duncan Matheson: John Macpherson, *Life and Labours of Duncan Matheson: the Scottish Evangelist* (London: Morgan and Scott, 1871), 244.

Prayers for Myself

1. I am indebted to Mark Bubeck's excellent book *Warfare Praying: Biblical Strategies for Overcoming the Adversary* (Chicago: Moody, 1984, 2013) for his insight into the armor of God, how it reflects the person and work of Jesus Christ, and how we are to practically apply this Ephesians passage to our daily lives. While I've endeavored to make these prayers my own, I've been deeply inspired by his work, and no doubt you'll find echoes of his book in these prayers.
2. This entire collection is inspired by Beth Moore's fabulous book *Praying God's Word: Breaking Free from Spiritual Strongholds* (Nashville, TN: B&H Books, 2009).
3. Ibid., 39.
4. This collection is based on my book *Full: Food, Jesus, and the Battle for Satisfaction* (Moody, 2017). Find out more at thefull.life.

Prayers for Every Moment

1. For a more liturgical approach to prayers for everyday ordinary moments of our lives, I highly recommend *Every Moment Holy* by Douglas McKelvey (Rabbit Room Press, 2019).
2. A version of this prayer first appeared in my blog post "A Prayer for First Thing in the Morning," https://onethingalone.com/a-prayer-for-first-thing-in-the-morning/, which includes a free printable and video of the extended prayer.
3. John Calvin's "Prayer Upon Beginning One's Work or Study," in *Prayer: Experiencing Awe and Intimacy with God* by Timothy Keller (New York: Penguin Group USA, 2014), 265.

House Prayers

1. I first heard about praying for a house in college, when a family I lived with during a summer internship moved into a new home and prayed over each room. I was intrigued and thought I might do that someday too, but it wasn't until the last week of writing this manuscript that I

actually did it myself. On a bright sunny Saturday afternoon, I invited my Instagram community to join me on a live prayer video, and together with readers from around the world we walked through every room of my house, praying as we went. You can find a replay of that video, as well as additional resource for home prayers, at prayersofrest.com.

Resting in the Promises of God

1. When I originally presented my publisher with the idea for a book of prayers, I had thought all 365 prayers would be based on promises from Scripture. And although promise-based prayers only ended up being a tenth of this book, I hope this collection still serves to help you root your prayers in who God is and what He has promised to His children. I encourage you to invite a few friends and pray through this section as part of a monthlong challenge, and share with one another how you're seeing God change you and move in your life. What a beautiful way that would be to grow in prayer together!

Where Do We Go from Here?

1. St. Augustine, *The Confessions*, translated by Henry Chadwick (Russia: OUP Oxford, 2008), 3.

Are you starting your day on empty?

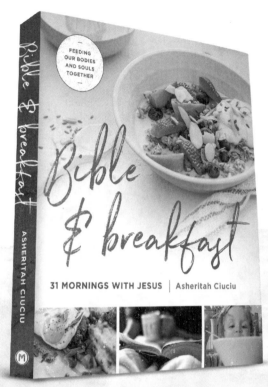

978-0-8024-1935-4

Kickstart a morning habit of meeting with Jesus and eating a healthy breakfast every day. Join Bible teacher and author Asheritah Ciuciu for 31 devotions for busy women and 31 breakfast recipes that are healthy enough for you to feel good about and tasty enough that your kids will eat them.

Discover the Secret to a Full Life

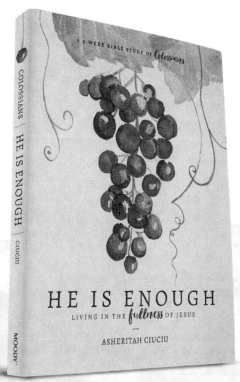

978-0-8024-1686-5

In this 6-week study of Colossians, Asheritah Ciuciu leads readers to discover the life-altering importance of Jesus' sufficiency and sovereignty. With short meditations for busy days, dig-deep study for days you want more, and supplemental service challenges for leaders, you can study the way that helps you the most.

Also available as an eBook

MOODY
Publishers®

From the Word to Life®